THE REAL LIFE AND
CELESTIAL ADVENTURES OF
TRISTAN TZARA
+ Marius Hentea

THE MIT PRESS
CAMBRIDGE, MASSACHUSETTS
LONDON, ENGLAND

MIT Press books may be purchased at special quantity discounts for business or sales promotional use. For information, please email special_sales@mitpress.mit.edu.

This book was set in Garamond Premier Pro and Helvetica Neue Pro by The MIT Press. Printed and bound in Canada.

Library of Congress Cataloging-in-Publication Data
Hentea, Marius.
TaTa Dada: the real life and celestial adventures of Tristan Tzara / Marius Hentea.
pages cm
Includes bibliographical references and index.
ISBN 978-0-262-02754-0 (pbk. : alk. paper)
1. Tzara, Tristan, 1896–1963. 2. Authors, French–
20th century–Biography. 3. Dadaism–France. I. Title.
PQ2639.Z3Z68 2014
841'.912—dc23
[B]
2013048605

10 9 8 7 6 5 4 3 2 1

CONTENTS

ACKNOWLEDGMENTS

Many years have gone into this book, and many debts have been accumulated in its writing. The deepest debts are personal, and in this case my wife, Elise, gave unstintingly of her time and expertise in helping me complete the manuscript. Without her constant support and encouragement, the final result would have been poorer and less of a joy to work on. My family is relieved to see this work completed, and their help throughout the time of its writing was incredibly important. My father checked the Romanian translations, but any faults that remain are of course mine. A number of friends read from portions of the manuscript or proved themselves unfailing in their encouragement.

Colleagues at Warwick University, the Université Paris-V, New York University in Paris, and now Ghent University have helped this project along. My great thanks to my current colleagues in the Department of Literary Studies at Ghent; it is a daily pleasure to be in such a supportive environment.

The entire team at the MIT Press has been extraordinary. My special thanks to Roger Conover for having faith in this project from the start and shepherding it to the end. Much praise needs to be given to Matthew Abbate, Justin Kehoe, and Gillian Beaumont as well.

A work like this could not have been written without the help of archivists and librarians. In Belgium I would like to thank the librarians at the Faculty Library at Ghent University and the staff of the interlibrary loan department at the Ghent University Library, as well as librarians at the Royal Library of Belgium and Ouiam Jouiyed at the Maison Internationale de la Poésie. In France I would like to thank the librarians and archivists at the American Library in Paris, Étienne D'Alençon at the Archives départementales du Lot, Pierre Boichu at the Archives départementales de Seine-Saint-Denis, the archivists at the Bibliothèque Littéraire Jacques Doucet, and the staff at Bibliothèque Nationale de France. In Romania my heartfelt appreciation to the librarians and archivists at the Arhivele Naționale ale României in Bacău, and in Bucharest the Serviciul Municipiului al Arhivelor Naționale, the Muzeul Național al Literaturii Române, the Muzeul Național de Istorie a României, the Library of the Romanian Academy, and the University Library of the University of Bucharest. In Switzerland, Thomas Rosemann at the Zurich Kunsthaus must be thanked, as well as librarians at the Zurich Baugeschichtliches Archiv and the Schweizerisches Sozialarchiv. In the United Kingdom, librarians at the British Library and the University of Warwick were instrumental in the work's early stages. In the United States, the staff at the Beinecke Rare Book and Manuscript Library at Yale University, the Houghton Library at Harvard University, the Newberry Library in Chicago, and Harvard's Widener Library were exceedingly helpful. Timothy Shipe of the Special Collections Department of the University of Iowa Libraries deserves endless praise for his generosity.

A number of people proved generous with their time. I would particularly like to thank Christophe Tzara, Tzara's son, who encouraged this project from the start. Mira Rinzler, Tzara's niece, was a source of valuable information about the Rosenstock family. Dadi Janco proved generous in her help. Michel Sanouillet welcomed me into his beautiful home on the outskirts of Nice. Both Serge Fauchereau and Giovanni Lista shared their considerable expertise. Vasile Robciuc was a wonderful companion in showing me around Tzara's hometown of Moineşti. I would also like to thank the Archipenko Foundation, Philippe Borgeaud, Alain Bouret, Marie-Claude Char, Comité Marc Chagall, Comité Giacometti, Comité Picabia, Jonas Ellerström, Bertrand Fillaudeau, Stephen Forcer, Jacques Fraenkel, Michèle Girard, René Guerra, Daniel Heller-Roazen, Anthony Hobson, Vicente García-Huidobro, Jean Jamin, Isabelle Jan, Julie Legrand, Walburga Krupp, Michael Lonsdale, François de Massot, Jacqueline Matisse-Monnier, Carlo Meriano, Maria Murguia (Artists' Rights Society), Catherine Noone, Pilar Ortega, Marthe Prevot, Anne Quarles, Jean Ristat, Catherine Rizea-Callois, Cecilia Sjöholm, Louise Van Moorsel, and Barbara Will.

A generous research grant from the Romanian Cultural Institute allowed me to make a number of research trips in Bacău and Bucharest. My deepest thanks.

Portions of this work have appeared in slightly different forms, and I am grateful to the editors and anonymous reviewers for their comments on my work. Portions of chapters 1–3 appear in "On the Outskirts of Modernity: Tristan Tzara and Dada in Romania," *Modernist Cultures* 8, no. 2 (Autumn 2013), and "The Education of Samuel Rosenstock," *Dada/Surrealism* 20 (2014). Portions of chapters 8 and 9 appear in "Federating the Modern Spirit: The 1922 Congress of Paris," *PMLA* (forthcoming); a section of chapter 10 appears in "The Aristocratic Avant-Garde: Le Comte de Beaumont and 'Les Soirées de Paris,'" *Neohelicon* (forthcoming).

1 "COME WITH ME TO THE COUNTRYSIDE": 1896–1906

IT TOOK SIX YEARS FOR THE BIBLIOTHÈQUE LITTÉRAIRE JACQUES DOUCET IN PARIS TO ARCHIVE TRISTAN TZARA'S FIFTY-FOUR BOOK MANUSCRIPTS AND OVER 4,000 LETTERS, POSTCARDS, AND TELEGRAMS, SOME SAYING NO MORE THAN THAT A FRIEND WOULD BE LATE FOR DINNER. This collection of almost every scrap landing in Tzara's lap did not contain a birth certificate. He received a "corrected" version in 1925, but its loss could be explained by a life marked by dislocation: from the Romanian provinces to Bucharest, Switzerland during World War I, bohemian 1920s Paris, the depression years and the Spanish Civil War, on the run and a *résistant* under Vichy, and then long years of privacy and rebuilding after the war. But if "there is no beginning and yet we don't tremble, we are not sentimental," is a birth certificate anything but an unassuming sheet of paper that will yellow with time, its ink fading and edges torn?[1] One is better off writing one's own, as Tzara did in 1922:

> **TZARA:** born at Constantinople, 22 January 1903, 63 kg, straight nose, short black hair, round face, broad forehead, distinguishing signs: 4 ears. Took courses in pure philosophy at the University of Sofia, injured in the Bulgaro-Serbian War of 1913. Engaged in the oak trade, has published 220 poems in Paris, 1st floor, 1st door on the right, has won many chess matches, height 1.90 m.[2]

The date and place of birth are fabricated and the physical description is wildly off, but his official birth certificate was no better at establishing an objective truth. Lodged in a dusty folder in a provincial archive, it states that "Samueli Rosenştok" came into the world in Moineşti, county Bacău, Romania, on 16 April 1896 at 11:30 p.m.[3] Not only was his name (Samuel Rosenstock) misspelled, but the farce of the official birth certificate continued when he changed it: a notary mark states that his surname—which variously appeared on the form as "Rosenştok," "Rostinstoch," and "Rozinstök"—was now "Tristan-Tzara," making his legal name "Samueli Tristan-Tzara"!

Because the form was dated 17 April, most schools considered that to be his date of birth (later in life, Tzara marked his date of birth as 14 April). But there is a compelling reason to rectify this bureaucratic error. Because Romania used the Julian calendar until

1919, Tzara's date of birth by the modern calendar is 28 April. In the wildest of coincidences, the Romanian Orthodox Church celebrates Saint Dada on that day.[4] The story is as follows: during the time of the Roman emperor Diocletian, three individuals named Cvintilian, Dada, and Maxim were caught professing Christianity. On their first night in jail, in Oxovia on Romania's southeastern coast, the devil came to tempt them: renounce your faith for your freedom. When they turned to prayer, an angel of God came to strengthen their faith. Refusing to renounce Christ, they were decapitated.

If Romanian newborns are often named after their saint's day, Saint Dada's story exceeds even a Balkan lullaby. Filip and Emilia Rosenstock, though, were Jewish. Presaging their fierce and at times overbearing parental love, they chose the name Samuel, who in the Old Testament is born in answer to his mother's prayers. "My mother my mother you wait in the amassed snow," Tzara wrote in "The Great Complaint of My Obscurity Two," an image of hopeless waiting that equally informs the story concerning his biblical namesake.[5] In time, though, this "newborn transformed into a rock of granite too hard and too heavy for his mother" would make his name synonymous with Saint Dada.[6]

Throughout his life Tzara kept a mysterious aura about his origins. He refused to divulge his given name to Michel Sanouillet, who was writing a thesis on Paris Dada based on Tzara's personal archive.[7] René Lacôte's 1952 book on Tzara for the prestigious *Poètes d'aujourd'hui* series begins in Zurich 1916, as if the first twenty years of Tzara's life did not count.[8] A half-century later, François Buot begins his biography of Tzara by stating that it is not easy to find any trace of his subject's early life.[9] But as the obituary in *Le Figaro Littéraire* put it, "Dada was born in Romania, Tristan Tzara died in Paris." Tzara's pseudonym seems to bear upon these years: *trist* in Romanian means "sad," and "Tzara" is pronounced like the word for countryside or nation, *țară* ("ț" is sounded "ts"), so the resultant "*trist en țara*" would mean "sad in the country." (When hunting for a pseudonym, Tzara first spelled it "Țara.") But the correct expression is *trist la țară*, casting some doubt on a direct translation. When asked about this, Tzara only smirked. His pseudonym is an incomplete effacement of his origins, the seemingly cosmopolitan name turning out to have a particular ancestry, and perhaps even a particular meaning, but it can all be denied.

On the opening night of the Cabaret Voltaire, Tzara was not yet twenty years old and had been in Switzerland for only a few months. The poems that he declaimed that night were in Romanian.[10] "It is hard to imagine," in other words, that Tzara left his native country "*tabula rasa*."[11] Although some interest in the Romanian context of Dada has surfaced recently, such as Tom Sandqvist's *Dada East: The Romanians of Cabaret Voltaire*, much more work needs to be done.[12] Tzara's immersion into poetry and modern art first occurred in Romania; not only were some of his poems published in the country's leading literary reviews, but he also edited two different reviews himself. When his Romanian-language poems were published in the early 1930s, he objected to the title "Poems before Dada"

because it gave the impression of a "rupture."[13] These poems are not without value; they are filled with extravagant wordplay as well as a lyricism that could be disrupted but never dislodged. Eugène Ionesco knew them by heart.

All of this makes it pivotal to situate Tzara in this borderland of Europe. When he returned to Romania for several weeks in the summer of 1920, he wrote to Francis Picabia of how "the Balkans and the mentality here disgust me profoundly."[14] That is the talk of a young man from the provinces who has made his way in the world and now lives in—wonder of wonders—Paris. A more comprehensive view of Tzara's relationship to Romania shows a deeper and more sustained bond. He had Romanian friends in Paris, like Constantin Brancuși and Ionesco, but out of a desire to fully integrate into French intellectual life, which had several times accused him of being a "foreigner," he did not join exile circles. His contact with friends in Romania slowly diminished, and his trips back were rare. The last one was in 1946, when he came as a representative of French letters; he did not attend his mother's funeral two years later, and by 1962, one year before his death, he did not speak Romanian with his niece and her husband, who stayed with him in Paris for a week.[15] Yet "[t]he most distant relationships open the drawers of my memory," he wrote in *Faites vos jeux* [Place Your Bets], an unfinished 1923 novel centering on his youth.[16] Tzara's only child, Christophe, remembers his father having very "fond" memories of his native country and drawing heavily from its culture.[17] Even after forty years in Paris, the long rolling *r*'s and clipped vowels of his French betrayed his Romanian origins.[18] And as Tzara himself stated in 1945: "I cannot evoke without emotion this hard country, where the essential values of life, under both their tender and rude aspects, so close to nature, have kept the freshness of the world's youth."[19]

In 1896 the X-ray was discovered, the Olympic Games were reinstated after two millennia, the Dow Jones Industrial Average was printed for the first time, gold was found in the Klondike, Queen Victoria became the longest-reigning monarch in British history, a man was given a speeding ticket in Kent for exceeding 2 miles per hour, and the shortest war in history was fought, beginning at 9 a.m. and concluding 45 minutes later. Between speed and tradition, 1896 was still part of that "world of yesterday" later evoked by Stefan Zweig. Tzara's hometown of Moineşti (the "ş" gives an "sh" sound, and the final "i" is silent) better exemplified this world in transition than most places.

Situated between heavily forested and steep hills at the foot of the Carpathians in northeastern Romania, Moineşti is 50 kilometers from the county capital, Bacău, and 300 kilometers north of Bucharest. The town was first mentioned in fifteenth-century chronicles. For centuries its economy was based on agriculture and woodland exploitation, and by the turn of the nineteenth century only 400 souls called it home.[20] Mainly peasants, theirs was the kind of grueling and repetitive existence depicted in Kafka's "The Problem of Our Laws." The place would have remained a hill hamlet with lovely forests and tough peasant

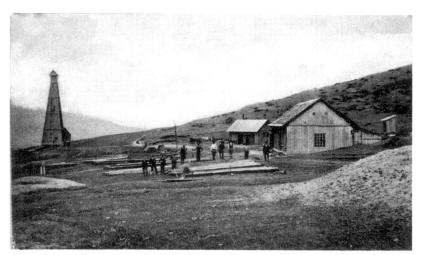

Sonda Moinesti

4

FIGURE 1.1
Moineşti oil derrick, 1902.
Courtesy of the National Museum of
Romanian History (Bucharest).

ways, "un village resté dans son état intégral," a village unspoiled by time, as Le Corbusier romanticized the Balkans in 1911, had it not been for something underground: oil.[21] In 1835 small companies began working shallow wells in the area, and Romania's first oil refinery was opened in a neighboring town five years later.[22] By 1863 Moineşti counted thirteen gas and petrol works (out of a total of fifty-eight in the country). If less than 100 tons of oil per year was exploited in Moineşti in the 1860s, by 1890 the figure had climbed to over 6,000 tons annually.[23] By this point Romania was the second-largest oil producer in Europe after Russia, and the refineries in Moineşti were the second largest in the country.[24] (When F. T. Marinetti visited Romania in 1930, he wrote "The Fire of the Moreni Derricks," a text directly inspired by the country's oil industry.) In this town, young Samuel noted, "red life boils in pits," while years later he recalled the wind with its "odor of petrol and bromide."[25] Moineşti's landscape, as Tzara recalled in 1916, was altered drastically by

> petroleum bogs
> from where at midday sweaty and yellow shirts rise.[26]

As an eager sign of this new wealth, one hundred lamps illuminated the streets: "The night begins because the petrol lamps are slowly lit."[27] The railway station was opened in 1899 in order to transport oil to foreign markets; it also became a social hub, with teenagers using it as a site for promenades and adults taking up seats in the café.[28]

The regional capital, Bacău, was, as it is today, a trade and administrative center constructed on flat and dusty land, but Moineşti is in glorious countryside. The steep hills and enveloping forest give the city a long, slender layout. There are curvy ascents and stunning views of the nearby "ripped mountain":

> On the leprous valleys in the mountain gorges
> It's like the eye of the brain.[29]

The trapped light is a "sparkling splendor," or so noted Ştefan Luchian, one of Romania's finest painters.[30] During the summer, people frequented the thermal waters that reputedly offered relief for chronic ailments, but in the winter heavy snows blocked the town off. The arrival of spring often caused severe flooding, making the passage of seasons a "moment of alarm."[31] Tzara evokes the natural world of his hometown with a slightly affected melancholy. In "Come with me to the countryside," the main character is told:

> Raise yourself to the sky in serenity
> Until the clouds serve you as curtains
> And the stars: the contentedness of lamps on balconies full of night.[32]

When the lamps go off it becomes "so dark that only words can light up."[33] If the heavy stones of the surrounding mountains emit "the coldness of an ancient tragedy," they place the individual firmly within nature and give a unity to life, which needs both the joyous and the tragic to be whole.[34]

5

Moineşti did not have much in terms of high culture. In nearby Bacău, the Atheneum was opened in 1890, but the city's denizens had a well-known "indifference" to culture.[35] There are records of traveling players coming to Moineşti; these must have been magical moments for young Samuel, the outside world breaking up the predictable daily routines of the isolated town.[36] It was only in 1908, when Tzara was studying in Bucharest, that a Jewish cultural association was launched in the town, with the purpose of establishing a multi-lingual library and organizing literary and musical evenings.[37] The establishment of this organization, though, implied that these things were lacking beforehand.

In this culturally desolate countryside, "these cities of fatigue /dried out like figs," Tzara first found literature.[38] For him it was an escape from boredom:

I'm bored; now is the time for autumn harvesting in the countryside
And literature is the worm that nibbles the subterranean road
Through which water will flow so summer fruits will ripen.[39]

Literature was light and poetry a song, while the people around him moved in darkness:

The souls from here
Are tiny
Your eyes sir
Are very diabolical.[40]

Another stanza in the manuscript of "The souls from here" is even more damning:

Boredom
The rack of the dead
Comes in a chute
All of them stone [*bolovan*].[41]

The stone in the final line, *bolovan*, is phonetically similar to the Romanian for sick, *bolnav*, making the dead alive and the inhabitants so toxic that they infect the natural world. The power of nature, which is being overturned by modern technology, is inescapable, though:

Beneath the abscesses of sadness,
Like thunder [*tunet*] below asphyxiated bolts,
I am a traveler whose soul is darkened [*întunecat*].[42]

Thunder, *tunet*, is played off the darkened [*întunecat*] soul, while the sadness the poet feels is described with a word that literally means the depths, but which has connotations of burrowing: the subterranean dark thunder (oil) is blocked by the bolts of the derricks, which are fated to a slow death, since they cannot breathe anymore. There is already the hint, Tzara writes in a poem entitled "Disgust," of "abandoned factories with ghosts of smoke" in a city with "riverbanks of mass death," bridges made of "tar," where even the clouds are "granite."[43] The natural world Tzara inhabited as a child was in the process of transformation, and the continual change he saw was paralleled in his poetry, which refused to be static.

6

Words were not precious objects but rather parts of a larger whole, a poetic belief he never abandoned. If views of language are ultimately views about nature, then Tzara saw its ceaseless movement early on.

Moineşti's contrasts did not stop at virgin forests and oil derricks, old-world thermal baths and new railway lines, Wild West oil boom and medieval peasantry. A large Jewish population made the town a *shtetl* with "narrow little streets, some cobbled and some no more than dirt tracks, and small houses with flat roofs."[44] With their *payot*, full beards, and black clothing—"the man in black passing on the street" in one of Tzara's Romanian poems—Hasidic Jews were often seen in the city center or in dim workhouses.[45] Jews had settled in Moineşti by the mid-eighteenth century, as attested by tombstones dated 1740 and 1748 in the Jewish cemetery lying "between two chestnuts impoverished like people leaving the hospital ... in the city outskirts, on the hill."[46] In *La Première Aventure céleste de Monsieur Antipyrine*, Tzara writes that "in the Jewish cemetery tombs rise like serpents."[47] In 1803 an estimated 10,000 Jews lived in Romania, many of them long-settled Sephardic Jews in Bucharest, but within a few decades the number of Jews in the country had grown to 60,000, most of them Ashkenazi Jews in Moldavian cities.[48] In Moineşti only 42 individuals paid Jewish taxes in 1820; by 1836, there were 193; and by 1885, there were around 2,000.[49] In 1896, the year Tzara was born, Jews made up a little less than half of the town's population of 4,000, but were poised to become a majority: of the 179 births in the town that year, 98 of them were to Jewish parents. Five synagogues and a ritual bathhouse served the Jewish community. Moses Rosen, who later became Chief Rabbi of the Romanian Jewry, recalls the "abject, grinding poverty" of the town's Jewish population, but also its exceptional religious spirit.[50] While the Jewish community had good relations with the other inhabitants, there was little intermingling: as late as 1926, out of 43 marriages in Moineşti, not one was interreligious.[51]

If one fact is central to Tzara's childhood, it is being born Jewish. Even if his family was not observant (his father marked "atheist" as his religion when he got a passport) and spoke Romanian in the home, being Jewish had a host of legal and cultural implications.[52] The 1866 constitution denied Jews citizenship (only after World War I would that change), but the Romanian state enforced upon native-born Jews duties like military service. In 1896 only three of the children born into Jewish families in Moineşti were Romanian citizens; most of the others, like Tzara, were "under no foreign protection." Citizenship had to be requested in the Romanian Senate; unsurprisingly, very few Jews—decorated war veterans or wealthy financiers, like Iosif Theiler, the driving force behind Moineşti's first oil field—were naturalized. Lacking citizenship not only limited foreign travel and denied political rights, it also impeded internal travel, as individual Jews often had to request an identity card to move to another city.[53] Furthermore, restrictive legislation—spurred on by such things as 60,000 signatures on a petition charging Jews with monopolizing "commerce,

industry, and trade" and exploiting the peasants—barred noncitizens, and thus Jews, from a host of activities, such as purchasing land in the countryside or attending free public schools.[54]

An 1881 article in *Fraternitatea* [Brotherhood] laid out the stark changes in social and political conditions for Jews in a generation:

> There was a time when Romania was an El Dorado for all the refugees and the persecuted from all over the world. Here reigned a boundless and most generous religious tolerance. … Today things have changed. … Selfishness under the name of national defense has been the inspirer of many restrictions, so that foreigners no longer look upon Romania as a country where they can find happiness and a good living.[55]

Any number of recent events could have confirmed this assessment. Bacău had seen an attempted expulsion of its Jewish community in 1868. Leading intellectuals, such as Nicolae Iorga, A. D. Xenopol, and B. P. Hasdeu, as well as the national poet Mihai Eminescu, professed openly anti-Semitic views. The most respected academic of his time, Iorga, did not mince his words: "Three-quarters of the inhabitants of Jassy [Iaşi] are Jews. Wealth, life and mobility are theirs. The flame of Zionism was lit there and burns strongly. … But, however high the dirty wave of profit-seekers, the soil is ours. And one day the wind will blow away the scum it has brought, and we shall remain."[56]

The rapidly growing Jewish population throughout the country was a cause of tension, and an emblematic case touched upon Moineşti a decade before Tzara was born. The livelihood of neighboring Brusturoasa was based on the surrounding forest until the local *boyar* (noble) decided to lease its exploitation to a middleman. Their traditional rights to the forest curtailed, the peasants turned to the courts, only to have their case dismissed. Their anger turned on David Grünberg, the newly appointed Jewish manager of the lands. *Boyars* often hired "foreigners" (Jews, Armenians, or Greeks) to be land managers for this very reason (Tzara's father and paternal grandfather were also involved in forest exploitation). One July night in 1885, a mob began to attack Jewish homes. The Jewish community made an official complaint, naming the aggressors, but there was no response. A few weeks later, the mob, swelled by the addition of the local militia, set about the expulsion of the village's 130 Jewish residents. One woman told her Jewish neighbor: "Run because those coming will kill you, for God's sake run." Those who did not leave voluntarily were expelled by force; one witness was "moved in the depths of [his] soul" at the sight of women and children, the elderly and sick, helpless on the road as "any Romanian passerby" insulted and beat them. The neighboring village did not allow these expelled Jews to enter. Finally, their homes and lives overturned, some found a haven in Moineşti, where a "Comunitatea evreiască" (Jewish community association) had just been founded.[57]

While nothing as dramatic as the Brusturoasa events occurred in Moineşti, the town was not immune to religious friction. Many of the same elements were present: a town divided between Jews and Romanians, and rapid economic expansion mostly in Jewish

8

hands. That tensions were felt is evidenced by the growing Zionist sentiment in the community. In 1882 about one-tenth of the town's Jewish population, members of *Hovevei Zion*, "The Lovers of Zion," left Moineşti on foot and founded Zichron Ya'akov and Rosh Pinna, two early Israeli settlements; they might have packed a book published that year in Bacău, *Der practiser araber*: *Lessons for the Arab language for those who will dwell in Eretz Israel*. Another mass emigration, this time of about 200 Jewish residents, occurred in 1900. *The Voice of the Wanderer: Manifesto of the Moineşti Emigrants* notes: "How disillusioned I am, and my hopes, how much they have failed me … an unending chain of worries and pains … look at those naked and hungry children and you will understand my tears."[58] In 1902 a Zionist journal was started up in the town. Many Jews were resolved to leave the country:

> We are treated like foreigners, though born and raised in this country of our ancestors, and obligated to the same duties and contributions as other citizens.
>
> Expelled from the countryside, expelled from the state schools, threatened with expulsion from the country …
>
> … Common sense shows us that we can no longer allow ourselves illusions about our standing in this country.[59]

A bright and aware child, Samuel would have seen how the apparent normality of life was underpinned by an unspoken but nevertheless real anxiety. A cousin recalls him running around the house, yelling out: "Dreyfus innocent! Esterhazy guilty!"[60] But the dangers were much closer to home. In a half-Jewish city, Jewish ways of life are as natural as the air; one sees long black robes trailing graying beards, one hears the sweeping of houses and the scurrying preparations for the Sabbath, another Sabbath in an endless line of Sabbaths. But given the knowledge that they were considered foreigners in a land that their ancestors may not have known, the feeling of transience would have been inescapable. Every generation, just like every word in Tzara's poetry, had to build itself anew; and every generation would be toppled in time, its imprint part of a larger context but indistinguishable from all the others.

9

While some Jews were leaving for Zion, others were arriving for black gold. In this externally calm but volatile town the Rosenstock family settled. It was a bourgeois household; as Tzara confessed in one of his Cabaret Voltaire performances, "look at me, a kind bourgeois."[61] It was only when his name was legally changed to Tristan that his parents stopped addressing him as "Samică," his family nickname. Protective in their love, the parents asked family friends passing through Paris to check up on their son. Even when Tzara had been abroad for over a decade and was already married, a "very respectful" man went to look him up in Paris and, finding Tzara out, made inquiries with neighbors and the proprietor, reporting back that Tzara was "a very serious man and beloved by everyone"—news that the very pleased paterfamilias relayed back to his son.[62] A photograph Tristan sent before his marriage showed, his mother claimed, that it was destined to be a happy union: he had put on weight,

which meant that his future wife was taking care of him.[63] When Tzara wrote one of his rare letters home and forgot to give his compliments to his sister's husband (a single line which had to say "salutations to Carol"), his mother reprimanded him for the oversight.[64] By this point Tzara had called upon Dada "to shit in diverse colors to ornament the zoo of art with the flags of every consulate," but to his parents, this was nothing compared to a *faux pas* affecting a family member.[65]

The amount of material about Tzara's parents is limited. Filip Rosenstock (1867–1936) was originally from Tîrgu Ocna, a salt mining town in Bacău County. His profession, as listed on Tzara's birth certificate, was "accountant." He worked, like his father before him, in forest exploitation. Filip did very well in business, allowing him to maintain servants as well as a vacation home in the mountains. His wife, Emilia (née Zibalis) Rosenstock (1874–1948), ensured that the house was kept in perfect order. The Doucet archive has fewer than twenty letters to Tzara from his family, most of them clustered around the mid-1920s, yet his parents were regular correspondents who in almost every letter complained that their son was not responding to their mail. Michel Sanouillet explains the mystery by noting that Tzara had a huge box of letters from his parents, which he offered to make available to the scholar, but since Sanouillet could not read Romanian, Tzara got rid of the letters.[66] In the Romanian archives, there are fewer than twenty letters from Tzara to his family. Just as he did not keep his birth certificate, letters from his family were objects of an extremely personal nature, and Tzara was always very reserved about his private life.

Emilia Rosenstock was the dominant figure in the family. In one of his letters to Tzara, Filip noted that he was writing without her knowledge, and, the tone implies, would his son keep the secret?[67] Apparently Emilia assumed that everything concerning the family had to pass through her, so of course secret communication between father and son would be forbidden. A short, squat woman with dark hair pulled tightly back in a bun, Emilia was a proper bourgeoise:

FIGURE 1.2
Filip and Emilia Rosenstock.
Courtesy of Mira Rinzler.

> Mother, you won't understand but listen
> Suffering can't be versed into a handkerchief …
> Mother, you won't understand
> But it's a beautiful thing to be in a poem.[68]

The image of suffering "versed into a handkerchief" encapsulates a particular philosophy of life: cry once and cry cleanly, and then get on with it. On his wedding day, Emilia wrote her only son:

> Finally after much disappointment, I received some news from you. I'm sorry
> that you were sick but thank God that you've recovered. Today you marry.
> May God bring you and your wife happiness. I'm very happy that you're so happy.
> You had an intoxication, because you were sick in the liver. Take care of yourself.
> You should drink a mineral water.
>
> I kiss you sweetly, Mama.[69]

This letter of conjugal felicitations begins with a reproach and ends with an injunction, one that Tristan had probably heard countless times (he later used the refrain "Buvez de l'eau [Drink some water]" in a Dada song). For such a short letter, it uses markedly fatalistic language. Emilia's writing is closer to speech, with trains of thought abruptly broken off for something entirely different; quite clearly, for Emilia, if the world had been perfectly ordered, she never would have written a letter in her life, because her loved ones would have remained by her side. The line on how her son should drink mineral water is not something one writes in a letter congratulating a son on his marriage; but it came to her mind and carried its own fierce logic. It is also exceedingly funny, but of course Emilia would have thought it serious: my son is sick, he should drink a mineral water. Tzara's rich talent for humor and language can probably be traced to being a child who had to use wit to combat a serious matriarch. Her influence on his life was remarkable; she was like stone, solidly there at the center of things. In his letters home, she is the one he addresses, at one point writing in parentheses that his father should not be upset that it is mainly his mother that he misses.[70] When his mother fell ill and asked for certain medicines from France, Tzara desperately consulted pharmacies all over Paris, even trade catalogs.[71] While at times he rebelled against her, and certainly thought her overbearing ways went too far, on his deathbed Tzara kept crying out her name.[72]

Filip Rosenstock was, as one of Tzara's friends put it, "a proper man."[73] Hard-working, with a bushy mustache and white hair, a solid face, eyes weighed down with responsibility and a chin sagging from age, he was withdrawn in front of his wife but an entirely different person outside the family home. His serious mien looks to have within it a suppressed lustiness that could break out at any time, at which point his heavy eyes could light up with booming laughter. In *Faites vos jeux*, Tzara alludes to this split self:

11

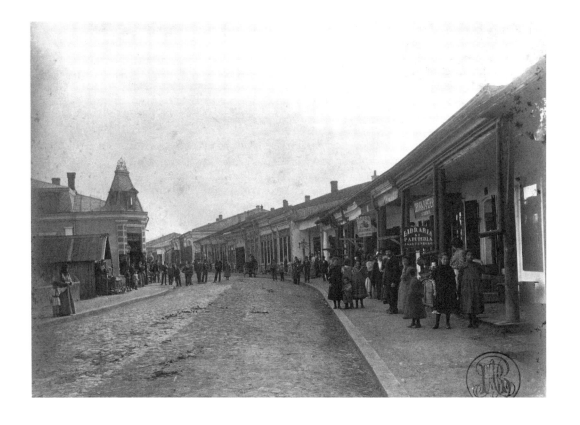

12

FIGURE 1.3
Strada Mare, Moineşti, 1910.
Photograph by Leopold Adler.
Courtesy of the Library of the
Romanian Academy (Bucharest).

My sick mother was abroad—I passed my vacation with my father. One day as I was walking with a schoolmate, my eyes breathing the looks of pretty girls, I met my father. I asked him where he was going, he told me to accompany him, but I preferred to continue my walk. My schoolmate at that moment disappeared. I met him an hour later. He told me that my father had gone to a woman of easy virtue. I took this for an insult. Then he told me: he had followed my father, who had entered a grand house. By means of a tip, he had learned from the concierge that the mister who had just come in was a rich widowed landowner who came twice a month from the countryside to visit his mistress. When I saw my father, that night, I asked him why he hadn't wanted to tell me where he was going. Cynically he responded that all I had to do was accompany him. Never have I been so angry … I should have killed him, told everything to my mother, provoked divorce. He didn't see anything wrong, and had the bad taste to tell me that very night how much he loved his wife.[74]

This story is perhaps pure fiction—the successive drafts of *Faites vos jeux* all show a noticeable rise in the sexual tension, and its general tone is one of fancy instead of veracity—but it cannot be entirely discounted in terms of how Filip might have appeared to his son. The hypocrisy is, of course, what the child seizes upon. As a teenager, Tzara became obsessed with Hamlet, and in one of his poems he posed the following poignant question: "Love, the heavenly kind, swells and sighs when he asks what shall I do / To please the king."[75]

This desire to please, but the knowledge that one never could, was an insoluble problem: the father of Hamlet had set a standard of leadership and courage that the son was unable to match up to, and this feeling Tzara acutely shared with regard to his own father.[76] But when Tzara was older, he appreciated the alternately calming and energizing influence his father brought. When Filip died in 1936, Tzara admitted that coming home to Romania would be too painful for him.[77]

Located on what was colloquially called "Strada Mare (Main Street)," the Rosenstock house was demolished after World War II to make way for a block of concrete flats. Moineşti was a three-street town; running from the railway station to the market, Strada Mare was "full of shops crammed one after another, overflowing with all sorts of goods."[78] The Rosenstocks lived just below the city's administrative center, a public square with the mayor's office and hospital at the far end. It was, Tzara recalls, a "rather large house built at the head of a courtyard giving way to an enormous garden."[79] Below it a ravine in the deep forest provided mineral water, and further down the valley, closer to the oil fields, was the train station.

"Every product of disgust capable of becoming a negation of the family is *dada*."[80] If Tzara's ire against the bourgeoisie is not simply a pose, it originated from his childhood within a family that took to being bourgeois as a professional and cultural duty:

the house of golden nostrils
is full of correct phrases.[81]

With its piano and servants rushing to attention, the Rosenstock household was "the violin of good breeding."[82] Tzara does not refer to any childhood friends from Moineşti, no doubt because as a child he was probably encouraged to play with his sister and cousins rather than with other children. Secular Jews had no network in the community, having distanced themselves from religious Jews and not having found acceptance among Romanians.

"Samică" was a tranquil and good baby, as his father later hinted when approving of the sight of quiet children.[83] While the Rosenstock home had modern comforts, tradition played an important role (although not religion). Young Samuel was dressed in the same shirt his father wore as a baby, and the shirt in turn was given to Tzara's son, Christophe, at which point it was at least sixty years old.[84] His mother probably made Tristan boots, as she did when Christophe was born.[85] The family friends who visited were worldly, the husbands engaged in business and with contacts throughout Romania and neighboring countries, while the wives served on the committees of charitable institutions and read not so much "to develop literary taste" but in order to catalog what they had and what they lacked.[86] Without distractions like the opera or theater, bourgeois households made do with gossip and a more penetrating look into the core of their family, which had to be scrubbed clean and healthy to be proper.[87] Tzara characterized a woman from this milieu in one of his Romanian poems:

> Her soul spent
> The night in hospital
> During the day she gave
> Piano lessons.[88]

The split between the soul and the activity of the character is the main issue, and with piano lessons Tzara finds a symbolic activity that becomes utterly devoid of any meaning, for what kind of training can such a sick soul give?

As a child, though, Samuel was less cynical. He had incredible energy, running around the house and garden and making the life of the servants a delightful terror. But this energy could also be controlled; he showed "an exceptionally strong interest" in music, which helps explain, in part, the lyricism that runs through his poetry and his preference for song.[89] He took piano lessons, and his interest in music remained; his father, taking a health cure in France in 1927, wrote to Tristan about a piano for sale at his hotel in Royat-les-Bains.[90]

But the energetic child soon turned sullen. Part of it was physical. Tzara was small, his myopia required glasses, and his health was never perfect. There was always one illness or another that kept him bedridden, and his early Romanian poetry is full of hospital scenes. This, coupled with extreme mental agility, did not presage the "violent vertigo" fits he later suffered from, but these fits did not come as a shock given his prior history. More important for this change, though, was the birth of his sister, Lucie-Marie, called "Lucică" by everyone, in June 1902. Samuel was used to being the center of attention, but the newborn made her own claims on the family. A deep fraternal love—"My sister, root, flower, stone"—was at

times upset by resentment at her existence.[91] Rather than having someone under his care, Samuel saw his sister as having responsibilities toward him:

> Be a younger sister
> To take care of me.[92]

A kind of broken, unequal love reigned:

> Little sister little sister—smelling of oranges
> Come here to put my soul in place.[93]

That this probably did not happen bothered Tzara no end: "Raised with all the prerogatives due to the first born, the slightest obstacles hammered precocious nails into me. ... I only had one sister, and the shrill file of my jealousy gnawed at the childhood of my absurd and turbulent heart."[94] Tzara relates a scene still "in front of the screen of my eyes": having lost his ball, he "coldly punctured" his sister's, then went to a shed and with a nail engraved the date and the reason for his feeling aggrieved, telling himself that from now on he would "not forget a thing of my torments."[95] And he was the one who ruined her ball! Even more cruelly, as Tzara relates, this made him act savagely toward her, and so he was filled with guilt. He savored this guilt, which brought back what he had lost, the feeling of being the center of the universe. Only this universe had shrunk to the workings inside his head, for he could not communicate these feelings to anyone. To some this would be a great impoverishment; for a future poet, it was essential.

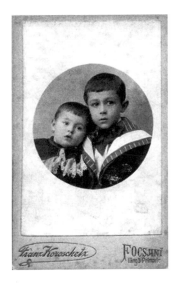

FIGURE 1.4
Samuel and his sister, Lucică.
Courtesy of Mira Rinzler.

Another dramatic childhood shock occurred in 1902, when young Tzara started to attend a private Jewish school for boys.[96] The Romanian constitution provided for free state education for its population, which was over 80 percent rural (and over 85 percent of the rural population was illiterate).[97] But the young country hardly had the funds to dot its territory with schools, railways, and hospitals. While Moineşti's first public school opened in 1864, and a school for girls was opened three years later, there was only one teacher. Starting in 1893, taxes on "foreign" pupils were introduced, a measure that was perceived as targeting the Jewish community.[98] In Moineşti Jewish students were taxed at a rate of 20 lei per academic year, and their enrollment in the public school accordingly dropped: in 1900, for instance, out of a total of 186 pupils in four grades, there were only three Jewish students.[99] The Jewish population also avoided the state school because of its endemic problems. It was in a physically shoddy state, as the principal reported in 1893: "These days the children do not have water, in the classrooms there is nothing to be used to clean in the mornings, the classrooms are quite cold and they need to be heated, there is nothing to cut the wood with."[100]

Jewish pupils were educated privately: in 1893, there were 10 different private Jewish schools in the city educating 199 students.[101] These schools were of varying quality. Some establishments were little more than single unfinished rooms "more crowded than Noah's Ark," with a master providing only religious instruction.[102] Other schools were recognizably modern, with instruction in Romanian, modern languages, and science. This was the case for the school Tzara attended, the Jewish School for Boys. Constructed in 1896 on a field donated by a local petroleum firm, and with funds from the Jewish Colonization Association, it was at the base of a hill on a street parallel to the mayor's office (today the local judicial chambers). Within three years it was educating over 180 students, using Romanian and Hebrew as languages of instruction. Lucică later attended the Jewish school for girls, which was opened in 1900; it was only in 1910 that the two schools were combined into a coeducational Jewish school, in an imposing building which now houses the town courthouse.

Tzara was a good student, with high marks in mathematics and the sciences. His marks for foreign languages were not as high as one imagines they would have been—and, as I will discuss later, the foreignness of French contributed to his distinctive poetry, which could be destructive and bric-à-brac in the way that a native poet could not be. His schooling was complemented by private instruction in languages and music at home. But in Moineşti the education on offer ended after four classes, and so Tzara had to leave home in 1906, aged ten.

The provinces became a life left behind. Looking back upon his childhood, Tzara asked: "What advantage is there in living alone in a small village? After ten years of slow reflection which has submerged me like the somber work of microbes, I can respond: None."[103]

But advantage is a slippery term; what is interesting is how much of Tzara's mindset was a direct product of this provincial oil town. As he wrote about leaving home in one of his Romanian poems:

> Mother,
> I always cry like the end of a [musical] scale
> Because the road is hard
> But still it calls.[104]

The poem is called "Song of War," and it was written in the wake of the 1913 Balkan Wars, which saw the introduction of aerial bombardment on the European landmass, a sort of dress rehearsal for the carnage a year later. It is oddly prescient that the calling away from home would come in a song of war, for what Tzara would do upon arrival in Bucharest, and then later abroad, was go to war with language and art. Even if it seems as if he did this without any place of departure, Tzara's worldview was intimately shaped by the home he had left behind.

17

2 THE EDUCATION OF SAMUEL ROSENSTOCK: **1906–1912**

THE COUNTRYSIDE IDYLL OF SAMUEL'S CHILDHOOD CAME TO AN END WHEN HE WAS SENT AWAY FOR HIS FIRST YEAR OF *GYMNASIUM*. MOST JEWS FROM MOINEŞTI CONTINUED THEIR STUDIES IN NEARBY BACĂU, BUCHAREST, OR EVEN ABROAD. The Rosenstocks could have sent their son to Bucharest but refrained from doing so, yet they did not keep him close to home either, as they sent him to Focşani, over 100 kilometers away. There was probably family there to keep an eye on the ten-year-old, as suggested by the portrait of young Tristan and his sister taken in a Focşani photographic studio (when making an application for a residence card in France in 1941, Tzara marked down his mother's place of birth as "Toscani," but since no such city exists, it is possible that he misremembered "Focşani").[1] What is certain is that Focşani had a reputation in Romania as a liberal city. A commercial outpost on the border between Moldavia and Wallachia, Focşani was called the "City of Unification" for the role it played in bringing the two regions together. It also had a dynamic Jewish presence, having hosted the world's first Zionist congress in 1881. The Rosenstocks sent Samuel to a private academy emphasizing modern foreign languages and science. As a boarding student, Tzara took the long trip home only during extended school vacations:

> And you're sorry to be far away from your own and to learn
> At the Nun's School where nights aren't warm
> Again you count the days till vacation.[2]

The only record of Samuel's school year is a certificate issued in September 1907.[3] In this strange environment, far from the comforts of home, young Samuel was a poor student, his highest mark coming in gym. For a student used to being top of his class, it must have been difficult to struggle in his two strongest subjects, foreign languages and mathematics. He barely passed the course in religion, and failed music.[4] Although there is no personal correspondence from this period, it must have been a difficult year for the brilliant son expelled from home. Pressures from the family to study would have been hard to understand for a child who wanted nothing more than to wander in the forests of the surrounding countryside.

FIGURE 2.1
One side of Romania: Arts Pavilion, Romanian International Exhibition of 1906.
Courtesy of the National Museum of Romanian History (Bucharest).

FIGURE 2.2
The other side: Workers in front of the Agriculture Pavilion, Romanian International Exhibition of 1906.
Courtesy of the National Museum of Romanian History (Bucharest).

But this year away from home would have been decisive in implanting a strong sense of self-reliance and independence, which stood Tzara in good stead for the numerous displacements that followed.

More decisive for Tzara's formation than the education he received in school was living through the most "traumatic event of Romanian history," the 1907 peasant revolt.[5] This nationwide uprising began in Tzara's home region of Moldavia as a series of protests against land managers (*arendaşi*), many of whom were Jewish. The Rosenstocks would have had reason to be anxious, since both Filip and Ilie Rosenstock were involved in forest exploitation as commercial middlemen. The revolt soon turned to the general plight of the peasantry: the life expectancy of Romanian peasants in 1905 was a dismal 32.85 years, among the worst in Europe.[6] As the uprising fanned out, a peasant army marched upon the capital. The Romanian king, Carol I, mobilized the national militia, and in a few days nearly 10,000 peasants were estimated to have lost their lives. All records of the event, including cabinet meetings and Ministry of War decisions, were burned.[7]

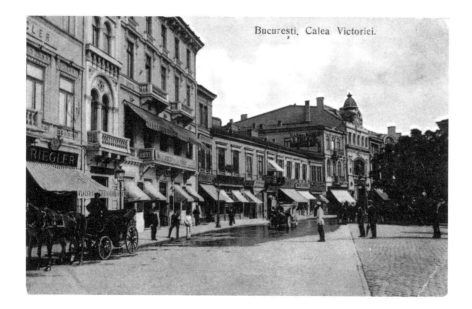

Bucuresti, Calea Victoriei.

22

FIGURE 2.3
Bucharest's Calea Victoriei.
Courtesy of the National Museum of
Romanian History (Bucharest).

1906–1912

The uprising was "a thunderbolt out of a clear blue sky."[8] The Romanian International Exhibition of 1906 had commemorated forty years of Carol I's reign by presenting a modern nation-state. The revolt showed the insuperable "abyss between urban and rural Romania."[9] The celebrated playwright Ion Caragiale observed: "Europe has been accustomed to thinking for many years that the young Romanian Kingdom is the most solid element of civilization among the Balkan states. ... In truth, perhaps in no state, at least in Europe, does there exist such a huge discrepancy between reality and appearances, between actuality and pretense."[10] The lesson of the revolt was that the settled world could be overturned in an instant: "All of Romania has to be remade, because everything has sunk."[11]

The ten-year-old far from home would probably not have understood much about the revolt, but he could not escape its consequences. The first effect was direct: he was dispatched to the relative safety of Bucharest. Normally he would have had four years of *gymnasium* at the same school, but his parents must have concluded that the capital would be safer. The second effect was indirect: it polarized the country's cultural scene. Just as the peasants had started by revolting against Jewish leaseholders, the cultural atmosphere became even more noxious for Jewish artists.[12] Articles with titles like "Samică and 1907" began to appear ("Samică" being a term used to refer to all Jews).[13] One of the driving assumptions was that Jews could not understand the folkways of peasants because they were "foreign from the start from the culture of the earth."[14] Iorga used two code words from the lexicon of anti-Semitism when demanding a "healthy," "national" culture.[15] "[F]oreign infiltration," stated the influential literary journal *Convorbiri literare*, was "the capital problem in our contemporary history."[16] A. C. Cuza, a professor at the University of Iași, did not mince his words: "*Eliminating the Jews from the cultural domain*—this is an existential problem for us."[17] The Jewish-edited *Critica* noted that a "high wall" of "disarming hatred" had been erected between Romanian culture and Jewish authors.[18] This worldview saw Tzara's Jewish roots as a threat, but also created an opposing tendency in a "leftist modernist aesthetic" in such newspapers as *Rampla* and *Facla*.[19] These modernizers developed a trenchant critique of how Romania was essentially a feudal society that needed to Europeanize its economy and culture. Tzara would soon be caught up in the crossfire of this cultural debate when he made his literary debut a few years later.

Young Tzara personally experienced the abyss between urban and rural Romania when he arrived in Bucharest in the autumn of 1907. For the next eight years his life was shaped by the capital's strange rhythms. Having arrived after a tragic national disaster, he would leave the city on the cusp of another: the aerial bombardment of Bucharest after Romania's entry into the First World War. Even if his arrival and departure were marked by dark omens, it was in lively Bucharest that Tzara began to develop his poetic voice. The city itself was an education. In a world so far removed from the Romanian provinces, the young boy was immersed into a nascent modernity with its attendant pleasures, but also its problems.

Bucharest extended over an "immense" area of 3,500 hectares.[20] A French traveler noted that it "truly had the aspect of a capital city: large boulevards, immense plazas, large buildings, luxury stores and beautiful hotels. An intense activity rules over the places; the streets and cafés overflow with people."[21] In thirty years Bucharest's population had doubled to 300,000 residents, and the city was a never-ending construction site, with the City Hall, the Athénée Palace, and the University Library all built during Tzara's time there.[22] "Everything which today makes up the capital's beauty, everything which gives it the air of a modern city," Frédéric Damé wrote in 1906, "only dates from yesterday."[23]

In this rushed modernity, jarring contrasts were inevitable. Palatial estates abutted hovels, and grand public buildings were approached via mud-soaked dirt sidewalks. What Tzara later lambasted as the incongruity of Western civilization, the official discourse of progress coexisting with an underlayer of barbarism, was already present to his schoolboy eyes. The contradictions of modernity and well-nigh medievalism side by side bewildered foreign travelers:

> It appears very simple in Bucharest to come across, two steps from each other, the finest Parisian coach and a carriage harnessed by four buffalos; an *homme du monde*, dressed in the latest Italian boulevard fashion, passes by a peasant in the sheep-skin clothing of the poorest of the lower Danube … there is barbarism and civilization; at times he [a traveler] would think himself in a village and at others in a capital. All of this is of a composite order, made up of pieces and shards; there is no characteristic form, no distinct society, but nonetheless the Romanian unity is made up of these bizarre contradictions.[24]

If Bucharest's elegant casinos, luxurious restaurants, abundant prostitutes, and easy mores made it "the paradise of *vieux garçons*," the city also had much to offer a budding young artist.[25] The Calea Victoriei was full of bookshops, such as the famous Socec. Open day and night, the cafés were thronged with jabbering poets and terrace politicians. While most people got around in horse-drawn Victoria coaches driven by Russian eunuchs, the city had a seventy-five-kilometer tram network.[26] These electric trams, introduced in 1894, let off an "incessant tam-tam" that disrupted the city's previously "quasi-pastoral harmony," but for their tens of thousands of passengers, this was the price of modernity.[27] Aurel Vlaciu circled above the city in his airplane, performing maneuvers that wide-eyed residents could scarcely believe.[28] Yet Bucharest's modernity was incomplete: "the radio did not exist … gramophones … were still a luxury, while cinemas were only beginning to flourish."[29] The Jewish quarter of the city was overcrowded, poorly ventilated, and poverty-stricken; it was also full of "extraordinary animation" as people promenaded, gossiped, and danced through the night.[30]

Bucharest had its fair share of modern problems: the mass suicide of a family of ten, marijuana use, violent films corrupting impressionable minds. Advertisements hawked the latest foreign goods, touted cures for baldness and impotence, promised women larger busts.

One newspaper wondered if children could grow up healthily in this monstrous urban agglomeration: "The child *cannot mature* in a modern city yet *he needs* to mature. Big cities, despite all their comforts, only offer children what is damaging: narrow spaces, humid gardens, luxury objects, advertisements, paintings and books, plus the spectacle of street life … all of which are injurious to the child."[31] One of the most astute Romanian literary critics, Emil Lovinescu, noted in 1915 that this malaise was now a global phenomenon:

> Modern life, with its ease of communication, has created a category of deracinated individuals, without country and without nationality. … Modern life has created inside itself an atmosphere of conventionalism, of polite proportion, of empty formulas without any interest, of artificiality. … It is no longer the case that two people of the same social class or race meet each other, but rather two people who come from two different points of the globe. To understand each other they begin by speaking a foreign language, and no matter how well it is mastered, it remains a cold and artificial means of communication.[32]

Tzara was leaving Bucharest at this time, entering into the cosmopolitan life that Lovinescu analyzed. Zurich Dada was an attempt to prove Lovinescu wrong: in a Europe at war, it was only by moving beyond the claims of a particular individual or ethnic identity that a flourishing culture could thrive. Taking pride in being stateless, Dada moved beyond the conventionality of prewar bourgeois internationalism by showing up the emptiness of European artistic forms and the hollowness of the corresponding faith in progress and reason.

If Tzara become one of those rootless cosmopolitans, it was largely due to his education, which made him proficient in foreign languages and the classics of European culture. Richard Huelsenbeck later recalled that Tzara had "brought from Romania a limitless literary competence."[33] If being sent down to Bucharest at the age of eleven was not strictly speaking traumatic, it could not have been simple. He lived under the strict discipline of a boarder, the academic curriculum was more demanding, and Bucharest was inhospitable to a young boy's horseplay. Being separated from his family was difficult: "[a]t home there's warmth and joy as when lambs are born in the fold."[34] At the same time, the sense of freedom that comes from living in a big city, even if at his age there was no way to truly take advantage of that, must have been exhilarating.

In October 1907 Samuel enrolled in the second year of *gymnasium* at the Schewitz-Thierrin Institute, one of the top preparatory schools in the country. Founded in 1847, it was located behind what is now the National Theater. When Samuel entered the school, there were a total of 128 students in four classes.[35] The student body mainly came from the emerging professional classes. The school was evenly split between students hailing from Bucharest and those coming from the provinces, but over 80 percent of students were boarders. Schewitz-Thierrin was not a Jewish school: in Tzara's class of 33 students, there was only one other Jewish boy, and the entire school had only twelve Jewish students.[36] In his final year, Tzara was the only Jewish student in a class of fifteen.[37]

25

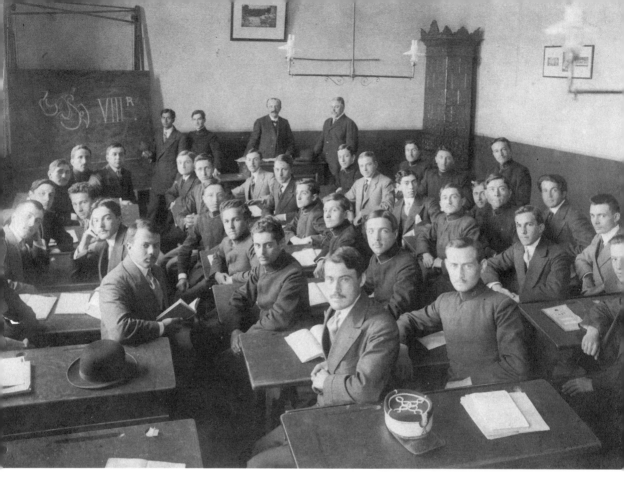

26

FIGURE 2.4
The classroom of an elite Romanian
school, turn of the twentieth century,
with student uniforms bearing
military insignia.
Courtesy of the National Museum of
Romanian History (Bucharest).

1906–1912

The school's broad curriculum included courses in Romanian, French, German, Latin, religion, history, geography, mathematics, natural and physical sciences, drawing, music, gymnastics, and calligraphy.[38] Young Samuel was exempted from the religion class (but only from his second year at the school).[39] Students were also required to do military training under a sublieutenant, and final-year students also took courses in civics and hygiene. The school program emphasized foreign and classical languages: there were only three hours of instruction in Romanian language and literature per week compared to nearly twelve hours of French, German, and Latin.[40] Both French instructors were native speakers, and the German teacher was on the university faculty. Starting at 8 o'clock in the morning, there were seven hours of lessons daily, with a full day of Saturday classes adding to the grind.[41] Samuel was a strong but not spectacular student. In his first year his best mark was in German, but he almost failed history.[42] The following year, he had the highest average in his class in German and was among the best students in French. Throughout his four years of *gymnasium*, in both Focşani and Bucharest, Tzara's grades fluctuated wildly: in the same subject, from one year to the next, he could go from failing to being top of the class. The exceptions to this general rule were foreign languages—although, curiously enough, he was always a better student in German than in French—and mathematics, in which he excelled.[43] But his otherwise inconsistent grades indicate that Tzara's motivation (or lack thereof) and his personal rapport with the teacher, not his abilities, were the primary determinants of his grades.

Even though Tzara was studying at a private school, there was a high degree of government oversight. State decrees instructed private schools to introduce Romanian-language music, to celebrate national holidays, and to require Sunday church attendance. Starting in February 1908, private schools were required to keep students' written work for inspection by state officials. Degrees had to be validated by a state exam, which cost anywhere from 30 to 80 lei (Tzara took an equivalent exam in June 1910).[44] The Schewitz-Thierrin Institute transmitted its curriculum to the Education Ministry. While not all of its records remain, the curriculum and textbooks used in Samuel's final year (academic year 1909–1910) can be pieced together, offering a unique insight into his formal education.

The history and civics textbooks combined a narrow understanding of Romanian ethnic belonging with boundless optimism for the young country's future. The civics book was a primer in nationalist ideology, although it did pause to praise the Swiss, who "are more apt to die to the last man for their country's freedom than to live under a foreign yoke."[45] Young Romanians would do well to adopt a similar patriotism toward their own country: "The nation is something so grand, so saintly, such that if one day your parents, who love you so much, were to see you come back unharmed from a war defending your country, unharmed because you shrunk from your duty and spared your life from the fear of death, then they, your loving parents, would receive you with sighs of grief; they would

no longer be able to love you and would die of heartache and deep sadness."[46] The history textbook identified the Romanian nation as the "Latin race of the Orient" and saw history as the means by which a nation comes to cultural self-understanding: "The present is nothing but the product of the past and a point of passage to the desired national future. ... Always seeking enlightenment and solidifying the powerful historical sense of the Romanian people, we are preparing its *national and cultural unity*."[47] With a series of illustrated lessons on great figures in national history, the textbook contains a great deal about the War of Independence (1877–1878) and the bravery of the Romanian army. The concluding lesson assures young readers of the nation's forward march: "Our country, after so much battling and suffering ... is today a free and independent country. From the outside, she enjoys the respect and esteem of other states; internally, she enjoys all the liberties of good laws and useful institutions. Thanks to this situation, Romania is becoming every day more powerful and more prosperous."[48] But young Samuel, in a private school far from home because the state denied native-born Jews citizenship, must have found this conclusion problematic, to say nothing of what the 1907 peasant revolt revealed about the country's presumed enlightenment.

The French-language textbook vaunted the glories of France's brilliant culture. Filled with sections on various aspects of French life, as well as short stories from the pantheon of its literature, the book assumed a fairly high level of linguistic competence. The chapter on letter-writing explains the different levels of formality in French salutations, offering a series of possible formulas: "Je te serre la main," which Tzara made use of extensively when sending out his Zurich Dada missives, is one of those suggested concluding phrases.[49] Another possible lesson for Tzara's later activities in Zurich Dada is the book's observation that "the need to correspond with one's peers" across frontiers is an essential aspect of modern culture; the book also lauds the international postal system as "a rapid and trustworthy messenger for the poorest as well as the wealthiest; it has become as necessary to our civilization as the circulation of blood in our veins is necessary to the body."[50]

At the end of his *gymnasium*, Samuel passed a state-run equivalency examination in June 1910. Before that he defended a final-year essay, "The Importance, History and Uses of Hygiene," in an oral examination in March 1910. Schewitz-Thierrin made final-year students take a course in hygiene, which at the time was a pressing national subject. Schools were routinely shut down because of typhoid and diphtheria epidemics, Bucharest had yet another cholera epidemic that year, and the capital was a European leader in tuberculosis deaths. Only 215 doctors practiced in rural areas, where 80 percent of the population lived.[51] There were systematic problems: "Dirty abattoirs and markets, unkempt streets, a detestable garbage pickup service, a complete disinterest in sanitation and public hygiene by authorities ... these are the striking examples that citizens confront daily."[52] Hygiene was also an ideologically charged subject, with "increasingly violent and fervent polemics" arising because

a proposed government reform redefined the role of the state, but also because hygiene was linked to the Jewish question, as overcrowded and insalubrious Jewish neighborhoods were often blamed for the outbreak of epidemics.[53]

Tzara's essay is interesting not only because of this larger social context but also because it is directly connected to the later avant-garde discourse of hygiene. "Dr. F. T. Marinetti," the signature Marinetti used for his early articles, was a proponent of "La Guerra, Sola Igiene del Mondo [War, the World's Only Hygiene]."[54] While the Dadaists referred to hygiene ironically, as a Band-Aid that failed to treat civilization's deeper ills, Samuel's essay is a model of sincerity and thoroughness, treating the subject with inflated schoolboy rhetoric:

> Hygiene is the science that concerns itself with the preservation and improvement of our health. It follows that this science shows us what is good and what is bad for our body, and it gives us at the same time the edification necessary for maintaining our health. Studying the different causes of disease, hygiene shows how these causes can be removed, and thus our health can be maintained; studying the different means by which the body can be strengthened, hygiene shows the best ways for us to be stronger and healthier; and in this way, hygiene comes to fulfill entirely its mission, the preservation and improvement of our health.
>
> This domain, hygiene, is one of the most important and most useful subjects that is studied in school, because it is only by knowing and applying the precepts of hygiene that we can prolong our life and keep ourselves healthy until its end. … Every passing day the importance of hygiene increases considerably because of new discoveries. Our health is less and less attacked because of hygienic measures that are taken.[55]

Mentioning Hippocrates and Galen, Samuel writes that the history of hygiene "like any science ... passed through many phases, phases of glory and others of debasement."[56] Christianity, he writes, stopped the progress of hygiene in medieval Europe because it "concerned itself with the soul but not the body," but with the coming of "the beautiful period of artistic and scientific flowering—the Renaissance—hygiene began to flower again."[57] The essay then speaks of more recent advances in hygiene and their application in Romania, using information from his textbook. Tzara's later formulation "la pensée se fait dans la bouche [thought is made in the mouth]" could have been a reworking of the textbook's obsession with "the flora of our oral cavity": "Air, water, and different foods bring to our mouth a wealth of bacteria. It is no wonder that in the mouth and in saliva of any man, no matter how healthy, there are thousands upon thousands of bacteria."[58]

By the end of the essay, Samuel launches into a series of rhetorical questions that are increasingly amusing when one imagines a prim, serious young boy in somber suit and tie, heavy eyeglasses on full cheeks, dark hair parted to the side, standing to attention and declaiming:

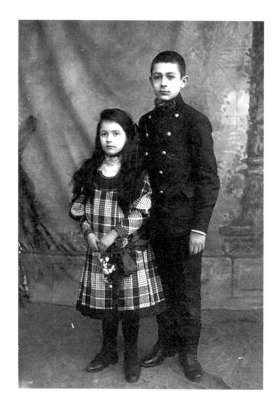

FIGURE 2.5
Samuel and Lucică, around 1910.
Courtesy of Mira Rinzler.

> Of course, to what are these good things due but hygiene?
>
> …
>
> Who can still doubt that it is only through hygiene that we could eliminate typhoid, the death of many hundreds of people every year?
>
> …
>
> Can anyone still deny the great importance that hygiene presents?[59]

"Having seen the importance of hygiene, nothing remains but rigorously keeping to its rules," Tzara continues: "'Man does not die, he kills himself'—yet in my mind, as I am writing about hygiene, please allow me to add: yes, truly man kills himself, but only when not following the precepts of hygiene."[60] This closing salvo of schoolboy logic reads ironically today, yet young Samuel's essay was warmly received by his examiners, with his grade in hygiene—an 8 out of 10—bettered that year only by his marks in German and music.[61] He was institutionally certified as competent in the field of hygiene; no one could have guessed that the hygiene he later taught would be focused not on public sewers but on minds.

After Tzara had completed four grades at Schewitz-Thierrin, his family moved down to Bucharest. Filip became a self-employed entrepreneur but also sought out opportunities in the country's economic center.[62] He could also call upon his sister, who had been settled in Bucharest for years and owned a number of successful commercial enterprises, including several cinemas. The jovial, free-spirited Filip would have appreciated being in a city with numerous attractions on offer; the fact that his work now required frequent travel would also have been appealing. For Tzara's mother, Bucharest meant above all the presence of her son, who had spent several years away and had blossomed into a young man without her attentive care.

This reunification of the family did not make life easier for Samuel, who had become used to independence. He was enrolled in the prestigious private high school Dimitrie Cantemir for the academic year 1910–1911. While there is no record of his marks, the fact that he stayed only one year indicates that he did not do well. The following academic year Tzara enrolled in Sfîntul (Sf.) Gheorghe (Saint George's), one of Bucharest's most academically rigorous high schools. He did not complete his year at Sf. Gheorghe—there is no mention in the official register of his attendance for the final term, indicating that his father must have pulled the boy out so as not to throw good money after a hapless cause, for it was clear that Tzara would have to repeat the year. He was failing mathematics, physical sciences, and history. He barely managed to pass natural sciences, and even in French his marks were just above passing.[63]

There was little excuse for such poor marks across the board: in both mathematics and physics, Tzara was innately talented, so it must have been a question of effort. This may suggest that the small class size—ten students in his year—could have been a reason for his difficulties; in such a small class, the student-teacher dynamic is much more influential.

There was a combustible mixture at work: Romanian teaching methods that most commentators recall as heavy-handed, authoritarian, and Ubuesque, pitted against a naturally gifted student who was one part stubborn and another part bored. The final possible explanation lies with his family life. His parents had sent him to Bucharest to live on his own, but now they had come down to live in the capital. As a boy who must have felt abandoned yet who managed to secure a kind of independence, the adaptation required for living with overbearing parents once again must have rankled with Samuel, who was on the cusp of manhood. As his grades started to flag, which must have resulted in his parents exhorting him to concentrate, Tzara did the opposite: in this third and final term at Sf. Gheorghe, his marks in seven out of ten subjects failed to improve.

If Tzara's academic progress was checkered, part of the blame can be placed upon having his head filled with "[s]tacking books, reciting verses."[64] Already in Moineşti Samuel was an avid reader, and the years spent away from home as a boarding student accelerated his intense private reading. But it was only in Bucharest, when he came in contact with other young *littérateurs*, that Tzara first began to write poetry. Two close friends were critical for this: Marcel Iancu (the spelling "Janco" only came later) and Ion Vinea (the pen name of Eugen Iovanaki). Both came from well-to-do and educated families that encouraged the arts; both were also, in the eyes of the vast majority of Romanians, foreigners: Marcel was Jewish, while Ion's mother hailed from the Ottoman Empire. Although they did not study with Tzara at the same high school, this band of three came to have an impact on the Romanian cultural scene through *Simbolul* [The Symbol]. First appearing in 1912, when the editors were all still in high school, this literary review was a training ground for Tzara's poetic development and his skills as an impresario. Although it was run by teenagers, *Simbolul* elicited reviews in the most prominent literary journals of the day.[65] But before examining the magazine itself, looking at the two close friends with whom Tzara collaborated is instructive for drawing out the basic philosophy of the review and the literary positions it took.

The Iancu family, whose fortune was made in textiles, financed the magazine. Among the small number of Jewish families who were Romanian citizens, the Iancus had both the largesse and the inclination to support their children's artistic gifts, arranging private lessons in music and drawing, and taking them on trips to museums and galleries in Italy, France, and Germany. The names of their three sons (Marcel, Jules, and Georges) testify to the family's European spirit. Iancu's mother, Rachel, was an amateur pianist who wanted her three sons to be musicians. As a young boy, Marcel was given private drawing lessons by Iosif Iser, a pivotal figure in Romanian art at the turn of the century. Having studied in Munich and Paris, Iser made his living as a caricaturist in the left-wing Bucharest press—mainly at *Facla*—and also took pupils (he taught M. H. Maxy, the pen name of Maximilian Hermann, a key figure in the Romanian avant-garde in the 1920s). As a 1913 reviewer put it, Iser "rebels

against painting schools and prejudiced academic thinking."[66] He believed that any genuine artist was "ipso facto a *primitive*" (technical proficiency had to be mastered so that it could be forgotten), and he shunned subject paintings, insisting that "only through forms can the subject exist."[67] He also brought to the capital new French art: works by Derain, Forain, and Galanis were shown in 1909 largely due to his efforts. It was probably also through Iser's efforts that Iancu's work was exhibited, when he was only seventeen, in the official salon of 1912 alongside work by Constantin Brâncuşi and Arthur Segal. Iancu's graphic contributions to *Simbolul* were heavily influenced by his teacher, and Iser himself contributed a drawing to the final issue. The emphasis on the graphic arts made *Simbolul* stand out among contemporary publications, leading Iancu to later claim that they were "the pioneers of a revolutionary era in Romanian art."[68]

Ion Vinea was a more important figure to Tzara at the time, a close friend with whom everything was shared. They vacationed together, excitedly collaborated on each other's poetry, and, besides *Simbolul*, edited a short-lived journal in 1915, *Chemarea* [The Calling]. In 1919, Tzara even announced a project to translate Vinea's poetry into French, with the book to be published under the imprimatur of Dada. A year older than Tzara and then a student at Saint Sava, the capital's elite high school, Vinea grew up in a split household: a father who saw no point in activity and a mother whose relentless spirit acknowledged no obstacles. Alexandru Iovanache had attended the prestigious École Centrale in Paris, but upon returning to Romania he showed no interest in work, which his position as a "functionary" did not remedy; he was "a strange man, an incurable Bohemian, lacking in energy and practical spirit."[69] Vinea's mother, Olimpia, who came from a Greek family settled in Constantinople, had also studied in Paris. When her family lost its fortune, she set up a private *pension* in Bucharest where she taught Latin and Greek. While the schoolmistress mother was driven, the son was neglectful of his studies, failing a number of subjects because he regularly skipped classes.[70] From 1913 to 1915 Vinea was a literary reviewer at *Facla*, a left-wing newspaper run by Nicolae Cocea, a socialist who had been condemned as an instigator of the 1907 peasant revolt. Vinea was thus put in contact with the most recent developments in arts and literature, and it is almost certain that he shared with Tzara the books he reviewed, among them Apollinaire's *Alcools*. Vinea could not have had his position had he not shared Cocea's left-wing sympathies. Besides sharing books and ideas, Tzara also would have heard about how *Facla* was run—before Zurich Dada, in other words, Tzara was personally exposed to a revolutionary press that combined culture and politics.

That a band of high-school students should seek to make inroads into culture is perhaps surprising, but at the time the capital seemed to be overrun by young bohemians "impatient to throw themselves into the great fight, having as their sole wealth their illusions."[71] Mircea Eliade's first novel, the fictional autobiography *Romanul adolescentului miop* [The Novel of the Myopic Adolescent], contains a portrait of an arts society run by teenagers, "Muza," whose members wrote poetry, fiction, and even delivered papers on the *Ramayana*; in that

FIGURE 2.6

Simbolul, no. 2, November 1912.

Courtesy of the Library of the Romanian
Academy (Bucharest).

novel, the protagonist comes to a crisis when he confronts the work of Giovanni Papini.[72] One of the country's leading philosophers and cultural commentators, Constantin Rădulescu-Motru, admonished youths for becoming too radical in their literary experimentation—and Rădulescu-Motru was no cultural conservative, but an advocate of Symbolism and cultural innovation.

Only a generation earlier, due to the paucity of schools, high levels of illiteracy, and the incredible gulf between rich and poor, literature was a privileged activity for a select few. One of *Simbolul*'s collaborators, Nicolae Davidescu, noted that not so long ago "publication of a piece in a magazine constituted for the public a guarantee [of quality] and for the author notoriety," whereas with the rapid explosion of writing it was now thought "that everything published is inferior [*prost*]."[73] The changes Davidescu alludes to were drastic. The earliest text written in Romanian appeared in the first half of the sixteenth century, and there were few secular printed texts in the language until the early nineteenth century.[74] The first Romanian-language newspaper, a four-page monthly, appeared in 1827, and not even within the country's borders, but in Leipzig; by 1910, though, Bucharest alone boasted 14 daily political newspapers and a huge number of weeklies and monthlies, including 25 magazines devoted to the arts.[75] The lack of censorship, which was outlawed by the 1866 constitution, ensured that the most extreme opinions could be aired.

Simbolul was able to make an impact because publishing was an open field and largely made up of amateurs. It was only in 1910 that the Society of Romanian Writers was founded; the association wanted to turn literature into "an honorable and noble profession" and also to relieve the "genuine misery" most Romanian authors faced.[76] In the year that *Simbolul* appeared, 1912, over 3,100 books were published, a figure surpassed only in the late 1930s.[77] A large chunk of those books were by foreign authors, though: the demand for new work by Romanian authors remained small. Iorga's *Sămănătorul* had only 300 subscribers and managed to sell only a few hundred copies on top of that.[78] Constantin Baldie, who worked at *Noua Revistă Romănă*, recalls that "the instinctive repulsion for Romanian magazines" was so strong that many people marked "refused" if one came through the post—unsurprisingly, the review's circulation was a paltry 150 to 200 copies per week.[79]

The dominance of Bucharest as a cultural center also eased the path for the young Turks of *Simbolul*. Whereas in Zurich Tzara would be cut off from personally engaging with the avant-garde, and thus had to resort to letters and postcards, in Bucharest he could personally approach leading poets by going to the cafés where they held court. In 1914 Vinea wrote a polemical article on café culture that Tzara must have read; while conceding that the café was a "vast society," Vinea insisted that it was a "field of battle for petty ambitions, the petty interests of little belligerents."[80] The tone of the article expresses the desire to shock, yet everyone reading it would have done so in a café![81] It was common knowledge that certain cafés were the home of certain artistic tendencies, social groups, or political ideas. Alexandru Macedonski was the lead figure at the High-Life on Calea Victoriei; Ion

Minulescu could be found at the Terasa Oteteleşanu, near the main telephone exchange.[82] There was even a Café Voltaire facing the National Theater, although Tzara would not have frequented it, as it was reputed to be a sanctuary for "classical traditions."[83] Tzara and his friends were not interested in that—rather, they wanted to chart a new course for Romanian literature.

Simbolul ran for four issues, from 25 October 1912 to 25 December 1912. Although the third issue stated that "*the entirety*" of the editorial work was done by "S. Samyro," Tzara's pen name at the time, he worked closely with Iancu and Vinea on it.[84] The editors sought out and published contributions from "almost all of the representatives of the 'new poetry' at the time."[85] The magazine featured, alongside poetry by Tzara and Vinea, work by Emil Isac, Adrian Maniu, Claudia Millian, Nicolae Davidescu, Ion Minulescu, and Alexandru Macedonski. These contributors were well-known champions of a modernist aesthetic. A number of the *Simbolul* collaborators had also contributed to *Insula*, a short-lived review that appeared several months earlier. Edited by Ion Minulescu, the explosive manifesto featured in its first issue may well have remained with Tzara for years:

> We want to live, so we need a new formula for life and we will find it.
>
> We will not follow a doctrine to guide our future action. Doctrines come later …
>
> We do not believe in the existing forms or in the possibility of rehabilitating them.
>
> We thus understand that we will be on untraveled roads. … We are not afraid of singularity; on the contrary, we seek it. We probably will be awkward and hurried; perhaps. We will repeat ourselves, we will contradict ourselves: surely. But this matters little.[86]

Among the younger collaborators, Isac famously called for "not just birds, but also airplanes" as poets undertook a "modernism along all lines"—this modernism would necessarily involve "the elimination of nationalism."[87] Maniu declared himself irremediably "bored" by "the stupidity of so-called poetic material" that "no longer had any value or sense."[88] The elder statesman of Romanian symbolism, Macedonski, proclaimed the absurdity of "the thoughts and means of expression remaining just as they were three thousand years ago."[89] In a 1913 article Vinea called on poets not to seek "false inspiration from books as nine-tenths of our poets do"; rather, they should "get rid of any aestheticism and affection" in their work by going beyond poetic conventions and only taking their cue from life.[90] One teenage collaborator, Charles Poldy, declared himself a Futurist.[91] *Simbolul*'s outlook was resolutely international: the first issue had a poem by Vinea inspired by Albert Samain, an obscure French Symbolist (whom Tzara also appreciated, as "Cirque" in the 1923 collection *De nos oiseaux* alludes to Samain). The third issue announced the release of *Du "Cubisme"* by Metzinger and Gleizes, "two of the most authentic representatives of the new movement."[92]

36

The title of the review was an unmistakable sign of the group's aesthetic ambitions. In Romania, Symbolism had a powerful hold on young *littérateurs*, who were "fascinated by the new French literature, which began with Baudelaire and culminated in Mallarmé and Verlaine. ... French culture, the reading, thinking about, and studying of poets who came after Baudelaire have spawned artistic taste and refined it" for an entire generation.[93] Symbolism's belief that the only value of a poem resided in its ability to translate private emotion through language appealed to aesthetically minded teenagers searching for a way to express themselves in a society marked by social and religious divisions: here was poetry for initiates. In "Le Manifeste symboliste," Jean Moréas calls Symbolism the "[e]nemy of teaching, of declamation, of false sensibility and objective description": it shunned poetic conventions in order to create an oblique approach to ideas, which were expressions of sensibility.[94] The reception of Symbolism in Romania was largely due to the efforts of Macedonski, who began to collaborate with *La Wallonie* in 1886. When he came back to Romania, Macedonski energetically promoted the new movement through reviews and translations (of Baudelaire especially).[95] His poetry was marked by muted desperation—"sad night, silent night, dead night, opaque sky"—and disgust with provincialism:

> The little town robs you slowly
> With its silent streets
> With its decent but stupid people
> Who don't even know I am a poet.[96]

Tzara had experienced this in Moineşti; many of the poetic themes found in his Romanian-language poetry, such as the dejected countryside and the melancholic poet, can be traced to Macedonski. Finally, Macedonski's influence came not only from his poetry but also from his playing the part of the bohemian artist through his loud and garrulous lifestyle.

While not without its adherents and supporters, Symbolism was also vigorously attacked for being a repudiation of national traditions.[97] The appearance of *Simbolul* became part of this larger debate. For the predominantly nationalistic *Viaţa romaneasca*, the "decadent" writers in *Simbolul* produced pseudo-poetry. The journal pointed out that with Romania on a war footing because of the First Balkan War, the magazine was "ridiculous," even "quite truly odious": "It is a lack of human solidarity, a guilty alienation [*instrăinare*] from common sentiments, a kind of moral abandonment. In this country originality can in no way excuse such a position."[98] Not for the last time, Tzara was accused of being a foreigner out to destroy a national culture: the term *instrăinare*, which comes from the root *străin* (foreign), means becoming foreign. But the editors of *Simbolul* seemed to court this kind of controversy: the first number published an article by Emil Isac (whose literary debut was in a Hungarian magazine) that proudly announced his own decadence and violently attacked the period's leading public intellectual and nationalist patron saint, Iorga.[99] Already Tzara was showing that he was ready to stir up polemics in the name of art—an art that was, moreover, from the start politicized, immersed in fiercely contested cultural debates.

Simbolul folded after four issues. This must have been disappointing for Tzara, since the journal had ambitious plans, even going so far as announcing rates for an annual subscription (at 5 lei) and even an international subscription (at 7 lei). Yet exposure in the press and impressive contributors were not sufficient to make the journal pay its way. Since more established journals were frequently run at a loss, it seems improbable that *Simbolul* could turn a profit. Since the young editors were still in high school, it was clear that the magazine took time away from their studies. For anxious bourgeois parents, it was more important for their sons to prepare for a career than to dabble in literature. Yet *Simbolul* was an important experience for Tzara. The ability to transform a youthful passion into something concrete must have been gratifying. Even if the end result was not as grand as he had hoped, there was tangible proof—those yellow covers stockpiled in the corner of a bedroom—that obstacles could be overcome. His own poetry was not only in print but had been read by the few people who mattered in Romanian letters. He also learned about publishing (layout, typography, the use of images) from working closely with the printer. While *Simbolul* was largely conventional in its presentation, the more basic skills involved in seeing a magazine to press were what mattered at this point. These were skills that he could use again, and it was clear that, after the magazine folded, Tzara did not consider this the end of his literary ambitions, but only the beginning.

3 SONGS OF WAR: **1912–1915**

ALTHOUGH TZARA BROKE INTO PRINT AT AN EARLY AGE, HIS POETIC DEVELOPMENT WAS HARDLY UNIFORM. His struggle to settle upon a pseudonym—it took over two years for him to go from "S. Samyro" to "Tristan Tzara"—reflected an uncertainty about his personal and national identity. Jewish authors in Romania were almost professionally required to disguise their identity if they wished to appeal to a wider public. In "Sister of Charity," Tzara plays with the idea of not being Jewish:

> I'm an Orthodox Christian
> I stay in bed and wonder if it's fine outside
> My suffering is arranged in rows.[1]

But the poem concludes with the poet turned into a Hamlet ravaged by nature, weeping silently into a pillow, showing the impossibility of this transformation. Being denied one's own identity by noxious cultural politics must have been infuriating, yet self-naming was a way of breaking the strong bonds of family and allowed one to adopt a persona. If "S. Samyro" played upon his given name ("Sami" plus the start of Rosenstock, although with a national twist, the "Ro" possibly alluding to "Romania"), "Tristan" was pan-European in its allusions to medieval romance, Wagner's opera, and Symbolist poet Tristan Corbière (the subject of several essays by Tzara after World War II). Over his adopted surname, though, Samuel hesitated. An early manuscript shows different signatures battling with each other: a 1915 poem is first signed "Tristan Țara," then the comma under the "T" is taken out, and it finally ends "Tristan Tzara."[2] The substitution of the diacritical "ț" by "tz" emphasized the "foreignness" of the bearer. The switch did not change the pronunciation; rather, the homophone was a confident assertion by the young poet that difference had its place within the understanding of the nation. He would change his name, but do it in such a way that his identity was not effaced.

Tzara's intellectual development was entangled within larger Romanian cultural debates about national identity and the value of culture—concerns that later formed the core of his

41

Dada activity. If modernism in Western Europe was marked by the artist's growing alienation from society, a sense of aloofness and separation brought on by mass democracy and market economies, literature in Romania was necessarily political because culture itself was politicized. "*Nations,*" A. C. Cuza noted, "*do not exist except through their culture.*"[3] "A new epoch of culture *has* to begin for us. It *has to*, or otherwise we shall die."[4] This statement from Iorga's *Sămănătorul* led a literary critic to comment on the exaggerated stakes of cultural politics in the period: "Culture and culturalization had become the axis of an entire politics, an assumed panacea for social and national problems."[5] There was a deep belief that a national culture could be drawn only from literature and printed books: "My heart soars: I read a learned book," Tzara writes ironically.[6] Even if the exaggerated stakes of literature were laughable to the young poet, this was inescapable: literature and criticism were not passive reflections of society but active agents of social change.[7]

The debate that raged for over half a century concerned how Romanian culture could be formed and what its place in Europe would be, with the basic opposition between modernization and native traditions. The classic exposition of this conflict was Titu Maiorescu's "Against the Current Direction of Romanian Culture" (1868). A founder of the nationalist *Junimea* literary group and future Prime Minister (1913–1914), Maiorescu diagnosed Romanian culture as a "form without substance [*formă fără fond*]"—it had the trappings of Western modernity with academies, theaters, and an opera, but Romania lacked an organic base to support high culture.[8] While the country was tied to the cultural mainstream in Europe—French newspapers were readily available, many students were educated abroad, and in 1909 a provincial magazine published, on the same day as *Le Figaro*, Marinetti's First Futurist Manifesto—the problem was that these modern forms meant little in a traditional society. For Maiorescu, the danger was that having "an academy … without science, an association without the spirit of society … and a school without good instruction" would discredit those very institutions.[9]

Romania was in many respects a "colonial culture" that imbibed the ideology of the culturally dominant center, from which all values derived. A dictionary from the 1870s accepted only words of Latin or French origin, relegating Slavic or Ottoman words to the glossary.[10] This ideological view was not confined to literature but was noticeable throughout society, as a Bacău magazine explained in 1905:

> We Romanians are satisfied to do everything we see others do. And so our laws, our professions and our businesses are nothing but an imitation of others. We ourselves have done nothing new. We haven't profited from our experiences but have left them aside. We have searched only to imitate and everything that is imitated is said to be better because it comes from others who are cleverer than we are, that is, foreigners; this is a very mistaken and very damaging belief for Romanian innovation.[11]

In 1910, Constantin Dobrogeanu-Gherea's *Neoiobăgia* [Neo-Serfdom] identified the preponderance of foreign capital and unequal land distribution as fundamental barriers to an autonomous Romanian culture. The lack of an authentic native culture was damaging, since nations could justify their existence only through culture: "a people never rises up the rung of other civilized peoples, does not have a right to exist, cannot conscientiously assure its immortality, until its creative genius is woven into artistic works that pass into the global cultural and artistic patrimony."[12] In "The Tragedy of Minor Cultures," the first chapter of E. M. Cioran's *Schimbarea la față a României* [The Transfiguration of Romania], Cioran speaks of "one thousand years of subhistory"—there could be no pride in being a minor culture, which was nothing other than "*a deficient organism*."[13]

And the highest beacon of culture was indisputably France. Romania was, as one writer put it in 1914, "*a veritable French intellectual colony*."[14] For the philosopher and literary critic Benjamin Fondane, who later befriended Tzara in Paris in the late 1920s, Romania was "intellectually nothing but a province of French geography."[15] The first periodical in Romanian territory, the *Courrier de Moldavie*, was published in French, and of 141 government ministers between 1866 and 1916, 101 studied in France or in French-language environments.[16] There was not much of a bitter revolt against this cultural annexation. In an 1898 thesis at the École Normale Supérieure, Pompiliu Eliade depicted French influence in wholly beneficial terms: through it, Romanian culture had gone from "an instinctive life, almost unconscious of the spirit, to a life of intelligence," as "barbarism [was] replaced by civilization."[17]

Tzara's education had a significant French component, and several early poems are strongly marked by French influences. The poem "Sister of Charity" takes its title from a Rimbaud poem of the same name, and other poems have entire stanzas in French, illustrating how the educated bourgeoisie could easily shift from one language to another. Tzara was also interested in English-language literature, translating sections of Walt Whitman's *Song of Myself* that were published in December 1915 in *Versuri și proză* [Verse and Prose], and writing a series of poems inspired by *Hamlet*. As a poet, in other words, Tzara was fully on the side of the internationalists, importing into the country foreign poets and models.

Yet the French model came to be contested in the early twentieth century as corrupting morals and enervating Romanian culture. In 1906 Iorga protested against three French plays being staged at the National Theater: "anyone who feels that he has a country, anyone who hears the authoritative voice of his blood," should boycott the performances.[18] When the crown prince and prime minister announced their intention to attend the opening night, students gathered in front of the National Theater. The protests turned violent, with tramcars overturned, bricks thrown, and shop windows broken; while there was no loss of life, over 30 policemen and 70 pedestrians were injured.[19] Iorga and his allies responded with speaking tours across the country; the protest centered on the idea that what Romanians imported was not truly French but "the decadent France of cosmopolitan Paris."[20] This echoed the reaction to the influence of French poetry: Romanian Symbolist poetry was

43

said to be "blindly" following "today's Parisian insanities," and one eminent critic called these poets "deracinated."[21]

Conservatives argued that foreign models should be dismissed in favor of a unique national genius that represented the country's folkways and peasantry. This critique was partly grounded in an ethnic nationalism, which saw the eagerness to accept foreign models as a possible step toward accepting foreigners (a code word for Jews) in the public sphere. The continued division of the Romanian people—Transylvania, with its millions of ethnic Romanians, was part of the Austro-Hungarian Empire until 1920—only raised the stakes of the national question. Literary critic Garabet Ibrăileanu's dictum expresses this view clearly enough: "The most talented writers coincide for the most part with the most nationalistic."[22] The conservatives accused the imported culture of being unhealthy: "We have broken the link of tradition, we are mocking the beliefs of our ancestors, we are deserting our national institutions" by "importing into literature, our spiritual altar, the most diseased ideas that are totally foreign to the Romanian spirit."[23] For A. C. Cuza, these foreign models destroyed a preexisting civilization and put in its place "a shameful parody in which men and women take on from outside roles that they do not understand, dressed in clothes that they do not know how to wear."[24] Finally, there was a view that the national culture could have value only if it developed independently; Iorga wanted "to give the Romanian people a literature that takes its start *from them*, from what is … most characteristic of them, and to give at the same time universal literature in its most worthy forms a new and original chapter."[25]

This question of originality was an important one. The first issue of the 1908 *Revista celorlalți* [The Magazine of the Others], which featured an article about Lautréamont at a time when his work was difficult to find in France, called for "abandoning the formulae that our forefathers taught us" and replacing them with "everything that is new, strange, even bizarre."[26] For some critics, this was problematic: "We have played too much with aesthetic formulae. We have reckoned that it is enough to take from a thinker or artist some dogma and to launch it in this country as a novelty, because in that moment, through a magic wand or some spontaneous generation, there will arise poets, storytellers, playwrights and novelists, an entire literature fashioned after this new formula."[27] The article's author, Dimitrie Karnabatt, was hardly a cultural conservative, but he had little patience for self-proclaimed innovators and their "unusual attempts, odd affirmations."[28] Not only did this originality have little to do with the reality of Romanian life, it had no basis in Europe either.

Karnabatt also alludes to the growing tendency for Romanian writers to divide themselves into literary schools.[29] In a March 1914 article on Simultaneism, a doctrine that would come to play an important role in Zurich Dada, Tzara's close friend Vinea argued that literary movements were inimical to art, which had to be concerned only with "Individualism" and "Talent," the only elements that "posterity takes into account."[30] This was the view of another *Simbolul* collaborator, Emil Isac, who complained that writers were "going off in different 'currents and schools'" instead of seeking their own path: "*Futurism* is not only

Marinetti's disease but the disease of all contemporary literature. Today in literature there is no respect for individuality, because its place has been taken by promotion and 'schools' … the artist's conscience disappears, because in its place come movements X and Y. … Look around and you will see artificial glories, so many unmerited victories and successes."[31] These criticisms of literary schools were not original, but they were forcefully expressed and probably made an impression on Tzara, who always maintained that Dada was a collection of individuals, not a doctrine. More broadly, the growing importance of literary movements could not have been lost on him. Even if his closest associates still maintained a fierce independence toward these schools, Tzara saw how the literary press was eager to cover the latest movement. Moreover, there were institutional pressures at work: since literature was confined to a limited group of people who tended to be concentrated in a small section of Bucharest, the individual artist needed the support of his peers, and had to make strategic alliances to secure publication of his works.

In this polemical environment, entitling one's journal *Simbolul* was, unmistakably, a taking of sides. Tzara was undoubtedly in favor of the modern, the new; he wanted to know about the most recent developments, not to go after some imagined national past. There certainly was something precious about the yellow-covered *Simbolul*, with its risqué drawings and suggestive poetry. But the fierce cultural debates raging in the country at the time had made their mark; it was clear to Tzara from a very early age that art operated in a wider social context.

The connection between art and society was nowhere more apparent than in the rumblings of war that began to sound as *Simbolul* was going to press. A week before the first issue, Montenegro, and then its Balkan League allies Serbia, Greece, and Bulgaria, declared war on the Ottoman Empire. From the autumn of 1912 until the conclusion of the Second Balkan War in summer 1913, the country was in limbo: "One thing is absolutely certain: from last autumn, when the Balkan War broke out, and until the day the Romanian army was mobilized, the entire Romanian population, in the cities and in the countryside, lived in a state of perpetual anxiety."[32] These were months of nervous waiting for the neutral state, with war expected to break out any minute. The Romanian army was eventually mobilized in the Second Balkan War. Over 300,000 soldiers crossed the Danube into Bulgaria and concluded the war within twelve days without a single combat casualty (although 6,000 soldiers died of a cholera epidemic).[33]

The scale of devastation of the Balkan Wars was enormous: 32,000 combat casualties for the Bulgarian army, 36,500 for Serbia, and nearly 8,000 for Greece, while the Ottoman Empire lost around 100,000 soldiers.[34] The cost extended beyond the battlefield as epidemics killed indiscriminately and civilians became "targets of war": "Deliberate terror created by arson, looting, murder, and rape was intended as a spur to move populations out of a particular piece of territory."[35] The Carnegie Endowment for International Peace con-

1913. - **Armata română in Bulgaria** (18) : *Vizita medicului veterinar.*

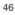

FIGURE 3.1

Romanian soldiers at the front,
the Second Balkan War.

Courtesy of the National Museum of
Romanian History (Bucharest).

cluded its report on the Balkan Wars by noting that "the war suspended the restraints of civil life ... and set in its place the will to injure." [36]

The Second Balkan War was a truly national event, creating "intense *social convergence*" as "a single goal tyrannically lorded over every person." [37] Nationalist agitation—receiving Bulgarian territory was the first step to "liberating" Romanians in Transylvania—created a kind of mass hysteria, with the army's triumph representing the possibility of social renewal after the disastrous peasant revolt. Some sensitive observers were less triumphant, concluding that the Balkan Wars belied claims of progress and international harmony: "[t]reaties were drawn to be promptly torn up." [38] The poet Tudor Arghezi remarked that war imparted one horrible lesson: a culture that had been "patiently built" over "hundreds of years" was powerless against "ten cannons assembled in several hours." [39]

If "[t]he rumbling sounds of arms seem to have intimidated the delicate muses," the appearance of *Simbolul* during the First Balkan War bucked this trend. [40] Yet the journal's silence on the war question led to harsh criticism in the press, which considered aesthetic fancies gratuitous during a national crisis. Before arriving in Zurich, Tzara already understood what it meant to be a poet in wartime. He did not want to turn *Simbolul* into a trumpet for nationalist propaganda, but he was not entirely immune to the gravity of the military situation. One of his most accomplished Romanian-language poems, "Furtuna și Cîntecul Dezertorului [The Storm and the Deserter's Song]," was inspired by the Balkan Wars. Although it was published in the second number of *Chemarea*, and thus appeared after the outbreak of the First World War, the poem nonetheless harks back to Romania's experience during the Balkan Wars. As its title indicates, the horrors of war are refracted through a deserter. Crucially, the deserter does not come from the losing side; he has not fled his regiment out of cowardice. By looking at the human cost of victory, Tzara moves beyond the classical poetry inspired by the unsheathed sword and the victorious arms of heroic soldiers. The first stanza details a military advance:

47

> We come up on the troops from behind and cut them down
> We trample corpses left in the snow
> We open a window to the drowned darkness
> Through valleys that sucked the enemy dry. [41]

These lines have an intense sonority and a marked internal rhythm. In the original, one of the lines is "Stîlcim stîrvurile lepădate în zapadă [We trample corpses left in the snow]": the "stî" of the first two words gathers speed, especially since the phrase starts with a rapid-fire verb and object combination, while the rest of the sentence comes together in the internal rhyme of "lepădate" [fallen] and "zapadă" [snow]. The basic stressed-unstressed accent of the line gives a ceaseless beat to the strophe: this is the music of war pushing the soldiers forward, linked together in rapacious cruelty as they survey the enemy's losses. The unspecified "we" advancing in this wasteland soon falls victim to an inhospitable nature:

The frost: bones shiver, flesh gets eaten
We let the heart cry.
Why are we sliding along the ripped mountain?[42]

As night falls, "It is so dark that only words are light"—but the words of the isolated deserter are collected in the second part of the poem as testimony to the futility and brutality of war:

If nations continue to war
Why does the moon still hang so red
A godly seal of the book of peace?
Grenades break off aubergine chunks of sky.[43]

The song of the poem's title is not much of a song, as the deserter, who is isolated from his regiment, tries to understand how war has destroyed him: "Look here: my body in dust and soul is coming apart."[44] The loneliness of the deserter is almost existential by the poem's end, as he implores his heart to weep but doesn't know if those emotions are still accessible, so utterly has war paralyzed him. It is a remarkably astute poem, forgoing sentimentality and concentrating on the physical and psychic breakdown of the deserter who becomes heroic by merely surviving and bearing witness. The rhythms of war are metonymically brought out, but otherwise the formal innovations are limited in order to emphasize the full force of the major theme, a sure sign of Tzara's growing poetic maturity.

The Balkan Wars were devastating, but nothing compared to the European conflagration that broke out in August 1914. Tzara had just completed high school; he was eighteen years old, and thus could be drafted at any moment, but that depended on a force he had no control over: politics. Two days after the outbreak of the war, a divided government met to consider its options. The interminable debate as to which side should be supported was finally resolved when a telegram arrived announcing Italian neutrality. Romania decided to follow suit in proclaiming its neutrality; and just as Italy had shirked its treaty obligations in favor of safety, so too would Romania.[45] One politician laid out the matter clearly: "We are a small nation. I do not believe that it is in our power to make grand policies. The Great Powers have started fighting; we do not have any business in their struggle. We should therefore stand aside, examine our own needs and problems, and save from torture that which was acquired through so much toil."[46]

For the two years that Romania remained neutral, Bucharest basked in "a scandalous luxury": "the theaters are full, the cafés are full; at beer houses, coffee houses and restaurants you cannot find a seat."[47] The city was full of intrigue, as spies from all over Europe invaded it. Newspapers were uncensored, giving Romanian readers a unique perspective on the terrible human cost of the war. When the country entered the war in August 1916, the casinos were still full, "the game continued as before"—but within months, food in the capital was scarce, aerial bombardments created mass panic, and the German occupation of the city led to a mass exodus to the northeast of the country.[48]

A combination of the horrors of war, but also a poignant questioning of how long the country could remain out of the European conflagration, appeared in Tzara's 1915 "Song of War." The poem projects Tzara's fears of being sent to the front:

> Drought
> Dried in my soul grass
> Mother,
> And I'm mortified.[49]

The poem plays on the dichotomy between the front and the civilians at home:

> Toward the borders we race,
> Alongside churches we no longer cross ourselves;
> Our loves
> If only they turned themselves into well water and the shade of nut trees
> Let's stop here.[50]

Tzara's poem is unusual for a "song of war" because there is no mention of the higher aims of the fighting or any view of the enemy; rather, the focus is on the human experience of being entangled in a conflict tearing away at the self: "The earth is burned by longing for home."[51] Wading through an increasingly hostile nature, fearful for the safety of loved ones, the poet-soldier sees that his days are numbered, and that all that life had promised will end:

> Old poplar running across the raised trench
> Spews out entrails, guts
> Truly blonde is the innkeeper's daughter from Hîrșoveni
> How many more hours do we have left?[52]

The final question about the time remaining does not concern only the individual soldier, but would also have resounded in a neutral Romania as a question of just how long it would be possible to stave off the country's entry into the war. In Bucharest it was an open secret that government policy was essentially being sold: whichever power offered more territorial and material recompense would find itself supported by the young country. In Tzara's poem the government's policy of playing off suitors against each other is represented by that shining symbol of innocence and hospitality, the blonde innkeeper's daughter. But the result of this policy, the poem seems to suggest, is that the ravishing young girl will end up a jumble of bones and guts. This imagery of body parts could have been taken from Tzara's close work on Whitman's *Song of Myself*, for the section of the poem that he translated in 1915 dealt with a ship at sea carrying "[f]ormless stacks of bodies and bodies by themselves, dabs of flesh upon the masts and spars."[53] Rather than taking from Whitman's poetic universe a joyous anarchic liberty, Tzara concentrated on the experiences of the volunteer wartime hospital nurse:

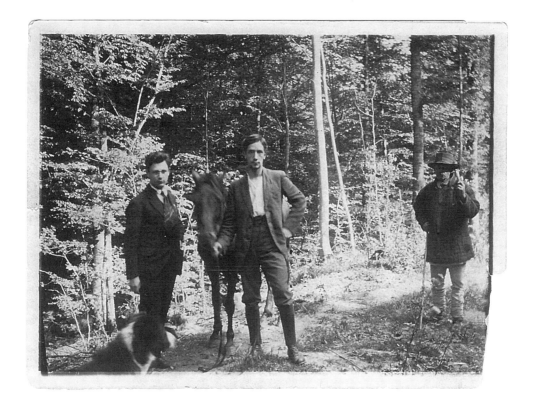

50

FIGURE 3.2
Tzara and Ion Vinea in the Rosenstock
vacation home in Garceni.
Courtesy of the National Museum of Romanian
Literature (Bucharest).

The hiss of the surgeon's knife, the gnawing teeth of his saw,
Wheeze, cluck, swash of falling blood, short wild scream, and
 long, dull tapering groan.[54]

The desire to confront the government's increasingly questionable policy of putting its services on sale to the highest bidder was the impetus for *Chemarea* [The Calling], a journal that Tzara edited with Vinea.[55] Plans for the journal were made in the summer of 1915, when the two were vacationing together at Tzara's grandfather's estate. The title suggests the idea of being "drafted" or "called up," but the contents of the review show a different understanding of the country's war situation. *Chemarea* was meant to be a weekly, but only two issues appeared in 1915, the first on 4 October and the second a week later. The review, put out by the printer of *Simbolul*, was the first organ to publish poems signed "Tristan Tzara," which is why Vinea later called *Chemarea* the "embryo" for Dada.[56]

Although Tzara's name appeared on the editorial masthead, Vinea was the driving force of *Chemarea*. The editorial of the first number is entitled "Incendiary Warning": Vinea speaks of the journal's "abandonment of all dogmas and stick-in-the-mud" beliefs, as *Chemarea* positioned itself "against the press, shameful trumpets, and against readers, these amorphous masses and brute victims, honest but unconscious."[57] Politics and aesthetics were interlinked in the review, with an exhortation for readers to replace pencils with knives, and for bourgeois homes to be bombed.[58] A review of the journal in the *Noua Revistă Română* spoke of the anticlassical tendencies in *Chemarea* but also noted that its seeming polemical nature was undermined by an elegant, beautiful cover page and aesthetic poems like Tzara's "Vacation in the Provinces."[59] Although it folded after only two issues, Vinea brought out *Chemarea* during the latter stages of the war as a self-proclaimed "radical socialist newspaper." After a satirical article by Benjamin Fondane on the benefits of censorship ("Long live censorship! … With it we will have a single art, a single ideal, a single Romania. … We like censorship because it is the sole reader who is attentive, free and interested"), one issue in February 1918 appeared with its title page and a number of articles blacked out, with the word "censored" over them.[60]

The start of the European war did not interrupt Tzara's schooling, as he enrolled in the Faculty of Philosophy and Letters at the University of Bucharest on 17 October 1914.[61] The university had expanded considerably since it was founded in 1864, and by the time Tzara enrolled it had nearly 3,000 students, 500 of them in the Faculty of Letters.[62] There is no record of Tzara's coursework, and his name does not figure in the attendance sheets kept for that year, or on the list of students who attended special seminars in philosophy entitled "About Affective Phenomena" and "The Duration and Intensity of Sentiment."[63] There were courses of interest that Tzara could have taken: Ovid Densusianu, who also published a number of little reviews, held a seminar course on French Symbolism.[64] Constantin Rădulescu-Motru, who had written the first monograph on Nietzsche to appear in Europe,

was on the philosophy faculty and, as the editor of the *Noua Revistă Română*, published some of Tzara's poetry in 1915.[65] Rădulescu-Motru's January 1915 article "War and Modern Culture" could well have appealed to Tzara: beginning with the principle that individual "personality" is the great achievement of modern culture, Rădulescu-Motru argues that war decimates everything civilization stands for: "And not only is the principle of personality in conflict with war, but so too are many other principles that are considered to be the basis of modern culture. The principles of morality and logic; principles of law and international justice, to say nothing of comfort; everything is diminished because of the war. Instead of these principles there is barbarism and deceit, the destruction of everything that has up to now been respected."[66]

Yet these two figures were otherwise isolated in a faculty that was parochial in its interests or openly anti-Semitic. The most decorated figure on the faculty was history professor Nicolae Iorga, whose undisguised anti-Semitism was emulated by the student body. The student magazine, *Cuvîntul Studențimii* [The Students' Word], ran articles entitled "Plutocracy and the Jewry"; its editorial line was that the state should be entirely "Romanian" and not in the hands of "kikes."[67] The other major student paper, *Viața studențească* [Student Life], reported favorably on a lecture arguing for linguistic purity by the president of the Society of Students in the Faculty of Letters: "The conglomeration of languages in a country inevitably leads that country to a disequilibrium of forces and eventually to destruction."[68] As there were only twenty Jewish students in the Faculty of Letters, Tzara was marginalized by the prevailing ethos of the university.

And the one piece of archival evidence about his university career confirms this marginality. In a formal letter signed 4 February 1915 by Samuel Rosenstock and Tamifil Popescu (but in Tzara's handwriting), the two students filed a formal complaint to the dean of the faculty: "On the date of 23 January at the Italian language seminar of … Professor Ramiro Ortiz, wishing to ask the professor to repeat a word that we could not hear, we were forced without any explanation to leave the room. Surprised by this request from the professor, we asked him to explain why, but the professor responded with insulting words like *magari* [swine] and *obraznici* [rowdy]."[69] Noting that their "dignity as students" was offended, the students asked the dean to force the professor to "retract his insulting comments at the next seminar."[70]

There is no similar letter of complaint in the University of Bucharest archives from the period. The letter was either childish naïveté or a deliberate provocation. Ramiro Ortiz had been teaching Italian language and literature at the University of Bucharest since 1909, and was appointed professor in 1913.[71] Ortiz was a specialist in Renaissance literature; his first-year Italian seminar included grammar exercises, translations, but also prose work by Gabriele d'Annunzio (whom the Paris Dadaists later mocked).[72] If this might indicate a classical taste, Ortiz was a regular commentator on Italian politics and literature, including avant-garde reviews like *La Voce* and *Lacerba*, in the Romanian press.[73] In 1923 he noted

that he considered every student "a fraternal soul," and that seminars were "laboratories" where students are "in the closest spiritual bond, where that cordial and sympathetic atmosphere is created that unites everyone ... where you see the maestro at work"—but a decade earlier young Tzara was not well disposed toward the maestro's methods.[74] There was no corroborating evidence for Tzara's complaint, and the dean of the Faculty of Letters marked the letter with a note indicating that the two students should not spread false accusations.[75] Tzara's position in the university was severely compromised. Several months later his parents sent him to Zurich—largely in order to keep young Samuel from being drafted, but also so that he could make a fresh start in his university studies.

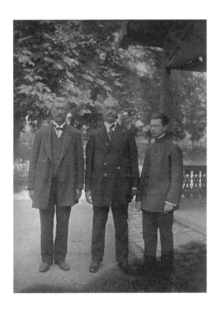

FIGURE 3.3
Three generations of Rosenstocks,
before Tzara's departure to
Switzerland: Ilie, Filip, and Samuel.
Courtesy of Mira Rinzler.

"Already in 1914," Tzara wrote in a letter to Jacques Doucet in 1922, "I had tried to take away from words their meaning, and use them in order to give a new global sense of the verse by the tonality and the auditory contrast."[76] Tzara's assessment was perhaps pitched with an eye to raising the value of his manuscripts (Doucet was an avid collector of literary manuscripts and a principal source of income for some Dadaists). But more important than the actual truth of his claim was the importance he gave to his early poetry. Some of his Romanian-language poems were published in the early 1920s as Dada productions: the poem "Însereaza," dated 1913, became "Soir [Evening]" in the 1923 collection *De nos oiseaux*. A number of these early poems were translated into French either in Zurich or in Paris, but these translations were at times interventions, paring away the accumulated literary effects of the original in order to create a more elliptical final Dada version.

While Tzara was certainly a promising poet before leaving for Zurich, that he was an avant-garde one is a different proposition altogether. If anything, the problem with his early poetry is that it is technically polished. The poet is always pushing himself to use poetic language and to create poetic visions. This is hardly surprising; young poets learn their craft through other poets, within a literary tradition. "And so, the learning that's not in books"— this is what Tzara was painfully aware that he lacked.[77] Technique can be learned and perfected, while sensibility matures mysteriously. The situation was compounded by the fact that most of the masters for the kind of poetry young Samuel liked were foreigners, drawing upon a deeper well of culture than that available in Romania. Tzara's early poems are rich in lyricism and sonority, but from the perspective of his future productions, they are incapable of breaking free from traditional syntax or conventional versification:

> Oh, why is the passage of days rare
> Foliage and flowers fall like folios from a calendar
> Life is sad, but it is still a garden![78]

Stock poetic themes such as the anguish of love, the loneliness of the poet, mutual incomprehension, and physical and spiritual illness infuse the majority of these poems:

> Mamie, you don't understand
> I sing of the soul that doesn't exist
> Your breasts are flowers without pots
> Your heart a handkerchief
> And raspberries tasting of milk sting
> Your blouse covers ripe peaches
> Look, stroke me, caress me
> My lover has died
> Ask me who she was
> And then tell me slowly, precisely when you leave.[79]

With its focus on the unadorned body and its hint of adultery, the poem's direct sexuality is remarkable, but the various metaphors for breasts—"flowers without pots," "raspberries

tasting of milk," "ripe peaches"—are hardly incomprehensible or destructive of language; if anything, they are too tame.

When he boarded the train from Bucharest's North Station en route to Zurich in late autumn 1915, Tzara packed not just the essentials that a young man uncertain of what to expect abroad thinks necessary, but also a number of his manuscripts. These early poems in Romanian were in many ways an education he left behind, for within a few months Tzara was writing poetry of a different order altogether. Being introduced to primitive poetry and art, seeing abstraction not just as an import from abroad but as a vital working practice of artists one knew—this was not possible in Bucharest. But the broader lessons of his literary apprenticeship served him well in Zurich. Tzara was already aware of the connection between literary production and social forces; if advanced Western European poets had largely sunk into a well of aestheticism, poetry in Romania was engaged with social and political reality. Editing both *Simbolul* and *Chemarea* was a crash course in the literary marketplace and the demands of publishing that was extremely helpful when the time came to work on *Dada*. He was prepared not just to hear of "far-away lands / of strange men," but to make their acquaintance.[80]

4 AT THE CABARET: **1915–1916**

AFTER THE OBSCENE LUXURY OF WARTIME BUCHAREST, TZARA EXPERIENCED ZURICH, AN AUSTERE CITY "CLEAN AND SHINY AS A LUNCH SERVICE," AS A LESSON IN CONTRASTS.[1] *Faites vos jeux* speaks of "a painful chapter of insults, terror, malediction, fury, intrigues, outrages, horror, hatred" forcing his departure.[2] Even if unhappy families rarely leave behind a documentary trail of their troubles, nothing corroborates this account, and given the fantastic and deliberately anti-autobiographic character of *Faites vos jeux*, it is more likely that he was sent to Switzerland in the autumn of 1915 for two reasons. First, his position at the University of Bucharest had been compromised by the official complaint he had lodged. The more important consideration was sparing Samuel from military service. Most intelligent observers understood that it was only a matter of time before Romania took up arms. As a safe haven with some of the best universities in Europe, Switzerland was a viable solution on both counts. The family may also have thought that there would be fewer literary temptations in this foreign country. Yet with well-meaning parents across Europe settling upon the same plan for wayward sons, being a young, artistic foreigner was all too common in wartime Zurich.

The economic and intellectual capital of Switzerland, Zurich during the First World War became an intellectual and cosmopolitan hotbed. Millionaires came to protect their fortunes, writers and painters swapped trenches for cafés, and theater troupes arrived to play to cultured, multilingual crowds. James Joyce, who arrived in June 1915, wrote *Ulysses* in the city. One of Switzerland's greatest attractions was a relatively free press. As Richard Huelsenbeck recalls, "In the liberal atmosphere of Zurich, where the newspapers could print what they pleased, where there were no ration stamps and no 'ersatz' food, we could scream out everything we were bursting with."[3] Foreign spies, who had a professional interest in this free exchange of ideas, came in droves. They were not much interested in Lenin, secretly plotting the Russian Revolution in a small apartment on Spiegelgasse, but began to direct their scrutiny upon his rowdy neighbors fifty meters up the road: the Dadaists at the Cabaret Voltaire.

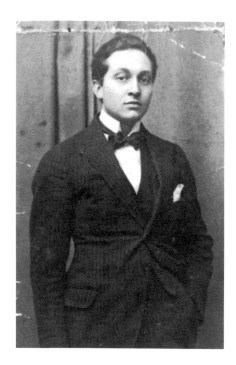

FIGURE 4.1
Marcel Janco, 1916.
Courtesy of Dadi Janco.

58

In a chapter of *Faites vos jeux* entitled "The City that Is the Navel of Luxury: Where I Ended up by Chance and Rested because of Weakness," Tzara describes the scene of his arrival:

> I arrived on a wintry night. An old friend was waiting for me at the train station, and to convince me to remain—because my trip was not supposed to have ended yet— he took me first to the old quarter, which tickled my romantic curiosity and gave me at the same time a false idea of its size. Tired and a bit surprised, I could not realize that we were taking several times the same street which showed itself under different aspects. … The street was obscure and tortured, embellished by the spices of a hierarchic and superimposed architecture.[4]

This old friend was Marcel Janco, who was in his second year of architecture studies at ETH-Zurich, one of the most prestigious universities in Europe (Einstein was an alumnus). But Tzara's memoir is problematic. Given the war, and his status as a stateless Jew, could the voyage have been planned for elsewhere? Even more problematic is the insistence that the first thing he did upon arriving was walk over the Bahnhofbrücke, down the Limmatquai, and into the old city quarter which housed the future site of the Cabaret Voltaire. No matter the tiring train journey or his luggage; Tzara insists that he made a beeline for the birthplace of Dada! Appropriating the Dada category of chance to his own life, Tzara turns Dada into a preexistent reality, the result not of individual subjectivity but of stronger cosmic forces pulling together the most disparate elements.

What is certain is that Tzara rented a room at Pension Altiger, where Janco and his brother Georges also stayed.[5] This boarding house was at 21 Fraumünsterstrasse, a posh street with a Thomas Cook travel agency and the Café Metropol. The future site of the Galerie Dada, on nearby Bahnhofstrasse, was one hundred meters away. Despite being in the city center, Tzara found the first few months in Zurich trying: "Boredom, with its painful varieties of melancholy, invaded me. Sensations of happiness became rare and all my pleasures were catalogued: excursions, cafés, friends."[6] The winter of 1915 was one of the coldest in living memory, and the "impetuous" Föhn winds of Zurich's microclimate accentuated the bitter frost that settled upon the city.[7] Continuing speculation about Romania's war position—a few days before the Cabaret Voltaire opened, the *Journal de Genève* asked "Where Are the Romanians Going?"—could not have raised his spirits.[8] Money was not a worry yet, and compared to the other foreign students Tristan was relatively well off, but the cost of living in Zurich never stopped going up. Although he read and wrote German well, he did not speak it easily, and the Swiss German spoken by the natives was difficult to understand.[9] Fortunately Janco had a number of artist friends whom he introduced to Tristan; they met in cafés and Hans Hack's secondhand bookshop. But Tzara found it hard to integrate with this motley bunch: "I was hard in my judgments and I kept to my unfair detachment, because I could no longer recognize myself."[10] The ostensible purpose of his new life here, continuing his education, was complicated by the fact that his studies in Bucharest were not sufficiently rigorous for entry into the University of Zurich, whose rep-

utation attracted students from all over the continent (in the winter semester 1915/1916, 500 of the 1,700 students were foreigners).[11] To join their ranks, Tristan enrolled in a private academy run by a Herr Hausmann.[12] But within a few months, cramming for entry into the university no longer mattered very much when all of Europe could be his stage.

On Saturday 5 February 1916, Tristan accompanied Marcel and Georges Janco to a restaurant on Spiegelgasse in Niederdorf, a run-down district in Altstadt (Old City). Going to the Cabaret Voltaire was Janco's initiative, as Tzara later recalled: "I was taken [*je fus amené*]," the passive construction removing his volition, turning him into the "little pal" who tagged along.[13] They were responding to an advertisement that had appeared a few days earlier in the *Neue Zürcher Zeitung*:

> Cabaret Voltaire. Under this name a group of young artists and writers has formed in the hall of the "Meierei" at Spiegelgasse 1 with the object of becoming a center for artistic entertainment and intellectual exchange. The Cabaret Voltaire will be run on the principle of daily meetings where visiting artists will perform their music and poetry. The young artists of Zurich, whatever their orientation, are invited to bring along their ideas and contributions. The artistic director is Hugo Ball, formerly *Dramaturg* at the Munich *Kammerspiele*. The opening will take place on the coming Saturday, 5 February.[14]

A cabaret of "artistic entertainment" must have been a welcome relief given the dire international and domestic news. The war showed no sign of abating, and the most recent development—German Zeppelins attacking Paris—was horrific to imagine. Domestically, Swiss politics was polarized over the policy of neutrality. In early 1916 two Swiss colonels were caught transmitting military intelligence to the German and Austrian embassies in Berne. Long having suspected the army of a pro-German bias, the French Swiss were outraged. Their anger was exacerbated when the trial was moved to Zurich, a solidly pro-German city, and fears that the colonels would get off lightly were confirmed by the sentence: dismissal from the army and twenty days in prison (several journalists received longer prison sentences for their coverage of the affair). On the day the Cabaret Voltaire opened, protesters at a mass rally in Neuchâtel vowed to disobey the next mobilization order: "Let's say it clearly," the *Journal de Genève* editorialized, "a gulf is being dug between the people and the federal council, which has lost contact with the people."[15]

Amid this political uncertainty, Tzara did not know what to expect of this cabaret with "international" pretensions. The opening program of lieder and a recital of Rachmaninov and Saint-Saëns was hardly revolutionary. To answer the call for literary contributions, Tristan folded some poems into his coat pockets. No one but Marcel and his brother would understand a word of his Romanian-language verse, but if the cabaret wanted international contributions and foreign artists, then that was what he had to offer. The group arrived before the scheduled opening, a scene the Cabaret's founder Hugo Ball recalled in his diary:

The place was jammed; many people could not find a seat. At about six in the evening, while we were still busy hammering and putting up futuristic posters, an Oriental-looking deputation of four little men arrived, with portfolios and pictures under their arms; repeatedly they bowed politely. They introduced themselves: Marcel Janco the painter, Tristan Tzara, Georges Janco, and a fourth gentleman whose name I did not quite catch. [Jean] Arp happened to be there also, and we were able to communicate without too many words. Soon Janco's sumptuous *Archangels* was hanging with the other beautiful objects, and on that same evening Tzara read some traditional-style poems, which he fished out of his various coat pockets in a rather charming way.[16]

Although the racial overtones (the "Oriental-looking deputation of four little men," the repeated bowing, the wordless communication) are off-putting, Ball's entry for the opening night is entirely devoted to this encounter, showing how decisive he sensed it would be. And he was right, for he and Tzara were destined to become, as Arp put it, "the great matadors of the Dada movement."[17]

Nearly ten years older than Tzara, and with a wealth of experience on the front lines of the avant-garde, Hugo Ball was an unlikely small businessman opening a money-making venture, which is exactly what the cabaret was at the start. Ball was tall, gaunt, always shabbily dressed; there was something unsettling about the intensity of the deep searching eyes that reflected a long history of personal trials, the most recent being a failed suicide attempt several months earlier. Born into a modest family in 1886 in the small town of Pirmasens, after an apprenticeship in the shoe trade and a mental breakdown at eighteen, Ball studied philosophy and art in Munich and Heidelberg, going so far as to start a dissertation on Nietzsche's role as a *Kulturreformator* (cultural reformer) in 1909.[18] After abandoning his thesis he enrolled in Max Reinhardt's drama school in Berlin, then took up various posts as a dramaturge in theaters in Munich and Plauen.[19] Unable to stay in one place for long, in 1912 Ball was back in Munich, where he befriended the poet Hans Leybold. The two founded a journal, *Die Revolution*, whose slogan was "Let Us Be Chaotic."[20] Its first issue was confiscated by the police, and Ball was put on trial in April 1914 for subversive poetry (the judge ruled that because the poems did not make any sense, they could not be subversive).[21] In the summer of 1914 Ball organized soirées on Futurist, Cubist, and Expressionist art, and worked on a book with Kandinsky on how the theater, as a total work of art, could revolutionize society.[22] As he later put it: "From 1910 to 1914 everything revolved around the theater for me: life, people, love, morality. To me the theater meant inconceivable freedom."[23]

The outbreak of the war changed everything. "Art?," Ball asked his sister on 7 August 1914, "It has become ridiculous, it is no longer worth anything": "War is the only thing that excites me."[24] Ball tried to enlist three times but was rejected for medical reasons. A trip to the Western front reoriented his patriotism: seeing the destruction and personally aggrieved by the injury to Leybold (who committed suicide shortly afterward), he turned against the

61

FIGURE 4.2
Hugo Ball, 1916.
Anonymous photographer.

war: "It is the total mass of machinery and the devil himself that has broken loose now. ...
Everything has been shaken to its very foundations."[25] In December 1914 he proclaimed:
"[w]e have to lose ourselves if we want to find ourselves."[26] In February 1915 he and Richard
Huelsenbeck, a medical student and journalist, organized a soirée in honor of fallen poets
(including French poets) and read out a manifesto "against intellectuals" and "all isms": "We
wish to be negationists."[27] But with a wartime atmosphere that was "one-sidedly nationalistic"
even among progressive artists, Ball found it impossible to live "entirely and exclusively in a
socialist nature."[28] The solution seemed to be Zurich and its thriving "international life";
having gotten hold of a copy of Walter Serner's *Mistral*, Ball marveled at how the Swiss
review had contributions from Germany, France, and Italy.[29] With his "Sepferchen [Little
Sea Horse]," Emmy Hennings, a cabaret performer, convicted thief, published poet,
morphine addict, and registered prostitute, he entered Switzerland on false papers in May
1915.[30] Ball found himself in prison for a few days as the police tried to sort out his status;
for her part, Hennings had only recently been released from a German prison for forging
passports.

Once the couple arrived in Zurich, Ball was relieved: "It is peaceful here, very peaceful."[31]
The original plan was to stay for the summer and be back in Munich in September. Hoping
to work as a political journalist, Ball joined *Schwänlianer*, a socialist discussion group, and
cultivated contacts through Fritz Brupbacher, a socialist-anarchist who shared his passion
for Bakunin and Nietzsche.[32] But with little work coming in, he found financial salvation
via a variety-theater troupe. The Maxim Ensemble, with its snake tamers, fire-eaters, and
tightrope walkers, included, as Ball ironically noted, "everything that one could wish for."[33]
After mornings spent in rehearsals and coming up with new skits, Hennings performed four
to six shows a night while Ball played the piano.[34] In October 1915, his *Der Sultan von
Marokko oder: Im Harem* [The Sultan of Morocco: Or, in the Harem] was performed at a
restaurant in the Niederdorf.[35] Ball and Hennings soon quit and created the Arabella
Ensemble to capitalize on Henning's stage fame (a beer garden advertisement dubbed her
"the darling of Zurich with her German and French *chansons*").[36] The Arabella program was
equally eclectic, consisting of "variety fare, a tightrope act, an escape artist, what was billed
as a modern ballet duo, singing, and intermezzi of zither and a good deal of yodeling."[37]
Wanting something more permanent than a touring group, Ball became convinced that
there would be "great interest" among Zurich's foreigners in a "literary cabaret" with its own
"lively newspaper."[38] The idea had been in his mind for months: "To have our own ensemble,
to write by myself the plays for it, and work on it until it becomes proper theater: our final
ambition."[39] One of Ball's obsessions, the problem of Germany's moral and intellectual
isolation, also could be confronted by bringing foreigners under the same roof.[40]

There were three driving motives for Ball in creating the Cabaret Voltaire: political
(international solidarity), aesthetic ("proper theater"), and financial (independence,
ownership). Of these motives, only one interested Jan Ephraim, the Dutch proprietor of

63

FIGURE 4.3
The site of the Cabaret Voltaire,
the "Holländische Meierei."
Baugeschichtliches Archiv (Zurich).

1915–1916

the Meierei restaurant: that "sales of beer, sausage and rolls" would increase "by means of a literary cabaret."[41] A "tall bearded man of royal carriage" who had spent years at sea, Ephraim had a tendency to hector customers as to whether their beefsteaks were perfectly grilled.[42] His restaurant was in a district whose ancient buildings housed students, men on the make, and immigrants fallen on tough times. As Debbie Lewer notes:

> The area enjoyed, or perhaps more accurately, suffered the reputation of *Vergnügungsviertel* or "amusement quarter" of the city. Its leisure industries, especially the type of bars known as *Animierkneipen*, were often the cause for fears of a gamut of social evils, chiefly alcoholism, extortion, indecency, violent crime and the spread of venereal diseases. Niederdorf's densely-populated network of steep, winding alleys housed numerous bars, restaurants, inns, and *Variétés* (Variety shows). These establishments offered entertainment of many kinds: comedy, popular songs, folk music, dancing girls, and the hawking of unusual animals, dwarfs, fat ladies and other "freaks." … The quarter offered food for all the senses: wine, women, song, and spectacle.[43]

With over 1,100 eateries and bars in the city, and over 20 of them on Niederdorfstrasse alone, "competition for custom and economic survival was fierce."[44] Ephraim had previously housed the Cabaret Pantagruel, which had opened in 1914 but was shut down a few months later.[45] In mid-January 1916, the Dutch owner petitioned for the right to convert his back room into a "meeting place [*Sammelpunkt*] for artistic entertainment" that would be different from the city's other "mondaine and official cabarets."[46]

Ephraim was happy to lend his back room, which had a small, 100-square-foot stage, a piano, and tables to seat about fifty people, but there was no question of putting his own money into the project. Neither Ball nor Hennings had any resources; the whole point of the cabaret was to become financially "independent by means of our work."[47] Ball exhorted friends in Munich and Berlin to support his new venture, which would be "in the style of the Simplicissimus [a Munich café], but more artistic."[48] He wanted Huelsenbeck to come down ("I have such a great need for him. He could make a name for himself here!"), but his friend had not been in touch for months.[49] Among Zurich's large immigrant population, Ball received help from Arp, who painted the walls blue and the stage black, and lent some of the paintings that had been exhibited in December 1915 at the Tanner Gallery to decorate the walls. Arp also invited Arthur Segal, a Romanian-Jewish painter, and Otto van Rees to contribute artwork. Marcel Slodki, a Polish artist who had collaborated with *Aktion*, designed the poster. In the days before the opening, Ball was busy finalizing the program, sending out press releases, rehearsing acts, and decorating the musty storeroom so that it would look presentable when the doors opened on that fateful Saturday night.

65

The cabaret's initial programming included readings from Russian masters (Turgenev, Chekhov), music by Beethoven, Brahms, and Liszt, military marches like "Sambre et Meuse," and music-hall favorites "Sous les ponts de Paris" and "À la Villette." True to the tradition of

cabaret, there was no guiding aesthetic; Ball's newspaper announcement indicated that the Cabaret Voltaire would accept contributions irrespective of artistic tendency.[50] On its walls, "the newest pictorial art calls out ... in every language," the *Zürcher Post* noted.[51]

This eclecticism was ideal for Tzara, who did not come armed with a predefined aesthetic. Even if he was widely read, his exposure to modern art was limited. There was something innocently sweet about young Samuel at the time, Ball noted: "When he says, with tender melancholy, 'Adieu ma mère, adieu mon père,' the syllables sound so moving and resolute that everyone falls in love with him. He stands on the little stage looking sturdy and helpless, well-armed with black pince-nez, and it is easy to think that cake and ham from his mother and father did not do him any harm."[52] As the youngest of the core members, Tristan did everything possible to make himself indispensable. He performed on stage, recited poetry, selected material for the evening programs, and also displayed a reservoir of organizational skills: "There was not one evening at the cabaret where he didn't explore the promotional possibilities."[53] This generosity was not entirely from the goodness of his heart, though: the outsider could consolidate his position within the group by being as helpful as possible.

The early soirées celebrated, and drew upon, the cabaret's international clientele. The program for Saturday 12 February included Tzara reading poems by Verlaine, Mallarmé, and Apollinaire, Futurist poems by Marinetti, Buzzi, and Palazzeschi, stories by Gottfried Keller, German lieder and French *chansons*.[54] There were evenings devoted to Russian, French, and Swiss art. Hennings was proclaimed by the *Zürcher Post* to be the crowd favorite: "The star of the cabaret, however, is Mrs. Emmy Hennings. Star of many nights of cabarets and poems. Years ago she stood by the rustling yellow curtain of a Berlin cabaret, hands on hips, as exuberant as a flowering shrub; today too she presents the same bold front and performs the same songs with a body that has since then been only slightly ravaged by grief."[55] Huelsenbeck, who finally responded to Ball's missives to come to Zurich, recalls the importance of her singing: "The songs created the 'intimate' atmosphere of the cabaret. The audience liked listening to them, the distance between us and the enemy grew smaller, and finally everyone joined in. The students rocked on their chairs, and the Dutchman, our landlord, stood in the doorway, swaying to and fro."[56] The audience was not always content to follow along, though. Anyone could demand the right to go on stage and perform, sometimes with disastrous results.

The intimate atmosphere of the small stage and confined quarters of the back room eliminated the traditional hierarchy between performer and spectator. But the fundamental problem of modern art remained: the marketplace, the need to go after "*la grosse caisse* [the big returns]."[57] Ball complained that the cabaret was not profitable: "Financially the venture is not yet running as it should do, at least not if one is to make a living from it. Most of the profit goes to the landlord."[58] The group—whose core was now established with Arp,

Ball, Hennings, Huelsenbeck, Janco, and Tzara—took up the challenge to entertain without sacrificing artistry: "Our attempt to entertain the audience with artistic things forces us in an exciting and instructive way to be incessantly lively, new, and naïve. It is a race with the expectations of the audience, and this race calls on all our forces of invention and debate. One cannot exactly say that the art of the last twenty years has been joyful and that the modern poets are very entertaining and popular."[59] One doubts that declaiming Apollinaire or Max Jacob could lead to the delirium Tzara described: "whirlwind alcohol the emotions taking Mont-Blanc proportions."[60] More raucous on this score was the arrival of Huelsenbeck in late February. He injected new life into the cabaret with his desire "to drum literature into the ground" through "Negro poems."[61] No one understood a word of his ecstatic shouting except the old Dutch sailor, who called these African poems nonsense. But veracity mattered little compared to emotion: "Everyone has been seized by an indefinable intoxication. The little cabaret is about to come apart at the seams and is getting to be a playground for crazy emotions."[62] In this dynamic group, "one member was always trying to surpass the other by intensifying demands and stresses."[63] The constant need to improvise and revise the program—"Let us rewrite life every day"—took its toll, though, and by mid-March Ball noted: "The cabaret needs a rest. With all the tension the daily performances are not just exhausting, they are crippling."[64]

Word about the Cabaret Voltaire spread quickly in Zurich. The foreign intellectuals who congregated at Café Odeon and Café de la Terrasse, less than a kilometer away, soon gave word-of-mouth publicity to the new venture.[65] These same individuals would often end up at the Cabaret Voltaire, which "became a meeting place of the arts. Painters, students, revolutionaries, tourists, international crooks, psychiatrists, the demimonde, sculptors, and polite spies on the lookout for information, all hobnobbed with one another."[66] Arp describes the chaos:

> On the stage of a gaudy, motley, overcrowded tavern there are several weird and
> peculiar figures representing Tzara, Janco, Ball, Huelsenbeck, Madame Hennings,
> and your humble servant. Total pandemonium. The people around us are shouting,
> laughing, and gesticulating. Our replies are sighs of love, volleys of hiccups,
> poems, moos, and miaowing of medieval *Bruitists*. Tzara is wiggling his behind
> like the belly of an Oriental dancer. Janco is playing an invisible violin and bowing
> and scraping. Madame Hennings, with a Madonna face, is doing the splits.
> Huelsenbeck is banging away nonstop on the great drum, with Ball accompanying
> him on the piano, pale as a chalky ghost. We were given the honorary title of
> Nihilists.[67]

Tzara also mythologized the pandemonium: "Every night we play, we sing, we recite—the people—new art to the greatest number of people ... Russian soirée, French soirée. ... The joy of the people, cries, the cosmopolitan mix of God and brothel."[68]

FIGURE 4.4
Marcel Janco, *Cabaret Voltaire* (1916).
© 2013 Artists Rights Society (ARS),
New York/ADAGP, Paris.

But not every night was debauchery and wildness. Sometimes only a few customers were in attendance. The strict curfew imposed by the Zurich police—bars had to be shut by 10 p.m., with policemen tapping on the windows an hour earlier to remind proprietors that closing time was near—limited the festivities, which typically began at 8 p.m. Contemporary newspaper reports do not draw attention to raucous audiences or give the impression that the cabaret had far-reaching implications for Zurich's cultural scene. Its impact, though, was much greater and more lasting.

With Picasso's Cubist art looking down from the walls and Arp's collages taking abstraction even further by removing any recognizable subject from the visual plane, Ball and company came to see themselves as "babes-in-arms of a new age."[69] "We wanted to make the Cabaret Voltaire a focal point of the 'newest art'," Huelsenbeck recalls: "as we danced, sang and recited night after night, abstract art was tantamount to absolute honor."[70] No longer isolated individuals, they were now a community devoted to experimentation.[71] But it was a community free of judgment or official standards, with a flourishing individuality: "The Cabaret Voltaire was a six-piece band. Each played his instrument, i.e. himself, passionately and with all his soul. Each of them, different as he was from all the others, was his own music, his own words, his own rhythm. Each sang his own song with all his might—and, miraculously, they found in the end that they belonged together and needed each other."[72] Arp forcefully exclaimed the necessity of abstraction; Huelsenbeck insisted that the demonic rhythms of Negro poetry best expressed the age; Tzara's multilingual simultaneous poems amounted to a speaking in tongues; Janco's frightful masks spurred their wearers into gestures "bordering on madness"; and Ball's *Lautgedichte*, sound poetry, reduced language to the alchemy of the word.[73] These were not new forms, but brought together in the cabaret they transcended the art of the age. There was a veritable cross-fertilization across media as music, painting, sculpture, design, and written texts worked together to further the cabaret's emergent goal, which was to break art out of its separation from life.

69

"All the styles of the last twenty years came together yesterday": that was Hugo Ball's verdict on the performance, in late March, of Tzara's "L'Amiral cherche une maison à louer [The Admiral Is Looking for a House to Rent]."[74] A simultaneous poem in three languages (French, German, and English), it was performed by Huelsenbeck, Janco, and the author himself, who read the French lines. As the title indicates, the piece is about searching for an apartment after being expelled from one's lodgings.[75] This predicament, made farcical in the figure of an elderly Swiss admiral, was not unfamiliar to the audience: the final line, said in French and in unison by the three performers, "L'Amiral n'a rien trouvé [The admiral did not find anything]," was a common enough experience for apartment-hunters in Zurich. T. J. Demos astutely analyzes the theme of homelessness in the piece:

> No single language could achieve dominance in order to orient the poem, no official
> voice could operate as a grounding frame of reference. Instead, the poem became a

cosmopolitan stage for multilingual interactions, nonhierarchically intermingling the plural speech of displaced subjects—words inevitably mixed with others from different languages, each continually invaded by an otherness not only foreign but also an integral part of the poem. One striking conclusion is that belonging and foreignness become identical, as the poem dismantles the exclusionary basis of national identity.[76]

As Demos points out, the admiral's homelessness is foregrounded in the ordered, tricolumned typography of the written version. Underneath the text Tzara wrote an explanatory "Note for the Bourgeois." The ironic title (what bourgeois would have come into possession of this poem?) and the mock-serious tone of Tzara's justification, replete with learned references to predecessors in Simultaneism, should be read as a sly acknowledgment of the futility of print. The reader struggles to find a set of literary codes to decipher the text, which cannot be "read" in any meaningful way. If language in the text is put in competition, shown to be multiple and various, the written text shows how language is, from the start, defined by a lack: there is no way to capture performance, the lived text.

Not only did Tzara compose the poem with performance in mind, he took into account the different styles of the original performers. A gifted musician, Janco sang his English lines. This created another layer of opposition beyond language and provided an underlying melody to the piece (after referring to such traditional British tropes as afternoon tea, his song ends in a Molly-Bloomesque orgasm: "She said the raising her heart oh dwelling oh yes yes yes yes yes yes yes yes ... oh yes oh yes yes yes oh yes sir").[77] Huelsenbeck's aggressive performance style was brought out by the greater number of pure sounds in his lines: "Ahoi ahoi ... prrzza chrrza prrrza." Tzara, whose small frame and young, bespectacled face set him apart, had the narrative center, so the helpless, gentle little boy who has a simple story to tell struggles against a bombastic Huelsenbeck and a melodic Janco. Huelsenbeck describes the performance in typically exaggerated fashion: "We came out on stage, bowed like a yodeling band about to celebrate lakes and forests in song, pulled out our 'scores' and, throwing all restraint to the wind, each of us shouted his text at the bewildered spectators."[78] Subjected to this roaring confusion, the audience cried out, which forced the performers "to start over three times."[79] But this uproar, the other voices joining in, was what the poem called for, and given the cabaret's international audience, the medley of Babel became even more pronounced.

The performance of "L'Amiral cherche une maison à louer" was followed by a "*chant nègre*" by Huelsenbeck. Ball recalls that the songs were "wonderful": "always with a great drum: boum boum boum boum—drabatja mo gere drabatja mo bonooooooooooooo."[80] Huelsenbeck's performances impressed Tristan, who began to take an interest in primitive poetry. Huelsenbeck valued African poetry because of its stage potential. Tzara, though, came to see in primitive poetry a sensitive rendering of lived experience in a form completely removed from the strict rationality of European art. The elliptical nature of the poetry and its rhythmic grounding through repetition appealed to Tzara, as did some of its

themes: "There is a day for songs[;] it is today."[81] As he later explained, the direct portrayal of objects couched a profound sensibility toward nature and the environment. He compiled a list of over thirty academic works to consult, complete with catalog numbers in the Zurich library, and scoured scholarly journals for examples of primitive poetry.[82] He solicited information about African cultures from the head of a missionary museum in Basel.[83] Unlike Huelsenbeck, who presented primitive poems as his personal invention, Tzara was always careful, in public readings and in print, to make their provenance known.[84] He wanted his first published poetry collection to be entitled *Mpala Garroo*, a clear sign of how important primitive poetry had become to him. He worked on a book of African and Oceanic poetry (he was among the first European artists to be interested in aboriginal Australian poetry), asking contacts in Italy if they could help him find a publisher for it.[85] Having assembled over fifty primitive poems, he never found a publisher for the anthology, although a number of the poems were published in *Dada 1* and other reviews.[86]

From multilingualism to the presentation of primitive poetry, the Cabaret Voltaire presented language as flexible and variable: "We have now driven the plasticity of the word to the point where it can scarcely be equaled. We achieved this at the expense of the rational, logically constructed sentence, and also by abandoning documentary work."[87] Tzara, who was juggling three languages (Romanian, French, and German), found a natural home in this multilingual ambiance. His later poetic theories would borrow much from these early Dada experiments, as they showcased the arbitrary nature of language but also what Ball called "the innermost alchemy of the word."[88]

The cabaret emboldened the performers into seeking out new territories of art and performance. The musty back room seemed to hold a special power. For Ball, the cabaret came to have a metaphysical significance: "Our cabaret is a gesture. Every word that is spoken and sung here says at least this one thing: that this humiliating age has not succeeded in winning our respect. What could be respectable and impressive about it? Its cannons? Our big drum drowns them. Its idealism? That has long been a laughing stock, in its popular and academic edition. The grandiose slaughters and cannibalistic exploits? Our spontaneous foolishness and our enthusiasm for illusion will destroy them."[89] The Cabaret Voltaire was "both buffoonery and a requiem mass."[90] The war was the backdrop that informed everything the group attempted, and there was a conscious desire to make the audience aware of the essential vacuity of European culture:

> The ideals of culture and of art as a program for a variety show—that is our kind of Candide against the times. People act as if nothing had happened. The slaughter increases, and they cling to the prestige of European glory. …
>
> They produce a farce and they decree that a Good Friday mood must prevail. …
>
> We must add: they cannot persuade us to enjoy eating the rotten pie of human flesh that they present to us. They cannot force our quivering nostrils to admire the smell

of corpses. They cannot expect us to confuse the increasingly disastrous apathy and cold-heartedness with heroism. One day they will have to admit that we reacted very politely, even movingly.[91]

Art and politics were no longer separate poles of reality, but intimately linked. Huelsenbeck admonished the audience: "The Cabaret Voltaire is not a common music hall. We have not gathered here to offer you *frou-frous* and naked thighs and cheap ditties. The Cabaret Voltaire is a cultural institution!"[92] Ball, too, grew exasperated: "The people get terribly agitated, as they expect the Cabaret Voltaire to be a normal night club. One first has to teach these students what a political cabaret is."[93] Ball's "Totentanz [Dance of Death]," a chilling antiwar poem, was set to the melody of "So leben wir [This Is How We Live]," a raucous soldier's song:

> This is how we die, this is how we die,
> Every day we die
> Death comes so cosily.
> In the morning, still sleepy and dreaming
> Gone by lunchtime
> Deep in the grave by evening.
> …
> We thank you, we thank you,
> Herr Kaiser for your grace, that you have elected us to die.
> Go ahead then, sleep, sleep peacefully and silently
> Until you wake to find our wretched bodies
> Scattered in the fields.[94]

Performances of Erich Mühsam's "Der Revoluzzerlied [Revolutionary Song]" and Jakob von Hoddis's "Weltende [The End of the World]" were also manifestations of this political urge. The very fact of having abandoned their native countries and the presumed duties of citizenship was already a political statement against the war.

But the desire to make overt political statements was tempered by the "discreet detectives amid red street lamps" who kept an eye on what these immigrants were doing.[95] All of the Dadaists were foreigners; for Huelsenbeck, it was a matter of principle to remain one: "Here in Zurich, I was a foreigner, and I wanted to remain one."[96] Ball had entered the country on false papers, Tzara was there as a student but was not a citizen of any country. Foreigners were subjected to intense scrutiny by cantonal authorities:

> Personal freedom! in a land where every non-Zürcher is obliged to go and announce himself at the nearest Kreisbureau within twenty-four hours of his arrival; where he dare not change his address without making a similar report; where, before taking a room in a private house, he must hand in a polite petition giving all his reasons and submit to a visit from a detective who asks him what seem most impertinent questions, such as "What are you doing in Zürich?" "How much money have you got?"[97]

This heavy police climate went beyond moving house or picking up litter dropped in a hallway, as Nora Joyce was told to do by a policeman.[98] One of the necessities of Swiss neutrality was keeping a close eye on political activity, and this meant surveillance of both foreign and native populations. Although there was little overt censorship, most foreigners had internalized the demands of neutrality and abstained from taking public positions on sensitive issues. As Saschu Bru argues, the "policed climate ... clearly weighed on the production and presentation of literature in the Cabaret," a point that was also made in Ball's 1918 novel *Flametti*, where the theater company is under constant police surveillance.[99] The major political parties, including the Socialists, did not accept foreign members. If Zurich Dada has often been characterized as apolitical, or somehow removed from politics, part of the reason was that the group was made up of foreigners who had to be careful, since the police could forcibly expel foreigners whose actions compromised neutrality.

The Cabaret Voltaire's most important political message, more so than any manifestation in favor of socialism or denunciation of the war, was more subtle: by declaring itself open to art from all of the warring nations, without prejudice, the cabaret made antinationalism the heart of its agenda: "The collaborators of the *Cabaret Voltaire* review belong to the following nations: French (G. Apollinaire, B. Cendrars), Italian (F. Canguillo, F. T. Marinetti, L. Modegliani [sic]), Spanish (P. Picasso), Romanian (M. Janco, Tr. Tzara), German (Hans Arp, J. van Hoddis, R. Huelsenbeck), Dutch (O. van Rees), Austrian (Max Oppenheimer), Polish (M. Slodki), Russian (W. Kandinsky), and stateless—Emmy Hennings."[100] The stubborn pride in being a foreigner was also a reaction to Swiss discourse about the "perils" of immigration. Although Switzerland considered itself "a civilizational community above races and languages," during the war years the Swiss public was aggrieved by the *Überfremdung* (over-foreignization) brought about by 30,000 *réfugiés militaires* or *Kriegsausländer*.[101] The public intolerance and prejudice toward immigrants served as a spur to the Cabaret Voltaire. Fortified in their numbers because Zurich had a large foreign population, yet aware that they were nonetheless a minority in terms of economic and political power, they considered Dada in many ways a calculated response to the marginality forced upon them: they embraced cultural and political marginality, but did so in ways that undercut the majority's right to define the bases of power. But rather than debilitating Dada, these prejudices made Dada self-conscious of its origins as a movement by and for foreigners; it would proudly carry the banner of internationalism to set itself apart from both the war and the mentality of the Swiss, who saw in everything foreign a threat to their regulated way of life.

The word "Dada" first appeared in print in Ball's editorial statement to *Cabaret Voltaire* on 15 May 1916. If there is one aspect of Dada that countless studies have not been able to resolve, it is the origin of the name.[102] The "battle of the Dada graybeards," as Huelsenbeck put it, has not leveled off.[103] One scholar argues that the term originated in the work of

73

Jean-Pierre Brisset, who was fêted in 1913 as the "Prince of Thinkers"—Brisset claimed that language imitated the croaking of frogs, and used the term "dada" to signify "a territorial paradise enabling a supreme state of linguistic and existential innocence."[104] Another points out that the term originated in Gauguin's obsessions with rocking horses as emblems of childhood innocence.[105] The stakes of this paternity battle are high, because it is believed that once the name was discovered, everything followed: that is to say, the term "Dada" already contained within it the seeds of the entire movement.

The dispute began, as John Elderfield notes, in Germany. In 1920, after his application to join Berlin Dada was rejected by Huelsenbeck, Kurt Schwitters claimed that Huelsenbeck peddled *Huelsendadaismus* (husk Dada), while *Kerndadaismus*, "core" Dada, meant Arp and Tzara.[106] A few months later the dispute came to Paris via Christian Schad, a German photographer who resented Tzara's appropriation of his "schadographs." (Tzara at the time was in daily contact with Man Ray and lauding his "rayograms," which were formally very similar to the "schadographs," both being cameraless photographs.) Schad's letter to Francis Picabia could not be more explicit: "I was in Zurich at the time of Dada. Tzara has usurped his title of founder of Dada. He is not inventor of the word."[107]

To answer this charge, Tzara asked Arp to attest otherwise, and the following mock deposition was printed in *Dada au grand air* [Dada in the Open Air] in 1921: "I declare that Tristan Tzara discovered the word DADA on 8 February 1916 at 6 p.m.: I was present with my twelve children when Tzara for the first time uttered this word which filled us with justified enthusiasm. This occurred at the Café de la Terrasse in Zurich, and I was wearing a brioche in my left nostril."[108] Although this is unmistakably ironic, Tzara used it as "evidence" in his case, and Huelsenbeck took it seriously. In an article published in 1936 in *Transition*, Huelsenbeck provides his version of the founding moment, which is set in Ball's apartment and involves a German–French dictionary:

> "Let's take the word dada," I said. "It's just made for our purpose. The child's first sound expresses the primitiveness, the beginning at zero, the new in our art. We could not find a better word."

> … And so it happened that it was I who pronounced the word Dada for the first time. I was the first to point it out and to insist that we use it as a slogan for our efforts.[109]

The problem, of course, is that Huelsenbeck's account was written twenty years after the supposed scene.

The first mystery to clear up is the date of the term's emergence. On 11 April Ball was still talking about the "Voltaire Society," which presumably means that "Dada" had not yet been discovered. A week later, on 18 April, Ball wrote: "Tzara keeps on worrying about the periodical. My proposal to call it 'Dada' is accepted. We could take turns at editing, and a general editorial staff could assign one member the job of selection and layout for each issue. *Dada* is 'yes, yes' in Romanian, 'rocking horse' and 'hobbyhorse' in French. For Germans it

is a sign of foolish naïveté, joy in procreation, and preoccupation with the baby carriage."[110] The term was first used in Ball's correspondence when he signed off a letter to Tzara "DaDa" in late April 1916.[111] Tzara's "Chronique zurichoise," published in 1920, dismisses the very idea that the term could be given an undisputed paternity: "A word was born, no one knows how."[112] The term "Dada" first appears in his entry of 26 February 1916: "Dada!! The latest novelty!"[113] But given that no other source by the Cabaret Voltaire group makes mention of "Dada" at this point, it seems more probable that it was "discovered" sometime in April 1916.

The question of who discovered it remains. There is no reason to credit either Huelsenbeck's or Tzara's version: whatever witnesses there might have been to the event have contradicted themselves, flat-out lied, or kept quiet for whatever reason. Hans Richter writes that at the time of the Cabaret Voltaire the question of "owning" Dada did not matter: "When I came to Zurich in the middle of August 1916, the word already existed and no one cared in the least how, or by whom, it had been invented."[114] Richter believed that the term came from overhearing Janco and Tzara talking to each other, the repeated "da, da" (yes, yes) that Romanian speakers commonly use as a conversation filler. If that was the origin of the group's name, then it was unlikely to be proposed by either Janco or Tzara, as the phrase "da, da" is banal for a native Romanian speaker—only a non-Romanian speaker would think it remarkable.

All of the energy expended on this debate overlooks one rather obvious point: "Dada" was not out there to be "discovered" or "invented." As Raimund Meyer points out, it was ubiquitous in the form of a hair elixir marketed by a Zurich firm, Bergmann and Company.[115] In his July 1916 manifesto, Hugo Ball alludes to another product by Bergmann and Company, "Lilienmilch-Seife [lily-milk soap]": "Dada is the best lily-milk soap in the world."[116] More important than the simple fact of "discovery" is the question of "use." On that point, there is no doubt that both Tzara and Huelsenbeck were driving forces, although Tzara had started the work of internationalizing Dada from Zurich's cafés and hotel rooms, whereas Huelsenbeck did so in person when he arrived back in Berlin in early 1917. Tzara's postal internationalization of Dada was much closer to the movement's initial spirit, for it allowed the key principles—indeterminacy, chance, irony—to flourish: the missives Tzara sent could not spell out the Dada spirit too clearly, so the recipients of the correspondence could do with Dada whatever they wished, which was the modus operandi of the original Dada participants.

The identity of Dada coalesced around the cabaret, but also in the group's first print publication, *Cabaret Voltaire*. Ball announced plans for an "international review" to be entitled "DADA": "('Dada') Dada Dada Dada Dada."[117] Six weeks earlier, he was hesitant about this: "There are plans for a 'Voltaire Society' and an international exhibition. The proceeds of the soirées will go toward an anthology to be published soon. H. [Huelsenbeck] speaks against organization; people have had enough of it, he says. I think so too. One should not turn a

whim into an artistic school."[118] Tzara had been pushing to consolidate the cabaret's activities under a common banner, for the only way the group would have any impact was to extend its activities beyond Zurich. Ball thought that the cabaret's *Kleinkunst* (cabaret art) was incompatible with a formal "ism" propped up by an official review. Only three days after the name "Dada" was accepted for the entire group, Ball noted: "I am anxious to support the cabaret and then to leave it."[119]

Ball did take a sabbatical from performing in the cabaret, but it was not a clean break. For a month he worked on putting together *Cabaret Voltaire*, a "documentary record" of the cabaret's activity.[120] A red-covered, two-franc "collection of literary and artistic contributions," *Cabaret Voltaire* appeared in late May 1916. Five hundred copies were printed, in two editions, a German and a French one, identical save for the language of the title page and Ball's editorial statement. The wild typography and innovative layout that characterized later Dada publications (starting with *Dada 3*) was not present in *Cabaret Voltaire*, save in the contributions by Italian Futurists. Otherwise, text and image are clearly separated, usually on separate pages. The literary contributions by the Dadaists—prose and poetry by Ball, Hennings, Huelsenbeck, and Tzara—are presented in a plain layout. There was no driving aesthetic yet: "In [thirty-]two pages it is the first synthesis of the modern schools of art and literature. The founders of expressionism, futurism, and cubism have contributions in it."[121]

The only explicitly "Dada" material in its pages comes from Tzara, who contributed "Dada Revue 2," a poem dedicated to Janco, and "DADA: Dialogue between a Cabbie and a Lark." This prose piece features Huelsenbeck as a German-speaking cab driver asking the French-speaking lark, Tzara, about the review *Dada*. The dialogue was a piece of advertising: "the first number of the review *Dada* will appear 1 August 1916. Price: 1 franc. Editorial offices and administration: Spiegelgasse 1, Zurich: the review has no relation with the war and attempts a modern international activity hi hi hi hi."[122] Janco illustrated the page with caricatures of the two, thus presenting Tzara for the first time to a wider public and creating the contours of an eventual cottage industry of Tzara iconography.

FIGURE 4.5
"DADA: Dialogue between a Cabbie and a Lark,"
from *Cabaret Voltaire* (1916).
Courtesy of the University of Iowa Special Collections.

DADA

DIALOGUE ENTRE UN COCHER ET UNE ALOUETTE

Huelsenbeck (cocher): Hüho hüho. Ich grüsse Dich, o Lerche.

Tzara (alouette): Bonjour Mr Huelsenbeck!

Huelsenbeck (cocher): Was sagt mir Dein Gesang von der Zeitschrift Dada?

Tzara (alouette): Aha aha aha aha (f.) aha aha (decrsc.) cri cri

Huelsenbeck (cocher): Eine Kuh? Ein Pferd? Eine Strassenreinigungsmaschine? Ein Piano?

Tzara (alouette): Le hérisson céleste s'est effondré dans la terre qui cracha sa boue intérieure je tourne auréole des continents je tourne je tourne je tourne consolateur.

Huelsenbeck (cocher): Der Himmel springt in Baumwollfetzen auf. Die Bäume gehen mit geschwollenen Bäuchen um.

Tzara (alouette): Parceque le premier numéro de la Revue Dada paraît le 1 août 1916. Prix: 1 fr. Rédaction et administration: Spiegelgasse 1, Zürich; elle n'a aucune relation avec la guerre et tente une activité moderne internationale hi hi hi hi.

Huelsenbeck (cocher): O ja, ich sah — Dada kam aus dem Leib eines Pferds als Blumenkorb. Dada platzte als Eiterbeule aus dem Schornstein eines Wolkenkratzers, o ja, ich sah Dada — als Embryo der violetten Krokodile flog Zinnoberschwanz.

Tzara (alouette): Ça sent mauvais et je m'en vais dans le bleu sonore antipyrine j'entends l'appel liquide des hyppopotames.

Huelsenbeck (cocher): Olululu Olululu Dada ist gross Dada ist schön. Olululu pette pette pette pette pette . . .

Tzara (alouette): Pourquoi est-ce-que vous petez avec tant d'enthousiasme?

Huelsenbeck (ein Buch des Dichters Däubler aus der Tasche ziehend): Pfffft pette pfffft pette pfffft pette pfffft pette . . .

<div style="margin-left: 2em">

O Tzara o!

O Embryo!

O Haupt voll Blut und Wunden.

Dein Bauchhaar brüllt —

Dein Steissbein quillt —

Und ist mit Stroh umwunden . . .

Oo Oo Du bist doch sonst nicht so!

</div>

<div style="margin-left: 4em">

Tzara (alouette): O Huelsenbeck, O Huelsenbeck

Quelle fleur tenez-vous dans le bec?

C'est votre Talent qu'on dit excellent

Actuellement caca d'alouette

Quelle fleur tenez-vous dans le bec?

Et vous faites toujours: pette

Comme un poète allemand

</div>

R . HUELSENBECK TR . TZARA

31

The insertion of advertising within the text points to one of the most striking aspects of *Cabaret Voltaire*: its presence within an international literary marketplace. Fifty luxury editions, at a cost of 15 francs, were available. These signed and numbered editions included original artwork by Arp, Janco, Oppenheimer, Slodki, and Segal. The review paid special attention to respecting intellectual property rights: "The drawing by Pablo Picasso is reproduced with the permission of Mr. Kahnweiler. The verses by Wassily Kandinsky are excerpted from the volume *Klänge* with the permission of Piper & Co. editorial house, Munich."[123] Above these editorial notes was a two-column list, "Catalog of the Cabaret Voltaire exposition." Works by Arp, Buzzi, Janco, Marinetti, Picasso, van Rees, Slodki, and others were listed in order to attract potential buyers.

The review does not make it clear, but an injection of funds was vital. Ironically, the publication of *Cabaret Voltaire* coincided with the Cabaret Voltaire going under: Ephraim claimed that the cabaret was "driving him to bankruptcy" and shut it down.[124] Just when the Dada group had found a cathedral for its many voices, it was, like the elderly admiral, forced to search for a house to rent. Unable to stop the eviction, they vented their rage through literature: "I cut the throat of the Dutchman."[125] Tzara was clearly frustrated by the cabaret closing down, but he also saw it as an opportunity: rather than being confined to a single physical site, Dada was going to expand beyond the Swiss "sanatorium."

78

5 DADA IN PRINT AND IN THE POST: **1916–1917**

IF THE CABARET VOLTAIRE WAS THE MYTHIC BIRTHPLACE OF DADA, THE IDYLL PROVED BRIEF. THERE WAS A TRAGIC IRONY IN THE FACT THAT THE PUBLICATION OF *CABARET VOLTAIRE* COINCIDED WITH THE LOSS OF THE PHYSICAL VENUE. Having a physical space had turned collaboration into an essential feature of the group's artistic praxis, and the intimate setting of the Meierei required a direct engagement with the audience. It was not inconceivable that Dada could have been abandoned, bracketed off as a few months' madness during an endless war: Arp and Janco could have returned to their painting, Huelsenbeck to his medical studies, and Ball to his political journalism. For Tzara to go back to his former life of attending lessons at a private academy was out of the question, though. The pain of being separated from his family was compensated by his adoption into this family of Dadaists where, as the youngest, he was the group's *chou-chou*.[1] He had devoted months to this improbable cultural project and discovered a new side to his personality. The austere reserve of the aesthete, evident in the somber clothing of the pained young poet, gave way to exuberant wildness as the stage granted license to compose outrageous poetry, to dance and sing, to put on masks and howl like a madman. He would not give up on that freedom easily.

In the summer of 1916, Tzara began sending copies of *Cabaret Voltaire* to cultural figures throughout Europe and the United States to solicit their support for Dada. Huelsenbeck admitted that Tzara was a "zealot propagandist to whom, in fact, we owe the enormous diffusion of Dada": "Tristan Tzara was one of the first to understand the suggestive power of the word 'Dada.' From this moment, he worked tirelessly to spread a word which would not receive any content until later. He packaged, boxed and sent: he bombarded letters to Frenchmen and Italians; little by little, he made himself the 'center.'"[2] Tzara took part in magazine exchanges, an avant-garde "gift economy" where Dada publications were sent in exchange for the most recent productions on the receiving end.[3] Gino Cantarelli, the editor of *Procellaria*, put the matter baldly: "we demand of you a treaty of friendship: would you accept an exchange between our review and your *Cabaret*?"[4] Propagating Dada through

the post, Tzara never defined it except to say that it was committed to the renewal of art, a vague goal that was backed enthusiastically by his correspondents. Although print Dada minimized the emphasis on performance, it allowed for a maximum of interpretive freedom. Starting that the summer, a press service company in Geneva was hired to provide clippings. The Dadaists marveled at how their movement was discussed in the press: "We met at the café every day to read there the articles that arrived from the four corners of the world. Their indignant tone revealed that with Dada one was hit right where it hurt. We were confused, we fell silent, and we rejoiced at our triumph."[5] Huelsenbeck taps into one of Dada's greatest myths: its inexorable, meteoric spread. The reality was more complicated. Dada's internationalization was slow and riddled with setbacks, from letters that did not get delivered to restrictive censorship laws that necessitated creative editing.

Having proven himself punctilious in the running of the cabaret, Tzara took over the reins of organizing Dada. He projected an inexplicable confidence in how a single word could revolutionize art, his rapid-fire delivery accentuating a sharp wit while his razor-sharp logic cut through the morass of indecision that frequently bogged down the group of ego-driven artists, as Richter recalled: "His crafty grin was full of humor but also full of tricks; there was never a dull moment with him. Always on the move, chattering away in German, French or Rumanian, he was the natural antithesis of the quiet, thoughtful Ball."[6] The foreign press took notice of Tzara's leadership, with Bologna's *Giornale del Mattino* highlighting his "passionate and profound knowledge of the latest direction of art, especially in France."[7] Transplanting the Cabaret Voltaire into another permanent locale was ruled out, partly because of the expense but also because nightly performances had worn down everyone. Although Dada had thrived on the spontaneity of the stage, Tzara felt that the movement could reach greater heights through calculated performances. The shock value of a single staged "event" would be much greater for both the public and the press.

To that end, Tzara organized the First Dada Soirée, which took place on 14 July 1916 at the Zunfthaus zur Waag, an ancient guildhall overlooking the Münsterhof, one of the great squares in the city center (conveniently enough, it was just up the street from Tzara's lodgings). The geographical displacement from seedy marginality to bourgeois respectability explains why Tzara said that the evening presented Dada "for the first time in the entire world" and why Ball called it "the first *public* dada evening."[8] The Zurich public, "more inclined to yodeling than Cubism," as Ball put it, knew very little about Dada.[9] *Cabaret Voltaire* was available only in Hack's bookshop, which catered to intellectuals, and the local press considered the Cabaret Voltaire ribald entertainment, not an arts movement. But the First Dada Soirée broke Dada free from its isolation as it assumed the institutional trappings of culture (tickets purchased in advance, a grand old stage, an after-dinner starting time, an intermission with refreshments). Anywhere from two to three hundred spectators assembled that Friday evening for "music, dance, theory, manifestos, poetry, paintings, costumes, masks."[10] If the program was not strictly speaking new, the combination of these

elements within the Zunfthaus unleashed a singular force. Held on Bastille Day, as the Battle of the Somme was in its first two weeks, the "Vive la France" in Tzara's manifesto that night was a sign of growing public engagement.

The performance began with piano music by Hans Heusser, then poetry by Hennings. But the calculated build-up of increasingly aggressive acts—Ball's sound poems, Tzara's simultaneous poems, Huelsenbeck's *chants nègres*—baffled the audience. The use of masks and the circus-like atmosphere of the First Dada Soirée took its cues from the Swiss tradition of carnival. Yet if carnival bracketed off a period of time in which morality was overturned, Dada called for a never-ending reinvention of public life. Ball's manifesto, delivered in German, blasted Dada through the hall: "Dada psychology, Dada literature, Dada bourgeoisie ... Dada world war and no ending, Dada revolution and no beginning, Dada your friend ... Dada Tzara, Dada Huelsenbeck, Dada m'dada, Dada mhm'dada, Dada Hue, Dada Tza."[11] The lanky figure in threadbare clothing exhorted the audience to chant along: "How do you achieve eternal happiness? By saying Dada. How do you become famous? By saying Dada. With a noble gesture and refined manners. Until madness, ad nauseam until unconsciousness. ... Dada is the soul of the world. Dada is the big thing, Dada is the best lily soap in the world."[12] The audience could not make head or tail of it, and that was the point: Dada was not a positive aesthetic building on an artistic tradition but, rather, a call for a clean break with the past.

Besides organizing the event, Tzara's major contribution was *La Première Aventure céleste de Monsieur Antipyrine*. The striking phrase "aventure céleste" is found in a letter Tzara had received earlier that year from Max Jacob, the French poet whose *Le Siège de Jérusalem* (1914) was subtitled "grande tentation céleste de Saint Matorel."[13] It is not surprising that Tzara, with his halting and at times ungrammatical French, would crib phrases— but the explosive cocktails he made of these borrowings showed how far he had traveled. There would be other manifestos featuring Mr. Antipyrine (perhaps too many, as André Breton later complained), a character named after a popular headache medicine Tzara took for his frequent migraines. The first version was a play-manifesto whose characters include Mr. Bleubleu, Mr. Cricri, Pipi, and Mr. Boumboum. There is almost no plot except for Mr. Director struggling to assemble a circus whose strident cries would awaken Europe—a metaphor for Dada, of course. No character is individualized, save for "Tristan Tzara," whose bombastic pronouncements were calculated to offend:

> Dada is our intensity ... Dada is art without slippers or parallel; it is against and
> for unity and decidedly against the future ... our anti-dogmatism is as exclusive
> as a bureaucrat that we are not free and we cry freedom; severe necessity without
> discipline or morality and we spit on humanity. Dada remains within the European
> frame of weaknesses, it's nonetheless shit, but from now on we want to shit
> in the different colors to decorate the zoological garden of art with all the flags
> of consulates.[14]

The performance concluded with Tzara as a forlorn child far from home: "my dear attentive listeners, I love you dearly, dearly I do, I assure you and I adore you."[15]

The evening proved a success on many levels. They had "taken the big returns," a relief for the cash-strapped artists.[16] The press also got caught up in the excitement: "One had laughed a lot, sometimes heartily, sometimes with pain."[17] The *Neue Zürcher Zeitung* called Dada "a symbol for everything. For hatred and love, for good and bad, for high- deep- dull- and nonsense, for insanity, madness and imbecility."[18] Essentially repeating the vocabulary of the manifestos, the review showed that Dada could set the terms of public debate.

The success of the First Dada Soirée also led to the publication of Tzara's first book. *La Première Aventure céleste de Monsieur Antipyrine* came out on 28 July 1916. Tzara had already understood the value of collector's items by arranging for ten numbered luxury editions colored by hand. Issued under the imprimatur "Collection Dada," *La Première Aventure* was printed by Julius Heuberger, who became the Dadaist printer of choice. The book allowed Tzara to raise his literary profile; if few copies were sold, he sent dedicated copies to close friends and contacts abroad, a practice that he continued throughout his life. Rather than targeting general readers in the book-buying public, Tzara treated the publication of his own work as an occasion for intimacy and a display of friendship. If Rudolf Laban read Mary Wigman's copy and found it "very interesting," other critics were not so kind.[19] One scathing review appeared in the August 1916 issue of *Demain*, a Swiss pacifist journal edited by Henri Guilbeaux.[20] Although—curiously—he attributed the book to Janco, the French writer did not hesitate to call it the expression of a freakish decadence (he had previously attacked *Cabaret Voltaire* for its "decadence and putrefaction").[21] Even though *Demain* had only a few hundred subscribers, the hatchet job merely raised curiosity about its contents, proving the cliché that the only bad publicity is no publicity.

84

LA·PREMIÈRE
AVENTURE·CÉ-
LÉSTE·DE·M r AN
TIPYRINE·PAR
T r·TZARA AVEC
DES·BOIS·GRA-
VÉS·ET·COLORI-
ÉS·PAR·M·IANCO

COLLECTION·DADA· 2 F r

Although the Zurich public could not have known it, *La Première Aventure* was the first attempt to deal with the inherent contradiction of Dada organization. Both Ball and Huelsenbeck were skeptical about codifying Dada into a movement. Tzara ingeniously resolved this problem by calling Dada "our intensity," both "against and for unity."[22] If other avant-garde movements coupled their critique of outworn principles with a call for substituting another body of directives, Dada was "decidedly against the future."[23]

The ostensible break that Tzara announces is misleading. In its first stages Dada indiscriminately took in almost every "modern" tendency; the newspaper advertisement for the First Dada Soirée announced that "Futurism, Dadaism, and Cubism" would be presented.[24] Futurist paintings had adorned the walls of the cabaret, and the only typographically advanced pieces in *Cabaret Voltaire* came from Marinetti and Francesco Cangiullo, who both signed their contributions "Futurista." As Hans Richter later put it, "we had swallowed Futurism—bones, feathers and all."[25] Tzara later claimed that Dada considered "Futurism, as well as Cubism and Expressionism as new academicisms."[26] But this post-hoc rationalization overstates the case: Futurism was a model, and Tzara could not help but envy Marinetti's injunction that "it was absolutely necessary to change methods, to go into the streets, to give battle in the theaters, and to introduce the fist into artistic struggle."[27] Tzara did not admire Futurism's exaltation of machines, speed, and war, but in this he was no different than other Futurists who disagreed with Marinetti's political pronouncements. Tzara studied the organizational practices of Europe's first international avant-garde movement and mastered its preferred genre, the manifesto. Friedrich Glauser suggests that Marinetti's "glory ... did not let [Tzara] sleep peacefully."[28] Raoul Hausmann replayed this theme by noting that Tzara "wanted to exceed Futurism ... and marinate Marinetti in his own sauce."[29] Hans Richter more calmly observed that Tzara simply "knew everything" about Futurism that there was to know.[30] There were uncanny biographical similarities between the two avant-garde chiefs: both were born into wealthy families isolated from the cultural mainstream (Tzara because of Judaism, Marinetti by virtue of being raised in the Italian colony in Alexandria, Egypt), both had shown their organizational talents at an early age by editing schoolboy magazines, and both were strongly influenced by French Symbolism.

It has been suggested that Tzara's version of Dada in 1916–1917 was heavily influenced by Marinetti because he was the "last" of the Dadaists to be exposed to Futurism.[31] Yet before his arrival in Switzerland, Tzara could not have been ignorant of Futurism. Marinetti's first manifesto (1909) was published in Romania in the Craiova-based review *Democrația* on the same day as it appeared in *Le Figaro*. While the Romanian translator questioned what Futurism might mean when "[w]e do not have museums to burn down or libraries to flood," the movement was extensively covered in the Romanian press.[32] From 1910 to 1912, the *Biblioteca Modernă*, an illustrated middlebrow monthly, regularly featured Futurist manifestos or detailed reports on Futurist *serate* (soirées). Vinea wrote about Futurism's international expansion in 1913, and one of the other young poets associated with *Simbolul*,

Emil Isac, noted that Marinettti's manifestos had produced "a veritable tempest in the artistic world" and were "discussed, analyzed, banalized" endlessly in Bucharest.[33] At the University of Bucharest, moreover, Tzara enrolled in a course on Italian language and literature.

In the early stages of Dada, contributions by Italian artists outnumbered those from any other country. This collaboration began in late June, when Tzara received, from the Parisian art dealer Paul Guillaume, the address of the Ferrara-based artist Alberto Savinio, the pseudonym of Andrea Alberto de Chirico, younger brother of Giorgio de Chirico.[34] Savinio put Tzara in touch with other Italian artists (Filippo de Pisis, Ferruccio Luppis, Giovanni Papini, Giuseppe Ravegnani, Ardengo Soffici), who in turn supplied other names for Tzara's "vigorous propaganda for the diffusion of Dada" in the peninsula.[35]

Tzara promoted an arts movement that was neither clearly defined nor in stark opposition to Futurism. Because of contributions by Marinetti and Cangiullo, *Cabaret Voltaire* had circulated widely in Italian artist circles. Dada was seen, as Julius Evola noted, as "Germanized Futurism."[36] This ambiguity allowed for loose affiliations and flexibility on both sides. Savinio, for instance, knew little about Tzara's aesthetics when he put him in touch with other artists.[37] There were misunderstandings as well: when Bologna's *Giornale del Mattino* called Tzara—and not Ball—the driving force of a "truly superb" "artistic anthology," Tzara did not go out of his way to correct the mistake.[38] After all, he was the one sending out copies of *Cabaret Voltaire* to Italian artists and arranging for sister Italian publications to arrive in Zurich. Tzara's poetry eventually appeared in *Le Pagine* and *La Diana* (Naples), *Procellaria* and *Bleu* (Mantua), *Arte nostra* (Ferrara), and *Valori plastici, Cronache d'attualità* and *Noi* (Rome). Since Tzara had forged epistolary friendships with editors (Gherardo Marone of *La Diana*, Nicola Moscardelli and Maria D'Arezzo of *Le Pagine*, Enrico Prampolini of *Noi*), advertisements for Dada publications and the publication of his poetry in an Italian review created a similar obligation on his part to advertise that review and to publish its representative work in Dada journals. This sometimes caused disappointment, as Tzara had no control over the contributions received in exchange.

87

Tzara recalled his Italian contacts in a 1922 letter to Paris art collector Jacques Doucet: "I was in correspondence with A. Savinio who lived at that time with his brother G. de Chirico in Ferrara. Through him my address spread throughout Italy like a contagious disease. I was bombarded by letters from all the corners of Italy. Almost all of them began 'caro amico,' but the majority of the correspondents called me 'carissimo e illustrissimo poeta.' That made me decide to break off relations with these people who were too enthusiastic."[39] By this point, nearly all of his Italian contacts had soured, but in 1916 and the early part of 1917 the "caro amico" salutation cut both ways: as he told Nicola Moscardelli, "I am especially interested in Italy being well represented in this publication [*Dada 1*]."[40] Tzara contemplated meeting his new Italian friends in the flesh, and there is a suggestion that in August 1916 he visited Savinio in Ferrara and Enrico Prampolini in Rome.[41] If Tzara wrote about wanting to visit Italy in 1917, and actually visited in the summer of 1920, it is not clear

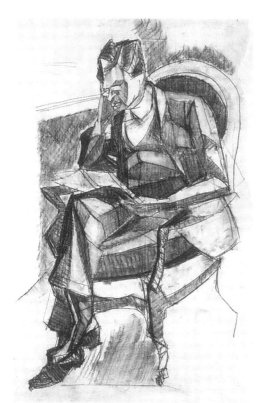

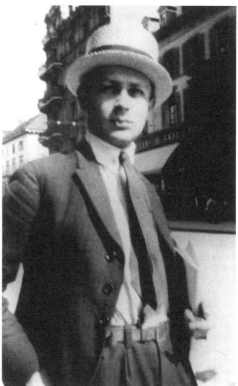

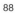

FIGURE 5.2
Marcel Janco, *Portrait of Tristan Tzara* (1916).
Israel Museum (Jerusalem). © 2013 Artists Rights Society (ARS), New York/ADAGP, Paris. Courtesy of the Israel Museum.

FIGURE 5.3
Tzara in Zurich, 1916.
Anonymous. From Raoul Schrott, *Dada 15/25*.

how in 1916 he could have secured the travel documents to enter a country at war, or how the trip was financed. Despite Ball and Tzara being in regular correspondence that summer, their letters do not mention this supposed journey, and in his letters to Italian artists Tzara never refers to a trip he took to their homeland, although such an admission would have raised sympathy for his projects. Tzara certainly wanted to visit Italy and to create closer connections with Italian artists, whose enthusiasm for Dada culminated in 1921 with a Dada season in Rome, but he had more pressing matters to attend to. If Dada were to expand abroad, it had to remain alive in Zurich.

Even though the First Dada Soirée had been a success, it had exhausted the Dada repertoire, and the next public event would be months away. As the summer of 1916 came to a close, outsiders saw very little of Dada, which lived on only in two limited-edition Huelsenbeck titles brought out by the Dada Collection imprimatur (*Schalaben, schalabai, schalame-zomai* and *Phantastische Gebete,* both illustrated by Arp). Ball left Zurich for Lake Maggiore, telling Tzara: "Vira-Magadino is more beautiful than Zurich, Dada and all other related subjects. We live in a small church by the Madonna del Sasso and the desperate church bells of Tessin create a frightening music. One sings: *Quanto è bella, quanto è nobile*! And one reads—Dostoevsky." [42] In this countryside idyll, Ball announced his intention of giving up Dada "for the time being." [43]

For his part, Tzara had a summer dalliance with a girl whose parents lived in Geneva, but abruptly broke off contact, which led to recriminations months later: "Tristan, does it amuse you to see me suffer? Even though you know that a few words from you would make me all better, you refuse to write." [44] Variations on these words would come to be repeated by other women in Tzara's life. Quick to charm and give his affections, Tzara was equally quick in shutting himself off—either because of the need to work or his own poor health, which often required summer rest cures. He feared commitment but was easily slighted if his partner did not pay him sufficient attention. That he kept this letter, taking care to transport it to Paris when he finally left Zurich, indicates that Tzara had a reservoir of private nostalgia, though—but that was hardly consolation for the broken heart who sent it.

That particular summer, the Zurich Dadaists were busy refining their ideas about abstract art and the social role of literature. This was café life, daily bull sessions at the Café de la Terrasse (they moved across the street to Café Odeon in a show of solidarity with a waiters' strike at Terrasse). Since customers were left in peace so long as a single drink was ordered upon arrival, the cups of coffee emptied hours ago would clutter the tables overflowing with cigarette butts and discarded ideas. Several tables were now required to seat everyone; besides the core group of Arp, Janco, Huelsenbeck, and Tzara, a number of Swiss and foreign artists and writers started to come along. Some became converts to the Dada cause, like Hans Richter, a German writer who arrived in August after being invalided out of the army. Arp brought along Sophie Taeuber, his future wife and an instructor at the

city's arts and design school, Ludwig Neitzel, an art critic who shared his store of indispensable knowledge about modern art, and Otto Flake, who became a Dada writer of the first degree in his own right (Tzara penned "Maison Flake" in his honor). Tzara was a constant presence at these sessions, having loved café life ever since Bucharest, but by August 1916 two clouds hung over his enjoyment of them: one political, the other aesthetic.

Politically, the war news was troubling. Most of the Dadaists had left their countries to escape the army. By this point they had not only reconciled themselves to that personal decision but proudly made their status as "war deserters" an integral part of their political and aesthetic identity. Yet after two years of neutrality, Romania in August 1916 entered the war in the Allied camp, putting Tzara in a difficult position both emotionally and administratively. One week after the country entered the war, residents in Bucharest, including Tzara's family, were cut off from the rest of the world as trains were stopped and the postal, telegraph, and telephone systems were shut down for civilians.[45] By mid-September German warplanes began bombing Bucharest, which led to the death of hundreds and mass panic in the civilian population. In late October Ball noted that Tzara was "very serious" because "horrible things" were happening in his home country.[46] Tzara confided to his friend that his parents had probably lost their fortune; he hadn't heard from them for months and feared the worst.[47] He would not have been able to read a Bucharest newspaper in late September that listed his family among the donors to a Jewish-Romanian war charity, indicating that they were both still alive and had some money to spare.[48] All he could do was anxiously read the war news: by the end of November, Bucharest had been occupied by the German army.

Tzara also told Ball about an upcoming medical board meeting in Bern. The Romanian army was so desperate to drum up its forces that Tzara feared that his headaches and myopia would not exempt him from military service. But he went prepared; not only did he ask Glauser to accompany him, but he took the trouble to visit a local psychiatrist. Having read his young patient's most recent poems, including some of the poetry slated for *Mpala Garroo*, the psychiatrist delivered a diagnosis of *dementia praecox*.[49] Worried that even this would not be enough, at the board meeting Tzara played the part, mumbling "Ha" and "Ho" but otherwise pretending to be incapable of speech. Glauser recounts that Tzara gathered his senses after he was declared unfit for service: he yelled out "in a loud and distinct voice, 'Shit' [*Merde*] and then added, as a kind of confirmation, 'Dada.'"[50]

Whether this story is apocryphal or not (Arp had a similar story about his draft board meeting), Tzara was relieved to escape military service, but his anxiety over the fate of his parents and his country did not abate. His emotional life was further troubled by a love affair with "Titzu," a young Romanian girl with whom he had an on-off relationship until the summer of 1918. A budding poet and painter, this young woman from Bucharest knew not only Vinea (perhaps too well, it appears) and Lili Haskil (the sister of pianist Clara Haskil) but also Tzara's family, as she often refers in her letters to his parents and Lucică.[51] Their relationship probably started in the summer or autumn of 1916, as Ball met her in the

Café de la Terrasse in late October. Ball sensed that the relationship was quite serious, for the couple asked him about the costs involved in renting a house in Ticino, the implication being that they would move in together.[52] But it was also stormy: "we once were two lovers who often fought, made up and then were rough, bad, and broke up again and again until we no longer saw each other."[53] It was strained, too, because Titzu lived in Bern, where she had an office job but evidently not enough money to pay back what she owed Tzara; she also suffered, like Tzara, from weak nerves (which led to a stay in the Victoria Sanatorium in the summer of 1917). In her absence, Tzara fell in love with a Slovak dancer from the Laban School, Maya Chrusecz: "You love her and you no longer love Titzu," the scorned lover, who burned all of his letters and his book, wrote in late January 1917—but that did not prevent the two from seeing each other again.[54]

These personal and political strains took their toll. In early December Tzara told Francesco Meriano: "At this moment it is impossible for me to edit a review, as this requires regular and constant work that I cannot undertake because of the political situation of my country."[55] The magazine that Tzara had promised in *Cabaret Voltaire*—"the first issue of the review Dada will appear 1 August 1916, price 1 franc"—had not yet materialized.[56] His own publication projects were stalled. In early December Tzara claimed that *Mpala Garroo* was with the printers; three months later he explained the delay by speaking of "an accident during the printing."[57] But the book never came out, no doubt because of Tzara's precarious finances. Romania's entry into the war had thrown up obstacles to receiving money or care packages from home: he had become, as Ball noted, poor.[58]

Equally troubling that autumn was the leadership fight over the direction of Dada. When Ball left Zurich in late July, Tzara was "the ideal promoter of Dada."[59] He had gone from the runt of an "Oriental-looking deputation" to a fixture in the literary scene, with contacts both in Zurich and abroad. But even that created some friction, as Janco, for instance, would complain to Tzara: "you do not keep your promises, because you have not sent me copies of the letters that you wrote to Italy and France."[60] The ideological thrust of Dada was anarchic, and other members did not take kindly to Tzara's attempts to give direction. Arp was unwilling to compromise when it came to his art; Janco had provided so much financial support to Dada that he felt some right of ownership over its direction; Huelsenbeck, who felt lost without Ball, suffered a nervous breakdown after a love affair with a salesgirl. By October, after a summer of almost no activity and just a handful of slim Dada publications, dissension had reached such a pitch that Ball had to "urgently" come back to Zurich to settle things down.[61]

That Ball could take on the role of arbiter seemed improbable. In mid-September, he renounced Dada entirely: "I hereby declare that Expressionism, Dadaism and other isms are all the worst kind of bourgeois thinking. All of them bourgeois, all of them bourgeois."[62] He was now living in the artists' commune in Ascona, next to Arthur Segal, and Hennings's daughter, Annemarie, was attending school in Locarno. Ball spent his days working on his

satirical novel *Flametti*.[63] He intended to run a cabaret with Hennings in Davos during the winter season.[64] But, prompted by his close friends, Ball returned to Zurich in late October and saw that Tzara was overwhelmed with anxiety. He observed that the other Dadaists were equally dejected: Janco was "very desperate, unable to work, complaining and complaining"; Arp was argumentative; and Huelsenbeck had already left Zurich for Germany.[65] The next day, Tzara and Janco pleaded with Ball to resettle in Zurich in order to get Dada back on track, but as Ball explained to Hennings, "I will not hear of it ... I am not 'desperate,' not a Dadaist."[66] A month later, he wrote: "I will not take part in cabarets any more ... I will write freely. That was always my goal."[67] Having renewed his political contacts with revolutionary socialists, Ball's diffidence toward Dada continued, as weeks later he was still in Zurich and planning a literary soirée with Tzara, while also repeating his vow to friends that he would stop all public activities and concentrate fully on his own projects.[68]

Tzara's own hesitations throughout that autumn cast doubt on the mythic view of Dada as an unstoppable juggernaut, and call into question the persistent criticisms of Tzara as an arriviste. The myth suggests that Dada, once discovered, converted followers all over the world. The reality was more complex—not only because Dada converts were few and far between in those early days, but also because the main "prophets," Ball and Tzara, had their own misgivings about the movement. Ball eventually fell by the wayside, leaving Dada for good, but Tzara also wavered in his commitment. To suggest that from the start he was bent upon turning himself into an avant-garde chief, and would stop at nothing to accomplish this goal, misreads Tzara's personal motivations. And while a flurry of new publication plans presented themselves (including an ambitious project, never realized, of a 160-page anthology of modern prose, poetry, and art), Dada's reinvestment with the energy of performance brought Tzara fully back into its arms.

Arp, Braque, de Chirico, Derain, Gris, Janco, Jawlensky, Kandinsky, Franz Marc, Matisse, Modigliani, Max Oppenheimer (Mopp), Picasso, Richter, Slodki, Utrillo, Van Rees, and de Vlaminck. Tzara wasted no time in presenting this stunning list of artists to his friends after Hans Corray, a local schoolmaster and art collector, had offered the Dadaists the free use of a four-room apartment on Bahnhofstrasse. Tzara was so enthusiastic about the proposed show that he indicated that it would travel to nearby Winterthur as well as Basel and Geneva.[69]

The difficulties of importing artworks in wartime were immense. Tzara craftily took advantage of Switzerland's neutrality by convincing foreign governments that allowing their artists to take part would be effective propaganda (as Richter gleefully notes, these artworks became "propaganda for us").[70] Political sensitivities remained. Paul Guillaume insisted that the show bar artists from nations at war with France, while Italian artists asked, and received, assurances that their works would not be sold to citizens of nations at war with Italy.[71] Yet Guillaume's political interests were not so overwhelming as his financial ones: the works he promised for the show never came through because the insurance guarantees

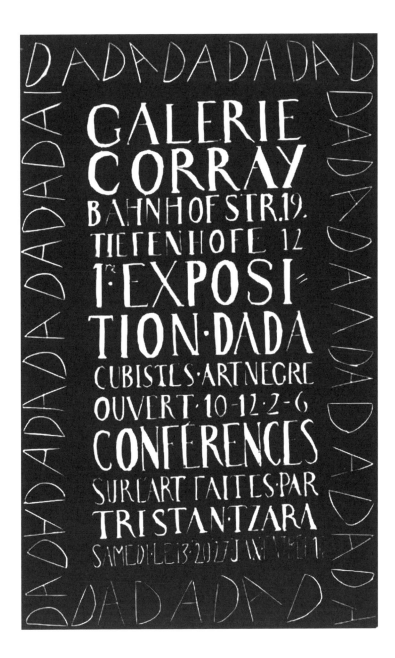

FIGURE 5.4
Marcel Janco, poster for Tzara's
lecture series on modern art.
© 2013 Artists Rights Society (ARS),
New York/ADAGP, Paris.

were never paid.[72] Artwork promised by Filippo de Pisis did not arrive because of the bureaucratic difficulties of receiving permission for Italian nationals to export art abroad.[73] Fortunately Corray had a number of African sculptures and Arp had a large personal collection of modern art, so the *Modernste Malerei, Negerplastik, Alte Kunst* [Modern Painters, Negro Art, Old Masters] exhibition opened in early January with works by Arp, de Chirico, Janco, Richter, Slodki, and Van Rees. A Swiss touch to the show was added with works from Walter Helbig and Oscar Wilhelm Lüthy.

As its title indicated, the exhibition did not have a uniform aesthetic. In the catalog Tzara was wildly enthusiastic about how Arp's work showcased "the body purified by the profundity of archaeologies."[74] Already in 1915 Arp had expressed a desire for art to go back to "lines, surfaces, forms, colors," "to go beyond the human and get closer to the eternal, the inexpressible."[75] Tzara found Arp's recent works, with their "several primitive lines," expressive of the "laws of the earth."[76] Tzara's later formulation of "cosmic" art owes much to Arp's visual experiments, which the artist always insisted were *travaux*, works, rather than art. For the Corray show, Arp displayed some recent collages that experimented with chance: paper constructions in which severe lines seemed to efface the material world. Yet it was Janco's work that received the most effusive commentary in the press, with the art critic from the *Neue Zürcher Zeitung* singling out his *Bal à Zurich* as "[a] picture of ingenious, extremely expressive animation."[77]

Coinciding with the exhibition, Tzara gave a cycle of Sunday afternoon talks. Even if the audience consisted of "[s]ome old English ladies carefully taking notes," he had an opportunity to present his views on modern art.[78] Reading the lectures today, one is struck by how no singular Dada aesthetic is promulgated: the second lecture was on Cubism, and the word "Dada" does not appear in any of the talks. There were no "anti-art" sentiments in the lectures, which were more interested in expanding the reach and spiritual significance of art than describing its futility. Tzara distances himself from authoritative criticism: "What is said about artworks is relative and personal. I love crystals, antiques and modern painting."[79] The only unity to modern art, Tzara noted, was the emphasis on "pure, clear thought" and the "force of abstraction"—but these general terms covered a gamut of aesthetic movements.[80]

The "stunning success" of the exhibition convinced Tzara that Dada could benefit from a permanent base of operations.[81] Although little art was sold, there was extensive press coverage, and Tzara sent the printed catalog to artists abroad as proof of Dada's vitality. Corray also warmed to the Dadaists and offered them a lease for the gallery space to set up Galerie Dada.[82] Its location was ideal: the third-floor apartment was in an impressive building giving onto Paradeplatz; its ground floor housed the chocolatier Lindt & Sprüngli.

For the Galerie Dada, Tzara teamed up with Ball, who had remained in Zurich throughout the winter. The psychic extremes and searching qualities of Ball's mind were documented in his diary: "our will will be greater, richer and deeper when we find ourselves."[83]

Fortunately for Tzara, Ball began to see modern painters and poets as "theologians" whose work existed "to convert" the public into a more humane way of life.[84] He had concerns about the Galerie Dada, though: "In the end we cannot simply keep on producing without knowing whom we are addressing. The artist's audience is not limited to his nation any more. Life is breaking up into parties; only art keeps on resisting, but its recipients are getting more and more uncertain. Can we write, compose, and make music for an imaginary audience?"[85] In the same diary entry, Ball bemoaned how "[t]rade in works of art has become a stock exchange business."[86] Permanently installing Dada in an art gallery seemed to be nothing less than buying into the capitalist exchange of the art world, but Ball was won over by the prospect of having a public venue devoted to modern art.

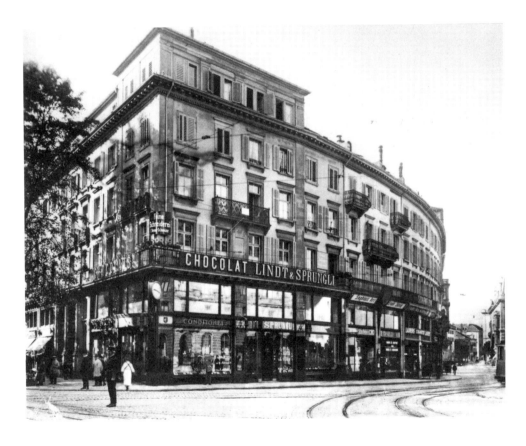

FIGURE 5.5
The Galerie Dada was in the same
building as chocolatier Lindt & Sprüngli
Baugeschichtliches Archiv (Zurich).

The lease signed, the Dadaists had only three days to prepare the opening on 17 March 1917. The inaugural exhibition featured Expressionist artists affiliated with the Berlin-based Sturm Gallery. During its three-week run, paintings by Kandinsky, Paul Klee, and other German artists were shown alongside works by Arp and Janco, and African art. This once again points to the aesthetic eclecticism of Dada and the importance of personal connections (in this case, Ball's ties to Herwarth Walden, who ran the Sturm Gallery, and Kandinsky). While the first number of *Dada* indicated that the gallery's artistic and cultural activities intended to "make Dada understandable," no single Dada line was pursued.[87]

The opening party on 23 March was a planned performance similar to the First Dada Soirée: dances, costumes, masks, and poetry readings by Arp, Hennings, and Tzara. If Tzara's later estimate of 400 people in attendance is exaggerated (Ball estimated it at ninety; it was a four-room apartment, after all), the frenetic activity of the Galerie Dada harked back to the heady days of the Cabaret Voltaire, albeit in a more refined locale, as Ball observed: "We have surmounted the barbarisms of the cabaret. There is a span of time between Voltaire and the Galerie Dada in which everyone has worked very hard and has gathered new impressions and experiences."[88] Arp, Neitzel, and Tzara held open sessions every Wednesday during which the public could question them about Dada and modern art. A series of talks—Tzara on Expressionism, Ball on Kandinsky, the Swiss writer Waldemar Jollos on Paul Klee—highlighted the novelty of the art on display.

After the first exhibition closed on 7 April, Ball and Tzara organized a second exhibition of Sturm artists, which opened two days later.[89] Featuring works by Kandinsky and Klee, it also introduced Max Ernst and Oskar Kokoschka to the Swiss public. A Sturm soirée was held in mid-April, with Kokoschka's short play *Sphinx und Strohmann* performed alongside prose and poetry by Apollinaire, Blaise Cendrars, Alfred Jarry, and Marinetti. Two weeks later, the "Soirée d'Art Nouveau [New Art Soirée]" marked the end of the second Sturm exhibition with Dada performances from the old guard—simultaneous poetry by Tzara, Negro music and dance, paintings by Janco, poetry by Ball and Hennings, dance works by pupils from the Laban School—as well as works by Ferdinand Hardekopf, an artist who went on to play a crucial role in German Dada.[90] Tzara was thrilled that the public began to "place its hope in the new spirit being formed, 'Dada.'"[91] Ball found the dance productions absolutely electrifying, "full of dazzling light and penetrating intensity," even if the five dancers dressed up as "Negresses in long black caftans and face masks" bordered on exoticism.[92] Another major art exhibition in May, with works by Arp, de Chirico, Janco, Klee, Richter, but also Modigliani and Prampolini, filled the calendar. With afternoon teas instituted in May, the Galerie came to have "three faces": "By day it is a kind of teaching body for schoolgirls and upper-class ladies. In the evenings the candlelit Kandinsky room is a club for the most esoteric philosophies. At the soirées, however, the parties have a brilliance and a frenzy such as Zurich has never seen before."[93] The soirée "Old and New Dada Art," for instance, proved so popular that it was put on twice,

while a "Soirée Hans Heusser" was also held, with the Swiss composer playing his own compositions.

For all the artistic novelty and innovation undertaken at the Galerie Dada—three major exhibitions, a cycle of talks on modern art, and six evening performances—its days were numbered. Once again, the problem was money. The Galerie had debts to the tune of 300 Swiss francs; on 1 June the doors were shut for "unlimited vacations."[94] The costs of running a gallery could not be recouped by a few successful evening performances. Despite the impressive roster of artists assembled, few paintings were sold. Like the Cabaret Voltaire, the Galerie Dada became a mythic site due to its dazzling but ultimately brief existence. Lost in this myth were the difficulties of running the space and the personal exhaustion of putting on a full and varied program (Arp, Hennings, and Janco went off to Ascona for long rest cures while the Galerie was still open). The financial troubles created a great deal of friction between Ball and Tzara. There was even talk of Ball taking Tzara to civil court, but Richter and Corray interceded so that two penniless immigrants would not find themselves in a Swiss court disputing an opaque case in which little documentation was available. Although the closing of the Galerie was a disappointment, the precious few weeks of its existence acquired the golden hue of nostalgia.

Exactly one month after the Dada Galerie closed, the 1 July 1917 entry in Tzara's "Chronique zurichoise" exclaimed: "We launch the Dada Movement. Mysterious creation! Magic revolver!"[95] His long-held wish to produce a modern art review bringing together poetry, prose, and visual art had finally been realized with the publication of *Dada 1*. After the Cabaret Voltaire shut down, Tzara realized that Dada needed a focal point for its activities and a "product" that could be sent to artists beyond Switzerland. His first project, a 160-page anthology, proved too ambitious, but the time spent working on it proved useful for the smaller scale of *Dada 1*. Like *Cabaret Voltaire*, different French and German versions were issued, along with a number of luxury editions. The precise print run is unknown, but it would have been over one thousand (*Dada 3* had a print run of 2,000), selling at two francs for a regular edition and up to ten francs for a deluxe copy.[96]

Dada 1's plain red cover and its academic subtitle ("a literary and artistic collection") belied the explosive contents of this "ultima rivista dell'universo" of twenty-two pages.[97] Entirely edited by Tzara, the review assembled an eclectic group of artists, mainly from Zurich and Italy. There was no opening editorial statement, but the inaugural text, Tzara's "Note 18 on Art," laid out an aesthetic program that was almost romantic in its idealization of art: "We want to make men better, so that they understand that the only fraternity is in a moment of intensity … I open my heart so that men will become better."[98] This view was complicated, though, by the ensuing collection, which featured copies of abstract reliefs and collages by Arp and Janco, the provocative "Un Vomissement musical [A Musical Vomit]" by Savinio, primitive poetry by Tzara, and experimental poetry by a number of

D A D A 1

RECUEIL LITTÉRAIRE ET ARTISTIQUE

JUILLET 1917

FIGURE 5.6
Cover, *Dada 1* (July 1917).
Courtesy of the University of Iowa
Special Collections.

contributors. The magazine was full of self-referential moments: Francesco Meriano's poem greeted Janco and Tzara, Nicola Moscardelli's poem was dedicated to the two Romanians, and Tzara not only dedicated poems to his girlfriend Maya but also wrote a poem entitled "Marcel Janco." The notes in the back pages documented the events of the Galerie Dada, reminded readers that Tzara had "discovered" simultaneous poetry during the Cabaret Voltaire, and excluded from the Dada family Friedrich Glauser, whose occupation "poet" was put in quotation marks and then dismissed with the damning parenthetical "sentimental."

Staving off the impression that Dada was a closed, local phenomenon were the contributions by Italian artists. Meriano's poem "Walk," published in the original Italian, proclaims the imminent spread of Dada throughout Europe:

> Dada ultimate review of the universe
> let us count how many we are
> good evening to you Mr. Janco
> to you too Mr. Tzara
> one
> two
> four
> ten
> fifty
> one thousand
> truly Marinetti we will speak to the stars
> …
> the infinite is ours.[99]

This brash proclamation was buttressed by advertisements for the Parisian avant-garde journals *Nord-Sud* and *SIC* and the Italian reviews *Le Pagine*, *La Brigata*, and *La Diana* (as well as *Italia Futurista*). Forthcoming books by Apollinaire and Jacob co-opted their work under the constellation of Dada, while a number of future works, such as Tzara's collection of primitive poetry and a Dada anthology, gave the impression of global spread and ceaseless activity.

To actually understand what this seemingly global and limitless arts movement meant, though, was more difficult. The contributions from foreign artists were free-form musings on the expressive potential of the word "Dada." The notes about the activities of the Galerie Dada were no more conclusive about giving form to Dada, since there were exhibitions, performances, primitive poetry, but also classical works. The only common theme running through *Dada 1* was a desire to transcend conventional understandings of art, but its potential readers would not have found this extraordinary, as any number of French, German, and Italian reviews proclaimed the same goal. What differentiated Dada from the rest of the avant-garde at this point, then, consisted of its international ambitions and its undefined quality. This translated into freedom—freedom from national boundaries and a predefined aesthetic.

99

Spending the summer of 1917 in the Swiss countryside, Tzara continued his correspondence with foreign artists, but little headway was made in giving Dada a new lease on life. Yet the summer was difficult because of continued worries about his parents, who were now refugees in Iași, in northeastern Romania. Having received news that his mother was sick, Tzara had been financially cut off by his father, who was furious that his only son showed no inclination to take his studies seriously. As Titzu told him, "You do not like the courses, you do not like the professors. But even you can make sacrifices for your parents. They want their Samică to have a career. ... At every exam session they anxiously await news from you that you have passed. ... Their Samică will be good, no? And obedient, he cannot be anything else for them. I beg you."[100] Although it pained him, Tzara had made his choice: he marked up the back of a letter with a draft of a poem.

After the long summer hiatus, followers of Dada might have expected the group back on stage or in print. That was not the case; daily café sessions continued, but the various proposals to reenergize Dada all proved unworkable. In mid-November, Arp and Segal participated in an exhibition at Zurich's Kunstsalon Wolfsberg. This show, lasting several weeks, brought together modern artists from all over Europe, and the Dadaist contribution to it was substantial. But these kinds of events hardly constituted avant-garde activity. That is why the publication of *Dada 2* in December was greeted with relief. Yet again the review was published in both German and French editions, its cover price remained 2 francs, and a number of luxury editions were available at 8 francs. The same unadorned red cover and cheap paper were used. The most important markers of continuity were the eclectic collection of artists and the refusal to pin down a "Dada" editorial program. The pictorial component included work by de Chirico and Kandinsky, two artists who had been shown at the Galerie Dada earlier that year. Italian artists continued to lead the contingent of foreign contributors, but a growing number of French artists, including Robert Delaunay and Pierre-Albert Birot, the editor of *SIC*, were included. The back pages were devoted to reviews of Apollinaire's "sur-realist" drama *Les Mamelles de Tirésias* and Pierre Reverdy's most recent novel.

Dada 2 started with a note on modern art by Tzara. A reader would struggle to glean from the piece any information about its ostensible subject, Hans Arp, whose abstract paper collage was printed on the next page:

> Man is dirty, he kills animals, plants, his brothers. He quarrels, he is intelligent, talks too much but cannot say what he thinks.
>
> But the artist is a creator: he knows how to work a form so that it becomes organic. He decides. He makes man better.[101]

By this point Arp had made chance a cornerstone of his aesthetic process, so Tzara was mistaken in claiming that the artist "decides" or reworks forms. But the note was not intended to be dispassionate criticism. Tzara's elliptical prose suggests a growing conviction that

art could not be critically analyzed or philosophically dissected but, rather, had to be approached through a series of associations, ranging from "my sister root, floor, stone" to Arp being seen as

symmetry
the flower of a meeting at midnight
where vertigo and the bird become the tranquility of a halo.[102]

This opening note should be read alongside the review of Reverdy's *Le Voleur de Talan* [The Robber of Talan], where Tzara provides a definition of "cosmic" art, which obeys two contradictory rules:

1. / give equal importance to every object, being, material, and organism of the universe

2. / accentuate the importance of man, assemble around him and subordinate beings and objects under him.[103]

As Tzara elliptically explains, there is "a need to CORRECT men, but also to leave them to be what they wish."[104] Once again Dada refused to take on a definite form; it was the hint of something, a rumbling in the depths of consciousness, a transformation brought about by dreams or wordplay. Readers of *Dada 2* dissatisfied with the lack of a clear definition for "Dada" had to wait for Tzara to enlighten them; however, when he did, in the *Manifeste Dada 1918*, they were none the wiser. But that was very much the point.

6 BEYOND THE SWISS SANATORIUM: **1918–1919**

"THIS IS NOT THE NEW ART, THIS IS NOT EXPRESSIONIST OR FUTURIST ART; RATHER THIS IS NOT ART AT ALL. THINK OF THE POEMS 'POUR DADA,' 'RASOIR MÉCANIQUE,' THINK OF 'UN VOMISSEMENT MUSICAL.' WITH THESE TASTELESS AND ABSURD SHENANIGANS THE NEW ART IS COMPROMISED."[1] If only expressing common sentiments at the time, the ferocity of this letter addressed to Tzara in mid-January 1918 was surprising considering that it was written by German writer Bruno Goetz, a proponent of the "new art" who had lived in Ascona since 1909 and knew many of the Zurich Dadaists personally. Yet what Goetz considered a fundamental critique—"this is not art at all"—Tzara took as a sign that Dada was slowly accomplishing its goals. From Germany he was receiving news about Huelsenbeck's "Club Dada," a brash, politically engaged combat against culture. Italian artists kept writing, so keen were they to expand Dada's reach in the peninsula, and French artists had come to be interested in the movement. Perhaps Dada was "not art at all," but a critical mass of artists increasingly saw in it a template for renewal on terms that were dictated not by critical categories or tradition but, rather, by the personal choices of both artist and spectator. The only problem for this anti-art movement was that more artists than spectators were interested in Dada.

Tzara was now living in the Pension Furrer at 19 Zurichbergstrasse, near the university. Janco also lived in this predominantly student district, which was convenient since the two showed the greatest enthusiasm in running Dada now that Ball had removed himself from its operations and Huelsenbeck was back in Berlin. Yet there was little Dada activity to organize in early 1918. Cash-strapped by the rising cost of living, and worn out by the energy Dada performances required, Zurich would not see another public Dada event until the "Soirée Tristan Tzara" in July, and no new Dada publications until the end of the year. Tzara repeatedly implored contributors to send money along with texts or art, but since most of them were hard up as well, little came in. He was devoting time to publicity and sales of *Dada 2*, entreating foreign artists to work their contacts so that a few paltry copies— anywhere from five to ten—could be sold. This informal distribution system created its

103

own headaches, though, as it entailed reciprocal obligations: having received *Dada 2*, Prampolini sent forty copies of *Noi* for Tzara to sell in Switzerland.[2]

Amid all these troubles, Tzara found some solace in his first love, poetry. *Dada 2* had announced the imminent publication of a book of his poems with illustrations by Arp, but financial difficulties delayed it until 1918. In a 1922 letter to Jacques Doucet, who purchased the original manuscript of *Vingt-cinq poèmes*, Tzara noted that all the poems were written with a single aim in mind: "In 1916 I resolved to destroy literary genres. I introduced in poems elements judged to be inappropriate there, such as newspaper phrases, noises and sounds. These sonorities (which have nothing to do with imitative sounds) were meant to constitute a parallel to the efforts undertaken by Picasso, Matisse, Derain, who employed in their paintings varied *materials*."[3] This retrospective justification overplays the theoretical impulse driving the collection, but there was some truth to the idea that Tzara's poetry attempted to express an entirely new sensibility, one that Swiss critic and Galerie Dada collaborator Waldemar Jollos characterized as "chaos, a struggle with the word, rough stammering."[4]

"Le Géant blanc lépreux du paysage [The White Leprous Giant in the Countryside]" starts this course of recharting poetic value by raising a question that plagues any reading of the volume: how can these poems be read? Should they be read out loud, as they had been on Zurich's stages? On one level, there is the impossibility of making sense of the meaning of particular lines, such as the opening:

> the salt arranges in a constellation of birds on the tumor of cotton wool
> [*le sel se groupe en constellation d'oiseaux sur la tumeur de ouate*][5]

The commonplace syntax (subject–verb–direct object) is turned on its head by the impenetrability of the line. There is a feeling that some deeper meaning inhabits each word. Natural substances—salt, constellations, birds—create a malignant growth on a substance associated with hygiene. The only structuring principle seems to be the serial alliteration of *s* and *t*, a movement in the alphabet that follows the line's accelerating rhythm and its rush for completion, which the next few lines, however, stop:

> in his lungs the starfish and the bugs swing [*se balancent*]
> the microbes crystallize [*se cristallisent*] into palm trees of swinging muscles
> hello no cigarette tzantzantza ganga
> bouzdouc zdouc nfoùnfa mbaah mbaah nfoùnfa[6]

The repeated use of reflexive verbs (*se groupe, se balancent, se cristalllisent*) emphasizes transformation, the passage from one state to another, but the objects remain inert matter. The introduction of a direct address with "*bonjour*" does not lead to greater familiarity or intimacy: the poet has no tobacco to share and is sprinting off into demonic laughter anyway. The "tzantzantza" alludes to both the author and dancing (the German *tanzen*), but the poet does not reveal himself, and there is little dancing as the words bury themselves

in a greater complication of objects, of flames that are sponges, of ladders rising like blood, of sponges made of glass, of scissors and scissors again, and thermometers and clouds. In what Stephen Forcer calls a "grammatically uncensored parade" of nouns, no wonder Tzara thinks the reader cannot handle the poem:

> here the reader begins to scream [*ici le lecteur commence à crier*]
> he begins to scream begins to scream then in this scream there are
> flutes which multiply corals
> the reader wants to die maybe or dance and begins to scream
> he is thin idiotic dirty he does not understand my verses he screams
> he is blind in one eye
> there are zigzags on his soul and many rrrrrrr[7]

This meteoric stanza unmasks the reader rather than the poet, as the images have become part of the reader's experience: those flutes multiplying into corals (or the flutes and corals multiplying together, for Tzara's French is ambivalent) are not a poetic image but have come to entangle the reader's mind in a welter of syntax and language that has become monstrous in its disorganization.

This aggressive metapoetry is belied by softer, more lyrical passages, turning *Vingt-cinq poèmes* into a more varied collection than traditionally assumed:

> come close to me so that the prayer does not disturb you it descends
> into the earth like the diving suits that will be invented
> then the obscurity of steel in wine and salt shall change
> lightning rod simplicity of our plants pay attention[8]

Addressing personal longing, encased within corporeal bodies on this earth where all must descend, these rather classical lines (the prolonged alexandrine in the first line, the medieval alchemy of steel, wine, and salt in the second) from "La Grande Complainte de mon obscurité un [The Great Complaint of My Obscurity, One]" are not hermetic, verbal machinations. They are revelatory of a lost, nostalgic spirit, as the poem's final line confirms:

> you must be my rain my circuit my pharmacy do not cry [*nu mai plânge*] do not cry [*nu mai plânge*] will you[9]

The repeated "*nu mai plânge*" would be unintelligible to most readers, but switching to Romanian to conclude the poem not only brings out the poet's obscurity but also shows the impossibility of returning to a prewar linguistic home. The desire to find a resting place where the ceaseless movement of nature and the destructiveness of war will not shatter the integrity of the self is a constant theme throughout the volume. This search never comes to fruition:

> let's run faster
> always everywhere we will remain between black windows[10]

The predominant tone of *Vingt-cinq poèmes* is separation and loneliness, loss on a cosmic scale. Tzara's formal decision to do away with punctuation (there are a few question marks but no capital letters, commas, or end periods) contributes to the devastation. Years later Tzara approved of how, in Apollinaire's poetry, "punctuation serving the illumination of logical thought no longer has a role to play." [11] In *Vingt-cinq poèmes*, if the bunched-up lines and severe alignment of the typescript brought about by the lack of punctuation bring words physically closer together, to the point where they almost seem to smash into each other, the poetry is formally nude. Individual words have become isolated atoms, and sentences have lost their center. The reader suffers a disorienting loss as subjects and objects cannot be isolated, and clauses either modify preceding words or become subjects in their own right: "concentration interior crackling of words which die crackle [*concentration intérieure craquement des mots qui crèvent crépitent*]." [12] Arp's illustrations complement the isolation of the object-word in Tzara's poetry: the black-and-white reliefs seem to be frozen in time, inhabiting an unrecognizable, alien space.

If *Vingt-cinq poèmes* was a "declaration of war," this slim chapbook, with its poems dedicated to Arp and Janco, was addressed to other artists and circulated through the network of the avant-garde: "The book moves only art dealers." [13] This ironic appraisal by Louis Aragon—for what public existed for such poetry?—contained an uncomfortable truth. The anti-poetry and anti-art message did not find many takers. A review in *SIC* lavished embarrassing praise: "Tzara is gifted with the necessary faculties for the elaboration of the new art, that is a fact. And that is not all. He truly had the extraordinary luck of being born a poet and he wears this sign stenciled on his forehead." [14]

FIGURE 6.1
Arp, Tzara, and Richter
clowning around.
Anonymous photographer.

Resigned to steering clear of the "rarefaction of academic knowledge," after a month in the university district Tzara took a room on the Limmat, steps away from Café Odeon. This move to the Hotel Seehof did not delay preparations for the "Soirée Tristan Tzara," held on Tuesday 23 July 1918. Billed as an evening of "the newest direction in art" by the "greatest poet of 'Dadaismus,'" the performance was at the Zunfthaus zur Meise, in the heart of bourgeois Zurich.[15] The enigmatic advertisement—"manifesto, antithesis thesis antiphilosophy, Dada Dada Dada Dada dadaist spontaneity dadaist disgust LAUGHTER poem tranquility sadness diarrhea is also a feeling war business poetic elements infernal helix economic spirit indifference national anthem"—attracted fewer than one hundred paying customers.[16] The performance started half an hour late, when a "dark, faint, pale and thin young man" stepped onto the empty stage and began to shout: "My head is as empty as a brothel cabinet. ... My heart is buried in a newspaper."[17] The program then continued with one of the most explosive manifestos ever written, Tzara's *Manifeste Dada 1918*.

The *Zürcher Morgen-Zeitung*'s art critic was enthralled by the evening: "It was an experience, it was the highest."[18] Others thought it an experience to forget, injurious to both the social and the intellectual order: "The search for originality and the tendency to make the French language *barbaric* is too apparent ... we ask whether incoherence, bad taste, and the illogical succession of words is poetry. Right now, when all intellectual forces should be united in fighting the war, one sees with a certain sadness the literary youth forgetting its duties to humanity and swindling people with these kinds of new dogmas."[19] But it was a review calling the Dadaists "the Bolsheviks of art" that forced Tzara's direct response: "I beg of you to note in your newspaper that the 'Dada Movement' is not at all engaged in politics."[20] This was disingenuous on Tzara's part. Zurich Dada did not engage in politics *sensu stricto*, but the irony, cynicism, and negation of the *Manifeste Dada 1918* was political in "attacking the moral and social foundations of the world."[21] A watershed in Tzara's poetic and aesthetic evolution, "the first, the true, and the great gospel of Dadaism," it was the veritable anti-art to which Goetz had objected earlier.[22]

Huelsenbeck later complained that "Tzara could think of nothing else to do but write manifesto after manifesto."[23] This image of the addict and master "*dall'arte di far manifesti*," to use Marinetti's felicitous phrase, overlooks the complexity of Tzara's manifestos and how they were literary acts rather than literary texts, manifestations in the sense of public performances rather than manifestos.[24] Nowhere is this more apparent than *Manifeste Dada 1918*, a violent text marking Dada's entry into a period of self-sufficient negation:

> And so Dada was born of a need for independence, of a distrust toward unity. Those who are with us preserve their freedom. We recognize no theory.
>
> …
>
> Let each man proclaim: there is a great negative work of destruction to be accomplished. We must sweep and clean. Affirm the cleanliness of the individual after the state of madness,

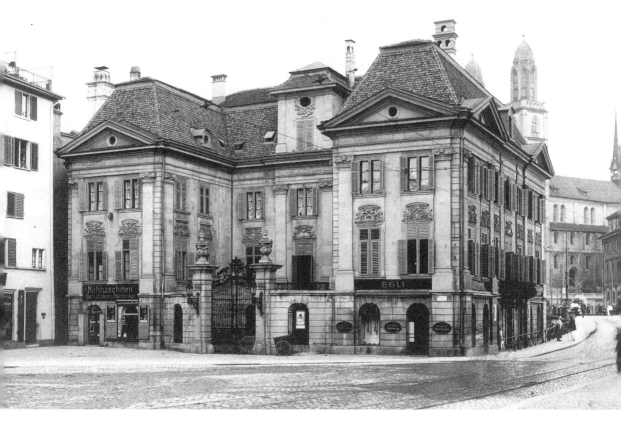

FIGURE 6.2
The Zunfthaus zur Meise, site of
the "Soirée Tristan Tzara" in
July 1918.
Baugeschichtliches Archiv (Zurich).

aggressive complete madness of a world abandoned to the hands of
bandits, who rend one another and destroy the centuries. Without
aim or design, without organization: indomitable madness,
decomposition.[25]

The "openness" and clarity that literary critic Martin Puchner claims is a defining quality of
the manifesto genre is deliberately obfuscated when the notion of teaching or imparting a
message is made ridiculous from the start:

To put out a manifesto you must want: ABC
to fulminate against 1, 2, 3
… To impose your ABC is a natural thing … [e]verybody does it …

I write a manifesto and I want nothing, yet I say certain things, and in principle I
am against manifestos, as I am also against principles … I write this manifesto
to show that people can perform contrary actions together while taking one fresh
gulp of air; I am against action; for continuous contradiction, for affirmation too,
I am neither for nor against and I do not explain because I hate common sense.[26]

Spectators expecting enlightenment can only be disappointed when Tzara thunders like
Zarathustra: "I destroy the drawers of the brain and of social organization: spread demoral-
ization wherever I go and cast my hand from heaven to hell, my eyes from hell to heaven,
restore the fecund wheel of a universal circus to objective forces and the imagination of
every individual."[27]

Dada is not part of the historical progression of things; it is not like Moréas's Symbolism,
something "awaited, necessary, inevitable"; its participants are not, as in Baju's Decadent
manifesto, "stars of an ideal literature"; and its theory is not, as in Marinetti's Futurist tracts,
the Hegelian march of history.[28] Unlike other avant-garde manifestos highlighting a "plan
of action" ("WE ANNOUNCE THE LETTRIST AVALANCHE"), the only message is a
thundering, double-barreled empty sound: "*Dada; abolition of logic, which is the dance of
those impotent to create … Dada; abolition of memory: Dada; abolition of archaeology:
Dada: abolition of prophets: Dada; abolition of the future: Dada.*"[29] An end in itself, a word
of brazen contradictions but miraculous potential: Dada. There is no guiding principle to
salvage the individual out of the chaos as the extreme limit of language, that moment when
it falls apart, has been touched.

If Italy had been the first site of Tzara's expansion of Dada, France represented his first love.
Tzara's strongest poetic influences came from French Symbolist poetry, and his own writing
was almost exclusively in French now. There were rumors in the summer of 1918 that Tzara
would soon be arriving in the French capital.[30] Paris not only had a glorious tradition as the
world's art capital, it fully merited that title due to the poetry of Apollinaire and Jacob and
the painting of Braque and Picasso.[31] The little reviews *SIC* and *Nord-Sud* further con-
tributed to the vitality of its artistic scene.

No French contact was initially more important than Apollinaire, the soldier-poet of mixed Polish-Italian blood whose bold verses and forms astounded Tzara. The first contact was made indirectly: in early 1916, Tzara sent one of his poems to Max Jacob, who in turn shared it with Apollinaire. Later that year Tzara sent Apollinaire a copy of *Cabaret Voltaire*. Although he promised to send Tzara a poem in return, Apollinaire, careful to dispel questions that continued to circulate about his foreign origins, suspected Dada of being German-led. Tzara assured him otherwise, but pretensions to "neutrality" did not satisfy Apollinaire's insistence that the publication of German or Austrian artists constituted support for the enemy. Even though he appreciated Tzara's poetry—"For a long time I have loved your talent, and I love it even more as you have honored me by taking it on a path in which I precede you but do not in any way surpass"—he refused to have his own work published in Dada reviews.[32]

Yet Apollinaire proved helpful in another way: the steady stream of poets visiting his flat in Saint-Germain-des-Prés became acquainted with Dada. This was how Tzara's "La Grande Complainte de mon obscurité deux" and "Verre traverser paisible [Glass Crossing Peaceful]," which were sent to Apollinaire, came to be published in Pierre Reverdy's *Nord-Sud*. Although Reverdy was a talented poet in his own right, he believed that "the moment has come for us to group ourselves around Guillaume Apollinaire."[33] *Nord-Sud* was a concrete effort to do that. For Reverdy, syntax and punctuation were playthings compared to the seriousness of poetic form; modern poetry had to get on to the job of reflecting the complexities of the contemporary epoch. Reverdy sent his own poems to Zurich, and for his part Tzara lavishly praised Reverdy's *Le Voleur de Talan* as "the novel one dreams of" and an example of "cosmic" art.[34] In February 1918 Tzara asked Reverdy to negotiate with Adrienne Monnier so that her bookshop would serve as an "exclusive [Paris] outlet" for Dada.[35] Coming to greatly appreciate Tzara's work, Reverdy suggested in the summer of 1918 that the financial problems besetting *Dada* and *Nord-Sud* could be solved if the two journals merged. The title *Nord-Sud* would be retained, as would its publication in Paris, "a more significant literary and artistic center" than Zurich, but Tzara would assume editorial control.[36] This was closer collaboration than Tzara had reckoned for, but the offer showed how important *Dada* had become. It was also a stinging rebuke, for *Dada 2* had come out over six months ago: it was high time to get the next issue of *Dada* published.

After being published in *Nord-Sud*, the next destination for Tzara's work was Pierre Albert-Birot's *SIC*, or "Sons-Idées-Couleurs [Sounds-Ideas-Colors]" (detractors claimed it stood for "Société Incohérente de Charlatanisme"). First appearing in January 1916, *SIC* had an ambitious message: "*SOYONS MODERNES … TOUTES LES AUTRES SONT ARTIFICIELLES* [Let us be modern … all the others are artificial]."[37] The September–October 1917 issue—whose "notes" section called *Dada* an "arts magazine of pleasant quality and sobriety"—featured "Note 6 sur l'art nègre" and "Retraite."[38] Throughout 1918 the review published Tzara's poetry and reviewed Dada publications; in turn, Tzara

published two poems by Albert-Birot in *Dada 2*. By early 1919, almost every issue of *SIC* contained an original contribution by Tzara.

With his stock in Paris rising, in the summer of 1918 Tzara received an unexpected offer from Paul Dermée, a Belgian-born writer. Although some of Dermée's poetry appeared in *Nord-Sud*, his singular talents were in organization and graphic design, the nuts and bolts of putting together a magazine (he had worked at *Nord-Sud* and went on to found, in 1920, *L'Esprit Nouveau* with Amédée Ozenfant and Le Corbusier). Dermée offered to act as the Paris distributor of *Dada 3*, even suggesting that Tzara send him page proofs so that he could clear them with the censors (several previous Dada publications had been confiscated). Dermée also offered to partly subsidize the publication costs and to eliminate "numerous annoying mistakes" by proofing each issue.[39] But this help came at a cost: "Give me a title: co-director or editor-in-chief (you know the importance of these charms for the public of literary men)."[40] Dermée had other conditions, the "first, but absolute" one being that no Austrian or German contributors could appear.[41] Besides this editorial censorship, Dermée told Tzara that the journal had to come out regularly, with each issue obeying a standard format. As *Dada 3* idled at the printer's that summer and autumn, Tzara came to have doubts about Dermée's conditions, which would undermine Dada's internationalism by sidelining German contributors. The prospect of *Dada* coming out at regular intervals and in a standard format, moreover, began to lose its appeal. Since Tzara wanted *Dada* to be characterized by fierce independence, it was difficult to imagine that worthy contributions could be found on a regular basis. Having caught wind of Dermée's entreaties, Reverdy warned Tzara to keep his distance from "this charming fake" who "fed on the fruits of others' talents" and had "spoiled" *Nord-Sud* with his "incompetence and nonchalance."[42] Tzara's enthusiasm cooled considerably, and when, after months of silence, he finally responded to Dermée's offer, his tone was controlled and diplomatic. *Dada* would remain irregular but international.

111

Dada 3 was not meant to be a "postwar" number when it came out in December 1918. The issue had been ready in May, but its publication kept being delayed. On top of the habitual financial troubles, Tzara had to contend with paper rationing, his own poor health (he took rest cures in August and September on Lake Lucerne), and Dada's printer getting arrested. The general strike that shut down Zurich in November, just as the armistice was signed, did not help matters.[43] In late November Tzara found another printer and supervised every aspect of *Dada 3*'s complicated production—for unlike the previous numbers, this issue stretched typographic conventions. The plain red cover and endearing subtitle "a literary and artistic collection" were scrapped in favor of a cover featuring a Janco woodcut and a pointed line from Descartes running diagonally across the page and into the title: "I do not even want to know if there were men before me." A passage from the *Manifeste Dada 1918*, the centerpiece of the issue, signaled these intentions: "Every page must explode, either by

DADA 3

Directeur :
TRISTAN TZARA

Bois de M. Janco.

Je ne veux même pas savoir s'il y a eu des hommes avant moi. (Descartes)

Administration

Mouvement DADA

Zurich

Zeltweg 83

Fr. **1.50**

profound heavy seriousness, the whirlwind, poetic frenzy, the new, the eternal, the crushing joke, enthusiasm for principles, or by the way in which it is printed."[44] In *Dada 3* pages are no longer evenly divided between text and image. No consistent font is used, poems are broken up, and notes and advertisements run vertically in the margins: as Tzara later put it, "[t]he typography of *Dada 3* is a manifestation in itself."[45]

With over 2,000 ordinary copies of the sixteen-page review printed, this was the most ambitious Dada publication yet (the original plan was for eight pages, but Arp and Janco provided the necessary funds in September for a longer issue).[46] Twenty numbered deluxe editions, including two original prints by Janco and a woodcut by Arp, were put on sale for 20 Swiss francs. Like the previous two numbers, a French/Italian and a German version were printed (differing in the contents of two pages), for the armistice had not put an end to stringent censorship and nationalist feelings among artists remained strong. The other significant change in *Dada 3* was the stronger editorial line taken by Tzara, who was named as sole editor. When the main goal had been to swell the number of foreign artists, Tzara had accepted contributions with relatively little critical oversight ("I'd be grateful to you if [you] would tell other men of letters to contribute to *Dada*").[47] Even if he was "no red-pencil dictator" as an editor, in *Dada 3* Tzara tried to create a more consistent Dada line.[48] To that end, only four Italian contributions (two of which were dispensed with in the German edition) appeared. Having condemned Futurism in the strongest terms in *Manifeste Dada 1918*, Tzara wanted to drive a wedge between the two avant-gardes. While a number of Paris-based reviews were advertised, no Italian reviews were mentioned—partly because he felt that their work continued to be influenced by Futurism, but also because he had become angry about the way they treated his work (either publishing without authorization or changing the submitted text). Attentive observers could see that the growing number of French contributors—Albert-Birot, Dermée, Francis Picabia, Reverdy, and Philippe Soupault—heralded a deeper change in the editor's orientation. This was appreciated in Paris, where *SIC*'s "Literary Thermometer," which was based on scale of 0 (a nullity) to 11, gave *Dada 3* the highest possible score, signifying "EXPLOSION."[49]

113

After *Dada 3* was published, Tzara remarked that "one publishes to search out [other] *men*."[50] The review had found a ready audience in the European avant-garde, but it resonated so strongly with two men in particular, Francis Picabia and André Breton, that they both sought out Tzara. The close friendships that were formed radically reoriented not only Tzara's life but also the course of the European avant-garde.

Born into an affluent Spanish-Cuban-French family in Paris in 1879, Picabia had already worked his way through several artistic influences (Post-Impressionism, Fauvism, Cubism, the Puteaux group) when he began experimenting in a "machinist" style in 1916. Armed with quick wits and a mercurial personality, outlandish in his love of fast cars and beautiful women, he was also a veteran of scandals, both artistic and personal. He spent the war years in New York, Barcelona, and Paris before coming to Switzerland in the summer of 1918 for a rest cure. He was accompanied not only by his wife, Gabrielle Buffet-Picabia, but also by his mistress, Germaine Everling. In his round trips between wife and mistress, he eyed up a young, married French painter, but his attempted seduction resulted in the jealous husband firing two shots at Picabia in a hotel hallway. Picabia laughed off the incident, penning a poem to the shooter: "Come now sit down" and light "a little candle to think of your mistress fucked by me."[51]

These tumultuous events were the immediate backdrop to Picabia's first contact with Tzara, which came via letter in August 1918. While Max Jacob had announced "the birth of the Romanian poet Tristan Tsara [*sic*]" in the review Picabia edited, *391*, Picabia had little knowledge of Dada.[52] He read through *Dada 1* and *2* and Tzara's poetry, and within a few weeks he and Tzara were "exchanging enthusiastic pledges of collaboration."[53] Asked to contribute to a September 1918 show at the Wolfsberg Gallery in Zurich, only to find his work censored, Picabia received this explanation from Tzara: "The Salon Director is an abominable, pretentious insect whose impotence and lack of talent are engraved in the form of vermin upon the feeble quality of his mind. ... There is also the spirit of prudishness of the proprietor (Mr. Wolfsberg), a character in whose stomach one could, on opening a door, find an entire store of alcoholic products, and the purely commercial mind of this same individual, which helps to explain this act."[54] Vituperative letters like this only raised Picabia's esteem for Tzara. For his part, Tzara promised to visit Picabia in November, but that trip was put off because he had to supervise the printing of *Dada 3*. When Picabia received a copy, he was overjoyed: "splendid, it has done me enormous good to finally see and read something in Switzerland that isn't bullshit. All of it is very nice it's really something; your manifesto expresses every philosophy seeking truth, when there is no truth, only conventions."[55] Even though he was scheduled to go back to Paris, the force of *Dada 3* overturned Picabia's plans and he resolved to visit Tzara in Zurich: "I won't conceal the fact that the reason is to spend a few days near you. It is so rare to meet an independent, intelligent mind, and optimistic for that matter."[56]

114

Arriving at Zurich's City-Hotel on 22 January 1919, Picabia and his wife were soon visited by Tzara and Arp, who later recounted this first meeting:

> We found him busy dissecting an alarm clock. … Ruthlessly, he slashed away at his alarm clock down to the spring, which he pulled out triumphantly. Interrupting his labor for a moment, he greeted us and soon impressed the wheels, the spring, the hands, and other secret parts of the clock on pieces of paper. He tied these impressions together with lines and accompanied the drawing with comments of a rare wit far removed from the world of mechanical stupidity. He was creating antimechanical machines … machines of the unconscious.[57]

The Zurich Dadaists formed a kind of diplomatic cortege as they waited in line to shake Picabia's hand; the elder artist thought that the young men in dark clothes looked like choirboys.[58] These initial impressions were soon erased as Picabia was seamlessly incorporated into the Zurich Dada circle. His machinist drawings enthralled Arp and Janco, while Tzara was enamored with his latest poetry, which made up the 1919 collection *Pensées sans langage* [Thoughts without Language]. The three weeks Picabia stayed in Zurich just *"flew by"* as he and Tzara played game after game of chess (Gabrielle Buffet wrote the poem "Queen's Gambit," which appeared in *Dada 4–5*, in honor of these matches) and walked in the surrounding countryside.[59] The two men, "warehousing the odor of coffee … amidst cigarettes and the feathers of primitive man," assembled material for two publications—the eighth number of *391* (February 1919) and *Dada 4–5*, the "Dada Anthology" (May 1919)—and talked about setting up a weekly review.[60] The decision to print a double number of *Dada*, rather than two separate issues as Tzara had initially planned, was driven by Picabia's desire to produce a Zurich number of *391*. Both reviews were able to come out quickly because Tzara had collected the necessary paper stocks, and because "the printer is no longer in prison."[61]

After its first appearance in January 1917 in Barcelona, a total of nineteen issues of *391* eventually came out, albeit irregularly, until 1924. The front cover of the eight-page Zurich number contained significant names from the avant-garde within a grid and a machinist drawing in its center. Unlike previous issues of *391*, which tended to be dominated by Picabia's texts and drawings, the Zurich number had a wide ambit of contributors, with manifestos from Buffet, Picabia, and Tzara, poetry by Picabia and Tzara, and artwork by Arp, the Swiss artist Alice Bailly, and Picabia (including his machinist "Shiny Vagina"). The final page relayed news from "New-York—Paris—Zurich—Barcelona." While not as innovative as *Dada 3*, the typography was nonetheless spectacular, with one page featuring simultaneous manifestos by Picabia and Tzara, although Tzara's was upside-down, an expression of how the two saw each other as perfect negatives. Michel Sanouillet relates that this double text, composed in Picabia's hotel room, was "*deliberately* written under the single dictation of the unconscious and published as such," thus making it an example of automatic writing that preceded Breton and Soupault's *Champs magnétiques* [Magnetic

Fields].[62] After Picabia's departure, Tzara was disconsolate at having lost contact with his new friend and offered to come to Gstaad for a week so that the two could continue working together.[63] This trip was aborted because of Picabia's relentless traveling; as soon as he arrived back in Paris in early March, one of the first things Picabia did was write Tzara: "If you can, *come as soon as possible*."[64]

Paris was in Tzara's mind at the time when he received Picabia's invitation, for the other great friendship that sprouted from *Dada 3* was with André Breton. In early January Tzara sent a copy to Breton, then part of the *Nord-Sud* circle, and on the day of Picabia's arrival in Zurich, Breton replied: "I felt genuine enthusiasm for your manifesto; I hadn't known whom to turn to for the courage you display. It is to you I turn my eyes today. (You do not know who I am very well. I am twenty-two years old. I believe in the genius of Rimbaud, Lautréamont, and Jarry; I loved Guillaume Apollinaire dearly; I have a deep affection for Reverdy. My favorite painters are Ingres and Derain; I am very sensitive to Chirico's art.)." As if embarrassed by this confession, Breton added: "I am not as naïve as I seem."[65]

Breton had known about Dada for at least six months before he wrote Tzara, but the trigger for his letter was not just *Manifeste Dada 1918* but also the recent death of his close friend Jacques Vaché.[66] Breton's letter actually begins by noting how much Tzara would have loved Vaché and how Breton, Tzara, and Vaché could have done "great things" if the latter had not died.[67] Vaché's devil-may-care spirit was far removed from Breton's studied seriousness, and his glib experience and quick charm were also a contrast to Breton's prickly self-consciousness. Breton was insecure, and his early life was largely a search for a leader: Paul Valéry, Vaché, Apollinaire, and Tzara all filled that role at different moments. With both Vaché and Apollinaire dead, there was no other star on the horizon than Tzara; as Breton told his friends, "We will live under the sign of Dada."[68] In February he wrote: "Tell me, I beg of you, that one of your first visits [here in Paris] will be to me. I am tempted to write to you as I don't write to anyone else. ... I support you on every occasion here and so many things in the future would seem impossible to me without you. But we will not be able to understand each other and plan our action until we are face to face."[69] With Tzara unable to confirm any plans for Paris, Breton made do with a photograph that Tzara sent: "I spend a lot of time scrutinizing this photograph. Even in your features, I feel I have always known you."[70] For the rest of the year their correspondence revolved around *Littérature*, the review that Breton had started with Aragon and Soupault, and *Dada*. Incensed that Dada publications were difficult to find in Paris, Breton offered to set up a more reliable distribution system. The two bonded over calumnies in the press against Dada, and Breton offered to help Tzara navigate the French literary scene. But their first meeting would have to wait, as Tzara still had unfinished business in Zurich.

With a series of modern art exhibitions in early 1919—the Kunsthaus show in January, individual shows of Arthur Segal and Viking Eggeling at the Wolfsberg Gallery in February

and March, and a one-person show by Alice Bailly at the Kunsthaus in April—artists associated with Dada had become fixtures of the arts establishment. While the negativity of Tzara's version of Dada had encouraged a breakaway group led by Arp and Janco, "Das Neue Leben [The New Life]," whose manifesto vowed to rebuild humanity through art, Tzara's editorial control of *Dada* gave him the upper hand in defining the movement, which was now very active in Germany as well. After his health problems the year before and the lethargy caused by his weak nerves, Tzara suddenly found himself active on all fronts. By early March *Dada 4* was with the printers, but several weeks later he announced that a double number, *Dada 4–5* (the "Dada Anthology"), would be issued instead (it came out in mid-May). He was also deep in preparations for "a big art (or anti-art) soirée": "imagine," he told Breton, "selling tickets and pasting up posters, we're expecting 1,000 people, a simultaneous poem for 20 voices. I myself am organizing the soirée, all sorts of productions etc. You can't help but feel sorry for me. For the moment it's amusing."[71]

The climax of Zurich Dada, the Eighth Dada Soirée was held on Wednesday 9 April 1919 at the Kaufleuten hall, a large venue on Pelikanplatz. Built in 1912, the Kaufleuten served as the headquarters of the Swiss Commercial Union, and the six-story building housed a stationery shop, a bookbinder's, club rooms, a large restaurant with dainty tablecloths and dark, embossed wood paneling, and a large meeting hall for lectures and conferences.[72] Organized by Tzara "with the magnificent precision of a ringmaster marshaling his menagerie of lions, elephants, snakes and crocodiles," the "diverse" program included manifestos, poetry, dances, and music.[73] Dada stalwarts like Arp, Heusser, and Richter were involved, as were two dancers from the Laban School, Suzanne Perrottet and Käthe Wulff. The new additions to the program were Eggeling and Walter Serner, a psychiatrist from Geneva who had published *Sirius* during the war years and was now close to Arp and Tzara (the three collaborated on automatic writing projects, and later that year they put out the first and only number of *Der Zeltweg*).

The evening began at 8:15 p.m., and "the last seat was full" as over 1,000 people—stolid burghers and elegant women seeking "a night freed from the constraints of everyday rules"—paid from 2 to 4 Swiss francs for a ticket.[74] The evening was structured in three acts, the first consisting of Eggeling lecturing on abstract art, Suzanne Perrottet dancing, then poems by Huelsenbeck and Kandinsky, and Tzara's simultaneous poem for twenty people.[75] Most of the second act—a lecture on modern art by Richter, music by Heusser, Arp's "Wolkenpump," and more dancing—was also well received. But then Serner came on stage to end act two with "Der Letze Lockerung [The Ultimate Loosening Up]." Serner kept reading his violent manifesto despite being heckled ("insect ... pig ... impudence") and having objects thrown at him.[76] At some point members of the audience rushed the stage to attack the unadorned mannequin that Serner had placed there. The entire hall was dangerously close to rioting, so the lights were turned off to cool nerves. The audience came to its senses, and it slowly

FIGURE 6.4
Tzara, "Bilan," in *Dada 4–5*.
Courtesy of the University of Iowa
Special Collections.

1918–1919

BILAN

virement, *crustacée long* bleu règlement

soigne *la parodie* et touche *A BAS*

étale lentement *la taille* paradis *A BAS* **cataphalque**

étalon *sur les rails* à travers hypocrisie

sur mes dents *sur tes dents* j'écoute *ressorts ressemblants*

qui baille extasié extraction de hameçons sentis dans les os

hamac perforé *et les insectes* du vide (soude) ou corridor tricolore

des nombres *on réveille* le nombril (sonde)

fini le paragraphe *et la seringue* pour phosphore **ZZ**

Voisinage du fer bravoure gymnastique balustrade

les chiffres astronomiques acclimatisées

SUR BILLARD A TOUS LES VENTS

gratuitement

drogue halucination transcaspienne sacristie

AVANCE LA COULEUR EN LANGUE DIFFÉRENTE

vivisection

EX-CATAPLASME PLAIT AUX AMOUREUX

à 3 fr. 50 ou 3 h. 20 invincible martyrologiste

ton cible et tes cils rappellent la naissance du scorpion en cire

syphilis blanchissant sur les bancs des glaciers

joli TAMBOUR crépuscule

auto gris autopsie cataracte

ô nécrologues prophylactiques des entr'actes antarctiques régions

t^{Ri}s^{tA}n T^zaR_a

dawned on the public that they had, in an instant, gone from applauding spectators to a riotous mob.[77] They then sat through Tzara's "Proclamation without Pretension," which railed against modern art: "Art needs an operation | Art is a pretension heated in the shyness of a pisspot, hysteria born in the studio."[78]

Tzara considered the evening "Dada's definitive victory," its brightest hour in Zurich.[79] He wrote two summaries of the evening's events, and the more contemporaneous one, published several weeks later in *Dada 4–5*, focused on the tumult that mounted during the performance:

> A date to remember, because we found out that the audience does not like the truth. The hall was full (1,000 people), and the agitation that began with Dr. Serner's manifesto grew into the kind of psychosis that explains war and epidemics. And so even more courageous was the gesture by Augusto Giacometti and Alice Bailly in bringing to Tzara, after the simultaneous poem in 20 voices, a 7-meter-long "VIVE DADA" banner. Eggeling spoke of "Abstract Art," Richter "For without and against Dada," Arp and Huelsenbeck read poems, Tzara was prevented from reading his own texts; in the slot reserved for Serner's poems, he contented himself with laying a bouquet of flowers at the feet of a mannequin on stage. Arp made the participants' masks. The dance "Noir cacadou" (5 persons) with Mademoiselle Wulff was the new rhythm of furnaces in a swamp. Madame Suzanne Perrottet played the new music—but Zurich has never experienced such strong emotions, the vitality of the hall leapt beyond the boundaries of family and convention; naked before their conscience, the hope-lessness of having to reject everything they learned at school made spectators rifle through their pockets to throw whatever they found onto the stage, and also that miserable double, their soul.[80]

Tzara's narrative makes it sound as if Serner's manifesto began the soirée, and thus the entire evening passed under the shadow of a restless audience, whereas in reality the first two-thirds of the evening was politely appreciated. If Dada memoirs tend to exaggerate the violence of the public reaction, two Swiss newspapers insisted that "a noisy, screaming, genuine scandal erupted" and that a "*wild row*" overcame the hall.[81]

The aggressive manifestos that so enraged the Zurich public were given further life in *Dada 4–5*, the fruit of the Picabia-Tzara collaboration that past January. The inside title page features a Picabia drawing of an alarm clock, the very object he was in the process of dismantling when the two first met: for this particular cover, Picabia actually took apart an alarm clock, bathed its parts in ink, and imprinted these parts on paper, a visual art equivalent to the process Christian Schad was developing at the time and that Man Ray would make famous several years later.[82] At thirty-six pages, *Dada 4–5* was a substantially larger affair than any of the previous Dada publications. With 2,000 copies printed, each one selling at 4 Swiss francs, the journal continued to have a French and a German version. Attentive readers who managed to get both versions could see that Dada was implicitly traveling along two tracks: a French version that was mainly textual, full of ironic wordplay;

120

and a German one that tended to be performance-based, more direct, since its manifestos and poems had first been delivered to an audience. In both versions the back cover detailed Dada's growing international reach, with bookshops and galleries in Barcelona, Brussels, Copenhagen, New York, Paris, and Stockholm listed as official Dada depots. Because paper was rationed, *Dada 4–5* was cobbled together from diverse stocks that Arp, Janco, and Tzara had accumulated, resulting in the unusual situation that different-colored paper, ranging from creamy white, dark pink, blue-gray to orange, was used for every single copy.

The visual component in *Dada 4–5* was more expansive and ambitious than in any of the previous numbers, featuring illustrations by Arp, Eggeling, Augusto Giacometti, Raoul Hausmann, Janco, Kandinsky, Klee, Picabia, Richter, and Van Rees. Arp's cover for the deluxe edition was a collage, featuring an abstract organic woodcut, the word "Dada" stenciled in black, and the classifieds section of *La Tribune de Genève*. The rest of the review continued this strategy of interspersing texts and images. Albert-Birot's poem is shaped into triangle standing on its tip, and Hausmann's woodcut on the same page is also triangular. Another page features poetry and advertisements, with no visual clues to help the reader distinguish between the different content types—and the injunction "Read the Manifeste Dada 1918," printed in red, is ostensibly advertising, but its central location on the page makes it stand out as a kind of Dada maxim. Tzara's poem "Bilan" on the next page continues this typographic experimentation with alternating fonts and print sizes in the final stanza. The reader's ability to scan the poem is slowed down, especially since two lines are printed in minuscule type, but the poem takes on the character of an advertisement as certain words—"gratuitement," "vivisection"—are brought into relief.

This was, as the root term for "anthology" suggests, a collection of flowers, the living, vital flowers of Dada activity scattered across Europe. Not a single Italian artist or writer contributed to the issue, showing that Tzara intended to mark a clear separation with Futurism. The emphasis on international collaboration in Dada was nowhere more clearly shown than in a bilingual, collaborative review of Huelsenbeck's *Verwandlungen* signed "H. A. W. S. T.T." [Arp, Serner, Tzara]: written in an automatic style, the review showed how artists could break down the barriers of language and nationality.[83] For the first time, Aragon, Breton, and Soupault were featured, and work by the most famous young artist in France, Raymond Radiguet, was printed, as was that of his mentor, Jean Cocteau. Georges Ribemont-Dessaignes, a painter friend of Picabia's who would become one of Tzara's closest collaborators in Paris Dada, was also introduced. Conscious of the growing importance of Berlin Dada, Tzara printed contributions from Hardekopf, Hausmann, and Huelsenbeck, while there were also important German-language contributions by Arp, Richter, and Serner. Manifestos once again were prominently featured, with "Dada" increasingly a focal point of investigation, as evidenced in Richter's contribution: "Our companionship ... lies beyond any group, movement or Dada magazine. ... Those men *da*, got going da ... Dada. ... That is our curse, to conjure the UNPREDICTABLE."[84]

DADA ne signifie **RIEN**

☞ Si l'on trouve futile et l'on ne perd

son temps pour un mot qui ne

signifie rien….

TRISTAN TZARA.

FIGURE 6.5
A Dada sticker to be placed on Paris's pissoirs.
Courtesy of the University of Iowa Special Collections.

The unpredictable was exactly what Tzara was looking for as the summer of 1919 began. The regimented life of Swiss society had taken its toll, as "Chronique Zurich" in *Dada 4–5* noted: "shit born for the first time Zurich in cheese."[85] To alleviate some of this boredom, Arp and Tzara sent a false declaration to the press in July, announcing that they had settled a matter of honor with pistols, and that this duel had seconds in the persons of Serner, J. C. Heer, Kokoschka, and Picabia, who traveled from Paris to Zurich for the event: "When the fourth shot grazed Arp's left thigh," the *St. Galler Tagblatt* reported, "the two opponents, not reconciled, left the battleground."[86] Heer, a popular Zurich writer, insisted that he had not been present at this duel and publicly declared that he had "no relations" with the Dadaists.[87] This hoax, dutifully reported in a number of newspapers, even one in Prague, confirmed to the Dadaists how easily the media could be manipulated.

That Arp and Tzara were not at loggerheads was not only pedantically confirmed in the press (a letter to the editor by a member of the public who saw the two together in a café) but was also apparent when both were on stage together at the Ninth Dada Soirée, an invitation-only event of manifestos and lectures. A Viennese reviewer stated that the evening revealed the "great difference" between Berlin Dada and its Zurich progenitor: in Germany Dada had become political and revolutionary, whereas in Zurich they were still playing games.[88] For the reviewer, Tzara's "Cosmic Concert," in which twenty mannequins draped in black silk robes were coaxed by a conductor's baton to make a noise, was "not amusing."[89] Yet the audience found this stunt, and the poems and automatic writing on the program, extremely comic.

But such laughter had its limits. The decision to throw an invitation-only soirée was a way to avoid the anxiety and great stress that the Kaufleuten soirée had caused, and by September Tzara was desperately in need of rest. His nervous condition, for which he was undergoing treatment by a certain Dr. Strasser, had flared up, and his severe migraines incapacitated him for days at a time. But rather than spending time recovering, on the evening of 29 September he was arrested. Considered by the Swiss police a mysterious "Russian national," Tzara was being watched because of his ties with Serner, whose mail was regularly intercepted and opened. After a night in police custody, Tzara gave an affidavit the next morning in which he declared: "I am not active in Bolshevist propaganda, and I admit to being an opponent of Bolshevism."[90] Signing it "Samuel Rosenstock," Tzara recounted the train of events leading to his arrest: at around noon, a certain Logeais came to Tzara's room at Hotel Seehof to ask for Serner's address, which Tzara dutifully gave, and in the course of the conversation, in which Logeais indicated that he had just been in Germany, Logeais invited Tzara to visit him later at the Hotel Beatenhof, which was just near the train station. Leaving his hotel room at 5:30 p.m., Tzara went to the Bahnhofstrasse to buy a ticket for a performance that evening at the Pfauen Theater. Recalling Logeais's invitation, he then went to the nearby Hotel Beatenhof, only to be told that Logeais was at the Café Splendid, an American bar on the other side of Limmat. This was convenient for Tzara, since the

Pfauen was in that direction, so he went to the Splendid because he wanted to ask about social conditions in Germany. By this point, he had traversed the city center on foot, showing just how compact Zurich was. Tzara sat down with Logeais and his female companion at the Splendid, but before he had time to order a drink the police arrested them all.[91] When Tzara appeared before a federal judge his version of events was accepted, and he was freed from police custody.

This brush with the law, while unsettling, did not prevent Tzara from engaging in a public hoax several weeks later. In mid-October, a Dada "happening" took place on Bahnhofstrasse: a three-meter-high statue made of cardboard, wooden planks, and colored paper was inscribed with Dada maxims. As a crowd gathered, a person hidden inside the sculpture yelled out that this Dadaist sculpture had been erected in honor of Marinetti's imminent arrival in Zurich to publicly convert to Dada. The police intervened, but the assembled crowd, as *La Tribune de Genève* reported, "discussed on the streets for a long time this strange incident and the flashy advertising of the Dadaists."[92] That Tzara's mind had turned to advertising in this period was also confirmed by the printing, at the end of the year, of thousands of little greeting cards inscribed "Dada: Société Anonyme pour l'exploitation du vocabulaire [Dada: Public Limited Company for the Exploitation of Words]." Plastered throughout Zurich, and sent by Tzara to correspondents throughout Europe, each card had Dada maxims printed on the back. This was yet another public joke, foreshadowing how Tzara wanted Dada to move away from organized events and toward more spontaneous action, fully engaged with the public, but in Zurich this was becoming increasingly difficult. The conservative Swiss public would never be won over to Dada, and the police were vigilant in protecting public morals. If Tzara was busy in December organizing a Zurich exhibition at the Kunsthaus of works by Alexander Archipenko, the calls of Paris kept resounding, and in early January 1920 he set off to answer them.

124

7 "EVERYONE IS DADA": **1920**

ALTHOUGH HE WAS IMPLORED THROUGHOUT 1919 TO COME TO PARIS "*AS SOON AS POSSIBLE*," TZARA WAVERED, HESITATED, PLEADED ILLNESS, BLAMED THE WEATHER, AND FEARED RISING PRICES; AND ALL THIS, FOR THE GOOD PART OF A YEAR, EXASPERATED HIS PARIS CORRESPONDENTS.[1] The fact that Marcel Janco had made it to Paris in late 1919, and met with Breton and Picabia, only raised further doubts. When that horrible decade finally finished, Tzara had still not arrived; with the Seine rising four feet and threatening to flood Paris, there was a growing feeling among the likes of Aragon and Breton that he never would. Tzara's hesitation to leave Zurich was understandable. Because the missives he sent were branded "Mouvement DADA Zurich," his name was closely linked to that multicultural, polyglot city. But Zurich had changed. Among the original members of the Cabaret Voltaire, only Arp remained; Huelsenbeck was in Berlin, Ball and Hennings were purging themselves in devout Catholicism in an Alpine village, and in December 1919 Janco left as well. In a word, Zurich had become boring, and Tzara, while not averse to the charms of ennui, knew how dangerous it was to stay in such a state for too long. Then, when no one expected him anymore, he set off. This move to Paris was not intended to be permanent. He was going because he wished to see Picabia again, and because he had epistolary friends he wished to meet. Tzara also knew that to truly internationalize Dada, Paris had to be conquered; its judgment was, as it had ever been, final.

The Treaty of Versailles finally signed, his papers packed, Tzara set out on a sleeper train whose all-stop whistle blew at the Gare de Lyon on Saturday 17 January 1920. Although Breton had stalked the *quais* on five separate occasions in early January to greet the Dada comet's arrival, there was no sight of his imposing countenance when Tzara arrived—as it was an election day, perhaps he was voting.[2] With no one there to meet him, Tristan went to the address in the 16th *arrondissement* that Picabia had given him: 14 rue (now boulevard) Émile Augier. Picabia had promised Tzara both a place to stay and material support, without which the trip could not have been made, as Tzara's income was nonexistent, and

127

128

FIGURE 7.1
Paris a few days before Tzara's arrival,
early January 1920.
Bibliothèque Nationale de France.

the little money he received from his grandfather could hardly cover the cost of the voyage. But in his generosity Picabia had forgotten to tell the current inhabitant of the apartment where Tzara would be staying. This oversight was disturbing, to say the least, because it was the apartment of his mistress Germaine Everling, who two weeks earlier had given birth to their son, Lorenzo. This was typical Picabia: the night she went into labor, he and Breton were so engaged in discussion that when she began to cry out after her water broke, Picabia kept yelling: "Leave us alone!" (As soon as Breton realized what was happening, the medical student grabbed his coat and left in a huff.)

With the maid unable to understand his "poor French," Tzara refused to leave until Everling came to the door: "He was a small man, slightly hunchbacked, with two short arms swinging, at the ends of which hung chubby but doubtless sensitive hands. His skin was waxy like a candle: his myopic eyes seemed to be looking beyond the pince-nez for a fixed point to focus on."[3] She tried to make him leave, but he told her, in a "strong Slavic accent," that he had come to live there.[4] Emptying his pockets to indicate that he had no money, he insisted that "Picabia told me to come straight here"; asked when that was, he responded: "In Zurich, a year ago."[5] She eventually relented, and the new arrival proceeded to unpack: almost no clothes, "few toiletries, but, on the other hand, numberless papers: correspondence, advertisements and color posters, tracts, reviews, subversively titled manifestos and assorted manuscripts."[6] A series of frantic telephone calls confirmed his identity. Mother and nanny looked on in horror when he went to rock the baby: "Dada, mon petit, dis Dada [Dada, little one, say Dada]."[7]

Picabia, who had gone out for a spin in his newly acquired Mercer, eventually showed up, and that first night a delegation comprising Aragon, Breton, Éluard, and Soupault came to meet their "Messiah." Aragon considered Tzara a new Rimbaud, a "wild adolescent" who would battle reactionary forces.[8] "I am waiting for you, I wait for nothing but you," Breton had written.[9] Given these grand expectations, disappointment was inevitable, and for no one was it more stinging than for Breton, who never spoke of that first meeting.[10] Tzara did not look the revolutionary. His halting French and loud laugh were disconcerting. Later accounts emphasize Tzara's foreignness, with Aragon describing him as a myopic "little Japanese."[11] He rolled his *r*'s and elongated his vowels; when his accented speech quickened it was almost unintelligible, or so the Frenchmen claimed. They were mystified that he could not pronounce "Dada" correctly, and so taught him "to say Dada as it is done here"![12] With both sides sizing each other up, Tzara went on the offensive, laying down plans and plotting out strategies for Dada.

The four-room apartment soon became a Dada war bunker. Tristan slept on the couch, put his typewriter on a Louis XIV console, and used the grand piano for his papers. Within a few days, "an avalanche of letters coming from many countries" started to arrive, which triggered an anonymous denunciation and a police investigation: "Mr. Aa waits for the post the civil applause of the perpetual criminal attack," Tzara later joked.[13] It did not much

MERCER 85 HP

Les 2 exhibitionnistes intoxiqués
par l'abus de l'automobile

(Le Populaire. — 17 mai 1920)

Messieurs les révolutionnaires vous avez les idées
aussi étroites que celles d'un petit bourgeois de
Besançon. Francis PICABIA.

FIGURE 7.2
Picabia and Tzara in the beloved Mercer.
Cannibale, no. 2.
Courtesy of the University of Iowa
Special Collections.

matter to him that, since he rarely woke before noon, lunched at four in the afternoon, and wrote through the night, the workings of the house were disturbed; he had arrived, and this would be, for the next year, home.[14] After four years of boarding houses filled with students, war deserters, and artists, the bourgeois apartment might have been a slice of heaven, but Tzara did not seem to care. Although it was his first time in Paris, he was not overly curious or—a stinging word on Parisian lips—"provincial."[15] He saw the city as a worksite: like a demolition expert, he would assess the lie of the land to see what needed destroying.

If 1920 became "Dada's Golden Age," things looked grim when Tzara arrived in Paris.[16] With an inflation rate near 30 percent, the cost of living was four times the prewar level.[17] Coal stocks were so low that railway station clocks stopped, elevators were out of order, and public lighting was curtailed.[18] During the final stages of the war Paris had been bombarded, every third day, by Big Bertha shells; these had destroyed not only buildings and lives but also cultural vitality. Modern art was supposed to mimic the effects of bombardment, but for a city whose experience of war was not academic, this was not easy. The public longed for old classics whose comfort and familiarity could restore the *status quo ante bellum*.

On the day of Tzara's arrival, Sarah Bernhardt was preparing to take the stage in Racine's *Athalie*, the "prince of poets" Paul Fort was awarded the Légion d'Honneur, and theater-goers could choose between a "three-act heroic comedy," a "three-act Egyptian operetta," a "three-act ultra-light operetta," and a "three-act libertine operetta."[19] There was a growing temperance movement and a widespread desire to restore public morals. The Catholic Church outlawed the faithful from dancing the tango and foxtrot and warned women off *décolleté* necklines. French little reviews, bent upon propagating a "French renaissance," were generally antagonistic to foreigners. If Apollinaire had been the "pope of modernism," his wartime service had whetted an appetite for military honors. Picasso was going through a neoclassical stage, and his social life with Olga was transformed into what Max Jacob called *l'époque des duchesses*.[20]

Dada had only a limited public presence in France. Even Breton admitted to having "rather vague" notions of Dada before Tzara's arrival.[21] Importing Dada reviews during the war had been difficult, and fifty copies of *Dada 4–5* were refused entry into France in the summer of 1919. Adrienne Monnier, the proprietor of La Maison des Amis des Livres who steered through the French publication of *Ulysses*, was "horrified" by Dada and refused to stock its publications (she later admitted to an error of judgment on that score).[22] It is true that *Littérature* had reviewed *Vingt-cinq poèmes* and the *Manifeste Dada 1918* in its inaugural issue of March 1919 and that it strongly supported Dada in its early numbers (in November 1919 Breton even proposed to merge the review with *Dada*, Tzara serving as editor in chief).[23] But "in both its look and its reception" *Littérature* "suggested a fledgling *Nouvelle Revue Française* or *Mercure de France* much more than it did *Dada* or *391*."[24] Picabia's *Pensées sans langage* went largely unnoticed, because its author was better known

for his shocking paintings and flamboyant lifestyle. When Cocteau had excitedly written in April 1919 that Tzara would soon be in Paris, the press had not been enthusiastic. The *Nouvelle Revue Française*, warning that Paris would not give in to "this type of bullshit" from Berlin, speculated that Dada was an elaborate ploy to sap the creative energy of French youth.[25] Its editor later stated that while Aragon and Breton had talent, the two foreigners leading Dada (Tzara and Picabia) were quacks. There was, in other words, a lot of work for Tzara to do if Dada were to triumph in the four-million-strong City of Light.

The first order of business was planning Tzara's introduction to the French public. Although he accompanied Aragon and Breton to the Café Certà—a Basque bar in the Passage de l'Opéra later immortalized in Aragon's *Paysans de Paris* and soon a stopping point on guided tours of Paris as the meeting place of the Dadas—Tzara did not speak a word, remaining anonymous because the other painters and young poets in attendance did not know him by sight. The nascent Paris Dada group decided that Tzara's public unveiling would take place on 23 January, at the Premier Vendredi de *Littérature*. This was the first (and last) of a planned series of modern art events featuring lectures, music, poetry readings, and paintings. Because the program had already been printed, the organizers met at Picabia's apartment to consider how Tzara could be incorporated into the show. Although Tzara was hesitant because of his "foreign" (which in postwar Paris meant German) accent, there was no question of him not taking part.

The event began at 4:30 p.m. at the Palais des Fêtes, 199 rue Saint-Martin. Even if this central location was "far from the stinking milieus of art and literature" that congregated in Montparnasse and Montmartre, a sizeable number of poets and painters came.[26] Because the Palais had a party room with a small stage, a café, and two cinemas, throughout the show the cinema orchestras could be heard through the walls. The entry price of 2 francs was collected at the door by René Hilsum, the director of Au Sans Pareil, the bookshop-cum-publisher which brought out Breton and Soupault's *Magnetic Fields* and Picabia's *Pensées sans langage*. The show began with a talk by art critic André Salmon, "De la Crise du change." The title literally translates as the crisis of foreign exchange rates, which resulted in a few local shopkeepers coming to hear about the turbulent currency markets; they were mystified to hear instead a lecture on modern art.[27] After that, poems of *les grands ancêtres* were read, followed by Breton lecturing on the exhibited paintings (de Chirico, Gris, and Léger). It did not help that he was nursing a high fever and had a pronounced case of stage fright, for even at the best of times it was difficult to listen to Breton: the sonorous, rich timbre of his voice had an "affected slowness," and he never deliberately accented his speech.[28] The first half of the program was an earnest and tame affair, with the reviewer from *Comœdia* (who did not stay for the second half) stating that "much should be expected" of these young artists "full of talent" in their search for truth and beauty.[29]

The second half of the program began with Aragon reading Tzara's "Le Géant blanc lépreux du paysage," an absurd collation of images punctured by meaningless sounds. But the poem also had scandalous lines the public had never heard on stage before: "ma queue est froide [my dick is cold]." The poem directly insulted the audience to boot: "he is thin idiotic dirty he does not understand my verses he screams."[30] After finishing the final lines of pure sound to whistles from the audience, Aragon announced the flesh-and-blood presence of the Zurich Dada leader. A "stupefying silence" fell upon the crowd as Tzara took exaggeratedly tiny steps onto the stage. From his pocket he unfolded the most recent parliamentary speech by Léon Daudet, a far-right deputy and coeditor of *L'Action Française*. He proceeded to cut it up with scissors, put the fragments in a hat, and pulled them out to make a poem. *Les Potins de Paris* related the scene that followed:

> He sat at the table with the very annoyed air of a gentleman whose bowels are being painfully troublesome, and he started muttering words—or rather perfectly unintelligible onomatopoeia. …
>
> There were shouts of "enough already." Unmoved, Dadaism's leader continued—and so did the racket.[31]

This foreigner mutilating the words of a staunch French patriot, whose cultural patrimony was incomparable (the son of novelist Alphonse Daudet, he had been married to Victor Hugo's granddaughter), sent the audience into a delirium. There were shouts of "enough, enough," "back to Zurich," "up against the wall." Aragon later said that "[i]t was three minutes of indescribable hullabaloo, and the audience, which had never experienced anything so insolent, were furious. They yelled and threatened."[32] Aragon and Breton rang bells to add to the chaos. Salmon was enraged, and Juan Gris, hardly sympathetic toward Daudet's politics but a foreigner whose residence in France could be revoked, threatened to punch Tzara. (They later became close friends.) Calm was restored when Tzara left the stage, but by the last act the hall was empty. Tzara was pleased: "all that I wanted to convey was simply that my presence on the stage, the sight of my face and my movements, ought to satisfy people's curiosity and that anything I might have said really had no importance."[33] Yet he knew that his actions on stage were not politically innocent. The show had created a public outcry and, most importantly, Dada had fired its opening salvo in Paris. The Dadaists were also delighted to find out that Jacques-Émile Blanche, a well-known art critic with pronounced classical tastes, had suffered a heart attack on his way to the show: as Aragon put it, "Dada has just made its first victim."[34]

Breton admitted that the first show suffered because of the recruits' "inexperience"; the next event, they all vowed, would be better.[35] But there was almost not another next time, because the following evening, when Aragon, Breton, Éluard, and Tzara went to see the Ballets Russes at the Opéra, some valuable jewelry was stolen from their box. The police set

their sights on Tzara. Paris Dada would have come to a quick end had their suspicions gone further. Luckily, a close friend of Éluard's, who worked as a secretary to a police official, made the case for Tzara's innocence, and the matter was dropped. Having had brushes with the law in Switzerland, Tzara did not let the incident interfere with his plans, but the event underlined just how precarious his position was, and how necessary it was to have friends. He enrolled as a student of chemistry—not out of any academic ambition (although the choice of chemistry is revealing) but, rather, to ensure that he had the necessary residence paperwork and suitable cover to explain what he was doing in Paris. He also joined an association of Romanian students in France; it was probably here that he befriended a young Romanian girl who lived in Fontainebleau and with whom he had a brief but passionate affair—which ended, as many of his relationships tended to do, rather violently, with her accusing Tzara of refusing to answer her letters or calls.[36]

Within three weeks of arriving, Tzara edited and put out over 5,000 copies of *Bulletin Dada* (*Dada 6*). The ambition of this number compared to Dada's humble origins astounded Ezra Pound:

> DADA No. 1. *Quelques jeunes hommes intelligents* in Zurich desire correspondence with other unfortunates similarly situated in other godforsaken corners of the earth.

> DADA: Bulletin 5 feb. *Ils ont échappé* [They have escaped]. They have got to Paris. *La bombe!!*[37]

A four-page review priced at 2 francs, *Bulletin Dada* is one of the most distinguished examples of Dada typography, with *L'Action Française* demanding to know how such "careful graphic" art was possible given the paper crisis![38] The cover superimposes three layers of text in different fonts and sizes. A machinist drawing by Picabia on the second page appears to depict a woman's bottom implanted with a "sexual apparatus" (a breast-shaped object with a plumb line for a nipple) and two coiled wires and a plug for an electric socket. Underneath her bottom (*fesse*) is a rectilinear triangle with the words "oviduct" and "chopped male" (*mâle haché*). Above the sexual apparatus's coiled wire is the word "sperm." The text to the right of the drawing is equally mystifying: "You do not understand, isn't it so, what we are doing. Oh well, dear friends, we understand even less."[39] The final two pages are devoted to a mixture of invented news, aphorisms, and advertisements for reviews like *391*, *Proverbe*, and *Littérature*. The list of seventy-six Dada presidents—featuring Tzara's close collaborators in Germany, Italy, New York, and Paris—did not claim to be exhaustive: "Everyone is a director of the Dada movement." Adding to the Dada presence in Paris was the February issue of *Littérature* with poetry by Tzara, Picabia, and Ribemont-Dessaignes, and the famous questionnaire, "Why do you write?"

The *Bulletin Dada* not only exposed Dada ideas to readers but was turned into a concrete advertisement for Dada when it served as a handbill for the program for the next Dada event, the Second Dada Matinée. Held at 4:30 p.m. on Thursday 5 February at the Grand

135

136

FIGURE 7.3
Advertisement for the Second
Dada Matinée. *Bulletin Dada*.
Courtesy of the University of Iowa
Special Collections.

1920

BULLETIN
DADA

SALON DES INDÉPENDANTS

GRAND PALAIS DES CHAMPS-ÉLYSÉES

(Avenue d'Antin)

Jeudi le 5 Février à 4 h. 1/2

Matinée

MOUVEMENT DADA

N° 6

Prix : 2 fr

écrire
à
tristan
tzara
32,
Avenue
Charles
Floquet
Paris
(VII°)

FRANCIS PICABIA

manifeste lu par 10 personnes

GEORGES RIBEMONT-DESSAIGNES

manifeste lu par 9 personnes

ANDRÉ BRETON

manifeste lu par 8 personnes

PAUL DERMÉE

manifeste lu par 7 personnes

PAUL ELUARD

manifeste lu par 6 personnes

LOUIS ARAGON

manifeste lu par 5 personnes

TRISTAN TZARA

manifeste lu par 4 personnes et un journaliste

Toutes les femmes sont déco-
rées de la Légion d'honneur
Les hommes portent cet
insigne à leur boutonnière.
Francis Picabia le loustic.

PROGRAMME de la
MATINÉE DU
Mouvement Dada le 5 février 1920

Palais des Champs-Élysées (the site of the Salon des Indépendants), the program consisted of manifesto after manifesto: one by Picabia read by ten speakers, another by Georges Ribemont-Dessaignes by nine, Breton's by eight, and so on, down to Tzara's, read by "four persons and a journalist."[40] Tzara was not exaggerating when he announced that the media would actively propagate Dada, for that was exactly what happened in the run-up after he drafted a press release announcing that Charlie Chaplin would publicly join Dada at the show. Despite the wildness of this claim, newspapers printed the story almost verbatim. The *Journal du Peuple* of 2 February reads: "Charlie Chaplin, the famous *Charlot*, has just arrived in Paris. We shall have a chance to applaud him; his friends, 'the poets of the Dada movement,' invite us to a matinée that they are organizing. ... The famous American actor will be speaking."[41] At the show itself, one reporter, convinced that Chaplin was being hidden for a surprise entrance, followed Tzara everywhere.

If the Chaplin announcement brought a "considerable crowd" to the Grand Palais, the realization that they had been duped led to some anger.[42] The crowd's fury became an integral part of the show as the Dadaists responded by more clearly pronounced insults. The audience could neither believe nor understand what exactly was happening on stage. The poster for the event was not mistaken when it said that the event would be "avant-garde, free, public, and contradictory."[43] Words mixed with music, sounds without meaning, decorations without sense, interruptions for no reason, a poem made by industrial scissors; it was madness, and the audience could not get enough of it. The manifestos were published in the May 1920 issue of *Littérature*, but at the time the only goal was to insult the audience, as Ribemont-Dessaignes recalls: "The essential thing was to obtain their hostility, at the risk of ourselves being taken for sinister imbeciles."[44] Breton concurred: "scandal, which to Apollinaire was only a means, became for us a goal."[45] The performance ended with a certain Buisson, a palm reader and newspaper vendor, asking women to come on stage to have their future read from the lines on their feet.[46] In true Dada spirit, he insulted the Dadaists for insulting the audience, which earned him a standing ovation. It was another success, and the Dadaists were pleased to hear that the Théâtre-Français de Bordeaux went up in flames as they were performing. Such chance events—like Blanche's heart attack on his way to the First Dada Matinée—added to Dada mythology (and Surrealism later made the connections between random events a key area of investigation).

The Second Matinée had more immediate effects when a spectator, Léo Poldès, approached Breton after the show. The chairman of a popular neighborhood association in the suburb of Puteaux, the Club du Faubourg, he offered the Dadaists free use of his local hall, the catch being that the space would be available in two days' time. This opportunity to come into contact with the working class could not be turned down, even if there was no time to prepare a new show. When Aragon, Breton, Ribemont-Dessaignes, and Tzara arrived (Picabia failed to show up) in the former chapel that housed the Club du Faubourg, over 1,000 people were there. But the audience was "a conglomerate of leftist intellectuals,

trade union leaders, and politicians," not working men who had taken a day off.[47] The Dadaists were also surprised to find that they were merely one act on a full billing, which included a discussion of Pierre Benoit's *L'Atlantide* (an exotic novel awarded the Grand Prix du Roman by the French Academy in 1919), a speech by the future Ho Chi Minh, and a lecture by a toga-wearing Raymond Duncan on Platonic theory.[48] Bored by these proceedings, at some point they began to distribute *Bulletin Dada*, which led to the crowd calling out "Dada, Dada, Dada." Aragon got up to castigate the audience for having sat through a morass of liberal humanitarianism. The audience reacted with howls and whistles, at which point Breton started declaiming Tzara's *Manifeste Dada 1918*. Duncan defended the Dadaists to the angry crowd, claiming that they were simply a new school of literature that had a right to exist; other speakers "took sides and spoke for or against us."[49] The meeting was soon called to a close, with no one leaving satisfied.

But Dada was now in demand. The next performance was scheduled for 19 February: "The Dada movement's 291 male and female presidents hold Messrs. Breton, Aragon, Dermée, Éluard, Picabia, Ribemont-Dessaignes, Soupault, and Tzara responsible for answering the following questions: Dada's locomotion, life, skating; Dada pastry, architecture, morals; Dada chemistry, tattooing, finances and typewriters: this Thursday at 8:30 at the Université populaire du faubourg Saint-Antoine."[50] Once again the Dadaists would perform at a neighborhood association which existed to "enlighten" and "politicize" the working class; once again there were few laborers present; and once again the Dada performance consisted of reading out manifestos to a perplexed audience. The "Manifesto Tristan Tzara" underlined Tzara's self-consciously mocking presentation of himself as the emblem of Dada:

> Take a good look at me!
> I am an idiot, I am a clown, I am a faker.
> Take a good look at me!
> I am ugly, my face has no expression, I am little.
> I am like all of you![51]

As funny as this might have been, Dada had by this point exhausted its repertoire. Daily meetings at Certà or at Everling's apartment revolved around new ways of shocking the public. A game began, consisting of writing letters about Dada to the press under false names. Besieged by these letters, *Comœdia* announced that it would not publish letters on Dada because their authenticity could not be guaranteed. Although it was juvenile in a way, this activity encouraged the new members to move beyond programmatic notions of art, although it created its own friction, as when Aragon was accused of signing Éluard's name to a particularly scurrilous letter, which incensed both Picabia and Tzara and forced Aragon to write a letter of effusive apology.[52] Dada is not modern, Tzara never ceased to repeat; by this he meant that modernist works were fast becoming academic and stale. This reverence toward art as the only viable element of culture was the viewpoint Tzara desperately wanted to dislodge.

MANIFESTE CANNIBALE DADA

Vous êtes tous accusés ; levez-vous. L'orateur ne peut vous parler que si vous êtes debout.

Debout comme pour la Marseillaise,

debout comme pour l'hymne russe,

debout comme pour le God save the king,

debout comme devant le drapeau.

Enfin debout devant DADA qui représente la vie et qui vous accuse de tout aimer par snobisme. du moment que cela coûte cher.

Vous vous êtes tous rassis ? Tant mieux, comme cela vous allez m'écouter avec plus d'attention.

Que faites vous ici, parqués comme des huitres sérieuses — car vous êtes sérieux n'est-ce pas ?

Sérieux, sérieux, sérieux jusqu'à la mort.

La mort est une chose sérieuse, hein ?

On meurt en héros, ou en idiot ce qui est la même chose. Le seul mot qui ne soit pas éphémère c'est le mot mort. Vous aimez la mort pour les autres.

A mort, à mort, à mort.

Il n'y a que l'argent qui ne meurt pas, il part seulement en voyage.

C'est le Dieu, celui que l'on respecte, le personnage sérieux — argent respect des familles. Honneur, honneur à l'argent ; l'homme qui a de l'argent est un homme honorable.

L'honneur s'achète et se vend comme le cul. Le cul, le cul représente la vie comme les pommes frites, et vous tous qui êtes sérieux, vons sentirez plus mauvais que la merde de vache.

DADA lui ne sent rien, il n'est rien, rien, rien.

Il est comme vos espoirs : rien.

comme vos paradis : rien

comme vos idoles : rien

comme vos hommes politiques : rien

comme vos héros : rien

comme vos artistes : rien

comme vos religions : rien

Sifflez, criez, cassez-moi la gueule et puis, et puis ? Je vous dirai encore que vous êtes tous des poires. Dans trois mois nous vous vendrons, mes amis et moi, nos tableaux pour quelques francs.

<div align="right">

Francis PICABIA.

</div>

140

UN MOT DUR - N° 58

Les petites rues sont
des couteaux.

> « Le bureau de poste est en face.
>
> — Que voulez-vous que ça me fasse ?
>
> — Pardon je vous voyais une lettre à la main. Je croyais...
>
> — Il ne s'agit pas de croire, mais de savoir.

Le plancher des
poissons.

Tous les poètes
savent dessiner.

S'asseoir à l'aube,
coucher ailleurs.

<div align="right">

Paul ELUARD.

</div>

TRISTAN TZARA

PIÈCE FAUSSE

Du vase en cristal de Bohème
Du vase en cris
Du vase en cris
Du vase en
En cristal
Du vase en cristal de Bohème
Bohème
Bohème
En cristal de Bohème
Bohème
Bohème
Bohème
Hème hème oui Bohème
Du vase en cristal de Bo Bo
Du vase en cristal de Bohème
Aux bulles qu'enfant tu soufflais
Tu soufflais
Tu soufflais
Flais
Flais
Tu soufflais
Qu'enfant tu soufflais
Du vase en cristal de Bohème
Aux bulles qu'enfant tu soufflais
Tu soufflais
Tu soufflais
Oui qu'enfant tu soufflais
C'est là, c'est là tout le poème
Aube éphé
Aube éphé
Aube éphémère des reflets
Aube éphé
Aube éphé
Aube éphémère de reflets

<div align="right">

ANDRÉ BRETON.

</div>

Nous avons fait le sacrifice de l'œil droit à DADA. Et l'insigne DADA se porte sur l'œil gauche. Entendu.

Dada s'est assuré la collaboration régulière des plus notoires traducteurs et plagiaires de la langue française.

PROVERBE n'existe que pour justifier les mot.
DADA dito que d to l'Emprunt.

Paul Eluard à Tristan Tzara :

« Les femmes grosses ne sont pas seulement cellet que vous imaginez fragiles, t ut objet fragile ess automatique et maigre Maigre et gros se prononce bien, une femme malheureuse pour finir une seule femme sans suite une femme heureuse »

PAUL DERMÉE

By mid-February, four Paris Dada events had been held, and the scandal of Dada had reached the art world. After Picabia's proposal to the Section d'Or (an association of Cubist painters founded in 1912 and revived after the war by Albert Gleizes) to accept Arp and Janco as members was refused, Picabia responded by sending a painting to the Salon des Indépendants entitled *M... pour celui qui le regarde* [S... for whoever looks]. In the meantime, Paul Éluard had reserved one of the planned literary soirées at the upcoming Section d'Or exhibition (the event was advertised in *Bulletin Dada* as "Dada anti-literature—Dada anti-music—Dada anti-painting").[53] With rumblings of discontent growing louder—Tzara noted that "some absolutely disgusting things" were taking place to discredit Dada— Gleizes called a general meeting on 25 February at the Closerie des Lilas, a leafy café in Montparnasse.[54] With Tzara leading the Dada delegation, tempers soon flared, and the café manager was forced to turn off the lights to prevent an outbreak of violence. When the final vote came in, Dada was officially banned from the Section d'Or—an expulsion that back-fired, since it "gave great force of cohesion" to Dada's desire to overthrow the existing insti-tutions of Paris's arts scene.[55]

In March 1920 this attack was waged on several fronts, but the most familiar was in print, in the form of *Dadaphone* (*Dada 7*). A thousand copies of the eight-page review, which cost 1.50 francs, were printed. *Dadaphone*'s cover was a Picabia drawing of a spiral coil surrounded by sexually suggestive phrases and an ironic title, "Dame!" *Dadaphone* also interspersed its text with portraits of eight leading Paris Dadaists: if Tzara looked singularly stiff in his mug shot, Paul Dermée held up a tennis ball to cover his face, and Picabia came across as a movie star on the Mediterranean. The only female Paris Dadaist honored with a portrait was Céline Arnauld (born in Romania as Carolina Goldstein), a poet and editor, and Dermée's wife.[56] Presenting the Dadas as celebrities, the polemical texts alongside the photos nonetheless exposed as hollow the reader's most cherished beliefs: "What is beauty? What is ugliness? What is big, strong, weak? What is Carpentier, Renan, Foch? Don't know. What is me? Don't know. Don't know, don't know, don't know."[57] This interrogative impasse by Ribemont-Dessaignes was followed by Picabia's "Manifeste Cannibale Dada," one of the most violent texts of the period, with its attack on patriotism and the war dead: "You die as a hero, or as an idiot, which is the same thing. ... You like death for others. ... Honor is bought and sold like ass [*le cul*]. Sex, sex represents life just like French fries, and all of you serious people will end up smelling worse than cow shit."[58] And then Picabia launched into a famous rant:

141

FIGURE 7.4
Celebrity Dada alongside Picabia's critique of that very process in "Manifeste Cannibale Dada."
Dadaphone, March 1920.
Courtesy of the University of Iowa Special Collections.

MAISON de L'ŒUVRE

(Salle Berlioz)

55, rue de Clichy

Métro : Clichy — Nord-Sud : Trinité

—✧—

Le Samedi 27 Mars, à 8 h. 15 précises

MANIFESTATION DADA

Prix des Places

Fauteuil d'orchestre { Les deux premiers rangs. 20 fr. / Autres rangs 10 fr.

Balcon { Les 6 premiers rangs de face. . . 5 fr. / Autres rangs 3 fr.

Tous les droits compris

Pour la location s'adresser :

A la Maison de l'Œuvre, Tél. : Gut. 67-31.
Au Sans Pareil, 37, avenue Kléber.
Maison des Amis des Livres, 7, rue de l'Odéon.

1

programme :

1. présentation des dadas

par Mac ROBBER

2. le ventriloque désaccordé

parade en un acte de Paul DERMÉE

Personnages : le ventriloque . . .
le marin le ventriloque Sapin, 3ᵉ creux
le soudier
une jeune fille . . . un homme

3. pas de la chicorée frisée

G. RIBEMONT-DESSAIGNES

Interprété au piano par Mlle Marguerite Buffet

4. dadaphone

par Tristan TZARA

1. manifeste
 Lu par André

2. tours de

3. dernières

4. manifeste

5. le serin

1. s'il vous

Personnages : L'Étoile . . .
Une dactylo
Lefebvre . . .
Un Monsieur

2. exemples

3. manifeste

4. tableau

5. la prem
 M. Anti

M. Bleubleu
M. Criri
La femme enceinte
Pipi

6 et un ma

II

nibale dans l'obscurité

:compagné au piano par M^lle Marguerite Buffet

Texte et Musique de Francis PICABIA

stidigitation

par Louis ARAGON

éations Dada

par MUSIDORA

par Philippe SOUPAULT

et

ièce en un acte de G. RIBEMONT-DESSAIGNES

Riquet............	André Breton
Barate	M^lle Louise Barclay
Ocie	Ph. Soupault

III

cis

it

MEDECIN

Comédie de André BRETON et Philippe SOUPAULT

Une Dame.........	Philippe Soupault
Deux quêteuses	M. et M^me P. Eluard
Un jeune homme	Henry Cliquennois
Un inspecteur de police	G. Ribemont-Dessaignes

par Paul ELUARD

l'huile

par Georges RIBEMONT-DESSAIGNES

par Francis PICABIA

Aventure céleste de

Dessins de Francis PICABIA

e

Double quatralogue de Tristan TZARA

M. Antipyrine.......	André Breton	
M. Boumboum, directeur	G. R. D.	
Arnauld	Npala Garoo	Th. Fraenkel
Tr. Tzara...........	Tr. Tzara	

té par M^lle Hania ROUTCHINE

DADA société anonyme pour l'exploitation des idées

VIENT DE PARAITRE : 391 N° 12. PRIX : 2 FRANCS
VIENT DE PARAITRE : PROVERBE N^os 2, 3, 4. PRIX : 0 FR. 50

VIENT DE PARAITRE : avec les photographies des Présidents du mouvement Dada

DADAPHONE N° 7. PRIX : 1 FR. 50

Administration : AU SANS PAREIL

57, Avenue Kléber

143

FIGURE 7.5

Advertisement for the Maison de l'Œuvre show, 29 March 1920. *Dadaphone*, March 1920.

Courtesy of the University of Iowa Special Collections.

DADA itself does not feel anything, it is nothing, nothing, nothing.
It is like your hopes: nothing.
Like your paradise: nothing.
Like your idols: nothing.
Like your politicians: nothing.
Like your heroes: nothing.
Like your artists: nothing.
Like your religions: nothing.
Keep on booing, keep on screaming, beat me up, and then what?
 What? I will still tell you that you are all suckers. In three months'
 time my friends and I will sell our paintings to you for a
 tidy sum.[59]

Picabia expresses discomfort with the growing popularity of Dada: the capitalist system and the processes of mass celebrity would invariably incorporate, and thus neutralize, it. In late February actors from the Comédie-Française and the Vieux Colombier had recited Dada poetry in a show called "From Symbolism to Dadaism." The Dadaists could not deny that they were, as critics emphasized, "the products of the wealthy grande bourgeoisie."[60] Conscious of these contradictions, Tzara attempted to complicate them further:

Dada is a virgin microbe
Dada is against the high cost of living
Dada
Public limited company
For the exploitation of words
…
Dada is against the future, Dada is dead, Dada is idiotic
Long live Dada, Dada is not a literary school howl.[61]

Echoing the *Manifeste Dada 1918*, Tzara emphasizes the continually variable nature of Dada and its inability to be pinned down. But in many respects literature was exactly what Dada was now offering: with the exception of the portraits of the Dadaists and Picabia's cover, only one image appeared in *Dadaphone*. It was, admittedly, a significant one, the first published "Schadogram," but the overall visual poverty of *Dadaphone* indicated that writers and poets were now the main drivers of the movement.

As an insert to *Dadaphone*, Tzara printed the program for the next grand Dada event. In celebration of the 25th anniversary of Jarry's *Ubu Roi*, Tzara hired for 29 March the venue where it premiered, the Maison de l'Œuvre run by Aurélien Lugné-Poe. It would be unlike the previous shows: Tzara devised a varied program, with music, painting, but also manifestos specially written for the event—he later said that the evening "showed the vitality of Dada at its height."[62] Ribemont-Dessaignes composed a piano piece that lacked melody or harmony; the random notes were impeccably performed by Marguerite Buffet, cousin of Picabia's wife and a professional musician. Once the audience were sufficiently agitated, Breton read Picabia's "Manifeste Cannibale Dada" as Buffet continued to thunder away on

144

the piano. This anti-Dada manifesto ("Dada smells like nothing, it is nothing, nothing, nothing. / It is like your hopes: nothing") further angered the crowd; offstage, Everling remembers Tzara crying tears of joy: "listen to them ... Dada lives, it's magnificent!"[63] The manifestos were followed by dramatic sketches, including Breton and Soupault's *If You Please* and Tzara's *La Première Aventure céleste de Monsieur Antipyrine*, first staged in Zurich. Tzara used a new prop—a bicycle wheel borrowed from Marcel Duchamp—for this performance. The staging for this veritable "boxing match between words" called for listless characters under greenish lights reciting their lines: but the audience's screams during the piece ensured that "not a single word" was heard.[64] Picabia displayed one of his most iconic works, a stuffed monkey on a canvas with the words "Portrait of Cézanne—Portrait of Rembrandt—Portrait of Renoir—Still lives" around it. An anti-Dada group, "Non," threw down tracts from the balcony while Soupault yelled: "You are all idiots! You deserve to be presidents of the Dadaist Movement!"[65] The spectacle ended with a popular artist, Hania Routchine, singing "Clair de Lune"—but given what preceded her recital, the "public took this for a profanation."[66] If the audience were perturbed, Tzara's organization and advertising had ensured that there was a full house, which recouped the steep costs of renting the hall (450 francs) and also meant profits for both Lugné-Poe and the performers.[67] The event was extensively covered in the press, the *Carnet de la Semaine* dubbing the show "the best theatrical event of the year."[68] Despite comparing the performance to visiting a mental asylum, one critic had to admit: "If these people are insane, their insanity is contagious; if they are pranksters, the public repaid them in full, for at the end of the evening, the whole room was in a frenzy, shouting and booing with them, repeating after them the senseless absurdities and profanities that were being uttered on stage."[69] *Comœdia*'s review, while disparaging Tzara's strong accent, called him "a true Dada, convinced, inspired, absurd, and unconscious."[70] The review continued by highlighting the creative gulf separating Dada from other avant-gardes: Dada intended to abolish art *in toto*, whereas other groups were merely interested in challenging its conventions. Aldous Huxley, then in Paris, told a friend in London that Dada set out "to destroy literature completely."[71]

If this message started to come across, the art world had its continued attractions. Picabia gave his first one-man show in Paris since the war at Au Sans Pareil; the exhibition ran for two weeks and included over twenty works. In his text for it, Tzara called these works monuments to their creator: "Don't look for anything in these paintings their subject and means are: Francis Picabia."[72] Yet the exhibition failed to attract either crowds or critics, and what followed—a show by Ribemont-Dessaignes, the gallery text again written by Tzara—met a similar fate, and Ribemont-Dessaignes never painted again.

Still living in Germaine Everling's apartment, Tzara rarely woke before noon. He scanned the newspapers for items about Dada and then proceeded to work before lunching in the

145

late afternoon. Germaine proved a gracious host, and the two became close friends despite Tzara's chaotic schedule, his colonization of the living room, and the racket of the typewriter as newborn Lorenzo napped—when Tzara left Paris in July, Everling wrote to him: "My dear Tzara come back here soon your absence is a great void for me."[73] A trip to the Certà was obligatory at some point during the working day, and it was there that the Dadaists met and planned their events. In Zurich Tzara had spent countless hours in the Odeon or the Café de la Terasse, but those two cafés were frequented by the whole gamut of Zurich's intellectuals, whereas the Certà was exclusively Dada territory (they even had a key to the bar). Over time the group expanded. Some young converts, like Robert Desnos and Jacques Rigaut, dreamed of joining the Dadas on stage; others, like Pierre de Massot, had only read about the shows and felt that Dada represented something that they, stuck in the provinces, had always needed. A number of established artists, like composer Erik Satie, Russian painter Serge Charchoune, and controversial writer Pierre Drieu la Rochelle, were also attracted to the movement.

The last great performance of the season was advertised on the back cover of Céline Arnauld's *Projecteur*, a twelve-page review that came out in late May (its motto: "*Projecteur* mocks everything: money, glory, and publicity").[74] The "Dada Festival" was held on 26 May at the Salle Gaveau, 45 rue de La Boétie. This large venue was more costly to hire (500 francs) than the Maison de l'Œuvre, but Tzara was convinced that the public would come in great numbers to partake of the advertised delights: "An unprecedented act: all the Dadaists will have their heads shaved in public. There will be other attractions: pugilism without pain, presentation of a Dada magician, a real *rastaquouère*, a vast opera, sodomist music, a symphony for twenty voices, a motionless dance, two plays, manifestos, and poems. Finally, we will discover Dada's sex."[75] Sandwichmen were hired, their placards containing suitably provocative maxims that did not fail to heighten curiosity about the show, which was sold out. The owner of the Salle Gaveau complained that the "respectable audience" frequenting his establishment could not be exposed to "something that could (in content as much as in form) be shocking to propriety and decorum"; he added that the announced program violated police regulations against entertainments "susceptible of harming morals and law and order."[76] But the advertising was merely bait; just as Charlie Chaplin had not materialized, the Dadas did not shave their heads or do much that was different from the earlier shows, which is not to say that anything edifying was presented on stage!

Tzara's contribution was *La Deuxième Aventure céleste de Monsieur Antipyrine*. This plotless play featured absurdly named characters (Mr. Absorption, Mrs. Interruption, Mr. Saturn, Disinterested Brain, the Ear, Miss Pause) and nonsensical dialogue: for one critic, it was "horrifying, indescribable ... pure madness."[77] Tzara provided the staging and scenery, but left the acting to fellow Dadaists (Aragon played the part of Mr. Aa the Anti-philosopher; other roles were played by Breton, Marguerite Buffet, Éluard, Breton's former classmate Théodore Fraenkel, and Ribemont-Dessaignes). Having barely rehearsed together, the

amateurs "showed little ardor in the execution," but this was also perhaps due to the costumes, which turned them into long white candles.[78] In the play itself, the characters are not given human traits but appear to be machines for discourse, spouting unintelligible, often verbless, lines:

> fresh pins
> testicular soap in the café
> a motor steak in hazelnut sauce[79]

Although it was inspired by the experience of living with newborn Lorenzo in Everling's apartment ("coagulated child on the baby seat chamberpot," "waking up in condensed milk"), the play's focus on mechanical objects and disease undermines any vitality or warmth.[80] The syntax is deliberately obscure, making it difficult to create natural rhythms, and there is no "dialogue" proper: this was the despair and irrationality of a postwar world where ideas and objects are incoherently jumbled together. The only element of narrative clarity is Mr. Aa's manifesto: "I will return at some point as your urine ... and all of you are idiots."[81]

For *Vous m'oublierez* [You Will Forget Me], Breton and Soupault had talked for weeks about an unforgettable conclusion: they would write their names on slips of paper and drop them in a hat, draw one out, and the chosen one would then shoot himself in the head on stage. This act alluded to the call made by Rachilde, one of the most popular writers of the day, for a war veteran to come to the show and shoot the Dadaists. Aragon, in on the secret, later revealed that this plan filled him with "terror" for weeks: "I knew it was no use trying to dissuade them. Behind the carnival of those first Dada months in Paris lurked this dreadful, sinister secret." But the moment came and passed: "My two friends simply abandoned their plan."[82]

Cocteau, whose name was written on a balloon and attacked by knives and hatchets, castigated the tameness of the proceedings: "Not a single Dada dares commit suicide, dares kill a spectator. One watches *plays*, one listens to *music*."[83] As the London *Daily Mail* headline put it, "Dadaists Disappoint: Still Unshaven."[84] Even if the performances remained within the confines of earlier shows, the public still reacted violently. The event overturned the conventional laws of the theater and the role of the spectator: "We search out the proper stimulants to make the public eloquent, comic, indignant, furious. ... We play the public like an immense, sensitive instrument. ... It unconsciously collaborates with us. ... We have transposed the moment where the work of art is created."[85] Dada performances invited the audience to become part of the show by yelling, shouting "the clippers" so that the head-shaving would start, throwing tomatoes, eggs, carrots or paper airplanes on stage; to all this, the performers reacted in turn, with dynamic results. For *L'Éclair*, "the show was much more amusing ... in the hall than on the stage."[86] "Luckily there's the public," *Carnet de la Semaine* added.[87] Marthe Chenal, the society hostess and opera singer, was entreated by

the audience to sing "La Marseillaise," a fitting end to an evening that had exhausted performers and spectators alike.[88] Critics were baffled by how Dada could have swept the crowd up into such a fury: "At the end of it all, I believe these young people were taking the piss out of us."[89] What Dada exposed, another paper noted, was "our snobbism ... our prejudices"—the public was getting what it deserved.[90] It had become, as Tzara noted, "very dada."[91]

As Tzara was preparing for the "familiar walk of train wagons" that would see him travel back to Switzerland and his native Romania for the summer, his suitcase was filled with a precious gift to distribute to friends across Europe: his first book published in Paris, *Cinéma calendrier du cœur abstrait / Maisons* [Cinema Calendar of the Abstract Heart / Homes].[92] Announced a year earlier in *Dada 4–5*, it was published in June 1920 by Au Sans Pareil. Ten luxury copies were on sale at 150 francs, while the 200 copies of the regular edition were also quite pricey, selling for 25 francs, about three times the price of a regular book.[93] Illustrated with a woodcut by Arp, the volume was a collection of poems written between 1918 and 1920, most of them previously published in *Dada*, *391*, *Littérature*, and other little reviews. Despite these disparate sources, the ensemble attains a unity of purpose in its poetic concerns and formal techniques. The bombastic violence of Tzara's early poetry and the manifestos that had resounded through Parisian theater halls gives way to a more subtle irony, a destruction that is even more deadly because it is unannounced and unprompted.

The twenty-one short, untitled poems in *Cinéma calendrier du cœur abstrait* are characterized by a dense concentration of varied images and unexpected movements, especially in lines packing a slew of nouns and objects:

wind desire cave sounding insomnia tempest temple
the fall of water
and the rapid jump of vowels[94]

The title promises such juxtapositions: both the cinema and the calendar are technical and social inventions that assemble, reproduce, and distort experience and life into a seamless unity. This unity is artificial, though, as language fails to bring together or forge objects into a common bond:

under the staircase
huddled up in the driving heat of this crucifix-airplane
a russet shadow
familiar in the steam
a cigarette approaching boat-like
and the acrid smoke of petrol on the lake
o needles crossing the clock streaked fish
and the gold of active houseflies:
the other[95]

148

This destruction of language and overriding "otherness" is superseded at moments when Tzara expresses a sensuous longing for communion:

> your fingers ride the keyboard
> can you offer me the scale of gasps
> I bent towards you like a bridge outstretched
> whose pillars are attacked by the waves but don't break
> and it is uncertainty in the guise of icy-cold decision
> that unleashed with the sudden movement of the wheels
> here comes the muscle of my heart opening up and shouting[96]

Of the twelve poems in *Maisons*, only one poem does not contain the name of one of Tzara's fellow artists, and most have in their titles a friend's name, even if the effect is bizarre: "The Tale of the Devil Is a Bicycle Éluard." A slim collection, *Cinéma calendrier* helped cement Tzara's poetic reputation within the Parisian avant-garde, but the general public did not react at all—not only because of the limited print run, but also because the antics on stage overshadowed everything else.

Before Tzara's arrival, Dada had been vaguely mentioned in artists' studios, but now it was everywhere: "That which was invisible has become visible. That which was known by some became known by everybody."[97] The arts daily *Comœdia* was publishing two leaders a week on Dada, and by June 1920, Picabia's press-clipping company was sending him ten to twenty articles per day about Dada—not only from every European country but also from China, Vietnam, and the United States. *Radical* blamed the press for being taken in and perpetuating Tzara's "vast fraud," which had given him "a celebrity that no writer or artist of talent" had ever previously acquired.[98] But as Éluard's *Proverbe* argued in May: "Madame Rachilde wrote an article on DADA. She argues that one shouldn't write articles about DADA. Mr. Georges Courteline spoke about DADA for over an hour at *Comœdia*. He said that one should not talk about DADA. ... IF YOU MUST TALK ABOUT DADA, YOU MUST TALK ABOUT DADA. AND IF YOU MUST NOT TALK ABOUT DADA, YOU MUST STILL TALK ABOUT DADA."[99] Perhaps the only way to silence talk about Dada was to kill its members, as one journal suggested in posing the question: "Should the Dadas Be Shot?" Not a single letter defended Dada, and the one singled out as "the purest truth" claimed that the chief of Dada was "in reality the Jew Braunstein, called Trotsky": the letter-writer noted that just as Trotsky would eventually face a firing squad or be hanged, so too would the Dadas.[100]

As this question illustrates, one of the persistent charges lodged against Dada, with Tzara as its representative figure, was that it was a foreign import. It was quite simply "literary Bolshevism" bent on "destroying ... everything that the French intellectual patrimony represents."[101] Dada's ideas "are not *French* ... [Dada] is an Asiatic, not a European, theory."[102]

"Extremists, revolutionaries, Bolsheviks, Dadaists—same flour, same origin, same poison," began Marcel Boulenger's "Herr Dada," a column in *Le Gaulois* that was widely reprinted.[103] These "undesirable wogs" were ruining the French language, *Liberté* noted, while a Le Havre newspaper told Tzara to go back to Romania and stop wasting French paper.[104] Tzara's "little-Negro" use of language was seen as a particular threat to the unsullied glories of the "the mirror of our culture."[105] The only thing to be done, a Caen newspaper observed, was to "exterminate" this "occult evil."[106] Less reactionary venues peddled the same ideas. The cultivated Jacques-Émile Blanche called Dada the product of "young mixed-raced persons from the Orient."[107] In the *Nouvelle Revue Française*, André Gide said of Tzara: "They tell me he's a foreigner. I can easily believe it. A Jew. You took the words out of my mouth."[108]

Tzara took all this in with a bemused indifference. The lethargic final year in Zurich, when he spent so much time in bed, faded as he lived in "perpetual exaltation" and was galvanized into a "young force" whose "spirit took everything with him."[109] He had to be a leader, given the personalities and temperaments of the core group. Breton, who never laughed with pleasure, was ill suited to be a Dadaist (and did not remain one for long); Aragon wrote too purely, but never about the demons in his closet (he thought that he had been raised by his sister; as his eighteenth birthday approached, it was revealed that his sister was in fact his mother); and Soupault had too much of a personal conscience. Picabia had done almost nothing for Dada in Paris before Tzara's arrival; needing to be the center of attention, he refused to go on stage, which pretty much says it all. These differences in temperament had already started coming to the surface, with *Carnet de la Semaine* speaking in April 1920 of two Dada camps at loggerheads.[110]

Breton was having problems accepting the anti-art line. In late March his parents had come to Paris demanding explanations and issuing an ultimatum: his mother showed him a newspaper article detailing scandalous Dada activities where André was mentioned by name. If he did not stop these disreputable activities and concentrate on his medical studies, his allowance would be cut off and he would come back with them to Lorient. Tzara found Breton one night resignedly packing his bags. His father wrote to Paul Valéry, who found André a job at Gallimard (which also involved being a proofreader for Proust).[111] The literary circles in which Breton operated—Gide, Proust, Valéry—reveal a great deal about his differences with Tzara. (For his part, Aragon asked Gide to read *Anicet*.)[112] While devoting the entirety of *Littérature*'s May issue to Dada manifestos, Breton was smarting under Tzara's leadership: "It might seem that everything was for the best, and yet from within—at least as far as Aragon, Éluard, and I were concerned—the situation was perceived differently. ... Each time a Dada demonstration was planned—by Tzara, of course, who never tired of them—Picabia gathered us in his salon and *enjoined* us, one after the other, to come up with ideas for it. In the end, the harvest was not very abundant."[113] Breton wanted Dada to be more united in its attacks on the public and more consistent in its message. Tzara

never considered Dada in such formal terms, nor did he see it as a "serious" activity as Breton understood the term. Tzara fought off Breton's demands for more meetings, tighter organization, and a constructive vision of Dada. After the Salle Gaveau show, Breton refused to see his friends for weeks; this created a split with Picabia, who wrote to Tzara in early July: "I write you these lines not in a fit of anger, but after a lot of *reflection and inspection—Littérature* doesn't give a damn about us, the Sans Pareil is hiding our books and magazines; at last, I'm faced with facts. Breton is an accomplished actor and his two little friends think like him that one can change men the way one changes boots; I myself have absolutely decided not to stand for it and am distancing myself more and more from his young men of letters."[114] At this point Tzara was back in Zurich before continuing on to Romania, Greece, Turkey, and Italy. It would be over four months before he would be back in Paris again, but the fires that would eventually engulf the Paris Dada group had already broken out.

8 TOURS AND SEASONS: **1920–1921**

WITH PARIS DADA AT THE HEIGHT OF ITS POPULARITY AND *CINÉMA CALENDRIER* JUST OUT, TZARA'S DECISION TO LEAVE PARIS IN JULY 1920 WAS NOT WELL TIMED. He insisted that his trip would be Dada propaganda, but the real reason was that he had not seen his family for five years. If Dada's public face spat on the morality, obligations, and duties that the family created, private Dada hearts beat differently. Tzara not only missed his family immensely, he also felt the stings of his parents' reproaches for having neglected his studies: armed with volumes of poetry published in Zurich and Paris and newspaper clippings from all over the world, he could show them that, thrown back upon his own devices, he had triumphed.

Serner had warned Tzara of how culturally stagnant Switzerland had become: "Absolutely nothing to do here. A catastrophe. ... Terrible idiots all of them." [1] Tzara had confirmation of this at his first port of call:

> Zurich is dead and unpleasant, only the air is good. What are you doing? What's happening? I'm sinking, I don't know why, into the Balkan darkness.
>
> All the films shown here are fiddled with, cut up, or censored. What a stupid country! Zurich is in the hands of a few old women. I can't imagine how I could have spent years here. [2]

The Cabaret Voltaire, the Galerie Dada, and Dada soirées had made little lasting impression on Zurich, which had reverted to type once the wartime foreigners left. The free flow of ideas was gone, with Tzara unable to find copies of French Dada reviews in bookshops. Only Arp remained, and he was "alone ... and terribly bored." [3] The only good news was that Arp had signed a contract with Paul Steegemann, a Hanover publisher, for a Dada anthology. Tzara excitedly solicited material from his Paris friends for this anthology (it never appeared, but Tzara tried, also without success, to revive the ambitious project with *Dadaglobe* that winter, hoping it would be anywhere from 160 to 220 pages, with a print run of 10,000

154

FIGURE 8.1
Venice Dada: Tzara with Aldo Fiozzi,
Gino Cantarelli, and an unidentified
person on the Lido Beach.
Tzara Collection, Bibliothèque Littéraire
Jacques Doucet (Paris).

copies).[4] Tzara stayed with Maya, but within ten days of arriving he seized upon a letter from Gino Cantarelli to board a train, destination Milan.[5]

Cantarelli and the painter Aldo Fiozzi had edited a wartime review, *Procellaria* (in which some of Tzara's poetry appeared), and the two now joined forces with Julius Evola to publish *Bleu*, whose first number had just come out. Tzara had been informed of their plans from the start, with Evola confiding to Tzara in March his hopes of establishing a "*Dada*, international" review and Cantarelli that spring pleading with Tzara to send "Dada propaganda."[6] *Bleu* eventually became the premier mouthpiece for Italian Dada, publishing texts and artwork from Aragon, Johannes Baargeld, Éluard, Ernst, Picabia, Reverdy, Serner, Tzara, and Van Doesburg—an impressive roll call of contributors, since *Bleu*'s three numbers totaled less than twenty pages. It was in Milan's "tropical heat," suffered alongside Cantarelli and Fiozzi, that Tzara saw the first issue, which he considered "quite good" despite its cover (a drawing of a nude woman and a landscape reminiscent of *Simbolul*'s precious aestheticism).[7] The group then moved on to Venice, from where they sent Picabia a postcard: "Dada just pissed on the Lido beach, we warmly think of you"—an allusion to Dada's symbolic conquest of Venice, the city of Marinetti's First Futurist Manifesto.[8]

"Venice Dada" was short-lived, though, as Tzara soon boarded the Venice-Simplon-Orient Express, which arrived in Bucharest on 27 July. The relief of seeing his family again was tempered by the depressing prospect of having to stay in Romania for part of the summer: "I arrived in Bucharest yesterday, I'm leaving this evening for the country and all I want is to return, either to Paris or elsewhere. The Balkans and the mentality here disgust me profoundly. ... I'll only be staying three–four weeks ... I don't think I'll be able to work at all here. It's too hot. It would perhaps have been better to have not left in the first place. I am *terribly* bored here and I've only been in Bucharest for twenty-four hours."[9] If Romania had changed dramatically in his five years away, Tzara had changed as well. He had grown up amid the chaos of Bucharest but now saw how overwhelming the city was—what Gregor von Rezzorri later dubbed its "garbagey modernity in which all the dubious aspects of technocratic civilization came to the fore, decaying and degenerating, but nevertheless swirling with life, color, adventure."[10] Tzara escaped this quickly enough by going to the family estate in Garceni, a small, isolated village in northeast Romania where his grandfather had worked as a forest manager (Tzara's mail was forwarded to the local wood workshop). The nervous energy that had been expelled for the past six months found no outlet in this isolation, and inactivity always brought about terrible self-doubt in Tristan.[11] His parents must have inquired about his Dada activities, for the Romanian press had reported the scandalous goings-on in Paris (Vinea had also written a column about Dada for a major Bucharest daily). If his parents were scandalized, there is no record of it; what they cared about after the long years of separation was to see him again and to know that he had escaped the terrible war without injury.

During his time in the countryside, Tzara had little news. Breton had asked Picabia for Tzara's address in Romania but did not get in touch. He perhaps felt uneasy discussing the August 1920 *Nouvelle Revue Française*, which featured an article on Dada by the NRF's editor, Jacques Rivière, and Breton's reply. Rivière's article identified a growing split within Paris Dada, one group of negative aesthetics forming around Picabia and Tzara and a more constructive school forming around Breton. Despite being entitled "Pour Dada [For Dada]," Breton's reply seemed to confirm Rivière's diagnosis. Claiming that his faith in Dada was justified because of the "revision of moral values" it would effect, Breton also called for "the arbitrary [to] be given the place it deserves in the creation of works or ideas"—both statements seeming to couch Dada within a programmatic (albeit vague) aesthetic.[12] If he approvingly quoted from Tzara's work, Breton also claimed that his former idol Jacques Vaché had "unknowingly verified the principal articles" of the *Manifeste Dada 1918*.[13] Moreover—although its importance could not have been known at the time—Breton first used the term "surrealist" in this article.

In no hurry to get back to Paris, in late August Tzara boarded the Orient Express to Constantinople. He stopped off in Athens for several days, sending Picabia a postcard, "Greetings from our friend Socrates."[14] At the Acropolis a theology professor supposedly told him that God would take vengeance against Dada, but the only manifestation of divine wrath Tzara felt was a lingering head cold.[15] He then continued on to Constantinople, a city still under British and French military occupation. He claimed to have met in the city a Greek doctor from Paris who said that he knew Tristan Tzara personally: "Tranquilly, but nonetheless stupefied, I asked him to describe Tzara. He told me: tall and blond. I couldn't hold back my laughter, because I am small and brown."[16] This was the only amusing incident of a long summer; sending Picabia a postcard of Süleymaniye Mosque, Tzara wrote: "Almost three months now since I've heard or seen anything that really interests me."[17] Éluard was urging him to come back to Paris:

> I'd love some new Dada events. Come back to Paris by October.
> They will be as successful as the past ones. All this has kept me
> going for six months—and in good spirits.
>
> … After the summer holidays we have to do something. What?
>
> I haven't seen Picabia for a long time, but it's not my fault.
> I'm afraid that he's upset—Certà is abandoned.
>
> Your leaving has pained me a lot. I was so used to seeing you.[18]

Yet Tzara did not rush back to Paris, choosing instead to spend about ten days in Italy, first in Naples ("I'm warming up a bit at the Vesuvius here") before heading on to Rome and Florence.[19] In the first week of October he arrived in Zurich, where he reconnected with Arp to see what progress had been made on the international Dada anthology (not much).

A letter from Picabia outlining further troubles with *Littérature* arrived, but at this point Tzara was exhausted: "But I plan to be in Paris on Wednesday ... Thursday. ... I'm a bit tired of this trip that's now lasted more than a month. So many things must have happened. I'm no longer up to date on anything."[20] Tzara spent a few more days in Zurich with Maya before arriving back in Paris on 14 October. No one had stalked the platforms waiting for his return.

The day after his arrival, Tzara received a long letter from Breton:

> This morning I heard you are here. Should I think you won't try to see me? It's probably up to me to go to rue Émile-Augier to get some news about you but I do so dread an argument with Picabia. Everything he may have told you about me is unfortunately true; I've behaved with him in too bizarre a manner for him not to be angry. If you think it right, my dear friend, tell him I apologize with all my heart. But will he understand? An apology—I hardly think so.
>
> …
>
> Forgive me for writing to you so freely. You are here: that counts for a lot. I'm anxious, very anxious, to know how you are. I already left you in such a bad manner.[21]

Despite Breton's entreaties, Tzara did not attend a *Littérature* general meeting a few days later. Picabia went into more detail about Breton's handling of *Littérature* (a text by Ribemont-Dessaignes had been inexplicably altered) and his coziness with the literary establishment: the consternation was not about aesthetics, for which Picabia allowed a wide latitude, but about the deeper level that Dada operated upon: friendship. And Picabia had set his sights on a new friend, Clément Pansaers, a Belgian artist who had come to Paris that summer with two exciting proposals: a large Dada public event in Brussels in December and the formation of a Dada publishing house.[22] Having rented out the Bonbonnière theater in downtown Brussels, Pansaers waited for the Parisian Dadaists to revolutionize Belgium, but Picabia's support for the project faded after the *Littérature* group declined the invitation, with Breton even refusing to send texts because Albert-Birot, Reverdy, but especially Cocteau, had also been invited.

157

These rifts were plain for all to see in the November number of *391*, coedited by Picabia and Tzara. Not a single *Littérature* editor was featured in the number, which otherwise had works by Arp, Marguerite Buffet, Charchoune, Cocteau, and Serner (who came to Paris that autumn). The cover ascribed the following line to Cocteau, an artist the *Littérature* group detested: "Rimbaud went to Harrar to escape *Littérature*."[23] Serner contributed the following aphorism, which pointedly took sides in Dada's rift:

UNE NUIT D'ÉCHECS GRAS

PagE composée par Tristan TZara ✱

Réclame pour la

VENTE DE PUBLICatIONS dada

du 10 au 25 Décembre 1920

chez PovoloZKY, 13, rue Bonaparte, Paris

HIHIHIHIHIHIHIHIHI

DA DA DADALINE DA DA DADASTE D'ADAPHONE DA DA DA CHOSE DA DA — FRANCIS PICABIA PARAIT AUJOURD'HUI — JÉSUS-CHRIST RASTAQUÈRE PAR FRANCIS

391
N° 6
2 Frs
New=York

mettez le Brodway à Besançon
et un petit parfum dans New-York
Saluez le timbre poste

391
N° 8
2 Frs
Zurich
rose

feu économique
rose

l'art est mort

Picabia, Gabrielle Buffet, Arp.
Tzara, Alice Bailly, Pharamousse
et le
VAGIN MYSTIQUE
de Zurich

II III IV V VI VII VIII IX X XI XII XIII
I
II
III
IV
V
VI
VII
VIII
IX
X
XI
XII
XIII
XIV
XV

Ne vous pressez pas
les 25 poèmes
de Tristan Tzara
sont
épuisés
Il ne reste que quelques
exemplaires sur hollande.
(tirage 10 exemplaires)
A 150 Fr.

XIV XIII XII XI X IX VIII VII VI V IV III I II

Vient de paraître : HÉLAS

MATCH
391
13
Achetez-le
dans votre
intérêt

Francis PICABIA
UNIQUE EUNUQUE
Préface par Tr. TZARA
COLLECTION DADA
Au Sans-Pareil, Paris : 3 fr. 50

La pierre s'exprime par la forme, et parfois la luminosité des
facettes, - vibration de l'air parcouru. Je hais la nature Picabia
n'aime pas le métier. Ses poèmes n'ont pas de fin, ses proses ne
commencent jamais. Il écrit sans **travailler!** présente sa person-
nalité, ne contrôle pas ses sensations. Pousse dans la chair des
organismes.

FRANCIS PICABIA :
La Fille née sans Mère
4 Fr.

Pensées sans langage
3 Fr. 50

La parole fertilise le métal : bolide ou
urubu ouragan ourlé et
ouvert — il laisse dormir ses senti-
ments dans un garage. 3 Fr.-50.

IL Y A DaDA ET dadA.............
Un livre de GEORGES RIBEMONT-DESSAIGNES
est sous presse — Lequel ? Ah !

Max Ernst, vous voilà célèbre. Max Ernst,
Max Ernst, vous voilà célèbre et BAARGELD
vous voilà célèbre par
cyographie de l'amour de la lune
et la flore dada arrange par
DIE SCHAMADE
(Cologne) 4 frs.
programme de PAUL ELUARD :
Tout est dans tout. Partout casse-cou

PROVERBE
N° numéros Fr. 2.50
Dir. gérant : PAUL ELUARD.

Serner
DERNIER DÉRANGEMENT
(Steegmann, Hannovre)
3 Fr.
manifeste Dada

La solution de tous les mystères de
l'univers

Des recettes contre :
la famine,
la blennhoragie
les indispositions de l'estomac cérébral,
le dadaisme de l'Académie Française,
les bordels mal exploités,
la peste de Constantinople et les exposi-
tions de peinture de Paris.

CINÉMA CALENDRIER DU CŒUR ABSTRAIT
par *TRISTAN TZARA*
19 Bois par ARP
Collection Dada
tirage limité

Réclame
pour
moi
Tristan tzara

10 exempl. sur Japon 150 Frs.
200 exempl. sur papier à la forme 25 Frs.

Adresser les commandes au " Sans Pareil"
37, Av. Kléber, Paris

Paul Bourget écrit sur ce livre :
 Il faut absolument lire ce livre merveilleux

Henri Lavedan écrit sur ce livre :
 Il faut lire ce livre. Tzara est un sinistre farceur

Henri Bo deaux écrit :
 Il faut lire ce livre sur un champ de violettes

Picasso écrit :
 Arp est le plus grand graveur sur bois

Anatole France écrit :
 Tzara est un idiot, son livre un attentat aux mœurs

FRENCH CANCAN
RIO TINTO

I LOVE YOU

DADA 3
Fr. 1.50
Edition de Luxe
20 Fr.
Occasion, Situation, Expropriation

ARP :
La Pompe à nuages
(Steegemann Hannovre)
3 Frs

voici le célèbre Arp
le voici venir
voici le célèbre Arp
le voici venir venir venir

MERCI

BRAVO ! BRAVO !

L'AMOUR dans le Cœur
Parlez-lui de moi ✱✱

Une homme dessin. cub. ou tr. bureau
très bon. réf.
Tout le monde
collabore. Toutle
monde lit. Tout
le monde mange.
Personne ne
vous met l'a-
mour dans le
cœur parlez-lui
de moi. Lisez Canni-
bale. Le secret de Rachilde de Foch
et la Mercer les origines secrètes de
Dada-band. La tête sur le chapeau.
Exempl. de luxe à 10 frs. Garantis.

N° 1 N° 2
1 Fr. 1 Fr.
Directeur : Francis
PICABIA

CANNIBALE

La Revue
BLEU
de Mantoue, courag usement dirigée par
Cantarelli et Fiozzi va devenir l'organe dada italien.
Mme Renée Dunan la célèbre philosophe, écrit que Dada
n'est pas une métaphysique mais une propsychie. Bleu
ouvre un concours pour la meilleure expiliration de

L'YPOPSYCHIE

! !
Je ne vous
conseille pas
D'ACHET. R
l'anthologie Dada

ELLE
est épuisé

LES
exempl. de luxe
coutent 25 Fr.

DIVORCE RAPIDE
90 s. l'heure

Vient de paraître
ALMANACH DADA
chez Erich Reiss, Berlin. coll.
Dermée Citroën, Picabia, Mehring, Arp.
Huelsenbeck, Tzara, Heartfield,
Ribemont-Dessaignes Lacroi,
d'Arezzo Delmonicos Huesmann
Hausemann
etc.

JÉSUS-CHRIST RASTAQUÈRE

par Francis
PICABIA

Chez POVOLOZKY, 5 FR. 1000 exemplaires de luxe et un
seul sur papier ordinaire il y a un tirage spécial sur papier doux et
transparent pour décalquer la Sainte Vieŗge.

DADAPHONE
Prix 1 fr 50

messieurs mesdames achetez entrez achetez ne
ne lisez pas vous verrez celui qui a dans ses
mains la clef du niagara l'homme qui boit
dans une boite les hémisphères dans une va-
lise le sac enfermé dans un lampion chinois
vous verrez vous verrez vous verrez la danse
du ventre dans le salon de massachusets
celui qui enferre le zinc et le pneu se dépouille
les bas de soie de mademoiselle atlantide la
malle qui fait 6 fois le tour du monde pour
trouver le destinataire monsieur et sa fiancée
son frère et sa belle-sœur vous trouverez l'a-
dresse du menuisier la montre à crapouih le
nerf un coupe-papier vous aurez l'adresse du
celui qui fait le sexe féminin et de
celui qui fait mieux obéissez au roi ainsi
que l'adresse de l'action française.

J. EVOLA
ARTA ASSTRATTA
Collection DADA. ROME. 2 Frs.
Théorie Poèmes, dessins.

Bulletin Dada
2 Frs 2 Frs

2 Frs 2 Frs 2 FR 2 fr 2 FR
2 Frs 2 Frs 2 Frs 2 FR. 2 FR. 2 fr.
2 fr. 2 Fr. 2 FR. 2 Fr. 2 Fr. 2 fr.
collaborateurs collaborateurs col-
laborateurs Ribemont Ribemont
Ribemont Picabia. Eluard Elu-
ard Eluard, Picabia Serner Serner
Bre on Breton Serner Breton Tzara
Dermée Dermée Aragon Soupault
Aragon Jacques Edwards Aragon
Aragon Arp Picabia Schad Arp Arp

You must read Shakespeare
He is truly an idiot
But read Francis Picabia
Read Ribemont-Dessaignes
Read Tristan Tzara
And you will stop reading.[24]

Tzara contributed an excerpt from *La Deuxième Aventure céleste*, a mechanical drawing in honor of Picabia, a mock interview with cubist Jean Metzinger, a translation of an Arp poem, but most importantly a page of stunning typography, "Une Nuit d'Échecs Gras [A Night of Greasy Chess]." This page was prepared—and identified itself accordingly—as an advertisement for Dada publications, with over twenty different reviews or books included, from Italy's *Bleu*, the Cologne-based *Die Schammade*, old Zurich Dada items like *Dada 3* and *Vingt-cinq poèmes* ("Do not hurry: the *25 Poems* by Tristan Tzara is sold out. Only a few copies on Holland paper are available for 150 francs"), Paris Dada volumes like *Bulletin Dada* and *Dadaphone*, Picabia's poetry collections and *Cannibale* and *391*, plus recent books by Arp, Evola, and Serner. With so much ground covered, *Littérature* was noticeably absent.

If advertising and publicity had long been Dada staples, this entire issue of *391* was in effect an advertisement for an upcoming exhibition of Picabia's paintings at the Galerie de la Cible (the Povolozky Gallery) on rue Bonaparte. The inability to create a more energetic public event spoke volumes about Paris Dada's disarray. The two-week show, while containing some recent mechanical paintings, was dominated by Picabia's Impressionist-inspired work from the turn of the century. For the *vernissage* on 9 December Picabia invited "ambassadors, poets, counts, princes, musicians, journalists, actors, writers, diplomats, CEOs, fashion designers, socialists, princesses and baronesses."[25] The event was thronged, but it was hardly a Dada spectacle worthy of closing the "Anno domini Dada."[26]

159

FIGURE 8.2
Dada advertising: Tzara's
"Une Nuit d'Échecs Gras." *391*, no. 14
(November 1920).
Courtesy of the University of Iowa
Special Collections.

The most eventful part of the evening was Cocteau's jazz band (Georges Auric and Francis Poulenc on piano, Cocteau on drums) punctuating Tzara's reading of "Dada Manifesto on Feeble Love and Bitter Love." The journalist from *Comœdia* described this reading: "Tzara installed himself on the counter. He raised his hand and the music stopped. In the thick silence, the great tongue-in-cheek artist launched, with terms of a maddening incoherence, into a lecture on love."[27] The first five sections of the manifesto revolved around the phrase "I find myself very charming." (A week later Tzara, in an afternoon matinée at the gallery, noted: "Several days ago I was at a meeting filled with imbeciles. A lot of people were there. Everyone was charming. Tristan Tzara, a small, idiotic, and insignificant character, gave a talk on the art of becoming charming. He was, by the way, charming. Everyone is charming. And witty.")[28] These moments of light comedy and self-deprecation turn the manifesto into a vehicle of doubt:

A manifesto is a communication addressed to the whole world, in which there is no other pretension than the discovery of a means of curing instantly political, astronomical, artistic, parliamentary, agronomic and literary syphilis. It can be gentle, good-natured, it is always right, it is strong, vigorous and logical.

A propos logic, I consider myself very charming.[29]

As an example, Tzara taught the audience how to write a poem, alluding to his first appearance on the Parisian stage, when the following method was applied to a political speech:

To make a Dadaist poem.
Take a newspaper.
Take a pair of scissors.
Choose an article as long as you are planning to make your poem.
Cut out the article.
Then carefully cut out each of the words that make up this article
 and put them in a bag.
Gently shake.
Then take out the scraps one after the other.
Copy these down conscientiously in the order that they were taken
 out of the bag.
The poem will resemble you.
And voilà you are a writer infinitely original and endowed with a sensibility
 that is charming though beyond the understanding of the vulgar.[30]

This ironic recipe for making a poem points out that any formula for poetry, any rule of art, became reduced to such senselessness. But in a Dada universe, logic could not escape infantile proclamations: "A priori, that is to say eyes shut, Dada places before action and above everything: *Doubt. Dada* doubts everything. ... Everything is Dada. Beware of Dada."[31] For this, language itself is blamed:

Must we cease to believe in words? Since when have they expressed the opposite of what the organ emitting them thinks and wants?

Here is the great secret:

Thought is made in the mouth [*La pensée se fait dans la bouche*].[32]

This reduction of language to a sensorial, animalistic expulsion unwittingly fore-grounded the next Dada battleground, Marinetti's public lecture on "tactilism" at the Théâtre de l'Œuvre on 15 January 1921. Before his arrival Marinetti called Dada merely an outgrowth of Futurism. Although Paris Dada was growing apart, nothing united them better than a common enemy, and this gibe, along with Marinetti's militarism and now postwar fascism, rekindled camaraderie and a sense of common purpose. A group manifesto, *Dada soulève tout* [Dada Lifts Everything], was printed on 12 January 1921. This one-page flyer, with the expression "yes = no" appearing four times alongside the proclamation that Dada's artists were "without any nationality," was distributed at Marinetti's talk: "Dada knows everything, Dada spits everything out. ... The Futurist is dead. Of what? DADA. A young girl commits suicide. Of what? DADA. ... If you have any serious ideas about life, if you have made artistic discoveries and if your head suddenly starts crackling with laughter, if you find all your ideas useless and ridiculous, know that it is Dada that has started speaking to you."[33]

Before Marinetti began his lecture, Aragon, Breton, and Tzara started insulting him. That, and the distribution of the pamphlet, fired up the audience, which began to insult Marinetti for good measure. A veteran of scandals, Marinetti impassively smoked cigarettes until the audience had spent its fury. When he launched into his lecture, the Dadaists lis-tened in silence, because some of its ideas resounded so closely with their own that Picabia afterward accused Marinetti of plagiarism. Tactilism, Marinetti explained, would move art beyond sight and sound; art had to penetrate the deepest recesses of the body: "we need to transform the handshake, the kiss, the coupling into a continuous communication of thoughts."[34] This "perfect spiritual communication ... through the epidermis" could take the form of rooms affording "different sensations to barefooted dancers of both sexes" or theaters where "[t]he audience will place their hands on long, tactile conveyor belts which will produce tactical sensations that have different rhythms."[35] Although Marinetti was keen to divorce tactilism from painting or sculpture, these ideas certainly found resonance in Dada object art like Man Ray's *Daring Gift* (1921), an iron with nails on it. It hurt the Dadaists' pride that Marinetti had come up with a new way forward for art while they were fighting out personal battles in private and repeating the same ideas in public.

That Marinetti's presence in the capital was required to give the group a sense of purpose was a sign of Paris Dada's slumber. Tzara's enthusiasm for Dada's growing international dimension in Germany and Italy counted for little in Paris. Plans were made for an ambitious "Dada Season" from mid-April to early June: guided tours (what is now called a "happening"), an arts exhibition, a mock tribunal in which a "reactionary" French writer would be tried, a salon, and a soirée. Taking his cue from the revolutionary atmosphere surrounding the

founding of the French Communist Party at the December 1920 Congress of Tours, Breton pushed for public events that would reinstate "The Terror." These initiatives, planned at the Certà, upset Tzara, who felt not only "gravely wronged" personally but also worried about the direction of Dada under Breton's leadership.[36]

The first event, planned for 14 April, was a parody of a guided tourist excursion. It would be the first of a series of weekly tours to "selected spots ... that do not really have any reason to exist."[37] The Church of Saint-Julien-le-Pauvre was in the 6th *arrondissement* but in a state of disarray, its large gardens serving as a "garbage dump" for local residents.[38] There was no clear sense of what the visit would entail, with a reconnaissance mission weeks earlier leading to the suggestion that the Dadaists would shout at the crowd from the windows of a nearby building.[39] That decision was scrapped in favor of Dada tour guides leading the crowd to the church and then walking around in silence, pointedly refusing to answer questions. The poverty of both ideas was no preparation for the heavy rain that fell on the afternoon of the visit, diminishing the turnout to fifty curious people, a number of them journalists. Under the cover of umbrellas, Breton and Tzara harangued the crowd:

> We find you as stupid as you were at the first Dada event, rushing in as a crowd after reading the first notice in the newspapers made in your image!
>
> Even last night we would have had a hard time telling you what we were going to do; we did, however, guess what was going to happen. And how! So tell us a bit about what you expect from us. Do you believe that we have talent, that we are destined for any success other than the scandalous success that we are having from you?

FIGURE 8.3
Visiting Saint-Julien-le-Pauvre.
Anonymous.

> We can imagine the worst abuse; you'll always find an excuse for us. But tell yourself
> one thing very clearly: We will never come to any good … but neither will you![40]

Ribemont-Dessaignes, who read out random entries from a dictionary, later called his the "most brilliant routine" of the event—"and that's not a value judgment," he ironically added.[41] After ninety minutes of this, with the rain pouring down, the crowd dispersed and the Dadaists, warming up in a nearby café, all agreed that the visit had been a failure.

Direct contact with the public proving elusive, the Dadaists retreated to the Certà, where the next Dada "event" unexpectedly occurred ten days later. *L'affaire du portefeuille* had no public or journalists to expose it. A single individual, and Paris Dada as a group, were concerned when a misplaced wallet was found. A fierce debate broke out over what should be done: return the wallet (and its sizeable contents: 3,500 francs) to its owner, a Certà waiter, or hold on to it, and, if so, do what with the money?[42] This was no problem in applied ethics, but a concrete test of Dada: Breton argued that since Dada dismissed morality, they should not feel guilty about profiting from someone's loss. Others responded by pointing out that since Dada stood for the dispossessed, the livelihood of the working-class waiter would be seriously damaged if the money were not returned. Unable to resolve upon a course of action, they agreed to continue the debate the next day. Éluard was given the wallet for safekeeping. He anonymously returned it, leading Breton to accuse him of treason to the group. Picabia, who heard about these events, was furious. For months he had been growing tired of the pontifical role Breton assumed, the severity of his expression, and his humorless hold over the group. Picabia publicly announced his separation from Dada, in spectacular fashion, in *Comœdia*:

> The Dada spirit only really existed from 1913 to 1918, a period in which it did not cease to evolve, to transform itself; after that, it became as uninteresting as the output of the École des Beaux-Arts. … By wanting to continue, Dada retreated into itself. … Dada, you see, was not serious, and it is for that reason that, like a trail of gunpowder, it reached the world; if some people now do take it seriously, it is because it is dead! … You have to be a nomad, go through ideas the way you go through countries and cities, eat parakeets and hummingbirds, swallow living marmosets, suck the blood of giraffes, feed on the feet of panthers![43]

Tzara supported Picabia's boycott of the Certà, for he too could no longer stand the heavy atmosphere.

It was amid this dissension that the next public Dada event took place: an exhibition of Max Ernst paintings at Au Sans Pareil, avenue Kléber. To display a German painter took some courage in 1921 Paris. Tzara had long admired Ernst's work (which had been displayed at the Galerie Dada); he not only actively contributed to *Die Schammade*, Ernst's Cologne-based review, but also solicited contributions for it from the other Paris Dadaists.[44] But it was Breton who handled all the preparations for the event, from renting out the hall to framing Ernst's works. The May 1921 issue of *Littérature* prepared the ground with an article

163

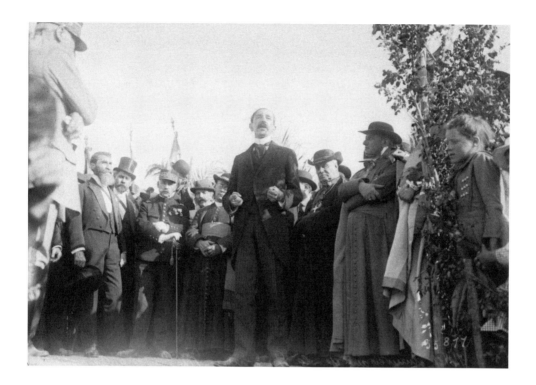

164

FIGURE 8.4
Maurice Barrès commemorating
the fifth anniversary of the "victory"
of the Battle of the Marne, 1919.
Bibliothèque Nationale de France.

by Ernst and a reproduction of one of his works. Newspapers received press releases calling Ernst the "Einstein of painting," and printed invitations for the private viewing promised such esoteric delights as the "distribution of surprises" at 11 p.m. and "intimacies" half an hour later.[45] In homage to the Dada-Cologne exhibition, guests were plunged into the enveloping darkness of the Au Sans Pareil basement, where the Dadaists performed specific roles: Tzara and Soupault played hide-and-seek, Charchoune and Péret continuously shook hands, Aragon did not stop meowing, and a Dadaist hidden in a closet insulted the celebrities in attendance by name. As the drinks were poured, Tzara invited the guests to play a Dada version of Russian roulette: "just one" of the glasses had been "poisoned."[46] The works on the walls were a secondary consideration, and after the hubbub of the opening, visitors who came to the gallery were not prepared for Ernst's art and found his enigmatic titles off-putting.

Maurice Barrès was a popular French writer who had entranced the younger generation, including both Aragon and Breton (who had asked Barrès to write the preface to Vaché's *War Letters*).[47] One of Barrès's maxims—"*One must feel as much as possible by analyzing as much as possible*"—particularly appealed to Breton.[48] But during the war Barrès turned virulently nationalistic (as the fourteen-volume *Chroniques de la Grande Guerre* attests), and in the early 1920s he was always on hand to remind Frenchmen of their duty to honor the war dead: "all higher life, all thought, all art, all of the nation," he expounded, must "transmit for centuries" the "profundity of sacrifice" of those "four sacred years."[49]

After a "very heated discussion" about Barrès began at the Certà, Breton insisted on organizing a mock tribunal charging him with an "attack against the security of the spirit."[50] With Breton as president, literary value would be assessed, an author's public responsibilities would be judged, and prescriptive norms issued. That this enterprise was inimical, in both method and goal, to everything Dada stood for was not lost on Tzara, who was, Soupault notes, "absolutely hostile" to the idea.[51] To him, Barrès was a minor French figure hardly worthy of comment. Aragon and Breton, though, were in the mood for settling scores: "how did the author of *A Free Man* become the propagandist for the right-wing *Écho de Paris*?"[52] As Breton later explained, the event had taken place outside the purview of Dada: "Though on the poster and programs it was still 'Dada' that led the dance ... in reality the impetus behind the event stood outside of Dada. This impetus actually came from Aragon and myself. The issues raised—which were of an ethical nature—might of course have interested several others among us, taken individually; but Dada, with its acknowledged bias toward indifference, had absolutely nothing to do with them."[53]

Breton was especially keen on this prosecution. Just a few months earlier *Littérature* had asked eleven Dadaists to rate nearly two hundred prominent authors and public figures on a scale from −25 to +20, with "−25 expressing great aversion, 0 absolute indifference," and +20 "unconditional devotion of heart and mind."[54] Tzara begrudgingly took part but

165

transmitted his contempt for this schoolboy exercise by giving the score of −25 for nearly two-thirds of the entries (his average score was −16, whereas both Aragon and Breton had positive averages). Despite putting Barrès on trial, Aragon had given him "14" and Breton "13"—high enough marks indeed.

The pretrial preparations included trips to the Palais de Justice to observe judicial procedure and Breton soliciting "depositions" from a wide swath of the literary establishment (even the editor of *L'Action Française*). The trial itself was held on Friday 13 May 1921 at the Salles des Sociétés Savantes in the 6th *arrondissement*. The main hall was hastily transformed into a courtroom, with a large banner reading "No One Is Supposed to Ignore Dada." The attorneys (Ribemont-Dessaignes as prosecutor, Aragon and Soupault for the defense) filed in wearing judicial robes while the head of the tribunal, Breton, donned his medical student uniform.[55] A dummy stood in for the accused (who was that night lecturing on "the French soul during the war" in Aix-en-Provence). The trial began at 9:30 p.m. when Breton read out a lengthy indictment. Despite its eight numbered charges, the text is rather muddled, with the "crimes" consisting of aesthetic failures ("Barrès's books are truly unreadable, the language only satisfies the ear"), expressions of disappointment at how Barrès had reneged on his earlier promise as a figurehead for liberation, and the charge that Barrès was a public threat because his works sullied the idea of revolutionary action.[56]

Six witnesses were called before the tribunal. After Serge Romoff, a Ukrainian writer who confessed to knowing Barrès's work "only slightly," Tzara took his place behind the music stand that served as the witness stand.[57] Asked if he would swear to tell "nothing but the truth," Tzara responded "No." Admitting to having no knowledge of Barrès and "no confidence in justice, even if justice is done by Dada," he nonetheless shared his opinions with the court: "You will agree with me, Monsieur le Président, that we're all just a bunch of bastards and so these little differences, a bigger bastard or a smaller bastard, don't matter at all."[58] The court's decision, he stated, inspired "my deepest disgust and most profound antipathy."[59] Increasingly agitated by Tzara's *je m'en foutisme* (couldn't-care-less attitude), Breton rebuked his nihilism and accused him of indifference:

Q: Do you know why you have been asked to testify?

Tzara: Naturally, because I am Tristan Tzara. Something of which I have yet to be persuaded.

Q: What is Tristan Tzara?

Tzara: It is the complete opposite of Maurice Barrès.

Q: The defense, convinced that the witness envies the lot of the accused, asks if the witness dares admit it.

Tzara: The witness says shit to the defense.[60]

As Tzara's verbal gymnastics continued, Breton desperately implored the witness to treat the court respectfully. Tzara refused, calling the proceedings nothing short of "a manifestation in his [Barrès's] honor":

> **Q:** Is the witness trying to pass himself off as a complete imbecile or is he trying to get himself taken away to a mental asylum?
>
> **Tzara:** Yes, I am trying to pass myself off as a complete imbecile, but I am not trying to escape from the asylum in which I am living my life.[61]

Tzara interspersed his answers with a mixture of nonsense and Dada philosophy: "I do not know what humor is, I do not know what poetry is, I do not know what the truth is, but I say textually what I say."[62] This reference to language's social role—the importance of which could not be lost on the tribunal, which was a court of rhetoric, as the crimes to be judged were literary and the sanction was to be literary as well—grew in importance during Tzara's testimony. Asked to take responsibility for his own language, he answered:

> My words are not mine. My words are everybody else's words: I mix them very nicely into a little bouillabaisse—the outcome of chance, or of the wind that I pour over my own pettiness and the tribunal's. My deductions are nothing but the result of fugitive thoughts more or less attuned to desires, the commodities of conversation. They present no absolute interest, they are not applicable, they are not pure fancy, they just represent a little need on my part to speak out, to wander about and to complicate things. My judgments. I don't judge. I don't judge anything. I judge myself all the time and I find myself a puny, disgusting man—a little bit like Maurice, although maybe a little less. All of this is relative.[63]

He finally left the witness stand, but not before launching into nonsense song:

> *Mangez du chocolat* [Eat some chocolate]
> *Lavez votre cerveau* [Wash your brain]
> *Dada*
> *Dada*
> *Buvez de l'eau* [Drink some water][64]

After Tzara's *tour de force*, the testimony from the remaining witnesses—the Italian artist Giuseppe Ungaretti, Rachilde, Jacques Rigaut, and Drieu la Rochelle—was anticlimactic. It was only when the "unknown soldier" (Péret wearing a gas mask and a German uniform) was called to testify that drama reentered the proceedings. The public, breaking out into "La Marseillaise," rushed the stage to prevent this defamation of the war dead. The curtain was drawn to prevent a riot. After that, the crowd was barely able to sit through the closing arguments and did not much care about the final sentence meted out by the jury: twenty years' hard labor.

Calling the trial "pitiful, grotesque, hateful even due to the introduction in this joyless masquerade" of the unknown soldier, *Comœdia* said that the Dadaists "should be punished:

absolute silence about their actions and gestures is unfortunately the stiffest sanction we can apply upon them."[65] Two papers called for their passports—Tzara's in particular—to be examined. *La Nation belge* claimed that the proceedings justified "a kind of literary 'fascism': a police intervention is called for."[66] But the only literary fascism in evidence in Tzara's opinion was the way his attempts to inject absurdity and humor into the proceedings had been dismissed by a heavy-handed Breton. If the show turned into a Dada masquerade, it was against Breton's wishes. Soupault noted that Tzara and Breton were both absolutely furious and that their friendship was irrevocably shattered.[67] Picabia walked out of the proceedings and again publicly departed from Dada: "Now Dada has a court, lawyers, soon probably policemen and a M. Deibler [the official executioner in France]."[68] For his part, Breton, who left Paris a few weeks later for his native Lorient, was contemplating an article "bidding farewell to Dada."[69]

Tzara was now living in the Hôtel des Boulainvilliers, a four-story building with "slippery waxed stairs" and a "strong odor of urine and disinfectant."[70] Luckily, Everling's apartment was only a ten-minute walk away; understandably, Tzara was often there, but not just to escape the hotel's smell. Earlier that year Picabia had hired the hall of the Théâtre des Champs-Élysées for a Salon Dada, but now that he had resigned from Dada he asked Tzara to organize the June event. This meant designing and writing the catalog, decorating the gallery space, and planning three soirées. The theater-cum-gallery space, renamed the "Galerie Montaigne" for the occasion, was on the top floor of a seven-story building without an elevator, which led to fanciful inscriptions on the staircase: "This summer elephants will be wearing mustaches. ... What about you?"[71] When the public finally reached the main gallery space, a clutter of objects greeted them: "From the ceiling hung an open umbrella, a fedora, a bundle of overly seasoned pipes, a cello wearing a white tie."[72] For the show Tzara had asked the Paris Dadaists to take up painting, which led to some incongruous work by poets with no artistic training. Breton pointedly refused to participate. There was artwork from Aragon, Fraenkel, Péret, Rigaut, and Soupault; for his part, Tzara contributed three paintings entitled *My, Dear, Friend*. There were also works by Arp, Baargeld, Ernst, and Walter Mehring, the three Italian editors of *Bleu*, and two Americans, Man Ray and Joseph Stella. Having published *New York Dada* with Man Ray in early 1921, Duchamp was also supposed to take part, but his recent decision to stop painting led him to ignore Tzara's frantic letters to send over works.

The art on display was a mere prelude to the soirée on Friday 10 June, for which over two hundred people paid a 10-franc entry fee. The performance kicked off with a colorful neighborhood character, an ambulant porcelain repairman named Jolibois. Although he was more enthusiastic than talented in his renditions of popular *chansons*, the audience were delighted. Soupault then walked in as "President of the Republic of Liberia" and delivered a pantomime performance. Aragon followed suit with songs from the balcony, but

the audience knew their favorite, shouting "Jolibois, Jolibois" during his number. This was followed by a dance performance, *The Miraculous Poultry*, in which the Russian poet Valentin Parnak swung around on stage with an artificial leg attached to his arm. When Dada poetry was read, the audience rebelled—only Jolibois's reappearance calmed it down.

The evening's highlight followed the intermission: Tzara's *Le Cœur à gaz* [The Gas Heart]. A play that radically calls into question theatrical conventions and whose absurdist humor brings to mind Beckett and Ionesco, its characters are EYE (played by Aragon), EAR (Soupault), MOUTH (Ribemont-Dessaignes), NOSE (Fraenkel), NECK (Péret), and EYEBROW (Tzara). Breaking down the human face had a special inflection for an audience in 1921 because of *les gueules cassées* (soldiers disfigured by the war).[73] Yet if Tzara subtly played upon this connotation, referring to "immobile navels" and "the man with star-shaped scars" in the first scene, it was only the better to assault the theater as a form, as the prologue reveals:

> NECK is upstage right, NOSE downstage left. The other characters enter and exit *ad libitum*. The gas-heated heart walks slowly. Lots of movement. This is the only and biggest hoax of the century in three acts. It will give joy only to industrialized imbeciles who believe that geniuses exist. The actors have been asked to give this play the same attention given to a masterpiece on the order of *Macbeth* or *Chantecler*, but to treat the author, who is not a genius, with little respect and to take note of the lack of seriousness of the text, which brings nothing new to theater technique.[74]

The elusive illogicality—stage directions which amount to no more than announcing that there would be no stage directions, calling the play a "hoax" but then insisting that it be approached as a "masterpiece"—was revelatory of Tzara's greater goal: disassembling the senses. Theater was being reduced to a staged enactment of language. Whatever plot, naturalist language, and understandable (if absurd) characters appear in *Ubu Roi*, for instance, are effaced in *The Gas Heart*, which consists entirely of senseless dialogue, undifferentiated characters, and no causal relationship between speech and "action."

169

If the play opens with EYE dividing the world into "statues jewels meats" (the bourgeoisie) and "cigar button nose" (the masses), the ensuing action subordinates this social question to a more all-encompassing chaos. The distinct body parts remain indistinguishable, unable to agree on anything and speaking at self-referential cross-purposes, as when EAR says: "The eye says to the mouth: open the mouth for the candy of the eye."[75] This teased the audience into thinking that somehow the unity of the face could be reassembled: "The needle reveals the left ear, the right eye, the forehead, the eyebrow, the left eye, the left ear, the lips, the chin, the neck."[76] As dialogue becomes a "mechanical battalion of clenched handshakes," the grip of language refuses to soften into meaning: "Look how the hour understands the hour, the admiral his fleet of words. Winter child the palm of my hand."[77] As EYE puts it, "Turn your back, cut the wind. ... Have you felt the horrors of war? Can you glide on the softness of my words? Do you not breathe the same air as me? Do you not

speak the same language?"[78] The classical tone adopted here, positioning the EYE as a supplicant pleading for equality with the interlocutor, dissolves immediately into a morass of objects that block communication: "Within which incalculable metal are your wretched fingers incrusted? Which music filtered by which mysterious curtain is preventing my words from penetrating the wax of your brain?"[79] Only MOUTH—appropriately enough, since *la pensée se fait dans la bouche*—consistently speaks in logically precise, grammatically clear sentences: but given that MOUTH's pronouncements are even more deluded than those of the other characters, the irony is unmistakable. It is true that the play's ending, when all six characters announce an upcoming "beautiful marriage" before telling the audience to go to bed, comes full circle to the ostensible problem first set out: social division. But there is little hope that characters who have been unable to agree on anything will break out of their disembodied separation. Everything natural about identity and the self on the stage is exposed as a "hoax," a spurious operation by the collective brain that marshals theatrical characters into order, the audience.

After this assault on the audience, the tables were turned a week later. When Picabia had hired the Galerie Montaigne, he had not claimed exclusive rights to the theater space. The performance space had been rented out to Luigi Russolo for a "bruitist" concert on 17 June and to Cocteau for the premiere of *Wedding on the Eiffel Tower* the following night. The idea of having an Italian Futurist and Cocteau in the middle of the Dada Salon was intolerable, so Tzara and several friends set out to sabotage Russolo's concert. But Marinetti, who was certain that this was going to happen, alerted the theater director, and, sure enough, as Dada's heckling started and flyers began falling from the balconies, the director told Tzara to stop. When he refused, a policeman was called to sit next to him. The director then told Tzara that the Dada Salon would be closed immediately, explaining to the press: "I thought that it was first necessary to prevent the children from disturbing the theater, and then to punish them by depriving them of their exhibition."[80] Tzara did not believe the order was serious, especially since a Dada performance was scheduled for the next afternoon. Arriving early to set up, he and his friends found the doors padlocked. With a substantial crowd having gathered outside, the circumstances were propitious for an improvised event; instead, Soupault and Tzara summoned a policeman and insisted that their contract was being violated. The theater director refused to open the doors; Tzara left fuming, yelling out that he would sue for damages. But now that the Dada Salon was irrevocably shut, the only thing to do was sabotage Cocteau's premiere: the Dadaists "stood up and sat down continuously in different parts of the theater throughout the entire show, shouting 'Long live Dada.'"[81] But this was a small victory amid a great defeat.

Before the various actors in Paris Dada left for their summer vacations, Picabia threw a bomb in their midst with *Pilhaou-Thibaou*. Tzara had no hand in the composition of this new number of *391*. Having rechristened himself "Funny Guy," Picabia had assembled a journal attacking Dada from all angles:

> Today by chance I wandered into a street where there is a large theatre and through one of the windows I glimpsed several paintings that were most probably the work of "artistic painters," that is to say monkeys who won't even give us the pleasure of true public onanism. What can you do? Everything is "spiritual," and jealousy and the spirit will always triumph.
>
> Young people in these parts go to the Théâtre des Champs-Élysées to smile at women who are not pretty but who dress with a pretty modernism. … The works at the Théâtre des Champs-Élysées are but the shadows of ghosts, discolored by the fancy of Parisian intelligence.[82]

Pilhaou-Thibaou also contained a number of personal attacks on Tzara, the most biting being that he had "usurped the paternity of the word DADA."[83]

With such rancor filling the air, it was just as well that Tzara boarded a train for Prague at the Gare du Nord on 20 July. Picabia's attacks having established a temporary truce between warring factions, Breton saw Tzara off at the station. Tristan and Maya were to meet in Bohemia, the destination chosen because Maya spoke the language and the vacation would be cheap because of the advantageous exchange rate. His wounded pride was comforted by her presence; the lovers took in the fresh air and visited picturesque mountain hamlets around the spa city of Carlsbad. Tzara also met Melchior Vischer, one of the leading Czech Dadaists. The 1920 novel *Sekunde Durch Hirn* is a series of disconnected entries, multiple lives, and adventures filling the brain of a man who has fallen off a scaffold. "Good then: a novel," but not really: in its moments of sound prose ("kroloscho su krolo su su suuuuu huih———iiihh! eternity!") and its incorporation of Tzara as a character ("I send, I Jörg, Serner and Tzara my intertelluric greeting and look forward to a boat ride over Niagara"), the novel is an example of Dadaist chance prose.[84] Although no concrete plans resulted from their meeting, Tristan regularly returned to Czechoslavkia, where his work was well received and translated into Czech.

It was in good spirits that Tzara and Maya left for Innsbruck in early August; they missed the *Anti-Dada and Merz* soirée, organized by Raoul Hausmann, Hannah Höch, and Kurt Schwitters, in Prague on 1 September. Vinea had begged Tzara to come to Bucharest, but Tzara had already agreed to meet Arp in the Tirol, where the devalued Austrian mark meant that food and lodging were cheap—for 130 francs, Tzara said, one could live for a month.[85] Arp asked Max Ernst to join them, and so the three couples took rooms in the Gasthaus Zonna in Tarrenz. Tourists from across Europe were attracted to the handsome fifteenth-century church, stunning mountain location, and sanatoria, and Tzara sent word of the cheap living, excellent food, and sunshine so that several Dada tourists— Paul and Gala Éluard as well as Breton and his new bride, Simone Kahn—would join them. Tzara shared his news of Paris Dada, and especially Picabia's attacks in *Pilhaou-Thibaou*, with Arp and Ernst. For his part, Arp issued Tzara a fantastic birth certificate for Dada: "I solemnly declare that Tristan Tzara discovered the word DADA on 8 February 1916 at 6 o'clock in the evening; I was present there with my twelve children."[86] But stronger action

171

IMST IN TIROL (GESAMTANSICHT).

172

FIGURE 8.5
Dada Tirol postcard to Theo van Doesburg.
From Raoul Schrott, *Dada 15/25*.

was needed against Picabia's attacks, and so Arp, Ernst, and Tzara decided to take advantage of their isolation to work on a new project, the eighth and final number of *Dada*, which was named, in honor of the bucolic setting, *Dada au grand air* [Dada in the Open Air]. With its title page announcing its publication date as "September 16, 1866–1921," the four-page *Dada au grand air* was a bilingual journal that responded to Picabia's attack by ridiculing his conceits: "Funiguy invented Dadaism in 1899, Cubism in 1870, Futurism in 1867, and Impressionism in 1856." [87] Picabia, the "celebrated moralist," was a "literary pickpocket." [88] But the journal was more than anti-Picabia musings; with its constant alternation between French and German, text and image, it was an example of Dada's internationalism and mixed-genre work. Because it was eventually printed and distributed in Paris, the significant presence of German artists—Arp, Baargeld, and Ernst—was a pointed message about continuing nationalism.

When the Bretons finally arrived, with André hoping to take part in *Dada au grand air*, the pages were ready. The group dynamic soured considerably in Breton's presence, and Tzara left Austria a few days later. By the time the Éluards arrived, Arp and Ernst had left as well, leaving the Parisians to stew in the Tyrolean air. Tzara, forced to return to Paris for visa reasons, arrived back in late September via Munich. He saw *Dada au grand air* to print. Picabia was so furious that he responded to each of Tzara's attacks via five thousand copies of a handbill which also served as an invitation to his own exhibition at the Salon d'Automne, where he promised spectators an "explosive" painting. The public took the term literally, forcing the director of the Salon to issue the following press release: "I would be grateful if you will let the public know that there is nothing to fear from Picabia's explosive painting. All the paintings were carefully inspected and none appeared suspicious. Visitors can therefore come to our Salon's *vernissage* in total security." [89] *Hot Eyes*, the "explosive" painting in question, was in fact a copy of an engineering blueprint for a turbine, so while Picabia accused Tzara of being a "fraud" who had "stolen" the name Dada, Picabia was being accused of plagiarism himself. The other Picabia painting in the Salon has become more famous: *L'Œil cacodylate* [The Cacodylic Eye] was a canvas that he had invited friends to sign, and over fifty signatures covered it, many of them coming from artists (Cocteau, Duchamp, Tzara) or entertainers (the singer Marthe Chenal, the Fratelli clowns, the couturier Paul Poiret). If paintings acquired value through their signature, Picabia seemed to say, instead of just one signature, this painting had so many that "there was no space left on it." [90] Even if he had formally withdrawn from Dada, Picabia showed that the Dada spirit could live on outside the group.

After the spring and summer of discontent, a new recruit to the Dada cause reenergized spirits: the American Emmanuel Radnitzky, who went by the name Man Ray. He took over Tzara's vacated room at the Hôtel des Boulainvilliers that summer, and through Duchamp he had met most of the Paris Dada group. The universal admiration for his abstract paintings,

FIGURE 8.6
Man Ray. Carl Van Vechten
Collection, Library of Congress,
LC-USZ62-63265.

174

airbrushed work under glass, came to acquire strategic undertones, for turning Man Ray into the leading painter of Paris Dada would undermine Picabia. When Tzara was back, in October, he and Man Ray rapidly became close friends (despite Tzara speaking only a little English and Man Ray no French), and plans were soon made for an exhibition at the bookshop recently opened by Soupault's wife, the Librairie Six, near the École Militaire. This was the first Dada event in over six months, and the advertising for the opening on 3 December made full use of the presumed death of Paris Dada:

> We read almost everywhere … that Dada died a long time ago. The haste to bury this character is simply the definitive and amusing proof of what an irritating nuisance Dada had been. … Thanks to Dada, the sinecure that was Art had become hell. …
>
> Yet we must find out of if Dada is really dead for good, or if it has simply changed tactics.[91]

This was followed by impressive figures detailing Dada's international reach: "17 exhibitions in Paris, 14 in Spain, 12 in London, 27 in Germany, 9 in Italy, 3 in Yugoslavia, 7 in Sweden, and 29 in the United States."[92] The same theme was taken up several weeks later in the collective tract "Dada n'est pas mort [Dada Is Not Dead]": "We are organizing 72 exhibitions in all of the capitals of Europe and the two Americas (Africa, Asia and Oceania are being spared); the same day, at the same hour, the 392 presidents of the Dada Movement will speak in 118 different cities."[93] The tract—which was signed by over a dozen Dadaists, among them Aragon, Breton, Duchamp, Man Ray, and Tzara—took evident delight in mystifying the reader: "Dada is ephemeral, but it is immortal."[94]

All of this was desperate self-promotion for the thirty-five Man Ray works on display, among them an object he created especially for the show, *Daring Gift* (1921). For the catalog Tzara wrote the following appreciation: "New York sends us one of its love fingers [NB: one of the paintings on exhibit was *Love Fingers*], which will not be long in tickling the susceptibilities of French painters. Let us hope that this titillation will again indicate the already well-known wound which marks the closed somnolence of art. The paintings of Man Ray are made of basilica, of mace, of a pinch of pepper, and parsley in the form of hard-souled branches."[95] Because there had been no Dada events in the city for six months, the public came to the exhibition to see what surprises awaited—but the only adventurous moment at the *vernissage* was the popping of balloons with lit cigarettes. The show ran until the end of December, but Man Ray's work did not captivate either the public or the critics: not a single work was sold, which led Man Ray to renounce painting in favor of commercial photography. By the end of 1921, Dada had few takers, but the New Year would produce some surprises. Even spurned girlfriends seemed to want to oppose Dada, as this letter to Tzara at the close of 1921 showed: "Dear little imbecile, Why have you spoken badly of me? I am going to start a group that will teach the Dada chief something about Dada love. … *Bonne année* and be a little kinder!"[96]

175

9 DADA'S FINAL HOURS: **1922–1923**

VISITING MAX ERNEST IN COLOGNE, TZARA MISSED THE PARTY OF THE SEASON, MARTHE CHENAL'S RAUCOUS "RÉVEILLON CACODYLATE [CACODYLATE NEW YEAR'S EVE]," WHOSE GUEST LIST INCLUDED BRANCUŞI, COCTEAU, PICASSO, POULENC, AND EZRA POUND. BRETON ALSO MISSED THE PARTY: HE WAS MOVING HOUSE TO 42 RUE FONTAINE, AN ADDRESS HE NEVER LEFT FOR THE REMAINDER OF HIS LIFE (SAVE FOR THE WAR YEARS IN NEW YORK). He was, moreover, preparing an event that would mark the dissolution of Paris Dada.

Although the cumbersome title "Congrès international pour la détermination des directives et la défense de l'Esprit Moderne [International Congress for the Determination of the Directives and Defense of the Modern Spirit]" left much to be desired, *Comœdia*'s front-page presentation on 3 January 1922 featured an arresting photographic collage of its impressive organizing committee: composer Georges Auric, writers and editors André Breton, Jean Paulhan, and Roger Vitrac, and painters Robert Delaunay, Fernand Léger, and Amédée Ozenfant. The journal of record of the Paris arts scene was confident that the Congress would lead to "new roads in thought" and unite competing artistic movements across Europe under the single banner of modernism.[1] Several days later, the Congress agenda was clarified:

> All those who in order to act do not seek cover under the tutelage of the past are invited to make themselves known. The opponents will line up to be counted.
>
> To clarify things, these are two of the many questions that the congress will be examining:
>
> Has the so-called "modern" spirit always existed?
>
> Of those objects deemed modern, is a top hat more or less modern than a locomotive?[2]

These questions were taken up in the popular press, and avant-garde reviews like *De Stijl* and *Ma* advertised the Congress, which, it was rumored, would be attended by Freud, Thomas Mann, and Marinetti. But Tzara's participation in this epochal event was in doubt.

FIGURE 9.1
The modernist top hat revived in
Littérature. *Littérature*, new series,
number 1 (March 1922).
Courtesy of the University of Iowa
Special Collections.

Although he feared that the Congress would be a reenactment of the Barrès trial, Tzara had tentatively supported Breton's idea out of friendship. While in Cologne for New Year's, he wrote an engagingly personal letter, not only asking Breton to submit material for a Dada review being planned by "our German friends," but also advising him on the Congress: "as the [organizing] committee stands, there isn't enough contrast and diversity to give everyone confidence."[3] When Tzara arrived back in Paris in early January (having gone to Berlin for a few days to arrange for the publication of *The Gas Heart* in the March 1922 issue of *Der Sturm*), he heard increasingly shrill reports about how Breton's Congress would be a serious academic conference. That seemed to be confirmed in the following Congress circular: "With the collaboration of those interested in the question, we have enough to proceed with the confrontation of new values, and for the first time we can render an exact account of the forces at work, and, if necessary, we can specify the nature of their conjunction."[4] The inevitable "committee and sub-committee reports" of such an undertaking did not sound very Dada.[5]

Tzara distanced himself from the event, but Breton feared the worst: would Tzara sabotage the proceedings? To preempt that, Breton asked Tzara to join the organizing committee. Tzara's answer took the form of a *pneumatique* dated 3 February:

Dear friend,

I have thought over your proposition that I join the Congress of Paris committee. I deeply regret to tell you that my reservations regarding the very idea of a congress would not change through my participation in it, and it is quite unpleasant for me to have to refuse the offer you've made me. Rest assured, dear friend, that this is not a personal decision taken against you or the other members of the committee, and that I appreciate your wish to satisfy every tendency, as well as the consideration you have shown me. But I think the current stagnation, the result of a mix of tendencies, the confusion of genres, and the substitution of groups for personalities, more dangerous than reactionism. You know very well how much I have suffered from it myself.

Therefore I prefer to stay put rather than to encourage an action that I consider harmful to this *search for the new*, which I love too much, even if it takes the form of indifference.

Do not look for other interpretations, and rest assured of all my affection.[6]

Barely able to contain his rage, Breton convened a meeting of the organizing committee, which resulted in the following vicious attack on Tzara:

At this time the undersigned, members of the organizing committee, wish to warn the public against the machinations of a character known as the promoter of a "movement" coming from Zurich, which demands no other designation, and *which today no longer corresponds to any reality*. The committee takes this opportunity to once again guarantee each person, contrary to certain malicious insinuations, complete freedom of action within the congress. All tendencies, even the most extreme, including those that claim to represent the person to whom

179

we are referring, will be taken equally into consideration. The only thing
we will not permit is for the fate of the enterprise to depend upon the schemes
of an imposter hungry for fame.[7]

The aggressive tone of the missive ("an imposter hungry for fame") and its xenophobic connotations (*venu de Zurich*) did not fail to arouse strong feelings. Tzara's reply was published the next day: "A few days ago I was not yet an imposter hungry for fame, since I was worthy of sitting amidst this noble conclave."[8] The shouting match that ensued in *Comœdia*, with Breton intimating that Tzara was not the "founder" of Dada, was gleefully reported in the press. A meeting was convened at the Closerie des Lilas to discuss the *ad hominem* attack, and while Breton boasted that the assembled artists would realize "just who they were dealing with," he could not stop their resolution of no confidence in his leadership.[9] Brancuși observed that "[i]n art there are no foreigners," while for Tzara it was self-evident that "an international congress that criticizes someone for being a *foreigner*" had no right to exist.[10] In private his fury was even greater, as Sanouillet observes: "Two years after their first meeting, the two men were already no longer speaking the same language; they were evolving on two distinct planes."[11]

In early March, Breton penned "After Dada," in which he accused Tzara of "bad faith" in parading himself as the leader of a movement he had not founded: "Dada, thank goodness, is no longer an issue. ... Although Dada had, as they say, its hour of fame, it left few regrets: in the long run its omnipotence and tyranny had made it unbearable."[12] Breton made public what the Dadaists had long suspected—that the Congress had been organized to sound the death knell of Dada. Breton later admitted that the initiative sprung from his conviction that Dada would always remain marginal under Tzara's leadership: "For my part I realized that Dada, to recover some of its vigor, would have to renounce its growing sectarianism and reinsert itself into a larger current; that it was time to put an end to our isolationist policies."[13]

Breton considered "modernism" a future state of affairs that had to be realized through the conscious actions of artists battling against forces of reaction. Jacques-Émile Blanche was shocked to find artists from the avant-garde speaking "about *construction*, about solidity."[14] Those who knew Breton more closely, though, were not so surprised. As Éluard, Ribemont-Dessaignes, Satie, and Tzara noted: "The ridiculous bureaucratic preparations and the henhouse capitalist advertising for the great congress on the outlining of modern art are already bearing fruit, leading to complications that reveal the organizers' true intentions: the desire to annihilate anything alive, the reactionary in all fields."[15] The whole point of Dada was to move away from artistic programs, as Tzara later stated: "modernism is of no interest to me. And I think that it was a mistake to say that Dadaism, Cubism, and Futurism rested on a common foundation. These latter two tendencies were based on an idea of intellectual or technical perfection above all, whereas Dadaism never rested on any theory and was never anything but a protest."[16] Tzara's understanding of the avant-garde was irrec-

oncilable with Breton's ideas. Breton wanted modernism to be a vanguard: a group of artists immersed in daily battles, seeking to win over society. Tzara saw these social battles as irrelevant when Dada was an ideal type, independent of theory and unmoved by history: "One of these days it will be known that before Dada, after Dada, without Dada, toward Dada, for Dada, against Dada, with Dada, despite Dada, it is always Dada. And all that is of no importance." [17]

The violence of the public disagreements between the core of Dadaists who remained loyal to Tzara and Breton's companions created such a poisonous atmosphere that by early April Ozenfant told Breton that the Congress could not take place. Watching all this from the Côte d'Azur, Picabia—whose temperament and ideas made him particularly unsuitable for Breton's Congress—played the role of scandalmonger through *La Pomme des Pins* [The Pine Cone], a violent pamphlet attacking Dada. Tzara rounded up his core supporters—Ribemont-Dessaignes, Péret, and Satie—to respond with *Le Cœur à barbe* [The Bearded Heart], which gloated over the fact that the "Congress of Modernism ... died of chocolate nationalism, of vanilla vanity and of the Swiss stupidity of some of our more precise co-citizens."[18] Although he had come out victorious, Tzara paid a heavy price: his friendships with Breton and Picabia were irreparably broken, and Paris Dada was effectively finished.

Ever since the start of 1922, Tzara had been featured more often in the gossip pages than the arts supplements. At the costumed ball at Magic City, a Mardi Gras tradition for Paris's homosexual community, he appeared with "his face all painted and powdered, masquerading as a Roman matron. He looked unbelievable, the very wreck of a female creature."[19] He played to the audience, alluding to Dada history: "Ah, I know what you are thinking about me. ... But you are quite wrong. No one knows the secret of Tristan Tzara's sex! There are some who say I am a homosexual; and others who say I am impotent. But the truth is that I am a virgin."[20] Tzara as *mondaine* Dada was increasingly in demand, and many evenings were passed at the newly opened Le Bœuf sur le Toit, the "crossroads of destinies, the cradle of lovers, the foyer of discords, the navel of Paris."[21] Man Ray—who had convinced Tzara to move away from the bourgeois 16th *arrondissement* to the Hôtel des Écoles ("Modern Comforts, Electricity, Central Heating, Bathrooms, Hot and Cold Water") on rue Delambre, in cosmopolitan Montparnasse—was also a regular at Le Bœuf. *Vanity Fair* profiled Tzara as one of the stars of the Parisian literary scene; the accompanying photograph by Man Ray showed Tzara in monocle, tuxedo, and bow tie.

Another faithful client of the Le Bœuf was Tzara's Romanian compatriot, Constantin Brâncuși. Tzara had paid his first visit to Brâncuși's "enormous studio, all white, full of blocks of marble and stone" soon after arriving in Paris.[22] He was so bewitched by the way Brâncuși's objects embodied "a fluid idea *within* hard material" that he took some of them to be photographed, which the famously possessive sculptor did not much appreciate.[23] But

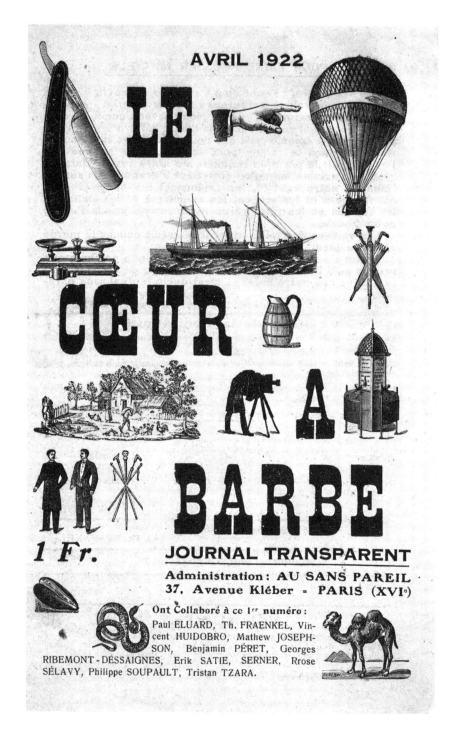

AVRIL 1922

LE CŒUR A BARBE

JOURNAL TRANSPARENT

1 Fr.

Administration: AU SANS PAREIL
37, Avenue Kléber - PARIS (XVIᵉ)

Ont Collaboré à ce 1ᵉʳ numéro:
Paul ELUARD, Th. FRAENKEL, Vincent HUIDOBRO, Mathew JOSEPHSON, Benjamin PÉRET, Georges RIBEMONT-DÉSSAIGNES, Erik SATIE, SERNER, Rrose SÉLAVY, Philippe SOUPAULT, Tristan TZARA.

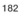

Tzara was always welcome, "with the door open, dear friend," and Brâncuşi was enthusiastic about Dada, writing under one of his drawings: "Dada will bring us the things of our time."[24] Brâncuşi entertained guests with folk songs and treated them to roast chicken baked in a traditional peasant oven.[25] Although he had been in Paris for nearly two decades, his art remained firmly indebted to a Romanian peasant tradition (Brâncuşi still performed liturgical services at the Romanian Orthodox Church). At the same time he was entirely modern, insisting upon the transcendence of abstraction, of the universal qualities of forms that no longer represented but rather embodied ideas and feelings. His devotion to art was complete, as he tirelessly filed away at sculptures and perfected their smooth lines. When Brâncuşi left his studio, Tzara was always happy to see him, and the two were often together at Le Bœuf or in other Montparnasse cafés.

These social adventures did not compensate for the loss of Dada. While Tzara continued to receive letters from foreign correspondents inviting him to undertake Dada tours abroad—Theo van Doesburg was particularly enthusiastic about the possibility of Holland becoming a staging ground for Dada—these could not replace the lack of activity in Paris. *Littérature* had recommended publication, but Tzara was no longer involved or welcome in its pages. Vitrac's *Aventure* had ceased publication, and its reincarnation, *Dès* [Dice], was not sanguine about the possibility of concerted group action: "Our mistake then was in believing that young men could—without thereby sacrificing their individuality or that relatively supple egoism from which genius emerges—form a group driven by the same tendencies."[26] Ribemont-Dessaignes, Tzara's closest remaining Paris Dada friend, had moved to the countryside because Paris had become too expensive, but life was no easier for him, as he told Tzara: "so many obstacles and fatigue. ... What are you doing? What shall we do? I am at a loss. ... Give me some news. The review? No projects?"[27]

FIGURE 9.2
Pamphlet wars over the Congress of
Paris: *Le Coeur à barbe.*
Courtesy of the University of Iowa
Special Collections.

DADA'S FINAL HOURS

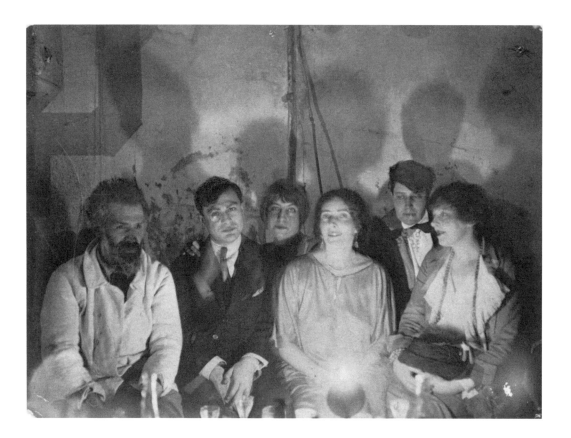

184

1922–1923

Prompted by these ruins of Paris Dada, Tzara worked on "Some Memoirs of Dadaism" for *Vanity Fair*. There was a veritable cottage industry of Dada histories coming out in 1922, from Pierre de Massot's *De Mallarmé à 391* to Aragon's *Projet d'histoire littéraire contemporaine*, which had been commissioned by Jacques Doucet, a fashion designer turned Maecenas of the avant-garde (Tzara sold the manuscript of *Vingt-cinq poèmes* to Doucet in 1922). Both Massot and Aragon called Dada a spent force, part of French literary history but no longer constituting French literary reality. Tzara's *Vanity Fair* essay, which appeared in July 1922, did not dispute that. Not only did *Vanity Fair* pay well—a most welcome change from avant-garde reviews—but Tzara was given free rein to express his version of Dada history. This impulse by Dadaists to write the group's history continued a tradition that started with *Cabaret Voltaire*, which was conceived of as a "documentary" record. Because of separate numbers of *Dada* covering events and the all-encompassing "Chronique Zurichoise" (which was published in Huelsenbeck's 1920 *Dada Almanach*), Tzara does not begin his *Vanity Fair* account in Zurich but, rather, in January 1920, with him being "back [in Paris] ... extremely glad to see my friends again" (an odd claim, since he had only met Picabia by then). Although he was still smarting from the bitter fights over the Congress of Paris and allegations that he had usurped the leadership of Dada, these events do not darken the article (save for its characterization of Breton as someone "whose behavior displays the stigmata of religious sectarians").[28] Instead, Tzara presents a triumphalist version of Dada history, enumerating the successes of the soirées and the hysterical public and media agitation they engendered in Paris. But an attentive reader could see the gaps in his account: the Paris section of the essay is devoted to the first six months of 1920, but there is nothing about more recent events (the second part of the essay looks at Dada's global spread).

But this excursion into Dada's past, remunerative as it might have been, was not as satisfying as imagining Dada's future, so Tzara pinned his hopes on re-creating the magic of the previous summer's Tyrolean tryst. Neither Man Ray nor Ribemont-Dessaignes was able to leave Paris; only Éluard and Matthew Josephson (an American who had come to Paris in late 1921 and issued *Secession* during the Congress of Paris scandal) showed any enthusiasm for the trip. The summer could not come quickly enough for Tzara, who left Paris at the end of June and checked into the Gasthof Post, an eighteenth-century château in Tarrenz. Gala and Paul Éluard were already there, as was Josephson. Lodgings were very cheap, with even the penurious Josephson (he had joined up with Dada because with them "thrills may be wrested at the lowest cost") able to take a spacious room with nine windows.[29] Max Ernst was nearby, and a few days after Tzara's arrival Arp and Sophie Taeuber joined the group. But if the plan was to make another number of *Dada au grand air*, the drama surrounding the love triangle between Gala and Paul Éluard and Ernst soured good feeling, as Josephson relates: "Tzara was quite vexed over this business and, when he was alone with me, expostulated: 'Of course I don't give a damn what they do, or who sleeps with whom. But why must that Gala Éluard make it such a *Dostoevsky drama*! It's boring, it's insufferable, unheard of!'"[30]

With more productive collaboration off the table, there was little to do but enjoy the scenery and talk. Josephson recalls discussions about Dada's presumed death and how Breton was "planning a new departure," to which Ernst proclaimed himself "always and forever a dyed-in-the-wool Dadaist"—but Tzara, for his part, showed himself "profoundly indifferent" to Dada's fate.[31]

By mid-August Tzara had settled in Reutte, a popular tourist destination in a heavily forested area about thirty kilometers away. A letter from Van Doesburg made Tzara extend his holiday: the Dutch artist asked him to hold a "Parisian soirée" in Weimar, an increasingly important artistic center because of the Bauhaus, which had been founded in 1919.[32] Van Doesburg wanted Tzara's talk at the Weimar Constructivist Congress in mid-September to be "a new blow at Expressionism and Romanticism at the Bauhaus."[33] In no rush to get back to Paris, Tzara accepted; Arp was even more enthusiastic about the trip. There was an undoubted symbolic value in bringing Dada to the former home of Goethe and German Romanticism, now the center of Bauhaus, where Gropius, Kandinsky, Klee, and Moholy-Nagy taught.

Arp and Tzara left for Germany in early September, first stopping in Munich. Tzara was captivated by postwar Germany, which he likened to "a film in episodes, a vast drama of multiple compartments, sprinkled with the vinegar of comedy. ... Events unfold quickly, and I often had the impression that all of Germany is in front of a huge camera, in an immense studio, acting out the twists and turns of a plot that remains mysterious to us."[34] In this travelog destined for *Vanity Fair* (but never published), Munich was for Tzara the city of Expressionism, a bohemian paradise of galleries; he and Arp visited the German Exhibition of Applied Arts. After a quick trip to Berlin, Tzara was expected in Weimar on 19 September. The Bauhaus faculty was not enamored at the prospect of Tzara's presence: "We saw in Dadaism a destructive force, outdated in view of the new Constructivist perspectives," Moholy-Nagy writes.[35] Gropius had rejected the application of Johannes Baader, the self-proclaimed "Ober-Dada," for a post on the Bauhaus teaching staff. For his part, Tzara had reservations about the "vulgarization" of "applying [Expressionism] to publicity, interior design, and industrial products."[36]

As it was, the Constructivist Congress had representatives from Hungary (Moholy-Nagy), Czechoslovakia, Yugoslavia, Russia (El Lissitzky), Switzerland (Arp), Germany, and France. Proclaiming the death of Dada, Tzara's address was a *tour de force*, a manifesto in the form of an academic talk pitched to destroy any positive programs for art:

> I know you are expecting explanations on Dada. I won't give any. Explain to me why you exist. You have no clue. You'll say: I exist to make my children happy. But deep down you know that's not true. You'll say: I exist to protect my country from barbarian invasions. That is not enough. You'll say: I exist because God wants it so. That's a tale for children. You will never know why you exist but you will always be influenced into bringing seriousness into life. You will never understand that life is a game of words.[37]

Insisting that he was speaking only for himself—"And that is already too much"—Tzara proclaimed "quasi-Buddhist indifference" to be a dominating principle of Dada: "For all is relative. What is Beauty, Truth, Art, the Good, Freedom? Words that mean different things to different people. ... We have become accustomed to giving these words a moral value and objective power that they do not have. Their meaning changes from one person to the next, from one country to the next. People are different, and in their diversity lies the interest."[38] Directly addressing the programmatic and formal objectives of the Congress of Paris, and also of the Bauhaus with its clear enumeration of principles, Tzara argued that Dada had to be placed outside of any system:

> Intelligence is an organization like any other ... a social picnic. It is used to create order and to provide clarity where there is none. Intelligence is the triumph of a good education and pragmatism. Life is, fortunately enough, something else, and its pleasures are countless. ...
>
> We are. We argue, we fret, we struggle. The intermissions are sometimes nice, but they are often tinted with infinite boredom—a swamp bordered with beards of moribund shrub. We are tired of the reasoned movements that have dilated out of proportion our naïve belief in the benefits of science. What we want now is *spontaneity*—not because it is more beautiful or more valuable than something else, but because everything that comes out of ourselves freely, without the intervention of intellectual speculation, represents us.[39]

For Tzara, an unbiased and unfiltered representation of the self, "the intensity of one's personality, directly and clearly transposed into one's work," entailed letting go of antecedent theory. This is why Dada remained outside of theory, and assumed an absolute indifference: "Dada applies to everything, yet Dada is nothing, it *is* the point where *yes* and *no* meet. ... Dada is useless, like everything else in life."[40]

The Bauhaus audience, whose reform of modern arts was premised upon utility in the first instance, on the functionality of art, did not take to Tzara's closing salvos well. Yet for all the philosophical and aesthetic differences between Bauhaus and Dada, Tzara could not easily dismiss a school that employed Paul Klee, a "seductive" artist whose work he had long appreciated.[41] He showed Moholy-Nagy copies of Man Ray's *Champs délicieux* [Fields of Delight], to which he had written the introduction, and thus introduced the Hungarian photographer to "rayographs." Gropius sent Tzara a warm letter just a few days after the talk, and Tzara so admired his *Denkmal fur Märzgefallenen* (a concrete, Expressionist-inspired monument for seven workers killed in the Weimar revolution) that he promised to look into the possibility of an American arts journal running a feature on it.[42] The Bauhaus faithful asked Tzara to write a book for their publishing house (a project that was not realized), and Gropius invited him to take part in a Bauhaus festival the following summer.[43]

Joined by Arp, Raoul Hausmann, Schwitters, and Van Doesburg, Tzara gave a talk on modern art in Jena and Hanover.[44] In the university town of Jena, he observed that "the

young fascist students attach little value to a man's life." Even though his talk was delivered in French, "To my great regret there were no incidents. I was hoping to learn interesting things in the tumult about the German character."[45] The traveling Dada troupe went on to Hanover, Schwitters's hometown. In 1919, his poem *Anna Blume*—whose cover prominently declared "Dada"—had been an astounding success in Germany. Schwitters called his version of Dada *Merz*, explaining its objectives in a July 1919 article in *Der Sturm*: "In essence, the word 'Merz' means assembling all sorts of possible materials for artistic ends and, by principle, asserting an equality between these materials on a technical level."[46] In a Germany in ruins, Schwitters constructed his art out of random objects picked up in the street: from "tram tickets, scraps of paper and newspaper glued together" to "bits of rusted metal, padlocks and broken wheels."[47] Schwitters was one of the strangest figures in the annals of Dada; Tzara was captivated by his enigmatic personality: "His mind is composed of a singular mix of jest, skepticism, satire, and poetry. Borders are never well defined, and you never know exactly when he is being serious and when he is making fun of himself or the public. … Add to this a disconcerting originality, an ambiguous smile, and a voice possessing every possible inflection."[48] Tzara was persuaded that Schwitters was a major artist, because his paintings did not rest on the illusions of art: "Unlike other artists, his paintings do not leave the studio new only to age later—they are half broken, rusted and soiled because, as he puts it, in life everything wears out and nothing is perfectly clean—not men, not furniture, not feelings."[49] Schwitters showed (to an extreme, it later turned out) the inseparability of art and private passions, an example that Tzara hoped to follow himself.

With Breton embarking on sessions devoted to interpreting dreams, Man Ray setting up a commercial photography studio, Picabia perpetually vacationing in the South of France, Ribemont-Dessaignes writing feverishly in the countryside for any publication that paid, and Soupault taking the reins of *Europe*, a literary monthly, when Tzara arrived back in Paris that autumn there was little in the way of Dada activity. The next few months would be characterized by personal projects, not collaborative ones: a poetry collection entitled *De nos oiseaux* [About Our Birds] and a mock-autobiographical novel, *Faites vos jeux* [Place Your Bets]. Neither project came to a satisfactory conclusion, with *De nos oiseaux* remaining unpublished in France until 1929 and *Faites vos jeux* abandoned unfinished. The American literary critic Malcolm Cowley tried to interest American and British publishers in translations of Tzara's manifestos and poetry, but the negotiations with Knopf proved intractable and the offer from Boni and Liveright was desultory.[50]

De nos oiseaux was published only in a French commercial edition in 1929, but the manuscript was ready in late 1922. Culling poems from the last ten years, it is one of the most international collections of poetry ever assembled, consisting of thirty-six poems originally written in two languages (Romanian and French), composed in three major cities (Bucharest, Zurich, and Paris), and published in reviews from ten different countries (America, Belgium,

Britain, France, Germany, Holland, Italy, Romania, Spain, and Switzerland). The illustrations were done by an Alsatian artist (Arp), and the work's first publication bore the mark of a Weimar printer!

The manuscript made the round of Tzara's friends, with Guillermo de Torre in Madrid asking for a copy, Cowley reading it in early 1923, and Soupault even penning a review of it in *Manomètre* in August 1923. In that review Soupault wrote a line that, given *De nos oiseaux*'s publishing history, seems ironic in the extreme: "The great merit of Tristan Tzara is to write too much and to publish even more."[51] Tzara was besieged by demands from editors of little reviews for original work, but book publishers were more hesitant to take him on (unlike Aragon and Breton, who both placed books with Gallimard). It did not help that French publishing faced a series of economic problems in the 1920s: paper was in short supply and expensive, typesetters demanded higher salaries and frequently went on strike, and books faced greater competition from the radio and cinema. Éditions de la Sirène was supposed to publish *De nos oiseaux* but inexplicably pulled out. There were talks with the publishing arm of *Les Feuilles Libres* (which wanted to bring out *Faites vos jeux*), but Tzara's failure to deliver his novel ruined the chances for *De nos oiseaux*.[52] Tzara tried to interest Gallimard, but the premier French publishing house indicated that its series "Une œuvre, un portrait" was full.[53] *Cahiers du Mois* refused *De nos oiseaux* in 1926 for "base commercial reasons": "We probably have never so much regretted having to give in to the public's imbecility."[54] The same reason was invoked by Au Sans Pareil, which rejected the collection in 1928 because "its commercial possibilities appear to us too limited."[55] It was only after Tzara invoked help from both Soupault and Fraenkel that the work was published in 1929 by Éditions Kra (the publisher, five years earlier, of Breton's *Manifeste du Surréalisme*). Fraenkel had given the manuscript to Léon-Pierre Quint, who worked at Kra with Soupault (who had unsuccessfully tried to interest the publisher several years earlier with the same volume, but Kra was generally averse to publishing poetry).[56] But now that Quint was on board, Éditions Kra proceeded—after receiving a check for 1,000 francs from Tzara—to publish the work in June 1929.[57]

Publishers were perhaps not mistaken in thinking *De nos oiseaux* a tough sell. It spans ten years of activity, and no consistent poetic voice comes through, although there were hints of *Vingt-cinq poèmes* in both the technical mastery of the poems and the obscure amalgamation of images:

> mornings drown the desires muscles and fruits
> in the raw and secret liquor
> soot woven in golden ingots
> covers the night clawed by brief patterns.[58]

With its immense powers, nature overwhelms the world of "precise secular economical men"[59] and transforms human longing and desire into an immense combat for self-sufficiency:

the tree bursts with food like a lamp
I CRY want to rise higher than the fountain snake in the sky for
earthly gravity no longer exists at school and in my brain
my hand is cold and dry but it has caressed the spurt of water
and I have again seen something (in the sky) as the water
screws the fruits and the gum.[60]

This battle for sovereignty, of becoming an independent will in a world where all is movement and change, is a poetic principle as well:

our special product
"INTELLIGENCE"
the cheapest and longest lasting
on sale
everywhere
always
can hardly steel the self against "the avalanches to come."[61]

The insufficiency of language—Benjamin Fondane later observed that throughout *De nos oiseaux* Tzara "suffers to use words, [and] the words suffer in so badly serving him"— is a constant struggle for the poet who searches out closure and self-standing forms, as in the image of the circus animal tamer who applies "blows of measured and appropriate force."[62] There is less use of pure "sound" in these poems, but sometimes Tzara uses the precision of technical language to create a similar effect, from the absurd *"poudre de perlinpinpin"* (a phrase referring to quack ointments), the enigmatic *"urubu"* (alluding to Jarry's *Ubu roi*, but actually a type of vulture from the American tropics), the antique *"phaéton"* (a horse-drawn carriage), and the sinister-sounding *"scolopendre"* (a centipede).[63]

But language can also become a mystical, bodily presence:

I was spending my time in counting sun rays
and the hair of your words
the tree of skeleton covered with leaves and springtime
the attraction of your face
invades the end of the game of chess[64]

The lyricism of these lines points to another quality of the collection: a strong poetic subjectivity immersed within a past and obsessed with human relations, even if at times this is done ironically:

I have not forgotten my mother and yet
the last commitment (so favorable)
she would forgive me I think
it is late
in all corners there are irregular drum beats
if I could sing only

always the same always somewhere
this blinding light ants transparency
surging from the guilty hand
I will leave
the Madonna carved in wood is the advert the critique

...

with the most subtle inflexion do you think too about me
four numbers on the wall
with the last worry
why search
and this is a bell that will never stop ringing[65]

The "planet of laughter" that Tzara's poetic world evokes is not incompatible with a tragic awareness of one's singular isolation and the realization that

insensitively clear
the keys of roots
didn't you know
were our medicine[66]

The impulse to seek out the past connects *De nos oiseaux* with Tzara's other major writing project in late 1922 and early 1923, *Faites vos jeux*. Having written poetry, plays, manifestos, and criticism, Tzara now tried his hand at the modern novel, with mixed results. While *Faites vos jeux* contains moments of brilliance in its metafictional dissection of the artificiality of *Bildung*, it is also a disorganized, scattered work better read in installments. This was perhaps inevitable given the history of its composition. From March 1923 until March 1924 the work was serialized in six numbers of *Les Feuilles Libres*. The last extract was prefaced with the following editorial note: "Due to previous engagements, *Les Feuilles Libres* regrets to announce that these pages end [our serialization of] Tristan Tzara's novel. Its complete text will only appear in book form."[67] Although there were plans for this book publication (and a Czech translation), Tzara never finished his "endless novel" despite the financial inducements that doing so would have brought: he was paid 300 francs for each installment in *Les Feuilles Libres*, and the book would have brought even greater rewards.[68]

Publishing the installments in *Les Feuilles Libres* was a sign of independence on Tzara's part. This monthly review, founded in 1918, proclaimed itself a refuge for "*la pensée*, for inspiration without constraints."[69] It had a traditionalist bent insofar it refused "poems in the shape of a pear" because "there are certain grammatical and syntactical laws that we wish to follow."[70] *Les Feuilles Libres* had not been enamored with Paris Dada, which its associate editor, Willand Mayr, called a "literary tam-tam" of "incoherence, onomatopoeia, interjections, exclamations, vituperations."[71] Yet its editor, Marcel Raval, who had supported Tzara in the Closerie des Lilas resolution against Breton, opened up his review to Tzara's

191

letters about the affair. And so an unlikely collaboration began, with Tzara's work appearing with some regularity in an otherwise high-culture review that Breton attacked for "opportunism."[72]

If the editors of *Les Feuilles Libres* appreciated how the prose reflected "the pure mirror" of its subject, *Faites vos jeux* is neither a novel nor a memoir.[73] It is in many ways a metafictional exploration of that famous *Littérature* survey: "Why do you write?"[74] Tzara was rethinking this question in the context of two important forces, the growing subgenre of Dada autobiography and the problem of the novel (in 1920 Aragon could not tell his friends that he was writing *Anicet* because everyone in the Certà crowd assumed that the novel was a base commercial form). Early readers were enthusiastic about Tzara's venture. Bernard Faÿ lobbied Grasset to publish the work, and Franz Hellens tried to interest a Moscow publishing house in translating it. Nicolas Beauduin, editor of *La Vie des Lettres*, told Tzara that he was "fully assured of [Tzara's] literary future" after reading it.[75] A young Belgian musician, E. L. T. Mesens, who had met Tzara at Brancuşi's studio and proposed a tour of Belgium and collaboration on a Dadaist ballet, was enchanted by the novel: "Within a single sentence you express ... more than many '*littérateurs*' manage to say in an entire work."[76]

The opening of *Faites vos jeux* inscribes the work within a literary heritage: Rousseau's autobiographical project and, more specifically, *Reveries of a Solitary Walker* ("I was walking in Paris in one of those old streets battered by storms, polished by the glances and the touch of passers-by.")[77] Just as Rousseau was haunted by the prospect of being turned into a spectacle for the greedy eyes of the public, Tzara continues: "In these narrow streets I always believe myself observed by everyone. I imagine that behind every window there are people looking."[78] But the ensuing text fails to live up to Rousseau's professed ambition to present "the only portrait of a man, painted exactly after nature and in all its truth."[79] Although some critics consider it to be Tzara's "autobiography," it only ironically gestures to the genre: "I am putting off, for when it will be easier for me, the desire to express myself as I wish to, sincerely, without restraint, in all the clarity whose consequences I can bear."[80] Vowing to take up the methods of "intra-cellular detectives" (psychologists), the narrator then proceeds to promise "an exploration of my sensibility, without method or chronology."[81]

But this promise is never fulfilled, as *Faites vos jeux* is made up of elaborate linguistic games, the first-person sentimental novel of education turned into a series of thwarted loves and bizarre events. There is a romanticized quality to some of the love episodes, and certainly a number of scenes from Tzara's own past appear in the work: memories of his friendship with Vinea, his arrival in Zurich, and his broken relationship with Maya. But the scenes are constantly reworked, and they are not recounted with honesty in mind. The nameless narrator reveals very little about himself, and the teleological focus of autobiography, wherein past events are significant in terms of a present, grounded self, is transformed into constantly mutating games of chess:

> Chess games are always unpredictable. Exchanging queens makes them uniform and poor. Each game bears the fingerprints of the player's character. Some games are slow and harmless, self-effaced and predictable, anxious and whimsical; some players want to take everything while others give, others make use of craftiness to win a piece, which makes them as detestable as they are in everyday life. Some games are rushed, which leads the opponent to react quickly and without thinking. I like taking chances; my moves stand on the edge of danger; I always move my pieces by comparing positions—the mental balance of constellations often leads to desperate leaps.[82]

The narrator's inability to play fairly should betray to the reader a certain apprehension about the text:

> A long time ago a lady I loved wrote to me to say that I was losing matches because I was cheating. I want to protest here, in the hope that these few lines will reach her one day. I cheat—of course I do—because I live between relations of boredom, satisfactions, pretensions, and human obligations. I breathe life into the flabbiness that lingers between a passion, an action, or one idea and another. The goal of life is to die; I admit this to myself, and this is the same cowardice that prevents me from coming to this normal ending.[83]

The incongruity of defeat being ascribed to cheating reveals the delight Tzara takes in overturning common expectations. Throughout *Faites vos jeux*, he refuses to fix the narrative time but foists upon the reader multiple plot lines from an unspecified moment in the past, as if simultaneous games of chess were being played and one confused the positions from various boards. If "the most distant relationships open the drawers of my memory," attempting to fix the relationship between them turns out to be an empty game, since memory is nothing but "a decoration of successions," a "professional" exercise with little relation to truth.[84]

The novel is set in an entirely delocalized and unspecified modernity: "The hotel room is the summary of your life, which could have been someone else's and which adapts itself to any past, any temperament, any occupation and any price."[85] While a number of important events in the narrator's life are referred to (violent fits of vertigo that lead to writing, his first sexual experience with a maid, his first love, his emigration abroad), he remains an empty vessel: "The probabilities of language have always served to disentangle myself from uncertain and delicate predicaments. I don't always want to take full responsibility for my feelings: they vary, they are often ambivalent, and if they are fresh it is because I haven't evaluated their power or their duration."[86] The first character in *Faites vos jeux* reveals just how far Tzara took these metafictional machinations. Germaine-Louise Cottard, twenty years old, lives in Octeville-sur-Mer, a village in Normandy near Le Havre: with her unhappy marriage and long days spent at home while her husband is at work, Germaine-Louise is redolent of Madame Bovary. But instead of committing suicide like Emma, Tzara plays upon the sordid *faits divers* of provincial newspapers and sentimental novels as

193

Germaine-Louise shoots her husband with a revolver, confesses to the crime, but then blames her lover for the act. The narrator admits being guilty himself in some way but never explains exactly how; Germaine-Louise is sent to jail, and the narrator drops her story in favor of another memory. A morass of details follows, bringing out the failure both in life itself and in the writing of a life: "I lack the necessary distance between the characters and the events they set into motion. My evaluation is not objective. My readers will never be able to follow me."[87] And with that, Tzara pretty much abandoned any hope of finishing *Faites vos jeux*.

When Breton and Tzara were interviewed, one week apart, by *Le Journal du Peuple* in early 1923, the differences between the two were once again aired in public. A few months earlier Breton, introducing a Picabia exhibition in Barcelona, had said that Tzara "no longer found his place" in modern art: "a few press clippings had, as was often the case, turned his head."[88] Back in Paris, Breton was depressed at the prospect of no longer having a guiding principle and vowed to quit writing. Tzara, though, was serene despite the recent tumult: "Dada has been a purely personal adventure, the materialization of my disgust. Perhaps there have been results, consequences. Before it, modern writers all valued discipline, rules, unity. ... After Dada, active indifference, spontaneity, relativity, and the current couldn't-care-less attitude invaded life."[89] Asked if he was, as Breton alleged, an *arriviste*, Tzara responded: "Clearly. Very much so. What I like most in life is money and women. But I have little money and not much luck in love. ... I want to cultivate my vices: love, money, poetry. I will push them to the final limits. And I'm afraid I won't be done before I die."[90]

By this point Paris Dada had been dormant for nearly a year, but Tzara was preparing its final curtain call. Rather than presenting a Dada "revival," however, the "Soirée du Cœur à barbe [Evening of the Bearded Heart]" turned to old hands, a dated pamphlet, and a re-staging of *Le Cœur à gaz*.[91] Despite the lack of novelty on offer, the problem of finding a venue large enough to accommodate the expected audience was acute, since most theater managers were wary of hiring out space to Tzara. The Georgian artist Ilia Zdanevich (who went by the name Iliazd), who had arrived in Paris in late 1920 and was a key figure in the Russian émigré avant-garde, had spoken with Tzara about a possible collaboration after a Russian soirée at La Licorne in April 1923 that Tzara attended. Iliazd was able to hire the suitably large hall of the Théâtre Michel on rue des Mathurins, not far from the Gare Saint-Lazare, for two nights on 6 and 7 July.

As Sanouillet explains, Tzara intended the evening to be "a show—an extremely avant-garde show, perhaps, but a show nonetheless—intended to be performed, seen, and heard under normal conditions—that is to say, in relative silence and with the audience's assent."[92] The program included poetry readings, music by Auric, Milhaud, Satie, and Stravinsky, and films by Man Ray and Hans Richter. Tzara had convinced Man Ray to put some rayographs on film, and *The Return to Reason*, an improbable and fantastically edited sequence of

objects (salt and pepper shakers, pins and thumbtacks) sprinkled on negatives was born.[93] The highlight of the evening was *Le Cœur à gaz*; Iliazd greatly admired Tzara's play (he had not seen its amateurish staging two years earlier) and pushed for it to be restaged.[94] Professional actors were hired: Jacqueline Chaumont and Saint-Jean from Théâtre-Odéon; Marcel Herrand, who had been cast in Apollinaire's *Les Mamelles de Tirésias*; and Lizica Codreanu, a Romanian dancer who had performed to Poulenc's *Trois Mouvements perpétuels* at Iliazd's La Licorne soirée.[95] Sonia Delaunay printed geometric patterns on jutting cardboard to serve as costumes (Tzara later composed poems in honor of her dresses, and they were lifelong friends). Iliazd used his network of Russian contacts to help with the scenery and the *mise en scène*, and he himself contributed a *zaum* (sound) poem. Van Doesburg, who had just moved to Paris, also worked on the production.

But controversy was inevitable. For Breton and his supporters, the show's title was an uncomfortable reminder of the Congress of Paris. More gravely, the evening was presented as an artistic spectacle, an entertainment, which aroused contempt. These displays upset the artistic "purity" that Breton and his friends demanded. That poems by Cocteau would also be read enraged them still more. After the previous summer's ill-fated Tirol vacation, Éluard had told Tzara: "Don't count on me any more for the cause that we had taken up together."[96] He now made it clear that he would do everything in his power to prevent his work being included alongside Cocteau's. Iliazd was accosted by Éluard, who demanded that his name be removed from the program—a demand that was satisfied (Reverdy's name took its place). Éluard's anger, however, was not assuaged, as he continued to blame Tzara for putting Cocteau on the billing; Satie, for his part, predicted a violent confrontation.[97]

It was in these particularly tense circumstances that the curtain was raised to a full house. What first triggered pandemonium was an impromptu manifesto by Pierre de Massot: "André Gide killed in action, Pablo Picasso killed in action, Francis Picabia killed in action."[98] Although Picasso was in the audience, and apparently unruffled by the mention of his name, Breton got out of his seat and stormed the stage. Accompanied by the two most faithful participants at the dream *séances*, Desnos and Péret, he attacked Massot with a cane and ordered him to leave the stage. A bemused audience looked on, thinking this was part of the show, but when Massot responded with choice words of his own, Breton struck with his cane and broke Massot's left arm. The police seized Breton and his accomplices and threw them out of the theater. (This police intervention was for many years a black mark on Tzara's reputation, as it was said that he had resorted to summoning the forces of law and order, and was nothing other than a "*police informer*."[99] But there was little choice here; not only had a serious crime—aggravated assault—been committed, but a full-blown riot could have broken out.) With some semblance of order restored, the performance resumed with music by Satie, a recitation of poems by Apollinaire and Soupault, and then the film portion of the evening.

195

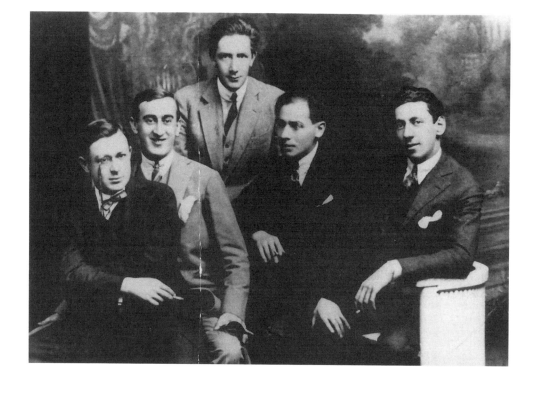

FIGURE 9.4

Tzara with the Romanian avant-garde,
autumn 1923: Tzara, M. H. Maxy,
Ion Vinea, Henri Gad, and Jacques Costin.
Courtesy of the National Museum of
Romanian Literature (Bucharest).

After a prolonged intermission, the stage was now set for *Le Cœur à gaz*. When the curtain dropped at 11:30 p.m., Éluard came on stage demanding that Tzara give an explanation for Breton's rough handling by the police. The police stopped Éluard, but his friends then came to his rescue. A period of relative calm was restored, but when Tzara finally came onto the stage—despite not being scheduled to perform in that evening's program—Éluard rushed back to assault him. Both Van Doesburg and Jane Heap, the editor of *The Little Review*, were shocked: "They almost killed Tzara."[100] "You must have heard," Cocteau wrote to Max Jacob, "about the abominable fight. ... Never in my life have I seen faces full of such stupid and petty hatred."[101] A genuine riot then broke out, with "fighting in the four corners of the hall."[102] The audience, now understanding that these were not planned Dada hoaxes, came to Tzara's aid. *Le Cœur à gaz* was eventually performed, but even after the show came to an end there was fighting well into the night on the surrounding streets. The director of the Théâtre Michel—"My nice little house, my nice little house," he could be heard saying when the violence erupted—had no choice but to cancel the next evening's performance.[103]

Tzara left Paris soon after, going to the South of France. He was in Romania in the autumn in order to legally change his name (with the unfortunate result that his surname became "Tristan-Tzara"). He stayed with his family in Bucharest and saw Vinea, who had started an avant-garde review with Janco called *Contimporanul*, and some of the new figures in the Romanian avant-garde, like the painter M. H. Maxy (throughout the 1920s Tzara contributed to Romanian avant-garde reviews like *Contimporanul* and *Unu*, but he mainly kept his distance from literary events in his home country). But the controversy over *Le Cœur à gaz* continued; before he left Paris Tzara had hired a lawyer, Roger Lefébure, a friend of Reverdy's and an habitué of Dadaist circles (he is mentioned in one of Breton's dream *séances* a year earlier), to file charges against Éluard, who complained to Breton that August: "I receive summonses from the nasty Bulgarian Tzara through the hands of Panmuphle, the good French bailiff. 8,000F he asks from me, because the audience was unable to appreciate the works performed and because the police banned the second show."[104] The legal writs continued for over a year, but the affair never came to trial, partly because Éluard made a dramatic departure from Paris in March 1924 for Southeast Asia.[105] Even though Éluard later regretted his actions, the damages of that evening reverberated for much longer.[106] Fifteen years later Tzara remained convinced that all this amounted to "personal vengeance against [him]self."[107] More to the point, Paris Dada was definitively buried, and there would be no further attempts on Tzara's part to resuscitate it. A little over three years after his arrival in Paris, many of the friendships he had made were broken, and he had to start over by finding something beyond Dada. But as an American girlfriend from this time put it, "you are such an uncertain quantity, almost anything might happen."[108]

10 AFTER THE WAKE: **1924–1929**

DADA AU GRAND AIR HAD ANNOUNCED THE IMMINENT PUBLICATION OF TZARA'S COLLECTED MANIFESTOS IN 1921, BUT THE SLATED PUBLISHER, ÉDITIONS DE LA SIRÈNE, WENT BANKRUPT IN 1923, AND OTHER FRENCH PUBLISHERS, LIKE GRASSET OR KRA, WERE UNWILLING TO TAKE IT ON. Éditions du Diorama, a boutique publisher run by Jean and Paul Budry and closely linked to Jeanne Bucher's art gallery, offered Tzara a contract—for a print run of 700 copies, 300 of them luxury editions—because of the commercial opportunities presented by the *Soirée du Cœur à barbe* (Tzara was asked to draw up a prospectus for pre-orders to be distributed at the performance).[1] But the disaster of that evening cooled Budry's interest, and by April 1924 there had been no movement on the book, which forced Diorama to advance Tzara 500 francs.[2] To recuperate this advance, as well as to cash in on the notoriety surrounding Tzara's coming participation in "Les Soirées de Paris," the layout was rushed, which meant that several glaring errors in the text could not be corrected save at great personal cost.[3] The final book contained two portraits of Tzara by Picabia, the two friends having been reconciled as they both found themselves increasingly isolated from Breton's nascent Surrealism. *Sept Manifestes Dada* came out at the end of 1924, and its publication was inextricably linked to Breton's "First Manifesto of Surrealism," with reviewers attempting to draw the line between Dada and Surrealism. Interviewed for *Les Nouvelles littéraires* by René Crevel (a close personal friend but also a Surrealist), Tzara underlined the distance between his Dada manifestos and Surrealism: whereas Dada "wanted to question everything," Surrealism as "a kind of technique" left him cold: "I have always thought that writing was without control, whether or not people were under the illusion that such control existed—and I even proposed in 1918 that Dada spontaneity should be applied to life."[4] Other reviewers were not so convinced; the publication of *Sept Manifestes* hardly amounted to Dadaist spontaneity when the most recent manifesto was four years old! Critics seized the moment to trot out old canards, but also gleefully pointed out that the hundreds of luxury editions of the book were proof that Dada had become a collectible museum piece.

199

Having already proclaimed Dada's death in Weimar, Tzara was resigned to this reaction. He had, in mocking tones, noted in *Faites vos jeux*:

> I fight only my weaknesses, my diseases, my imperfections. I make them part of my vital strength. … I conscientiously develop my impurities and my vices, I would like to increase them, to give them the central part in my destiny, to shelter them from the evil spells and the revolts of the flesh. But I find method repulsive and I give myself enough leeway to be allowed to change tunes about any event whose outcome appears practical and profitable for me. All in all I am an austere opportunist.[5]

This "austere opportunist" made a living through the shrewd sale of artworks and manuscripts. He had recently received the princely advance of 250 American dollars from *Vanity Fair* for a series of articles on contemporary art (which were never published).[6] By early 1924 he wanted his own apartment, but the coming Olympic Games brought an influx of tourists and a hike in prices, so he moved to the Hôtel Istria on rue Campagne Première in Montparnasse.[7] The Istria was a mini-artists' colony, having throughout the 1920s lodged Aragon and Elsa Triolet, Man Ray and Kiki of Montparnasse, René Crevel and Erik Satie, as well as Duchamp whenever he was in town. As Tzara later put it, "almost the entire hotel was full of friends … it was *la belle vie*"; the hotel was "an immense apartment we shared."[8] It was in these conditions of "great friendship" that Tzara found again the spirit of collaboration between artists that Dada had so earnestly sought from its earliest incarnations, but which the bitter personal disputes of the past two years had made increasingly elusive.

"[A]n ironic tragedy or a tragic farce in fifteen short acts, separated by fifteen commentaries": if this phrase encapsulates Tzara's tumultuous life up to this point, it was actually a description of his most recent venture, *Mouchoir de nuages* [Handkerchief of Clouds].[9] This 1924 play was the result of genuine collaboration: its odd title came via Nancy Cunard, and the play was first performed as part of a series of avant-garde productions, "Les Soirées de Paris," financed by the wealthy patron Le Comte Étienne de Beaumont.

Poetry by Nancy Cunard, an Anglo-American heiress of the transatlantic Cunard Line, had appeared in *Wheels*, the Georgian literary anthology, and she later founded The Hours Press, which published Beckett's *Whoroscope* and Pound's *A Draft of XXX Cantos*.[10] Living in a luxurious apartment on Île Saint-Louis, she met Tzara during a night out in Montparnasse. The two rapidly became close friends and collaborators, working together in the summer of 1924 on a translation of Marlowe's *Faust* (they wanted to stage the play, with Brancuşi persuaded to do the décor and Jean Hugo the costumes, but the project was never realized). In the late 1930s, when she was reporting from the Spanish front, she asked Tzara to contribute to a collection of anti-Franco poetry she edited, and they met again in Toulouse in 1945; toward the end of her life, when she found herself penniless, Tzara helped Cunard sell several paintings.[11] When they first met, Tzara was startled by her large, colorful African bracelets and Cubist necklaces. Given his own burgeoning collection of

200

"so-called primitive" art, the two had a lot to discuss, for Cunard's concern for racial justice manifested itself years later when she edited *Negro* (1934). Both enjoyed a night out and smart company, and it was at Le Bœuf sur le Toit that the title for *Mouchoir de nuages* was conceived: Tzara said that his current play lacked a title, so they both agreed to write a single word on a napkin, and Tzara accepted the result of this literary game of chance.

Eventually published in the Belgian review *Sélection* in November 1924 and as a luxury edition, featuring nine original etchings by Juan Gris, by Galerie Simon in 1925 (only twenty-nine copies were sold by 1930, probably due to the very elevated prices: 200 and 350 francs), *Mouchoir* is written in a straightforward style.[12] It also has individualized characters and a dramatic denouement, a classic love triangle that goes wrong. The plot can be rapidly summarized: a woman in an unhappy marriage to a banker confesses her love to a poet; the banker, who has lost all his money gambling in Monte Carlo, attempts to win back the love of his life; the poet, who rejects the woman's advances, flees to a desert island, only to realize that he was in love with the banker's wife all along; the banker dies; the poet commits suicide. Despite its obvious debts to sentimental romances and the early cinema (but also *Hamlet*, from which three scenes are directly transposed), *Mouchoir* nonetheless puts on stage the central fiction of the theater itself, not only in its innovative *mise en scène* but also in the dramatic theatricality of individual lives ensnared "in a reciprocal exchange of attractions and reactions."[13] Nothing is hidden from the spectator. The actors, on a raised platform, are called by their own names, and when "not performing, they turn their backs to the audience, change costumes, or talk among themselves"; the technicians change the scenery and adjust the props without the curtain drawn or the lights lowered.[14]

The Poet is an isolated figure: "I don't love men, I don't love women; I love *love*, that is to say, pure poetry."[15] Weary of all action—"either you do things or you don't, and the result is always the same: you drop dead in the end"—the Poet models himself after Hamlet, a "simulacrum" that the banker's wife finds ridiculous.[16] While the actors play out their fictions with each other, squabbling over feelings that they themselves are not sure of having, the commentary at the end of each act dissects the unity of the "play":

C: I think that Andrea loves Marcel, but she doesn't know it yet.

D: That would be sad, because the Poet does not love anyone; as he himself said, he loves only pure sensuality, which, through a play of subtleties, he calls poetry.

B: Don't make too much noise. Our heroes are probably trying to sleep in their first-class compartment that is leading them toward a destination still unknown.[17]

But the commentators are no more enlightened than the characters about the meaning of the action on stage:

C: That is the reason this play is badly made. Even though we are the Commentators, that is to say, the subconscious of the drama, the playwright never even let *us* know why the Poet does not love Andrea.

E: Yet she is pretty and intelligent; you are aware that I know her very well myself.

B: The fact that you act the role of Andrea's friend on stage does not give you the right to believe that you are her friend in real life.[18]

As the spectator is taken on a breathless world tour (Paris, Monte Carlo, South America, a desert island) only to end up seeing nothing, the action is interspersed with flashbacks signaled by a tulle curtain being lowered, just "like the movies do," we are told.[19] But this turn backward does not further illuminate the motivations of the characters:

C: They are in the process of dropping the stories of their lives like a rosary of pebbles that they let fall on the road in order to help them find their way back.

B: But soon it will be night and they will not be able to find the road that they marked with the pebbles, because the next day those pebbles will look just like all the others on the road, and everything will be thrown into confusion, the confusion which we try to escape from every day.

C: You are right, we can never turn back on the road of memory.[20]

This gratuitous entertainment actually contains a deep philosophical critique, as Tzara attempts to show that the future world is not necessarily the result of some ordered, meaningful past. Every movement in the play contains an opposite reaction that repulses its forward motion, creating a situation where the actors, actions, and psychological motivations are ensnared in a never-ending, inescapable circle of futility:

To what point the truth is true.
To what point the lie is false.
To what point the truth is false.
To what point the lie is true.[21]

As light-hearted as it is, *Mouchoir* is far from being *théâtre de boulevard*. Tzara was fortunate to have the backing of a wealthy patron, Le Comte Étienne de Beaumont, who considered the play a work of "pure Poetry."[22] In early 1924, the distinguished and refined Beaumont, "the last of the Medicis," wanted to display the "elite of Parisian artists and writers" during the city's upcoming Olympics.[23] Consisting of six weeks of specially commissioned plays and ballets that would "give a multifaceted image of cutting-edge artistic Paris," the series was named, in honor of Apollinaire, "Les Soirées de Paris."[24] Tickets cost anywhere from 10 to 300 francs, with proceeds going to charities for war widows and Russian refugees. Over one million French francs were poured into this enterprise; the six-week series at the Théâtre de la Cigale included *Mercure*, a ballet with music by Satie and décor and costumes by Picasso; *Salade*, a "choreographic counterpoint in two acts" with music by Milhaud and décor and costumes by Braque; *Vogues*, "three danced pages" with illustrations by Valentine Hugo and poetry by Paul Morand; and Cocteau's adaptation of *Romeo and Juliet*. An exhibition of impressionist art, which included Cezanne's *Arlequin*

but also works by Degas, Delacroix, Seurat, and Toulouse-Lautrec, was set up for the audience's benefit during the intermission. The popular press was in raptures over the initiative: "A bouquet of artists, whose budding reputation has grown over the past few years and whose talent goes hand in hand with their boldness, will be handed over to us in the balmy nights of spring, and the most beautiful flowers, as it were, will be renewed each week."[25] In the four months before opening, rehearsals day and night turned Beaumont's immense *hôtel particulier* on rue Duroc into a "battlefield."[26] Beaumont claimed that he had no time to sleep, but with Braque, Picasso, Satie, and Tzara in his home every day finalizing preparations, it was an exciting time for everyone involved.

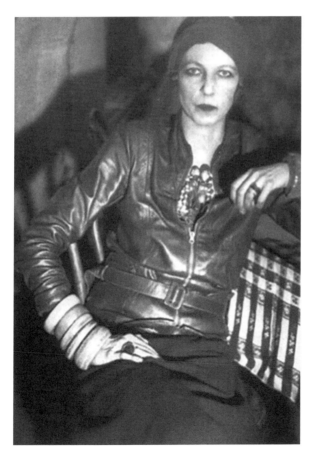

FIGURE 10.1
Nancy Cunard, who inspired
Le Mouchoir de nuages.

Mouchoir was slated to premiere at the opening gala on 17 May: "today in the world of art the only talk is of the 'Soirées de Paris.'"[27] The guests' names "were among the most prestigious of France," and European nobility, among them the King and Queen of Romania, came for good measure.[28] In this audience hailing from the "five continents, every language was spoken"; the ambiance was playful and elegant: "What talent, what beauty, and what charming ease! This light, music-hall ambiance, this air of spontaneity around works of art was very pleasant."[29] The *Comœdia* journalist described the scene: "It really was the social event of the season for Parisian high society. The hall was scintillating with lights and the balconies were illuminated. The artists, whose reputation has grown over the past few years, were received with great enthusiasm. Tristan Tzara's creative whims did raise a few eyebrows, but since everybody had already chosen sides, protest was immediately followed by applause."[30] The ostentatious jewels, *haute couture* gowns, and prattling social ambitions of the assembled audience made an easy target for some sections of the press, but the rancor found in certain reviews (an audience "reeking of imbecilic vice, the snobs of essayism ... fake intellectualism") was nonetheless breathtaking.[31]

Tzara extensively rehearsed the play with the actors, insisting that the décor and costumes be ready ten days before the premiere; the actors were uniformly praised for their "cold authority" in handling such a difficult text.[32] Marcel Herrand, who had appeared in *Le Cœur à gaz* a year earlier, played the lead, while the banker's wife was played by Andrée Pascal, known for her talent and stunning beauty. A leading fashion designer, Jeanne Lanvin, did the costumes, while the lighting by Loie Fuller was "a true poem ... an orgy of iridescent lighting through which the works of our young avant-garde artists appeared fixed like precious jewels."[33] Yet critics were not won over, with one particularly savory hatchet job calling *Mouchoir* "a case of incoherence and snobbery, the manifestation of a desire to admired in spite of a complete absence of talent, to mystify a few clueless bourgeois—and most importantly, a sign of hopeless stupidity."[34] A number of reviews insisted that Tzara had "betrayed his [Dada] friends" and complained about the lack of "scandal"—but Tzara had few Dada friends in Paris, and *Mouchoir* was not meant to be a Dada provocation.[35] "A firework does not go off twice," one critic noted, alluding to the similarities with Luigi Pirandello's *Six Characters in Search of an Author*, which had been staged at the Théâtre des Champs-Élysées in March—a facile comparison, since both works deconstruct the fictive nature of acting and the theater itself, but Tzara's experiences at the Cabaret Voltaire and earlier plays had pointed to this as well.[36]

A play that was "essentially poetic," Tzara responded, "could find only a few supporters": "I am thrilled that the defenders of the *théâtre de boulevard* found my piece bad, incoherent, insane."[37] What stung more was that the eclectic program of "Les Soirées de Paris" was rebaptized "Soirées de Charenton," not only because of the avant-garde works performed but also because of the maddening disorganization. Beaumont's vast reservoir of energy and enthusiasm could not make up for the fact that he was not a producer. Performances were

changed at the last minute, or an evening show was stopped halfway through when the orchestra went on strike. As Satie put it after *Mercure*'s debut was postponed for one week, "at the 'Soirées de Paris' there is such disorganization that one has to do everything oneself." [38] If *Mercure*'s delayed premiere was interrupted by Breton and friends shouting out "Down with Satie! Long live Picasso!," for less partisan critics the series as a whole lacked artistic spontaneity or scandal: "It is long, it is boring, it is ridiculously stupid." [39] But for Tzara *Mouchoir* was a success on a number of levels; although his collaboration with Beaumont was roundly criticized, his play had been written and staged on his own terms, and by early June it had been performed fourteen times. [40] Although he was extremely tired from the long nights out, the performances were very profitable, with nearly 40,000 French francs coming his way. [41] But the most important result of *Mouchoir* was something much more personal. In a curious twist of life mixing with art, the Poet who declaimed his inability to love anything but "pure poetry" found his worldview crumbling after meeting a "ravishing" Swedish artist at a *Mouchoir* after-party. [42] Unlike his dramatic alter ego, Tzara did not have to flee to a desert island to realize that he was in love.

Greta Knutson had come to Paris to study under the Cubist painter André Lhote, but she had also come, like so many others, to flee a dreary home life. Born in 1899 into a wealthy family from the suburbs of Stockholm, Knutson had studied painting for two years at Stockholm's Academy of Beaux-Arts. Her father, who had trained as a concert pianist but could not pursue a career because of a nervous condition, was by all accounts overbearing, and opposed his daughter's pursuit of an artistic career. Although rich in culture, the Knutson home was weighed down by "a heavy atmosphere with punishments for the slightest misdemeanor." [43] In her 1933 poem "Foreign Land," published in in *Le Surréalisme au service de la révolution*, Knutson's poetic imagination seems to focus not on her adopted *patrie* but on the one she left behind:

> sailboats icebergs sugar and ebony
> and the humble silk of the moon
> …
> path to the broken porch shelter of the pursued
> night came morning gone
> toward the gentle flock and the boat sleeping
> against the temple of the riverbank
> to the bitter tree's bark
> between the girl's teeth
> road beneath blood under rock
> Was it the stag throat slit by a thorn
> but that would hunt at dark of night
> that cried let us awake
> where is the morning. [44]

Becoming part of the Swedish artist community in Paris must have been a relief. The Ballets Suédois had a notoriety matching Diaghilev's Ballets Russes, and young Swedish artists had a communal space in Montmartre where they organized exhibitions, courses, and a lecture series. Kiki remarked that the Swedes threw a good party, and Tzara, who had befriended the young Swedish painter Thora Klinckowström (later Dardel), also attended these soirées.[45] Knutson was also close friends with Thora, who introduced her to Tzara in the bar at La Cigale after a performance of *Mouchoir*. By this point largely independent, with a studio on rue Ernest Cresson in Montparnasse, Knutson was captivated by Tzara's charms, and the feeling was mutual. "Between Greta and Tristan, it was *le coup de foudre*," matchmaker Thora recalled: "Before having time to finish off the bottle of champagne … they were a couple."[46] With her stunning looks (Aragon noted that her pale skin seemed to be "fresh snow"), fiercely independent spirit, and keen intelligence, Knutson was a formidable partner. She never sought publicity or the company of artistic coteries, but she was a keen observer of life. A methodical artist, she refused easy pictorial solutions as she worked and overworked her brightly colored but undefined paintings. If Tzara was a disappointed student of philosophy, finding comfort only in Nietzsche's later writings, Knutson was a voracious reader of Heidegger and Husserl, and of German Romantics like Jean Paul and Novalis.[47]

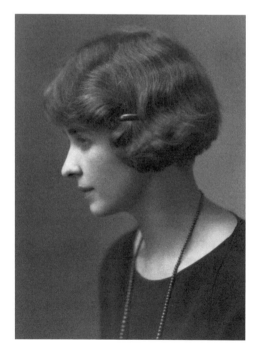

FIGURE 10.2
Greta Knutson, Tzara's wife.
Courtesy of Christophe Tzara.

Tzara had summer plans, probably arranged by Cunard, to stay in the Oxfordshire country house of Lord Berners, an eccentric homosexual composer who had collaborated with the Futurists and whose *Fragments psychologiques* had been performed at the Salle Gaveau in Paris in 1919. After his profitable collaboration with Beaumont, the son of Moineşti was looking forward to an extended stay with the English aristocracy—but meeting Greta had put those plans on hold.[48] Tzara had always taken his summer holidays abroad, trips connected to continuing doubts about the viability of remaining permanently in France. But now that his *raison d'être* in the eyes of the press no longer existed—there was no Dada movement to lead, no Parisian spectators to scandalize, no public hoaxes to stage—Tzara paradoxically took the first step in putting down roots in France by vacationing, with Greta, in the Toulon area. He fell in love with the seaside, the *paysage*, and the picturesque Romanesque churches. From this moment on, Tzara spent long stretches of every summer and parts of the winter in the South of France, attracted by "a very particular kind of rest that can be cut into slices and an extraordinary silence, one that almost hurts, but which prolongs time"—these connections ultimately helped him survive during the Second World War.[49]

The newfound support from Knutson was an invaluable boon, for with *Mouchoir* closed and *Faites vos jeux* stalled, he found himself in the Parisian literary wilderness:

> which one is the path setting us apart
> through which I hold the hand of my thought
> a flower is written on each fingertip
> and the end of the road is a flower walking with you[50]

Breton's *Les Pas perdus*, which had just been published by Gallimard, led to old wounds resurfacing. If Breton's book disappointed Tzara, it did not surprise him: "André Breton was among the first who tried to impose upon others his will as a magus and a prophet."[51] The Surrealist movement had attracted an increasing number of the old Dada faithful: Aragon, Baron, Crevel, Desnos, Éluard, Ernst, Morise, Péret, Picabia, and Vitrac all found their way to Breton's apartment on rue de la Fontaine to engage in sessions whereby the unconscious would be revealed, a new reality could emerge, and the "Revolution" would finally be staged.[52] *Persona non grata* at these sessions, Tzara had his own reasons to stay away. Promoting Dadaist principles like spontaneity and irrationality was one thing, but trying to order them into a methodical system defeated the enterprise from the start. "If today's Surrealism is a form of technique," Tzara observed, "it leaves me quite indifferent."[53] If anything, Tzara detected in Breton's initiative a conjunction with those postwar forces calling for a "return to order," a diagnosis confirmed by the opening of the "Bureau of Surrealist Research," where functionaries kept open hours and maintained written records of correspondence received and visitors welcomed.

Tzara kept his distance, working that summer on a translation of Marlowe's *Faust*. The choice of looking back on two of literature's greatest figures—Hamlet in *Mouchoir* and now

Faust—was not driven by a desire to reconnect with a literary tradition but, rather, to understand his own personal evolution. He had been obsessed with Hamlet as a schoolboy, and *Faust* was a means of coming to grips with the personal cost of that quest:

from myself I am separating but who am I
a worldly heap of organs of fake memories[54]

The project also forced Tzara, a bilingual poet who had abandoned his native language, to consider "the difficulties, when translating the meaning of a sentence, of keeping intact its original value."[55] He made progress with the translation, but he was in no rush to complete it as he spent the long vacation with Greta. This was the first summer without Dada magazines to edit or propaganda to fire off. That letters went unanswered showed just how much Tzara simply wanted to take time for himself and Greta that summer.[56]

By the time they arrived back in Paris, the relationship was serious. Tzara had now settled into an apartment on rue Delambre, and friends recall that he was happy in this new life. The calm of working days and of coming back to poetry—he began *L'Homme approximatif* [The Approximate Man]—were more rewarding than regrets about Dada. But Tzara could never entirely escape his past, and the publication of *Sept Manifestes Dada* led Pierre de Massot to pointedly ask in *Journal littéraire* on 9 November: "Will Dada Be Resuscitated?" Not only had Tzara's manifestos been published, but Picabia had returned to the Paris stage that autumn with *Relâche*, a Ballets Suédois production with music by Satie. Yet these were false polemics. Tzara had no interest in reorganizing Dada, and few would have followed him on that course. *Relâche*, while an ambitious production (the backdrop called for 400 light bulbs illuminating the stage), saw its opening night canceled; this was not Dada irony ("relâche" is the term used when a performance is canceled) but the result of a dancer's illness. There was much more excitement surrounding the opening of the Bureau of Surrealist Research (11 October), Breton's "Manifesto of Surrealism" (15 October), and the first number of *La Révolution Surréaliste* (1 December). Tzara could not resist attacking Surrealism, insisting not only upon the primacy of Dada but also its more expansive nature: Dada, he claimed, "did not attack only literature" but "put everything in question."[57] Yet the grand ambitions of Surrealism ("A NEW DECLARATION OF THE RIGHTS OF MAN MUST COME ABOUT" [*IL FAUT ABOUTIR À UNE NOUVELLE DÉCLARATION DES DROITS DE L'HOMME*], the title page of the first number of *La Révolution Surréaliste* announced) seemed more universal and significant to the French intelligentsia, for whom Dada had always been a public provocation, not a philosophy.[58]

By now Tzara was no longer interested in the "vulgar literary quarrels" that animated Paris's cafés.[59] He and Greta talked about marrying before Christmas, but the difficulty of bringing together both sets of parents for the wedding made them wait until the following summer. There were also administrative matters to resolve: the petition Tzara had lodged with the Romanian Ministry of the Interior in October 1923 to change his name was approved

only in July 1925. Greta and Tristan traveled to Stockholm in mid-June; Tristan was impressed by the city, "a flower of archipelagos and islets fallen into the sea," but stayed for only one week, leaving Greta with her family to organize the wedding.[60] Returning to Paris for the month of July, he then made his way back to Stockholm and the wedding took place on 8 August 1925. Tzara's family could not afford to make the trip, and they did not even know if the wedding was going to be held in Paris or Stockholm (Tzara wrote home quite irregularly, as his mother complained: "You who write so much, and to us you don't write at all, how disappointing").[61] On her way to a rest cure in Carlsbad, Tzara's mother congratulated him on the wedding. Tzara promised to come to Romania the following spring, but he and Greta were too busy with their new project: the construction of a family home. And not just any old house on the market would do; rather, the newlyweds were set on hiring Adolf Loos to design it.

It was very fortunate that Greta's parents had given the newlyweds a considerable sum of money for a house, for Tzara had little. Although *Mouchoir* had paid handsomely, it was a one-off payment that within months had been spent. There were talks of *Mouchoir* being staged in Budapest, Moscow, or even New York, but these did not materialize.[62] The long years of poverty in Zurich made Tzara extremely frugal, but *mondaine* society had its costs. His books—most of them published on his own account—did not command a large public. And prices kept going up; if Tzara was exaggerating when he said that the cost of living had increased by 60 percent, his anxieties were shared by an entire nation that saw the franc falling in value.[63] Tzara's income came mainly from the valuable collection of artworks and manuscripts he had assembled from artist friends or acquired at auction, such as the several Picassos at the Kahnweiler sale in 1922; whenever necessary he would sell off an item to one of the many dealers and gallery owners in his address book. Some books that friends gave him remained uncut in order to conserve their value. But these forays in the art market could not cover the massive outlay for purchasing land in Paris or for hiring one of Europe's greatest architects to build a family house.

Greta and Tristan, seeking advice among their friends, including Le Corbusier, decided to purchase an empty field on avenue Junot, in Montmartre, then a relatively underdeveloped quarter.[64] Far away from the literary hubbub of the Latin Quarter and Montparnasse, Montmartre had housed a number of artist's studios, most famously the Bateau-Lavoir, where Picasso had painted *Les Demoiselles d'Avignon*. But these were former glories, not contemporary realities. The artists who made Montmartre a thriving cultural center in the prewar period had by the mid-1920s migrated to the other side of the river. Living in Montmartre set the newlyweds at a comfortable distance from artists' intrigues, and also allowed them to purchase a spacious plot.

Tzara had met Adolf Loos over a decade ago in Zurich. They crossed paths again when the architect moved to Paris in 1922. As a regular at Le Bœuf and the Café du Dôme, Loos

was a fixture of the Parisian avant-garde scene; he and Tzara enjoyed nights out on the town and went to the cinema together.[65] Loos was an inscrutable character: loving nightlife and beautiful women, he dressed impeccably and was polite to the point of exaggeration; his hatred of the petite bourgeoisie knew no bounds, but his architecture was strongly classical.[66] Growing up speaking Czech and German, he studied in Brno, Dresden, Weimar, and Vienna. Professing great admiration for the English, he was strongly influenced by the three years he spent in the United States in the 1890s.[67] Loos was also a strident cultural critic who ruthlessly attacked Viennese *fin-de-siècle* decadence; his articles on this topic were published in 1920 as *Ins Leere gesprochen* [Spoken into the Void].[68] If Tzara was unfamiliar with this work, he certainly knew Loos's essay "Ornament and Crime," which had been reprinted in Le Corbusier's *L'Esprit Nouveau*. After moving to Paris, Loos was a regular contributor to the Salon d'Automne, and in 1926 he delivered four lectures at the Sorbonne under the title "Man of Modern Nerves." Loos had come to Paris with grand plans, but found himself living in cheap hotels, with his third wife refusing to follow him (they divorced in March 1926).

Tzara was the only client in Paris who had the necessary "resources or ... faith" in what Loos was trying to achieve to hire him (Josephine Baker never acted upon the plans Loos showed her for a fantastic house with a black-and-white-striped façade and an open swimming pool).[69] It was not easy to be "Germanic" in postwar Paris, and Loos's hatred of Jugendstil and Art Nouveau did him no favors in drumming up business.[70] Tzara considered Loos a "great architect, the only one today whose works are not photogenic, and whose expression is a school of depth and not a way to attain illusions of beauty."[71] Loos's home designs, with their blank and featureless façades, pointedly lacked any recognizable style: the "cladding" of a house, Loos argued, had to be unornamented to best allow the personality of its inhabitants to take over the interior spaces for living. This external anonymity was also a result of his conviction that there was a fundamental difference between architecture and art, as he outlined in *Der Sturm*: "The work of art does not have a responsibility to anyone; the house has a responsibility to everyone."[72] The richness of a house had to come from its interior, not its external aspect. These ideas resonated with Tzara, who had long harbored the dream of losing his personality through art.

While scholars consider the Villa Müller (1930) Loos's architectural masterpiece, the Maison Tzara, "in all respects the most grandiose house by Loos," was an important predecessor.[73] Loos's notion of *Raumplan*—the idea that the height of spaces has to be differentiated according to their function—was in full display in the Tzara house:

> The elevation makes it unusual, almost monumental, due to the differences in height between and within the levels. The large walls with relatively small windows giving out onto the street endow the house with an almost sculptural presence. The asymmetric façade giving onto the garden seems to occupy three stories but surprises by the size of its openings and a covered terrace. The collages of different materials

and the link between different spaces (balconies and terraces, symmetrical spaces and asymmetrical annexes) never fail to constantly surprise. The interior spaces are designed according to a very elaborated concept of *Raumplan*.[74]

The main living space consisted of two salons, a dining room, and Tzara's office, but these rooms were all at different heights to emphasize the unique functions of each space, with a curtain separating the rooms on different levels. The materials Loos chose for the interior created a kind of permanent coldness, "a cladding of columns and posts with plywood boards with the fastening screws visible."[75]

The young couple were free to experiment with the "naked spaces" of Loos's design.[76] When Jane Heap came to visit the house under construction, Loos gave some perfunctory indications as to what the layout might mean but insisted that only "the owner of so much grandeur" could give meaning to the house.[77] Heap thought the house magnificent, but Alice Halicka, the wife of painter Louis Marcoussis, had her doubts, thinking it looked like a "prison" and that the ultramodern interior was "very uncomfortable."[78] When the Tzaras moved into the house, they occupied the top two floors and rented out the bottom three levels; the ground floor had a stairway that went directly to the upper levels.[79] The top level contained three bedrooms, with the terrace annexed to the master bedroom giving out over the garden.[80] Loos designed some furniture especially for the house, but these modern pieces were complemented by Italian antiques, rustic French furniture, and Romanian carpets the Rosenstocks sent after Tzara asked for something "to remind me of home."[81] Tzara's growing collection of primitive sculptures and artwork by Arp and Ernst completed the space. But there were things left out: no separate studio space was designed for Knutson, which necessitated a change in the plans as a small studio was erected on the terrace.[82]

Under the watchful eye of Loos and his associate, the Yugoslav architect Zlatko Neumann, the house took over a year to be finished. The effect of rooms on the same floor having different heights would often become apparent only during the construction, leading Loos to yell out: "I do not like the height of this ceiling, change it!"[83] Delays mounted as the original construction firm went bankrupt. All this meant "a lot of time" and "a lot of money" as the Tzaras lived in the South of France waiting for the building to be finished.[84] In late 1926, with Greta in the early stages of pregnancy, they rented a villa in Collioure, a small village a few kilometers from the Spanish border in the Pyrénées-Orientales and a favored resting place for artists (Picasso lived there for a while). Tzara bought a 10-horsepower Citroën that he recklessly drove on the coast (he was in a car accident a year later).[85] When the young family finally moved into the house in May 1927, it was with a young baby in tow, a boy named Christophe. A "very serious" Swiss governess, Tzara told his parents, had been hired.[86] But those first days in the new home were anxious times. Greta had a "nervous, lymphatic and somnolent pregnancy"; in her last two months she had been bedridden by a mysterious illness, with a high fever incapacitating her to the point where she could not walk unaided.[87] Her brother, who was a doctor in Stockholm,

was summoned, as were her parents. Tzara was overwrought with worry, as nothing seemed to bring any relief: "Consultations, professors ... nothing helps."[88] As far as he was concerned, it was a "miracle" that she survived the ordeal.[89] Not only was her labor difficult, but afterward Greta had four operations to treat an abscess that had infected the entirety of one of her breasts. Luckily the doctors at the private and expensive Neuilly clinic were among the best in France, and Knutson was cured: "this will remain just a bad dream," Tzara confided to his parents.[90] He himself hoped to put the episode behind him and to revel in fatherhood; as he put it a few years later, when he had some experience with the matter, "that which touches us most profoundly" is childhood.[91]

By 1927 Tzara found more solace in the comforts of hearth and family than in the open-top circus of literary Paris. His parents made the journey from Bucharest to see Christophe, with Emilia dressing the newborn in a "very beautiful" handmade shirt, a family heirloom that both her husband and Tristan had worn as babies.[92] This was the only time Tzara's parents came to Paris, and it was the last time he saw his father, who died in 1936. The Rosenstocks stayed in the new house before going down to Vichy, where Tzara's mother underwent a spa cure. They implored their son, who they both felt had a "great need" for rest, to come down as well, but Greta's health did not allow it.[93] In lieu of their son visiting, "with much love and many thoughts toward you all," Tzara's mother made two pairs of boots for Christophe.[94] The Rosenstocks ended up staying in Vichy for nearly six weeks, and they arrived back in Romania in late August, eagerly expecting another birth in the family (Tzara's sister was pregnant).[95]

FIGURE 10.3
The main salon, Maison Tzara,
avenue Junot.
Albertina Museum (Vienna).

FIGURE 10.4
Tzara's study.
Albertina Museum (Vienna).

Despite the happiness of a new home, a new wife, and a newborn, Tzara was very conscious of his increasing literary isolation. *The Little Review*, through its editor Jane Heap, an increasingly close friend, continued to support him, but even that created problems, as when he was asked to organize a special number on contemporary French poetry. Michel Leiris had objected to his poetry being included alongside other writers he found retrograde:

> I cannot let this occasion pass to let you know once and for all that whatever admiration I may have had for the poet that you *used to be* does in no way prevent me from seeing you today as you *are*: a pathetic, spineless little bastard.
>
> Please know as well, Tzara, you who the last time we met dared to talk to me about "purity," that I am more than happy to grant to you too a form of purity: the purity of raw shit—shit unaltered, without even a trace of other substances. It is very likely that Dada, which you will use as usual as the Parisian screen to mask your stupidity and cowardice, will allow you once again to get kicked in the ass without a peep—it is with great pleasure that I recognize you as the "founder" of a system whose primary function is to protect your behind.
>
> When I see you so manipulative, so petty, and so dirty, I begin to think that one day you will end up—like your buddies Cocteau and Stravinsky—swallowing your own vomit as if it were a sacred wafer.[96]

While it would take years for their friendship to be repaired (Leiris played a crucial role in seeing Tzara's *La Fuite* staged), the polemics animating the Parisian literary scene were increasingly distasteful to Tzara. In April 1927 the Bucharest avant-garde review *Integral* printed an interview by Ilarie Voronca that makes for difficult reading: "I have found men, but how truly they have disappointed me," Tzara starts. In his view the Surrealists were not engaged in a "revolution of the mind"; rather, their activities betrayed the "impression of discipline and unanimity where there is only poverty or repression." Their recent siding with communism, "a bourgeois form of revolution," was problematic, "a regrettable necessity" that could lead only to "bureaucracy, hierarchy, the Chamber of Deputies, the Académie Française." For his part, "Right now I continue to write for myself and unable to find other men, I keep searching for myself."[97]

Tzara's search found expression in a new direction in his poetry. The one-word titles of the ten poems in *Indicateur des chemins de cœur* [Guide to the Paths of the Heart]—published in a limited edition in January 1928 by Jeanne Bucher—all signaled a fresh start. With its three watercolors by Louis Marcoussis, a Polish-Jewish émigré artist whom Tzara had befriended, a certain softness envelops *Indicateur*. Directions had changed, and the move was inward. The critic André Salmon thought the collection was Tzara's best poetry to date, while the editor of *Les Feuilles Libres* was of the opinion that parts of the book matched the best of Apollinaire.[98] Yet only a few hundred trade copies were printed, and the review copies for the press were not ready for three months.[99] But what a different reality *Indicateur* conveyed! The mangled syntax, obscure imagery, and nonsensical language of

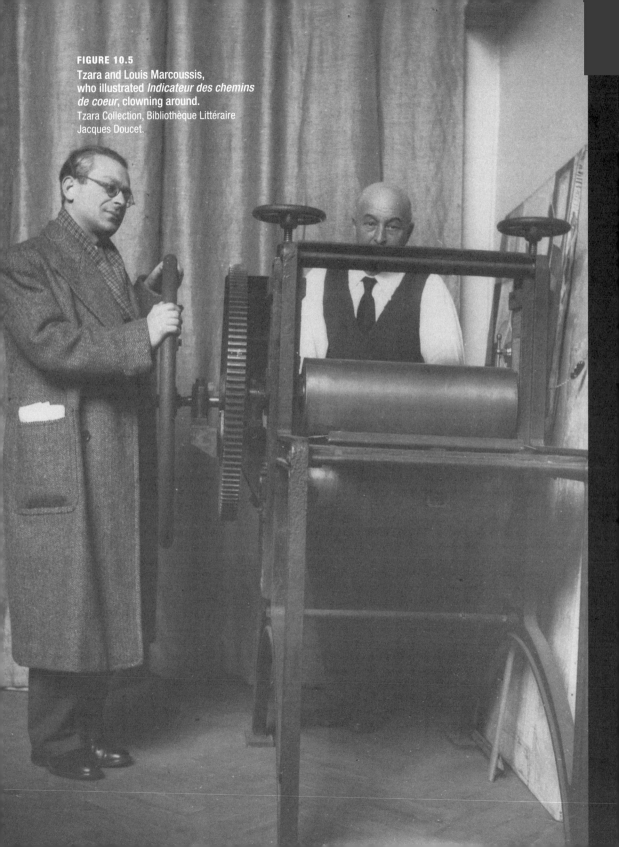

Tzara's Dada poetry were nowhere on view in this "human book, a book that comes from the head, the heart, the belly, the hands and the feet."[100] That praise from Georges Hugnet—a fellow poet who years later wrote one of the first general histories of Dada, with Tzara's help—perfectly describes "Bifurcation":

> I do not want to leave you
> my smile is fastened to your body
> and the kiss of algae to stone
> within my age I carry a loud, cheerful child
> only you know how to take him out of the shell
> like a snail with delicate voices[101]

Indicateur was written in the rush of new love and happiness with Greta. If the sentimentality harks back to his early poems, as a mature poet Tzara had better control of his language and forms. The stanza grows in complexity as the two foreign bodies—the lyrical I and the woman he loves, the algae and the rocks—create a literal metamorphosis of the body with an ambiguous final point:

> but only your voice is delicate
> like your hand is delicate like night is unseizable like calm[102]

The next poem, "Pente [Gradient]," takes up these images of a hand at night:

> sick with nights too bitter
>
> …
>
> on the tablecloth set by bony hands
> hands that pick others hands of dead branches
> light up the floods in inescapable lives

to further qualify the "unseizable distance" between longing and reality.[103]

De nos oiseaux came out a year later, transporting readers back to Tzara's Dada past, but it is in the 1930 collection *L'Arbre des voyageurs* [The Tree of Travelers] that a fuller survey of Tzara's poetic evolution in the 1920s can be found. Dedicated to his wife, who had just held her first solo exhibition at the Galerie Zborowski in June 1929, *L'Arbre* was illustrated by Joan Miró, an artist with whom Tzara developed a close bond.[104] Published by Éditions de la Montagne, whose managing director, Hugnet, had been so enthusiastic about *Indicateur*, only 500 copies of *L'Arbre des voyageurs* were issued.

The book was divided into three sections: an untitled first section made up of poems mainly written in the early part of the 1920s; a second section entitled "À perte de nuages [The Interminable Snow]" containing work from the middle part of the decade, most of it written in traditional poetic forms; and a third section, "Le Feu défendu [Forbidden Fire]," consisting of a single long poem. Each section has its own tone and particular forms, but the ensemble is held together by a singular theme: the understanding that "nothing but a game of life and its varied writings" marks the search for companionship and love amid the devastation of time.[105] There are still traces of the sentimentality of *Indicateur*:

216

you come you eat you swim you dream you read
you run sometimes after the light unlimited why of your actions
you wonder sometimes where you come from so alone
properly dressed and unreadable according to the song's looks
with the impractical, heavy hour in your sleep[106]

or:

the shadow goes off by itself
by itself forgotten discolored
only you hold of this world
the indefatigable secret that links you to the sun[107]

The figure of the woman guides the poet in his search for greater certainty in a world thrown into confusion by the elements and the corrosive decay of time, symbolized here by the shadows that have become forgotten and discolored.

The title *L'Arbre des voyageurs* hints at the need for a point of reference, something rooted into the ground for the poet who was "still alienated [*dépaysé*]," and this translates into a poetic search through the obfuscations of memory, here hinted at by the forests of Tzara's youth:

is it long and lively the wait
that acknowledges us at the edges of thoughts
on the slopes are gathering the violent
late echoes of forests stripped of leaves[108]

These memories—the "leaves and injuries / that scatter us on the dark road"—threaten to dislodge the present unless the poet steels himself:

but if a new wait comes and holds me to its breast
bruised with the sleep of languid, infinite moans
and the moans will be dull and their calling powerless
dreams will be closed and gazes will be new[109]

The certainty or closure that such action might bring, though, is called into question by the realization that the future holds no promises:

still I live still I want still I call
but what will tomorrow be without fervor
there are still many blows of wind that
the bitter bird of the poor wolves of solitude awaits[110]

The voyagers encircling the fixed mode of memory are ultimately pulled apart; in the "sweet absence of words where the shadow gets mixed up," the possibility of "limitless loves" is shattered as the poet travels "detached from you alongside you."[111] But the saving grace of this devastation derives from the poetic affirmation that loving and living are the only possible responses. Despite the bleakness of the world in April 1940, when he was writing an

217

essay on Miró, his illustrator for *L'Arbre*, Tzara gave a clue to the ultimate lesson of his collection: "For nothing can be *accomplished* without love."[112]

Besides family life and poetry, the other succor for Tzara during these years was primitive art. Indeed, one of the great challenges facing Loos when he was designing the house on avenue Junot was considering how Tzara's collection of primitive art could be displayed. Tzara had written short essays on African and Oceanic art as early as 1917 and had transcribed over forty primitive poems. By the late 1920s, although he no longer inflected his poetry with primitive themes, dealers knew that Tzara was always amenable to a meeting if they had newly acquired pieces to sell. In 1929 he paid 4,500 francs—a considerable sum at the time—for a piece from Gabon.[113] That same year some of his collection was reprinted in the special number on *Cahiers d'Art*'s special number on Oceanic Art. Tzara was a knowledgeable collector who read up on the subject and spent days going through the collection housed at the Trocadéro Ethnography Museum (and photographing collections elsewhere). His collection of primitive art was "the most coherent and the best documented" among the French avant-garde.[114] Scholars regularly consulted him on the subject, and on the basis of unpublished documents he had found in Italian libraries and archives, Tzara even proposed to write a short, essentially academic, survey of Oceanic Art.[115]

After the 1927 exhibition "Yves Tanguy et objets d'Amérique" at the Surrealist Gallery, the Paris Museum of Decorative Arts hosted in May 1928 a four-room show, "Les Arts anciens de l'Amérique," which attracted over 10,000 visitors.[116] The Paris daily *L'Intransigeant* sought out Tzara's review. While deploring the commercialism of the exhibition, which led to parts of the show being used as window displays for private collectors and dealers, Tzara was enchanted by "the intense grandeur, the purity of expression and the powerful idea" of the objects on display, which were not attempts at representation but, rather, embodiments of a culture and religion, even of the world itself.[117] Primitive art was not a historical relic but a profound window into thinking about "the crisis traversing the arts today." Tzara claimed that the antagonism between the individual creator and modern culture, which was manifested in the struggle for form and subjective appropriations of reality in modern art, did not affect primitive art, where each object was an undiluted expression of both an artistic personality and the surrounding culture. Primitive art was not a symbol struggling for aesthetic autonomy but "perceptible reality" containing the entirety of the culture producing it. This made it poetry itself, a parallel that Tzara's review of Oceanic Art, published a year later in *Cahiers d'Art*, explored further.[118]

These theoretical divagations into primitive art were put to the test when he was asked by Charles Ratton (who later helped to prepare the 1934–1935 Museum of Modern Art show "African Negro Art" and whose gallery hosted the 1936 "Surrealist Objects" exhibition) to help organize an exhibition of African and Oceanic art.[119] Ratton was interested in a public event that would present primitive art to a mass public as a living form.[120]

Powerful patrons for the show were recruited, including Beaumont and Baron Henri de Rothschild, owner of the Théâtre Pigalle, in whose basement galleries the show was held from 28 February to 1 April 1930. Over 425 objects—many from museums like the Trocadéro, others from private collections, including Tzara's but also those of his artist friends Derain, Marcoussis, Matisse, and Picasso—were displayed. *Comœdia* called the exhibition "the most important manifestation of primitive art that ever took place in Paris," for in the "tender, even provocative, intimacy" of the Pigalle gallery space, primitive art took on a different light for the visiting public.[121] The illustrated weekly *Miroir du Monde* used the show to criticize "the obstinacy of our national museums in closing their doors to this art from two continents."[122] In *L'Intransigeant* art critic Maurice Raynal applauded the "rigorous taste" of the organizers, for not a single "mediocre work" made it into the show. He did object, though, to the rigorous cataloging of the provenance of each piece and the attempts to precisely date the works: there was "no more of the marvelous" because the "mystery" of primitive art was "unveiled," an "excessive seriousness" which would lead to "catalogs, books, and specialists," even the Louvre itself, taking up the subject.[123] For Carl Einstein, whose 1915 *Negerplastik* was one of the first treatments of primitive art, this was one of the outstanding qualities of the exhibition: "We must treat this art historically, and no longer only consider it from the point of view of taste and aesthetics."[124]

Other critics, though, were bothered by what they perceived as obscene "Negrophilia." *Cahiers d'Art* detailed the controversy: "The exhibition ... has hurt the modesty of all the guardians of morals. Thanks to the numerous images we have published, our readers know that African and Oceanic artists ... never make their sculptures ridiculous by covering the genitals with the infamous fig leaf. ... Our dear moralists did not want to take these considerations into account. For them, some of the African and Oceanic sculptures were nothing if not obscene."[125] *L'Ordre*, whose name gave away its political leanings, pilloried the show as "a manifestation of decadence and seduction."[126] The owner of the Pigalle gallery threatened to pull out seven works that he considered "obscene," but Ratton and Tzara held firm, demanding that the courts send an expert to verify "the purely artistic character of the works on display, and to ordain if need be their formal reintegration into the exhibition."[127] The matter never reached the courts, but the polemical debates about the obscenity of primitive art continued in the popular press, showing once again that the aura of scandal never entirely left Tzara.

11 APPROXIMATE SURREALISM: **1929–1935**

"THE DESTINY OF HEROES AND REVOLUTIONS IS OFTEN TRAGIC. THEY INSPIRE AN ABSURD MISTRUST, A VAGUE HORROR. YET TZARA, DESPITE HIS CATLIKE RESOURCES AND NOTICEABLE FISH SCALES, WALKS SHROUDED IN SOLITUDE."[1] Benjamin Fondane's 1930 profile expresses the ambiguity of Tzara's life and poetry at the time: although removed from the currents of the Parisian literary scene, his work was not a predictable throwback to a Dada past but showcased an originality and freshness that his contemporaries lacked. One of the most influential literary figures in Paris agreed. In his "Second Manifesto of Surrealism," which appeared in the final issue of *La Révolution Surréaliste* (December 1929), André Breton publicly saluted the work that Tzara had undertaken in silence:

> We believe in the *efficacity* of Tzara's poetry, which is the same as saying that we consider it, apart from Surrealism, as the only really "situated" poetry. When I speak of its efficacity, I mean to imply that it is operative in the broadest possible area and that it represents a notable step forward today in the direction of human liberation. … [I]n the front rank of the things that Lautréamont has not rendered absolutely impossible there is Tzara's poetry. *De nos oiseaux* having just appeared, it is fortunately not the press's silence which will succeed in stopping the damage it can do.[2]

Given that "[i]t is to [Lautréamont] that the surrealists will appeal most frequently; it is his work that they will try to equal by their own," this was genuine praise.[3] Breton was also defending his former friend against Georges Bataille, who in the August 1929 issue of *Documents* accused Tzara of being "inert in all circumstances."[4] Breton's plea continued: "Therefore without having to ask Tzara to get hold of himself, we would simply like to suggest that he make what he is doing more obvious than it was possible for him to do over these past few years."[5] Willing to welcome Tzara into the Surrealist fold, Breton signed off the apology in unmistakably biblical language: "let him not forget, we were like him. Let no one think that we found ourselves, then lost ourselves."[6] Tzara, who placed such a premium on friendship, was touched by what he read, and the poetic wilderness was rapidly exchanged for the joyride of Surrealism's adventures. It proved a bumpy ride, but the 1930s did not provide a smooth road to anyone.

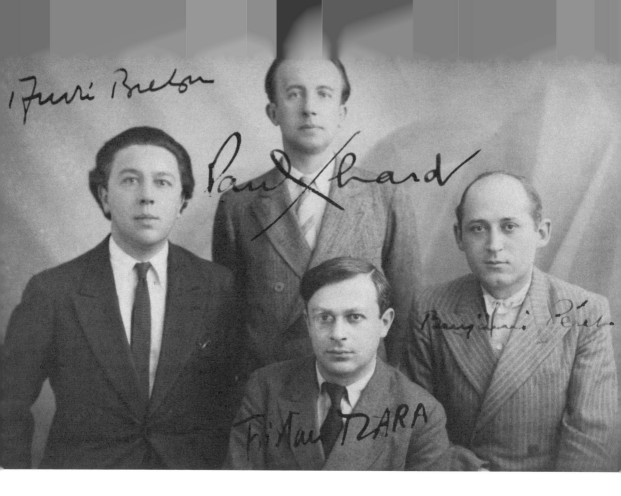

222

FIGURE 11.1
Breton, Éluard, Tzara, and Péret, 1932.
Tzara Collection, Bibliothèque Littéraire
Jacques Doucet.

Tzara remained very well informed of Surrealism's activities throughout the 1920s by René Crevel, a regular visitor to avenue Junot. The vitality of Surrealist publications and their public scandals—the pamphlet *Un cadavre* [A Corpse] upon the death of the "human servility" that was Anatole France; calls for a "total liberation of the mind" in declarations summoning up the Terror; appeals for the "barbarian" Orient to invade sclerotic Europe; anti-French tirades at the Closerie des Lilas; plays disrupted because of personal antagonisms; stickers exhorting parents to recount their dreams to their children—all these harked back to the glory days of Dada.[7] But these were not spontaneous eruptions but, rather, minutely calculated assaults. Tzara did not want to exchange the poetic wilderness for the regimented life of daily café sessions, where tardiness was unacceptable, the drinks one ordered were judged by others, and Breton insidiously questioned one's orthodoxy.[8] But the world had changed, mostly for the worse, and Tzara had warmed to the possibility of engaging with the Surrealists. Breton had sent him a dedicated copy of *Nadja*:

> To Tristan Tzara
> by this singular poetic justice
> that made me consider again
> how I knew him
> what a lovely laugh he has.[9]

In turn Tzara sent a copy of *De nos oiseaux*. In summer 1929, Tzara, on vacation with his wife and Christophe in Brittany, wrote to Breton: "I am deeply touched by what you told me regarding 'de nos oiseaux,' and especially by your desire to clear up the stupid misunderstanding that has been so difficult and often distressing for me for such a long time now."[10]

If Breton's very public apology was made only after he knew it would be accepted (the final chant of *L'Homme approximatif* was published alongside the "Second Manifesto," which indicates that the friends had been reconciled in private), Breton later stated that Tzara was "strategically motivated" to join the Surrealists.[11] But Breton had his own strategic reasons for a reconciliation. In early 1929, he had sent out a circular letter to over sixty recipients, among them Tzara, asking whether Surrealism should pursue individual or collective action. The troubles that the Surrealists had experienced with the French Communist Party, stemming from an ill-fated alliance with the socialist review *Clarté*, haunted the group. Breton wanted individual members to set out their ideological positions; this was seen as either a call to arms or an inquisition (in the wake of Breton's "Second Manifesto," he was accused of being no more than "a cop and a priest").[12] Collective action seemed impossible given the fissures in the group, which had already seen its membership change over the years through expulsions and defections. Ribemont-Dessaignes was furious, telling Breton: "So this is where all your collective efforts lead: judgment, judgment, judgment, and of what kind! Your revolutionary action: sweeping people away. ... You are all bureaucrats of purity and judgment."[13] The "Second Manifesto" had its share of *mea culpa* moments, and Breton realized that things could not continue as they were; the group had

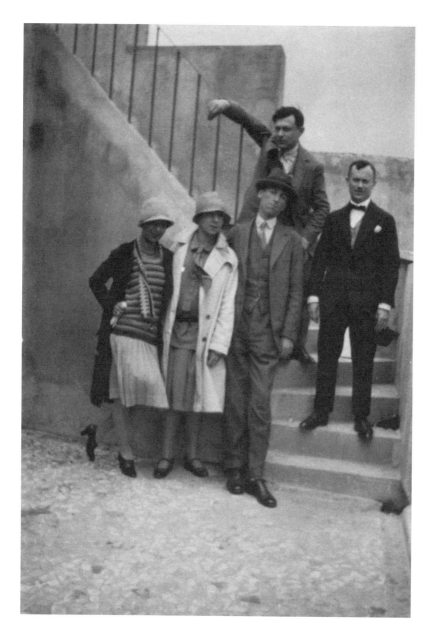

FIGURE 11.2
Greta Knutson, Alice Halicka, Tzara,
Joan Miró, Henri Rivière at the back of
the house at avenue Junot, early 1930s.
Tzara Collection, Bibliothèque Littéraire
Jacques Doucet.

to be energized with new thoughts and directions "into *the life of this period*."[14] With his independence of spirit and mind, Tzara was an important figure for claiming the moral high ground when it came to intellectual responsibility.

For his part, Tzara was eager to be part of group action again. He was regularly fêted in Romania, with Jacques Costin sounding out the possibility of Tzara coming on a "quasi-official visit" for "a solemn modernist tam-tam of French nuance," so long as he found someone to accompany him—"but an authentic Frenchman."[15] But in France Tzara exuded solitude to such a point that Alberto Giacometti felt compelled to adopt a similar posture whenever he was in Tzara's company.[16] The Surrealist group, which included ex-Dadaists like Aragon, Baron, Breton, Crevel, Éluard, Ernst, and Man Ray, offered a fresh start with old friends. He became one of the most active Surrealists, attending the café sessions at the Cyrano and opening up his house for a significant number of meetings. Aragon later recalled Tzara's "enthusiasm" and impartiality as "a kind of referee" during this period, while André Thirion notes that Tzara was one of the "bankers" of Surrealist publications.[17] Greta was also an eager participant, influencing the group through her deep knowledge of the German Romantics and also taking part in the *cadavres-exquis* (exquisite corpses) sessions. This exercise involved folding a sheet of paper and having individuals draw on it, each person unaware of what the other was doing. The results would be dissected and analyzed in terms of the properties of chance that brought together an unintentional unity in the final composition. Tzara also took part in these sessions, and even drafted a set of rules for both written and drawn exquisite corpses.[18]

Besides group life, Tzara's great support for Surrealism came through his own writing, both critical and creative. The December 1931 issue of *Le Surréalisme au service de la révolution* published "Essai sur la situation de la poésie [Essay on the Situation of Poetry]," Tzara's first systematic effort at explaining modern poetry.[19] While his shorter texts on modern poets or artists from the Dada period were either infused with irony or lyrical effusions with no recognizable link to the text or artwork in question, Tzara here endorsed—as Aragon had done in the previous number of the journal—dialectical materialism as the only critical-methodological tool capable of understanding the role of poetry in modern society. Art, Tzara begins, is "engendered by its social and economic relations."[20] Suggesting that "poetry as a means of expression [*poésie-moyen d'expression*]" is connected to "directed thinking [*le penser dirigé*]," Tzara argues that "poetry as an activity of the mind [*poésie-activité de l'esprit*]" is the product of "undirected thinking [*le penser non dirigé*]," which consists of dreams, fantasies, and the subconscious.[21] The categories of directed and undirected thinking were borrowed from the Swiss psychoanalyst Carl Jung, but the poetic implications could already be found in Dada's attack upon the organization of the senses and the rationalism of *poésie-moyen d'expression*. Spontaneity for Dada was a positive ideal which "emerges freely out of us without the intervention of speculative ideas, it represents us."[22]

225

Yet one consequence of this schema is that poetry's ability to taken an active role in social revolutions is necessarily limited: "poetry … cannot act upon social reality, because only its aspect that is poetry as a means of expression might be capable of doing this, and this aspect must tend to progressively diminish."[23]

The categories Tzara lays out can suggest a certain simplicity: "There are only two forms," Mr. Aa proclaimed, "the poem and the pamphlet."[24] Yet the essay is not simply an exposé of theoretical thinking; it is an attempt to understand the emergence of a certain type of poetry through historical developments, which leads Tzara to trace the manifestations of *poésie-activité de l'esprit* from the Romantics onward. For him, poetry is not a literary form, as this textual return to Dada made clear:

> Language, with respect to human relations, was for Dada a problem and a constant worry. Across the sprawling and dispersed activity that was Dada, poetry— a certain poetry, it must be specified, art poetry, based upon the principle that beauty is static—was harassed, insulted, and despised. Dada opposed to this a certain *state of mind* which, despite its principled antidogmatism, was capable of showing that everything is movement, a constant alignment with the flight of time.[25]

Dada did not consider poetry "an end in itself" but, rather, insisted on its intimate connection to the audience and a broader social context, a point that most critics refused to see.[26] Dada also wanted to break down the boundaries between creative forms via its insistence that art was everywhere: "It is perfectly well admitted today," Tzara notes, "that one can be a poet without having ever written a single line of verse, that there exists a certain poetic quality on the street, in a show, truly everywhere."[27] Poetry, in other words, resides in "daily life."[28] It was the individualist, competitive nature of modern capitalist society that bracketed off poetry from life itself. Poets were mistaken in thinking that formal innovations, which only cut to the surface of things, could supplant these social conditions. "The social revolution does not need poetry," he concludes, "it is poetry that needs the revolution."[29] Only a modern society capable of using *le penser dirigé* toward the ends of satisfying the entirety of man's material needs could truly experience the full humanity of a poetry that was the genuinely free expression of a personal liberty.

The essay's utopianism, its concern with literary history only insofar as it spotlighted the material transformations of a coming society and a resplendent future, makes it very much a period piece. The first issue of *Le Surréalisme au service de la révolution* opened with a proclamation—through telegraphs to Moscow—that the Surrealists would support Soviet policy in the fight against fascism and imperialism. Politics and society were no longer abstract demons to be slayed but pressing realities that no one in 1931 France could overlook. Yet the political urgency in Tzara's essay was not a *volte-face*. Tzara had been sensitive to political questions ever since his time in Romania, where he personally experienced what it meant to be marginalized via politics. The status of the Zurich Dadaists as "war

226

deserters" and the casual xenophobia that greeted their every step, to say nothing of the workers' uprising in Zurich after the war, had also contributed to Tzara's political education. And the Surrealists had their own political demons to slay in this period. Aragon's poem "Front Rouge," which called for politicians to be assassinated, led to the government charging him with provocation to murder. In *Misère de la poésie*, Breton defended his comrade with the sophistic reasoning that prose writing might fall under the remit of government, but poetry could not. Yet Breton's defense also included pointed criticisms of the French Communist Party. Aragon, who had affirmed his commitment to the Soviet cause at the Second International Congress of Revolutionary Writers in Kharkov, objected to Breton's comments, which left Breton no choice but to expel from the Surrealists his closest and most faithful companion. Tzara, whose position would eventually gravitate toward Aragon's, supported Breton's actions.[30] "Essai sur la situation de la poésie" ultimately reflected this ambiguity, calling for poetry to be subordinate to political action but insisting that *poésie-activité de l'esprit* could be free of politics and ideology because it was a pure expression of the self.

Although Tzara's major creative contribution to Surrealism, *L'Homme approximatif*, appeared in 1931, he started working on it years earlier, when "holed up in the solitude of [his] arteries."[31] As he later told Breton, "these poems have been turning in my head for so long that they no longer have body or meaning [for me]."[32] A long poem with nineteen separate sections, or chants, it was published by Éditions Fourcade in a print run of 510 copies and illustrated by Paul Klee. Tzara had known Klee from Zurich, where the Galerie Dada had shown his work. Long committed to abstraction, Klee's paintings seemed to match perfectly Tzara's vision of "approximate man," an incomplete product of the forces of time and nature, "man slightly animal slightly flower slightly metal slightly man."[33]

The fragmentation of *L'Homme approximatif* is leavened by an epic, incantatory lyricism:

> so many hours have formed me with their friable cement of cruciformtibias
> so many men have preceded me in the noble furrow of exaltation
> so much soul has been squandered to build the chance I gamble
> in the lonely jail where a blood prowls thick with remorse
> so many soft frenzies have brought the landscapes toward my eyes
> and bitter consciences restrained the ground swells in the sieve of their anxiety
> so many unseen voyages have soaked in my senses
> so many miracles have linked us
> to the fleet of words—dregs of divine innuendoes—
> hypotheses rolling in the midnight crucibles of the mind
> where the ground swells break and the waves of love
> and so many others swell and sink again
> and so many others break in secret.[34]

The plentitude—"so many"—starting each line, which gives such an easy cadence to the stanza, becomes disturbing: there is no material plenty to be had when the heaviness of the unseen, the unknown, and the intangible weighs down the voyager. Memories have come to overtake the self:

> the heavy shutters of your youth swing open
> a wind as far as the days can reach moves in you
> the windows opened on the pediment of things
> send old reminders coursing through you
> the anxious avidities submit without restraint
> to the carnal bitterness of the lichen ambush.[35]

Indeed, this voyage of the self through a world of chaos and confusion is the poem's central problem:

> you wonder where you're going the weighty heritage
> of trees the survivals
> and why you move about under this sign
> garden invaded by evil loves
> the seductive pallors found outside yourself
> what you are what you do not know
> sibilant insect searching between the lines
> …
> trailing tatters of temporary meaning
> rigid pallors of knowledge and of wells.[36]

By addressing the reader here, the poem underlines the commonality of its concerns: "approximate man like me like you reader and like the others." [37] In the third chant the poet promises: "I empty myself before you pocket turned inside out," but the pockets of this confessed self-kleptomaniac turn out to be empty: "facing others you are another than yourself." [38]

Instead of the adventures and journeys in conventional epics, *L'Homme approximatif* focuses on the shaping of a consciousness "moving in the almosts of destiny." [39] A child of modernity, "approximate man" is Tzara's term for the "heap of noisy flesh and echoes of conscience" struggling to find a center from which the self and its component parts can be positioned.[40] In his 1921 "Dada Manifesto on Weak Love and Bitter Love," Tzara ironically noted: "Everyone (at a certain moment) was complete in the head and body. Repeat that 30 times." [41] *L'Homme approximatif* develops this idea further: "[F]or I want the map to show me clarity," the poet begs, but the cartography of the mind and the heart is fragmented as

> the uncomfortable existence we have rented
> and in which we try to settle down

is forever out of reach because

> words are spinning
> leaving a faint trail majestic trail behind their meaning scarcely a meaning.[42]

Acknowledging that "a man is so few things that a fine net of wind carries him off," the poem details disasters and catastrophes, both natural and man-made, that ceaselessly knock the individual off his course, among them language.[43] Emanating out of nothingness, settling among the debris of the self:

> where did it come from the vowel with beating wing
> which prolongs the panting questionnaires of strangled flutes
> the bridges and caressing jetties
> elastic wakes the animal proceedings perhaps the stars
> and crashes suddenly on plateaus of flesh and bushes.[44]

Crushed by history,

> blind are the words which from their birth can only find their place again
> their grammatical place in universal safety
> meager is the fire we thought we saw kindling in them in our lungs
> and dull the predestined gleam of what they say.[45]

The poem attempts to move language beyond the social world, where "hostility all is hostile around the nebulae of talk."[46] This agony and despair are tempered by an undercurrent of hope that the word can be salvaged:

> I think of the warmth spun by the word
> Around its center the dream called ourselves[47]

"[T]he infinitely mobile flesh of dream," memories, the vagaries of the mind: these are the poem's centers as the inarticulate struggles to become, for a fleeting moment, a link between past and present, poet and reader, "man celestial pitcher when the dream draws its hallway light."[48] The struggle is to find the connection, "from your dreams to mind the word is brief."[49] The duality of language, radiant vision yet also empty vessel, creates a constant opposition that makes it impossible to collapse the poem into a singular meaning. Because "reason is captive to a fable of discord," we have built up only a "diffuse mythology of our wild fragments of knowledge," "the haughty flood of tyrannical numbers and turnings" that the arrogance of man has mistaken for science, a "prophecy of order at last to crystallize in death."[50]

L'Homme approximatif concludes with the slim hope that these inert applications of the word can be overcome:

> a slow furnace of invincible constancy—man—
> a slow furnace rises from the depth of your slow deliberation
> a slow furnace rises from the valley of glacial principles
> …
> harmony—let this word be banished from the feverish world I visit
> savage affinities undermined by emptiness covered with murders
> …

229

230

FIGURE 11.3

A moment of levity: Christophe learning his ABC.

Tzara Notebook, Houghton Library (Harvard University), MS. Fr. 340.

> I have pledged my waiting to the oxidized desert of torment
> to the unshakable advent of its flame[51]

The fire raises the possibility of moving toward "the celestial pasture of words" in the future, when the self has been stripped of its vanity:

> one day one day one day I shall put on the cloak of eternal warmth
> hidden forgotten by others in their turn forgotten by others
> if I could reach the luminous forgetfulness[52]

Contemporary reviewers picked up on these positive images of a final liberty and saw Tzara's poem as a manifestation of how, amid the travails of history, the self could be renewed. The grandeur of his poetic voice in *L'Homme approximatif* indicated a new sensibility: no more Dada irony, but rather a clear-sighted assurance of the intricate connections between man, nature, and society that did not conceal the fraught vulnerability of the poet:

> I speak of the one who speaks I am alone
> I am only a little sound I have several sounds in me[53]

For Jean Cassou, who commissioned the work for Éditions Fourcade, and asked Tzara to read part of it at the École Normale Supérieure in 1931, "In persevering in that which could appear as only sterile negation or a fatal explosion, Tzara produces a positive, abundant, generous, passionate work. ... In the realm of the spirit, it is often on burnt soil that virgin forests are reborn."[54] The Hungarian poet Gyula Illyés thought it "very grand and very tragic, a dignified follow-up to what you have done and preached in your youth ... a sincere despair, a contempt for life as it now is that no one else before you managed to accomplish."[55] Jacques Lévesque, the editor of the French review *Orbes*, which had published Chant XVI in spring 1929, congratulated Tzara on "*one of the most important works of our epoch.*"[56] But the small print run of *L'Homme approximatif*, and its difficult formal structure, limited its impact to a constrained circle of admirers.

Tzara's next volume of poetry, *Où boivent les loups* [Where the Wolves Drink], was published on the same day (25 June 1932) as Éluard's *La Vie immédiate* and Breton's *Le Révolver à cheveux blanc* [The White-HairedRevolver]. This publishing coup by *Cahiers libres* was an attempt to put Surrealist poetry front and center in French literary debates. Valentine Hugo, whose monumental oil painting *Les Surréalistes* was begun in 1932 (but not completed until 1948), no doubt chose to start the painting with Breton, Éluard, and Tzara because of the three volumes that came out at the same time.

The literary critic Gaston Bachelard, who became close friends with Tzara during this period, later spoke about the "absolute poetics," "the surrealist action of a pure image" in *Où boivent les loups*.[57] The volume was another point of departure for Tzara, with the hermeticism and the onslaught of discordant images in *L'Homme approximatif* giving way to a simpler, more controlled language that remains, as one literary critic puts it, "surprisingly obscure."[58] There are sixty-three untitled poems in four titled sections of *Où boivent les loups*; the opening lines announce the collection's great themes:

231

then there was a flying light
and I saw ugliness
then on the obtuse rope broke
the look of your flame[59]

Starting at an equivocal time, the poet's entry into language—"flame alone I am alone," one reads a little later—is met with the "ugliness" of a world where things are falling apart.[60] The language is deceptively simple and metrically regular, but the confusion is nonetheless total, for the identity of the subject is cut "shred by shred" as "neither peace nor intoxication / bound tongues" can cobble together a rational sense of constant movement "amongst all that has been forgotten" and "sealed-up doors."[61] The sense of loss and disorientation is an emanation of

a life made of silence profound vigor
at the edge of the storm[62]

In a rare personal intervention, Tzara wonders about the impact of his origins and the roads taken by his adolescent self that have now contributed to making "my foreign face [*ma face étrangère*]":

maybe he had thought about fleeing too much
though no flight would have released him from his primal fervor[63]

Seeking to marshal these memories into order, the free verse and irregular poetic forms of *L'Homme approximatif* give way to more controlled, but not more uplifting, emotions:

breaking all the ties all around
to dress with a complete death[64]

Then there is the following:

what has become of beliefs of silences
the roads were open at our proudest days
knocking on the light doors of laughter with flames[65]

Although the poet delivers himself to nostalgia, the poem nonetheless hopes for a resplendent, luminous future:

one day perhaps will emerge
the light in grandeur
and raising your head at last from the mud like a suckling babe
you will go forth in the audacity of immemorial whiteness[66]

For all the desperation found in *Où boivent les loups*, there is a hint of being able to find a resting point in the solitude of language:

since the word has no lie or truth to live alone
and make loneliness live in front of the fire from the word to the grave[67]

232

As one of the final poems in the collection announces,

> open your eyes again
> the distances will slip between your fingers
> doors will unmask
> the shore will approach the lips of the earth
> even under the stack of sleep there will be no more loneliness
> everything will be filled deeply with the smell of hay and sun
> words will stop when the insatiable secret
> which lives removed from enclosures and bodies
> will have silenced the nudity of words
> words will stop—open your eyes again
> deep meanings will be inseminated
> and the hayloft of sunny words will be full of them
> shadows will turn to dust[68]

No shadow followed Tzara's life and works as persistently as Dada. The publication of Ribemont-Dessaignes's "Histoire de Dada [The History of Dada]" in the July 1931 issue of *Nouvelle Revue Française* saw a renewed interest in the movement. It also obliged Tzara to clarify his position as a Surrealist: "I formally declare that a majority of the stories are false, incomplete, arbitrarily interpreted, insufficiently documented and envisioned solely from a picturesque, anecdotal, and journalistic point of view—one that the majority of adherents to Dada had always found repugnant." Ribemont-Dessaignes's article, Tzara noted, "detach[ed] Dada from social and even literary phenomena that preceded and surrounded it."[69] To correct that, Tzara opened up his rich archive to Georges Hugnet, who was writing a series of articles for *Cahiers d'art*. Tzara himself was also making use of his archive, working with Crevel to select the works that would comprise *L'Antitête* [Anti-head] (1932). Illustrated by Picasso, this collection of prose poems, the bulk of which came from the Dada period and featured the irrepressible Monsieur Aa, raised further doubts about Tzara's orthodoxy, as did the publication of his Romanian-language juvenilia that same year in Bucharest. Both books were meant to underline the continuity of his thought and engagement, with the final part of *L'Antitête* consisting of *autocollages* (texts in which earlier writings, in this case passages from *Faites vos jeux*, were cut up and reordered). But suspicion remained, since Tzara had not collaborated on either the second or third issue of *Le Surréalisme au service de la révolution*. The Brussels-based *Journal des Poètes*, which was not kindly disposed to Surrealism, began an article on Tzara with a series of quotations from the *Manifeste Dada 1918*, creating the impression of an irresolvable contradiction between his former positions and his current fidelity to Surrealism.[70] Tzara responded by issuing a circular to the Surrealists, insisting on his "complete good faith" toward the group and bemoaning the "low, disgraceful" rumors against him.[71] Two days later he wrote an open letter to *Le Journal des Poètes*: "I insist on publicly declaring that my adhesion to Surrealism [is] total and all its goals [are] mine," reaffirming: "my active collaboration with the Surrealists and my friendship with them" should be proof enough of this position.[72]

But the campaign of insinuation and rumor did not entirely disappear, and the strains in Tzara's personal life only made matters worse. With Greta he went down to Tunisia in spring 1933, picnicking in the desert in the company of E. E. Cummings, who noticed the tension between the "formerly a would-be poet" and "the asperine queen" who was exceedingly sensitive to any stray remark or look.[73] Alice Halicka also recalled Greta's "extremely sensitive" nature: "The tiniest insignificant event—a soup served too cold, a curtain brought back discolored from the wash—took on the proportions of a somber Strindberg or Ibsen drama. An atmosphere of Nordic tragedy weighed down the house."[74] Yet Tzara was not entirely blameless in the event that pulled the couple apart, for he had started a passionate affair with a German woman named Hilde: "I dream of you," she wrote him, "your skin at the touch is liquid."[75] It did not help that his new lover sent letters to avenue Junot: "Tell me right away if G[reta] found and read the letter that I sent to your Paris address, that would be terrible."[76] It was indeed, for Hilde turned out to be a family friend who knew Greta well: "How is G[reta]? I am so sad that she saw my letter. Now she won't want to see me anymore and I love her so much."[77] Perhaps because it was not the first time Tzara had strayed in his affections, some of Greta's letters evidence a remarkable continuing attachment: "Wolf, my little wolf. I don't know if the wolf will be entirely, entirely unhappy at having a letter from the crocodile, because I do not know what he is feeling. Is wolf only concerned about his work? Not needing anyone?"[78] To try to patch things up, Tzara went to stay with his family in Nice. Christophe was quickly growing up: "Children cry alone at home, they cry tears of milk and pave the way for the disappointments of middle age."[79]

After a spring 1933 Surrealist exhibition at the Galerie Pierre-Colle, which featured works by Arp, Dalí, Ernst, Giacometti, Miró, and Tanguy, Breton and Éluard sought Tzara's support for a new project, the arts review *Minotaure*. Poised to become one of the most influential arts journals of the interwar period, *Minotaure* was known for its high-end illustrations and exquisite design. Skeptical of the project in many respects, Tzara contributed only a single article, "D'un certain automatisme du goût [Of a Certain Automatism of Taste]," which appeared in the December 1933 issue as part of a series of Surrealist object studies. Illustrated by Man Ray with photographs of female hats, Tzara's article was an attempt to understand the sexual underpinnings of modern fashion. The source of fashion—and of all art, Tzara insisted—could be found in "the desire to return to prenatal life": "the feeling of outpouring, of total, absolute, irrational comfort, of the absence of consciousness and responsibility."[80]

This intrauterine security, though, was exactly what was lacking in France and Europe in the 1930s. Tzara's hesitation toward *Minotaure* stemmed from his conviction that artists had to move beyond writing "revolutionary poetry" and actually dirty their hands in politics. Tzara's politicization took the form of joining the Association des Écrivains et Artistes Révolutionnaires (AEAR), an organization which had strong links to the French Communist Party but believed in the need for a diverse "cultural front."[81] At its founding in March 1932,

the AEAR had 200 members, but two years later its numbers had swelled to over one thousand artists.[82] The AEAR was committed to "reeducating" bourgeois artists on the class struggle and preparing "the dictatorship of the proletariat" by supporting working-class art and propaganda.[83]

The distance that Tzara had traveled by this point was striking. In 1923 he had signed, along with Arp, Schwitters, and Van Doesburg, the "Proletarian Art Manifesto," which declared: "An artist is neither proletarian nor bourgeois, and what he creates does not belong either to the proletariat or the burghers but to everyone. … Art is free in the use of its own means and responds to its own laws and to its own laws only; as soon as a work becomes a work of art, it is largely above the proletariat-bourgeoisie class difference."[84] But a decade on, Tzara felt that the "autonomous and independent existence" of art was a fiction that only "the lowest art critics (a particularly gelatinous species)" could believe in.[85] It is telling that, though he was poor in 1923, he dismissed proletarian art, while as a rich property owner in 1933 he railed against "capitalist oppression."[86] In both cases, though, he was committed to an international, progressive art. The earlier dismissal of proletarian art came from his feeling that communism represented "a bourgeois form of the revolution," not a change in the consciousness of man but "a regrettable necessity."[87] This necessity was even more pressing in the early 1930s. In the December 1932 issue of *Nouvelle Revue Française*, Denis de Rougemont organized a *Cahier de Revendications* [Dossier of Demands], a series of pieces by younger writers all calling for greater political engagement on writers' part. In his preface, Rougemont called for intellectuals to be organized into "a single front" to defend progressive causes against the tyranny of the market and the dangers of fascism.[88] The continuing attraction of Mussolini to large swaths of the French population, and Hitler's rise to power in Germany, only added to the exigency of political action for the French left.

The Surrealists were suspect in the view of the AEAR, which was led by Paul Vaillant-Couturier, poet-lawyer (who had taken the podium at the 1920 Dada event at the Club du Faubourg in Puteaux), editor at *L'Humanité*, and cofounder of *Clarté*. AEAR cofounder Léon Moussinac had to be persuaded that the Surrealists' penchant for "individualism"— their preference for poetry "*d'activité d'esprit*" as opposed to revolutionary poetry "*moyen d'expression*"—would not impede the organization's common goals.[89] In the essay where those terms were developed, though, Tzara had made it clear that he accepted the necessity of direct political action because genuine poetry expressing an undivided, complete individual was impossible under existing political and economic conditions. Other Surrealists were less flexible; after *Le Surréalisme au service de la révolution* roundly criticized the USSR, Breton was excluded from the AEAR for sanctioning "counterrevolutionary" propaganda; this led the Surrealists to turn against the organization. Because Tzara was away from Paris for long periods, and avoided the café sessions when he was in town, his continuing loyalty to the AEAR was a source of consternation to the Surrealists. Breton had admitted in his "Second Manifesto" that Surrealism's political engagement had been an

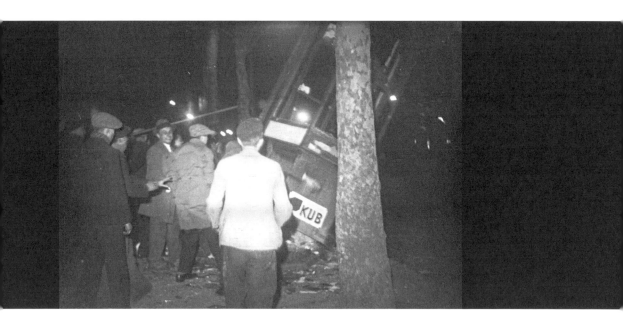

236

FIGURE 11.4
Riots at Place de la Concorde,
6 February 1934.
Bibliothèque Nationale de France.

"uninterrupted succession of lapses and failures, of zigzags and defections," and the position of the group in 1933 was no better—not with Salvador Dalí proposing to undertake a glorified study of "Hitlerism."[90]

The decisive political test came on 6 February 1934, when Paris's Place de la Concorde was the site of armed combat that resulted in fifteen dead and nearly fifteen hundred injured. If the trigger for this riot was a sensational *fait divers* involving a con man who had swindled hundreds of millions of francs but had close ties to ministers, senior judges, and other prominent officials, the public impact of those riots cast a dark shadow on mid-decade politics in France, suggesting widespread corruption and an oligarchic elite (the "200 families"). Tzara was in Nice at the time; three days after the Paris riots, the Mediterranean city was overwhelmed by popular anger that resulted in shattered shop windows, destroyed kiosks, and police columns set up in the middle of the street. Éluard, who was visiting Tzara at the time, described the scene:

> Yesterday at 6 o'clock we went to a demonstration of civil servants in Nice—to tell the truth, we didn't expect much. Well, Nice is not so bad after all. Thousands of demonstrators, behind red flags held by high-school teachers singing the *Internationale*, managed to take over the main streets of Nice for more than an hour. Until the mounted police were called. Then, the real fun began. The soldiers struck out with the butt of their rifles to defend themselves. They were overwhelmed. A red flag that had been lost was recovered. Everything was flying off the rails. It was, in the fair city of Nice preparing its carnival, a genuine hurricane. ... At some point I was very worried for Tzara (without a passport), *very courageous*, very excited. He had taken shelter with some demonstrators separated from the main group in an alleyway. An unconscious and injured gendarme was brought there, and they began arresting everyone. We stayed until midnight.[91]

The viciousness of the scenes and the widespread fear that France was veering toward civil war deeply affected Tzara:

> plenitude of ample crowds
> for having drunk at your springs
> I thought I saw walking together
> the sun and the future.[92]

Even though it was rumored that Breton penned "Appel à la lutte," which appeared in the 11 February 1935 issue of the socialist *Le Populaire*, neither Tzara nor Éluard in Nice had any news from their Surrealist friends in Paris. Two months later Tzara, still in Nice, told René Char that the Surrealists seemed to be "falling asleep for good."[93]

"It is not necessary to renounce poetry in order to conduct revolutionary social actions, but being revolutionary is an inherent necessity to being a poet."[94] That line from the 1935 *Grains et issues* [Seeds and Harvests], Tzara's last major contribution to Surrealism, was indicative of the growing attraction of political action and "the revolting spectacle of contemporary society."[95] In many respects, *Grains et issues* was far removed from the reality of

politics, with the first part of the work devoted to "experimental dreams," "an irrational residue of a lyrical nature."[96]

"The poet, through the help of dreams acting like a projector, strives to render reality confused, to dislocate it, to break it into pieces, to disseminate and anaesthetize it," Tzara notes—a far cry from socialist realism.[97] A certain anguish and solitude—"I remain a stranger to everything I have been left out of everything"—permeates these excursions into the fantastic world of darkness.[98] The book begins:

> Starting now, the content of days will be poured into the demijohn of night. Despair will take on the joyous forms of the end of apple time and will roll like a hail of drums freshly poured on the humid shadow which we use for a coat. The nights will be lengthened to the detriment of days, in broad daylight, according to the rules of the most obstinate and sordid moods. Eggs of light will be piled up on the breasts of buildings. Dreams will be forbidden to accost women in the street. At rush hour, packs of invisible dogs will be released throughout the town; they will slip between feet and vehicles, all of them covered with a phosphorescent substance lightly musical like satin. Men, women, and children will touch each other's hands with an obvious satisfaction taking the place of politeness. No one will be called upon to account for the prolonging of these touches. From this formula, seemingly devoid of interest, unlikely knowledge and capital arrangements will be born. ... A new voluptuousness will blossom forth to replace love. Its chains will disappear and in their place will be silk threads as invisible as certain gazes expressing the world in its present complexity, sentimental and atrocious.[99]

The second part of the work, which consists of a series of notes diagnosing the current malaise of civilization in the vocabulary of psychoanalysis and historical materialism, was unmistakably engaged writing. But even within the dream sequences there is a push for social transformation: "in a world where total forgetting has installed itself as the first rule of life, when inspiration and enchantment become objectives to reach complete innocence," he writes, we will come to see "the vanity of our mania of fixation and the innumerable possibilities of change, not only in the décor of life, but in the specific content of notions and sentiments and the multiple shifts of which man, this walking desire, will be the thirsty and infinitely transformable object."[100] Only a social revolution could resolve these contradictions: "All of my anxiety and the fire supporting it, I entrust them in the hope of seeing one day—thanks to the reduction of the monstrous antagonisms between the individual and modern spirit—the ambivalence of feelings able to be expressed freely, openly, fluidly in a world where customs will no longer forbid this ambivalence and where justice will no longer be executed on the grounds of a simplistic black and white opposition."[101] Yet these excursions into *penser non dirigé*, Tzara admits, are not revolutionary acts in themselves: "Because they try to change the conditions of man only through propaganda, persuasion, education or violence, without touching the social necessities of their movement, these revolts die out quickly and return to the norms from which they have sprung."[102]

238

That line could not be taken any other way than as a criticism of Surrealism, which saw revolution as primarily an event of the mind. If there is a certain unevenness in *Grains et issues*, it is largely because Tzara continued to long for poetry while having to admit to the impossibility of poetry in a bankrupt society. The schizophrenic structure of the work—experimental dreams in the first half, Marxist social commentary in the second—only contributed to the bewilderment of critics as to Tzara's motivations. But it left no doubt, for Breton and company, about Tzara's distance from Surrealism. The preface Tzara wanted to insert to *Grains et issues* accused literary movements of making poetry and literature "an *end in itself*," and he asked Dalí, who had been cast out of the group, to illustrate the work.[103]

Tzara's formal break with the Surrealists, coming less than ten days after *Grains et issues* was published, appeared in the March 1935 issue of *Cahiers du Sud*. Calling automatic writing "powerless" and devoid of interest, Tzara repeated the charge that the Surrealists saw poetry as "*an end in itself*," for which he marshaled evidence in the form of David Gascoyne's *A Short Survey of Surrealism* (1935).[104] In Tzara's opinion this work remained purely on the aesthetic plane but did so falsely, distorting the history of the avant-garde by refusing to give proper credit to Dada. For his part, Breton had no regrets about expelling Tzara from Surrealism, telling Éluard: "I no longer want to hear about Mr. Tzara for any reason at all."[105]

When the Surrealists got involved in politics, Tzara found their actions indefensible. Breton's recent poetry and art criticism, including his criticism of the Soviet Union in "La Grande Actualité poétique," confirmed Tzara's belief that the movement had backtracked on its political commitments. In the aftermath of the 6 February riots and the failure of the left to assemble a coordinated response, the Surrealists issued a lengthy questionnaire (ten general questions, some of them with five subsections) asking intellectuals to provide their thoughts about the possibility of a united front against fascism. Tzara found the effort risible: "I totally refuse to play the role of advisor of the revolution and to adopt, in its most sterile form, the attitudes of the Russian intelligentsia before the Revolution." In his view, a detailed knowledge of actual social conditions was required, "and not a vague, sentimental appreciation which would be adorned by whatever theoretical embellishment."[106] After the *Cahiers d'art* article, Tzara's break was confirmed when the Surrealists issued "La Planète sans visa," a tract calling for the French government to not deport Trotsky, who had been living in France for the past year. Tzara refused to sign the appeal. He was not alone among French intellectuals in taking such an intransigent stance, but it was the logical consequence of the positions he had laid out in "Essai sur la situation de la poésie." Even though he did not join the French Communist Party (PCF) until after the war, politics had taken center stage in his life, largely against his will and with uncomfortable consequences, and it would dominate his thinking for the next two decades.

12 POETRY AND POLITICS IN TIMES OF WAR: **1935–1944**

POETRY'S ENTRY "INTO DAILY LIFE AS A HUMAN ACTIVITY," TZARA OBSERVED IN *GRAINS ET ISSUES*, REQUIRED A "TOTAL REVERSAL" OF SOCIAL LIFE.[1] With his break from Surrealism complete by early 1935, Tzara redoubled his efforts on the political front. Greta submitted artwork for the Artists' International Association antifascist exhibition in London. Yet amid these political involvements, Tzara did not alter his poetry; it was a "misrecognition" of poetry's aims and nature, he claimed, to make it "a mediated, documentary activity of allegorical description with the moralizing goals of fabrication and propaganda."[2] Poetry was simply too important—"in the totality of its complexity, it covers the destinies of thought"—to be turned over to such a barren course.[3] Tzara's evolution would remain full of contradictions and hesitations, but there was no doubt in his mind that the times required personal engagement.

Meeting "in the very storm's eye of the thirties," the 1935 Congress of Writers for the Defense of Culture brought together intellectuals from thirty-eight countries.[4] With *L'Humanité* revealing on the conference's opening day, 21 June, that "a confidant of the Führer proclaims that only war would permit Hitlerism to realize its ambitions," the political moment was tense, especially since the newly installed French prime minister, Pierre Laval, proved more willing to negotiate with far-right groups than with the left.[5] The five-day Congress at the Palais de la Mutualité, chaired by young firebrand André Malraux and elderly doyen André Gide, brought together liberal humanists (Julian Benda, E. M. Forster, and Aldous Huxley) and communists in a united front against fascism.[6]

But the united front did not include the Surrealists. One of the Congress's lead organizers was Soviet journalist Ilya Ehrenburg, who had in a recent book characterized the Surrealist revolution as the study of dreams, pederasty, and living off inheritances. A week before the Congress's opening, Breton saw Ehrenburg on the street: "After having introduced myself," Breton later recounts, "I slapped him several times over, while he pitifully tried to bargain without even raising a hand to protect his face."[7] Ehrenburg later responded

by demanding that Breton be denied the floor at the Congress. Although René Crevel pleaded Breton's case at a meeting of the Congress organizers at the Closerie des Lilas, the Soviets remained intractable: if Breton spoke, they would boycott the Congress. Sharing a taxi home with Crevel and Jean Cassou, Tzara woke up the next morning to hear that Crevel had committed suicide, leaving a short note: "Please cremate me. Disgust."[8] Even if the suicide was also due to Crevel's long-standing health problems, Tzara was shattered. The two had been the closest of friends for the best part of a decade. They had shared their philosophical and personal doubts about Surrealism (as a homosexual, Crevel found it difficult at times to be around the notoriously homophobic Breton); both were active in the AEAR and had invested great hopes in the 1935 Congress.

Crevel's funeral was held on Saturday, 22 June, the very day he had been scheduled to address the Congress. Tzara was in attendance at the funeral, having gone to the Congress opening the night before. For five nights the speeches continued, but there was little formal debate. At times the organizers summarily cut off speakers; this happened to Brecht, who was allowed only three minutes when the original plan was for fifteen, while others, like Barbusse, were allowed to go on for so long that the audience filed out. Amid this disorganization, though, there was a genuine sense of possibility and a tragically exaggerated feeling that intellectuals could reorient a Europe dominated by hate. Jean Guéhenno recalls: "We didn't stop talking for five days and nearly five nights. The smoke and the dust didn't have time to dissipate."[9]

Tzara's speech was scheduled for Monday 24 June, in a session entitled "The Problems of Creation and the Dignity of Thought." The audience had been infuriated earlier in the evening when Gaetano Salvemini, a professor at Harvard who had been expelled from Italy, raised the problem of intellectual freedom in relative terms: "The liberty of creation is compromised in nonfascist bourgeois societies. It is entirely suppressed in fascist bourgeois societies."[10] During his speech, Tzara mouthed agreement with the Soviet model but insisted that poetry was "more alive, more complex and more profound" than a statement of principles.[11] His position on the need for political engagement on the part of poets was clear, but their exact role was not: "The revolution is not a sudden, spectacular flame produced outside of us. It is a patient, shifting and conscientious work. ... Our choice is made. Should we adopt a watered-down line that can only take us out of the fight? No. If our choice is made, we must accept what it entails."[12] The ambiguity of these lines, considering Tzara's disqualification of *poésie-moyen d'expression* as a valid goal and the resignation of the phrase "we must accept what it entails [*il faut que nous en subissions le parti pris*]," was not cleared up in the conclusion:

> Today the poet who ranks his literary work above his own existence places himself in the camp of reactionaries. ... If we need to not only interpret the world but to change it, nobody has ever claimed that it is unnecessary to know and understand the world. For knowing the world implies in itself the necessity of changing it.

> The modalities of this change have been tested in the USSR better than anywhere else. …
>
> The highest poetic value is that which coincides, *in its own proper terms,* with the proletarian revolution.[13]

What is "proper" to poetry, though, could hardly be assimilated to direct political action. Tzara's position had not fundamentally changed since his 1931 "Essai sur la situation de la poésie": poetry could not be an end in itself, but neither could it be "revolutionary" unless society had been transformed. His position was Marxist in that he saw culture as a super-structure, but it also raised doubts about the official Soviet position that art could be "revolutionary." Contemporary poetry could only express "*désespoir*" [hopelessness], but it had to be written from a position of hope that a new regime would be instituted. This bind was inevitable and painful.

On Bastille Day in 1935 over 200,000 people from left-wing groups linked arms in mass parades, but over 30,000 supporters of the far-right Croix-de-Feu donned their uniforms for a military march on the Champs-Élysées, an organized display of force that some saw as insurrectionary. The musical chairs of French interwar parliamentary democracy hardly filled anyone with confidence, and the recent moves by Hitler—the Saar referendum and rearmament—further contributed to insecurity. In March 1936 Hitler's troops marched into the Rhineland; several weeks later, Mussolini's blackshirts captured Addis Ababa. The May 1936 electoral victory of the Popular Front government, with Léon Blum becoming the first Socialist prime minister of France, was a tiny sliver of hope for brighter days ahead.

For Tzara, this political optimism was tempered by the news that his father had died of a cerebral hemorrhage on 25 May 1936. He was crestfallen, telling his mother and sister that the prospect of coming home and not having his father there would be too painful.[14] The fact that fascism, in the form of the Iron Guard movement led by Corneliu Zelea Codreanu, was also gaining ground in Romania probably made him cautious about going back as well. Tzara could have taken pride in how his father had laid out very precise instructions for a secular ceremony: no rabbi in attendance, the body to be cremated, and only Beethoven's Ninth Symphony for the music.[15] Tzara was further isolated when Greta and Christophe left for Sweden in mid-June; when Greta came back she caught the measles, which led to her being quarantined for weeks.[16]

There was some comfort in seeing *Inquisitions*, with a cover designed by Greta, come out in June. This was the official organ of the Study Group of Human Phenomenology, founded earlier that year by Tzara, Roger Caillois, and Jules Monnerot. Its goal was "to bring to light, from the vantage point of immediate necessity, today's most pressing intellectual problems."[17] Caillois and Monnerot were literary critics; *Inquisitions* would be—polemical title aside—a forum for contemporary philosophy interested in both the human

243

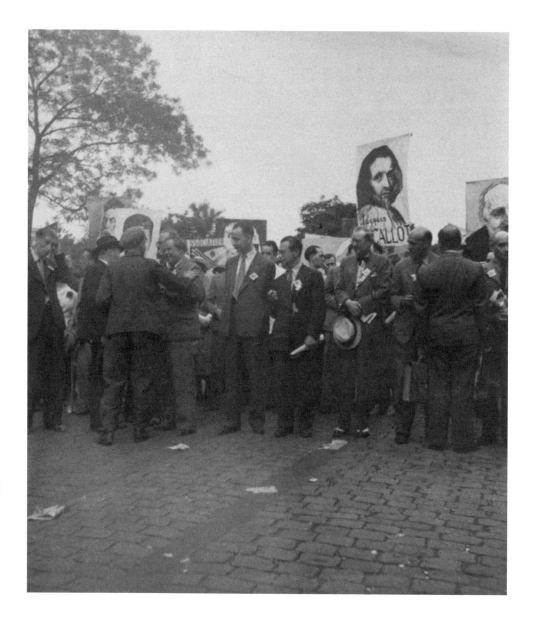

244

FIGURE 12.1
At a Popular Front march: Aragon,
Vaillant-Couturier, Tzara, Jean Lurçat,
Jean-Richard Bloch.
Bibliothèque Littéraire Jacques Doucet.

spirit and modern science. At the opening meeting of the study group, Tzara explicitly laid out its political goals: "we align ourselves deliberately with the platform that the Popular Front wants and must create."[18] The group met regularly at avenue Junot to discuss varied topics (quantum mechanics, psychoanalysis, contemporary philosophy, and social movements in China). The first number included Tzara's "Le Poète dans la société" (a follow-up to his address at the 1935 Congress) as well as work by Aragon and Gaston Bachelard, whose article "Le Surrationalisme" argued for a *"experimental reason susceptible of organizing reality surrationally just as Tristan Tzara's experimental dreams organized poetic freedom surrealistically."*[19] But the universal sweep of the study group, its desire to establish "an orthodoxy in the conception of all human phenomena," and the difficulties of reconciling intellectual speculation with political action, rendered the project impracticable.[20] The journal, slated to appear six times a year, never saw a second number.

Inquisitions had tried to break intellectuals free from the "tragic solitude" of the times, but Tzara's growing isolation was heightened by the December 1936 Museum of Modern Art exhibition "Fantastic Art, Dada, Surrealism." The show took up four floors, exhibiting works from over one hundred and fifty artists across five centuries. Tzara lent twenty-six items from his personal collection: a Picasso collage, "Head" (1913), and a collage by Aragon; five Baargelds; a "cadavre exquis" he had done with Breton, Valentine Hugo, and Greta; nine items by Ernst; a woodcut by Janco; a Picabia drawing; two items by Man Ray, including "Object of Destruction" (1932); two Ribemont-Dessaignes paintings; and three items by Christian Schad. Alfred Barr, Jr., envisioned this blockbuster show as the natural successor to that spring's "Cubism and Abstract Art": both shows "present in an objective and historical manner the principal movements of modern art."[21] This objectivity did not necessarily include chronology, which dated the opening of the Galerie Dada to March 1916, and stated that Tzara had joined Surrealism in 1929, but only "for a brief period" (errors that would have irritated Tzara, who was always "scrupulous about facts" and historical dating).[22] What bothered him more were rumors that Breton was going to write the catalog preface. Tzara threatened to pull out his items, telling Barr that he lacked "a sufficient guarantee concerning the objectivity necessary for the presentation of Dadaist works."[23] Barr had to reassure Tzara that Dada would not be sidelined. With the earliest item in the MoMA show dated 1450, there was a conscious effort to link Dada and Surrealism to an art-historical tradition that included Dürer, Leonardo da Vinci, and Hogarth. Both movements were, in other words, shorn of the immediacy of politics. Yet when the show opened its doors to the public, politics was unavoidable: Tzara was in Madrid in early December, writing about an experience that "overturned" "the habitual notions that we have about life"—not Dada, but the Spanish Civil War.[24]

The Spanish Civil War became the greatest event of the 1930s, "a symbol of hope for all antifascists ... a true ideological conflict"; for the Valencia-based *Hora de España*, the

"incalculable transcendence" of the war was a given.[25] For Tzara, "no tragedy has engaged us more deeply, to the roots of our being, than the period when our lives were shaped by events in Spain."[26] It did not appear so at first. In mid-July 1936 *L'Humanité* proclaimed "The Republican Victory Becomes Certain," but Jean Cassou, who had just returned from a trip to Madrid and knew Spain well, told Tzara differently.[27] Tzara's first contacts with Spain dated from Zurich Dada, when Guillermo de Torre spearheaded Dada propaganda there, and he had first visited the country in the mid-1920s, with a stop at the Residencia de Estudiantes in Madrid (whose members at the time included Luis Buñuel, Salvador Dalí, and Federico García Lorca).[28] Just before the civil war broke out, three Picasso works he had lent had been safely returned from Spain.[29]

After Madrid, Paris was the most important political center during the war.[30] Massive pro-Republican rallies challenged France's official neutrality with chants of "*Des avions! Des armes*! [Planes! Weapons!]" Tzara worked to that end at a relief association before becoming the director of the Comité de soutien aux intellectuels espagnols [Support Committee for Spanish Intellectuals]. This organization worked closely with the Alianza de Escritores Antifascistas para la defensa de la cultura, whose collective manifesto on 30 July 1936 drew attention to the "explosion of barbarism" destroying Spain, a cry confirmed with Lorca's brutal murder on 19 August.[31]

"No injustice was ever felt more atrociously," Tzara noted about Lorca's death, which prompted him to write "Sur le chemin des étoiles de mer [On the Road of Sea Stars]" (published in *Europe* in November 1936 and then in Spanish translation in *Hora de España*).[32] Like "La mort de Guillaume Apollinaire," the poem does not contain a conventional narrative about the subject but transmits the experience of loss and grief through an ensemble of beautifully serene imagery:

what wind blows on the world's loneliness
so that I remember loved ones
frail despair aspirated by death
above the heavy hunts of time
the storm regaled its end closer
that the sand's tough haunch had yet to swell
but on the mountains pockets of fire
emptied without fail their victim's light
pallid and brief such a friend dies
whose outline nobody can describe with words
and no call on the horizon has time to aid
his form distinct only at his disappearance[33]

The haunting power of an implacable nature artfully conveys the finality of loss, with the catalog of disaster coming to be focalized on "the child of the roads" and his "longing for joy" in a world where

> the morning remakes its world
> according to its yoke[34]

"Men fall when they want to stand erect," Tzara notes, "men sing as they've tasted death," but the only answer to this inevitability is continuing the fight: "despite it all one must go on."[35] The poem's elegiac conclusion restates this necessity:

> open up eternal heart
> to enter the road of stars
> in your life countless like the sand
> and the joy of seas
> may it hold the sun
> in your breast where the man of tomorrow shines
> the man of today on the road of sea stars
> has planted the forward flag of life
> as it should be lived
> the bird's flight freely chosen until death
> and until the end of stones and ages
> eyes fixed on the only certainty in the world
> from which light streams skimming the ground[36]

Widely appreciated by critics, "Sur le chemin des étoiles de mer" marked a transition toward a more humanistic poetry on Tzara's part. Its appropriation of certain proletarian images—the "sweat that pushed [the wheat] up to the throat" or the "length of hostile centuries" marking the fields with "greed"—were emblems of the time, but the poem itself did not fall into easy didacticism.

But poetry by itself was not enough. Commissioned by Pierre Unik's communist review *Regards*, Tzara visited Madrid, which had been turned into a battlefield, and Valencia in late 1936. He stayed for several weeks in Madrid's Palace Hotel, which had been transformed into a hospital: "Every time the door opens, the sickly sweet smell of dead bodies invades the room."[37] The Spanish capital was "an immense lottery of death": "Day and night shells and bombs fall. ... It is hard to believe that the ear comes to gauge the location and calibers according to the noise and intensity, and that the feel for music, when discerning vibrations, can take such barbaric, if subtle, forms."[38] Visiting a bombed-out neighborhood, Tzara found in the rubble of a library "a numbered copy, blackened with ash, of one of [his] first books of poetry."[39] Despite the devastation all around, he was encouraged: "An entire people is in arms. Human solidarity has become a daily reality there."[40]

247

Tzara relayed his impressions of this "Verdun of Democracy" at a mass meeting on 15 January 1937 at the Palais de la Mutualité, where over 3,000 people came to hear him and Georges Soria talk.[41] That month Tzara took over from Aragon as secretary of the Committee for the Defense of Spanish Culture. Liaising with Spanish intellectuals based in Paris—such as José Bergamín and Juan Larrea—the Committee sent printed material to the front and organized cultural events in support of the Republican cause, such as tours of Catalan orchestras or the staging of plays by Cervantes.[42] Tzara solicited intellectuals to write on behalf of the Republican cause for the press.[43] For the Université ouvrière de Montreuil, he led a guided tour of the Exhibition of Catalan Art at the Jeu de Paume.

Tzara also worked tirelessly throughout the early part of 1937 in organizing the Second International Congress of Writers in the Defense of Culture, which was held in Valencia, Madrid, and Paris in July. The urgency and political importance of staging an international congress of antifascist writers in Spain grew once the battle for Madrid began: bringing together the world's leading intellectuals in support of the Republican cause, *Hora de España* noted, was nothing less than an "act of war."[44] But there were immense logistical difficulties in bringing one hundred delegates from nearly thirty countries to Spain; moreover, planning had to be done in the utmost secrecy because of fears that Franco's forces would try to strike at the Congress.[45]

Cameramen and photographers were on hand to relay the opening session in the bombed-out council chambers of Valencia's City Hall. The Congress was opened by the new President of the Spanish Republic, Juan Negrín, who called the war "a battle for the liberty and freedom of mankind."[46] If the sentiment was widely shared, the words were hollow to some, given the treatment meted out to André Gide. For a congress meant to show solidarity for the Spanish cause, there were countless attacks on the "counterrevolutionary" stance of Gide's *Retour de l'URSS*, a work that was harshly critical of the Soviet regime. José Bergamín went so far as to claim that the blood of civilians in a besieged Madrid was sufficient reproach for Gide's book.[47] A single day of sessions was held in Valencia, and the next morning the group left for the frontlines of Madrid, although everyone slept fitfully, since at four o'clock in the morning sirens went off as six Nationalist airplanes dropped forty bombs on Valencia.

In Madrid the sessions were held at the Residencia de Estudiantes. Visits to the front and to local hospitals were dutifully arranged. Although Madrid was a shell of itself, Tzara was heartened by what he saw, telling the Republican press: "When I was here a few months ago the streets showed the effects produced by the fascist bombardment. Today the impression that I have of Madrid is of a city that has returned to find its rhythm and everyday life. The streets are clean of debris, the big stores from bombed-out neighborhoods are now open in other streets. The city atmosphere is magnificent and everyone lives in the absolute certainty of triumph."[48] While describing the destruction of a city "bombed, machine-gunned,

shelled and starved," Malcolm Cowley concurred, calling it a "miracle" that the "daily business of living" continued despite the circumstances.[49] The normality of the Congress, though, was affected by the war: "it was almost impossible to talk about literary questions. … Instead people talked about the immediate struggle, often in terms of political slogans. Sometimes the discussion was very nearly drowned out by the sound of the guns."[50] The Republican offensive at nearby Brunette, timed to coincide with the Congress's arrival in the capital, brought "the scent of battle in the nostrils of the assembled writers."[51] In honor of this victory, the sessions were presided over by General José Miaja, commander of the capital's Republican forces; armed soldiers stood guard, and a military band was on hand to belt out the "Internationale."

The delegates returned to Valencia on 10 July. In "L'Individu et la conscience de l'écrivain [The Individual and the Writer's Conscience]," Tzara spoke of the "duty to take a side" and to abandon the "pacific conscience of prerevolutionary epochs."[52] At the Madrid sessions, the *Pravda* editor Mikhail Koltsov justified Stalin's purges in the following terms: "How many hundreds of thousands of lives would have been saved in Spain … if a military tribunal and a firing squad had eliminated the treacherous generals at a suitable moment? Our country is completely safeguarded against the adventures of big and small Francos. It is safeguarded because the Soviet security forces will stop the little Trotskyite Francos before they can start and the military tribunal, with support from the people, will punish them."[53] An odious position, to be sure, and Tzara, while not going as far as Koltsov and not referring to the Soviet Union by name, nonetheless agreed that liberty of expression could no longer be absolute given the greater goals of revolutionizing society and sweeping away "centuries of oppression."[54] The division between artist and society had to be broached, painful as that might be: "I know how acute the conflict can become, for a sensitive being, between the awareness of the desired goal and the necessary path to reach it. This is not about lessening or castrating man, but, on the contrary, enriching him, leading him toward fullness."[55]

Two liberties were in balance: a social liberty for a people, involving certain positive rights to education and well-being, and the negative liberty of free expression: "Are we not sufficiently aware that the liberty which infringes on the liberty of another individual is called tyranny?"[56] The belief in liberty *à tout prix* Tzara rebuked as emanating from "uncontrollable instincts" in the service of "momentary satisfactions," as if the testimony of Gide and Koestler about Stalinist oppression were self-serving.[57] The masses, Tzara continued, "are floating," and the intellectual had an "enormous role in the battle that he must deliver to shatter their indifference."[58] These words would not have been out of place in Raymond Aron's *L'Opium des intellectuels* (1955). Given the danger that fascism posed (in Spain the civil war led to 500,000 casualties and nearly four decades of authoritarian rule, to say nothing of Hitler's Germany), Tzara was not alone in thinking that the time of liberal democracy had passed, or that the political standards of the *belle époque* were inapplicable,

FIGURE 12.2

L'Humanité spreads the word about the
1937 Congress. *L'Humanité*, 17 July 1937.
Bibliothèque Nationale de France.

if not dangerous. In a world where saving one's skin no longer made sense because the problems of the times spared no one, the need for communal action was, in his view, indisputable. Tzara had the honesty to admit the individual cost that this would entail, yet a horrible moral algebra infuses his address.

But revolution was on everyone's lips in those heady days. The Congress delegates arrived in Paris on the morning of Bastille Day, greeted by other writers and a horde of photographers. A number of delegates then took part in the Popular Front rally going from Bastille to Nation. The Congress resumed on 16 July at the Théâtre de la Porte Saint-Martin, while that same night a rally in support of Republican Spain was held at the Palais de la Mutualité. But amid these rallies, speeches, and folk dancing at the Congress's closing gala, diplomats were solidifying the policy of "nonintervention." A certain deflation permeates the final collective manifesto of the Congress, which was at pains to point out that it did not amount to a "false collectivism" but arose "spontaneously." [59] The final impact of the Congress on the war was minimal. Tzara might have hoped that "speech can become a more terrible arm than the strongest cannons," but the Congress failed to sway government policies. [60] If culture had "gone on the offensive," as the September 1937 issue of *Commune* argued, that battle largely remained confined to literary supplements. [61]

Tzara was not disheartened, though, for he was convinced that "this desire to live has only one meaning today: that of combating the obscure forces of the basest instincts," fascism. [62] He was part of the French delegation to the 16th World PEN Congress in Prague in late June 1938. If Prague was a city Tzara loved, "the city of the wise kings where poetry circulates along the trams and the smiles of things and beings," the atmosphere was extremely tense. [63] The *Anschluss* had taken place several weeks earlier and, as Hitler's speeches throughout that spring noted, the Sudetenland was the next target. While the Czech hosts sounded the call for the absolute importance of literature—"Here, literature truly formed the nation"—the delegates were nonetheless taken to witness Czech army maneuvers. [64] For his part, the French president of the meeting, Jules Romains, urged the Czech people to be "wise" and "moderate," "equitable up to the point of generosity" toward Germany, so that "a new era of tranquil prosperity" could be established. [65]

The isolation and division of Europe into warring blocs was mirrored in Tzara's home life. In Prague he had an affair with a Czech actress, even arranging for her to get an exit visa—but the woman evidently could not leave Czechoslovakia that summer. [66] Both Greta and Tristan were susceptible to severe bouts of depression; Tzara dealt with those moments by throwing himself into work to such a point that, as he put it in *L'Antitête*, "he did not realize that work had eventually eaten away his life." [67] As another of his female friends later chastised him, "Are you simply a machine for dreaming? So inefficient in tenderness—in reality." [68] For her part, Greta could no longer stomach having to write her family for money and complained that Tzara was extremely frugal, if not stingy. That no studio had been set aside for her still galled; her own work she barely dared to show to Tzara or his friends. [69]

251

With the exception of two shows in Paris in 1929 and 1931, Knutson mainly had success abroad, regularly exhibiting in Sweden in the 1930s at the Galerie Svensk-Franska. The only relief from the pressures of married life came when either Tristan or Greta left avenue Junot for extended stays in the South of France. Tristan loved the "cell of dreams" of the sea that seemed to penetrate his life with a "light, young substance."[70] But even in separation there was drama, and all of this took its toll:

> like beaten light like dead light
> like the glare of a crime
> the stream of silence entered the room
> it does not bark does not think does it take us for dogs
> ten years
> ten years since weigh on the door
> a block of solitude has turned memory to ice
> ten years of washed-out streets ten of dormitories
> where the unsatisfied river of pearly queens still trembles
> ten years[71]

In 1938 Greta formally asked for a divorce, which led to Tzara moving to a flat on rue de l'Odéon. That summer Greta had a passionate affair with René Char (one of Tzara's close friends); the next year she and Christophe went to live in Aix-en-Provence.[72]

With both politics and his personal life in crisis, Tzara's poetry searched out new beginnings:

> and everything must be started again
> at the point of solitude[73]

Soon after the defeat of the Republican forces in 1939, Éditions Denoël released Tzara's *Midis gagnés* [Noontimes Gained]. This collection of poems and experimental prose writing spanned the last half of the decade and was illustrated by Henri Matisse, whose intimate drawings of female nudes brought out "the insidious questions" that Tzara's poetry posed about the relationship between life and art.[74]

There is no singular or coherent aesthetic to *Midis gagnés*. The first section, "Abrégé de la nuit [Summarizing the Night]," contains experimental narrative prose of a "night traveler" and poems marked by a desire to broach the distance between separate bodies caught in an unforgiving world.[75] The question of perspective is crucial:

> It would be difficult to convince me that a given individual (let's take the one who is right now synchronizing as best he can his organic needs with the time he has at his disposal until the bus comes) sees, hears, feels, perceives at the same speed and in the same dimension as I do what is going on around him and that his watches, meters, and adjectives have not been, from the moment of his birth, rigged by the unanimous and constant relationship of things and beings to which he has subjected the norms of his judgments.[76]

252

To eliminate those "stiff and stubborn faculties of the intelligence which direct our lives according to schematic rules," the closing stanza points to the mystery of consciousness and man's place in society:

> night border I recognize you by the subdivided precautions you
> take with my terrestrial memory
> slimmer and slimmer nights wrapped around one another
> all embedded in the cracks of duration like in a trunk a perpetual flight
> under the sea scale peace lined up
> at the tail of punctual loves tangencies
> to surround oneself within disasters to pursue oneself without result
> the repetition of dreadful things
> that rise to assault a world sprung from the flame I sowed[77]

This almost phenomenological investigation of the destiny of consciousness is increasingly confronted by a pressing social reality whose own forces demanded attention, although Tzara expresses this in a poetic manner: "The storms which succeed each other in the head of man stifle under the weight of amassed cotton. But it is a question of a more luminous life which, on the edge of independence and with the aid of its appeal, will be made imminent, dazzling us by the rapidity of its comprehension of things and of beings. It is a question of an axiomatic of desires, of being luxuriously swathed in the drizzle of their possible satisfactions."[78]

Certain poems in the later sections are overwhelmed by the weight of politics:

> the world revised by the constant force
> the flame of man carried to the face of assured life
> and sudden life making victory victory[79]

The resolute confidence of a final revolutionary victory marks the conclusion of "Espagne 1936" [Spain 1936]:

> the earth of this country is red but its men
> have the substance of iron that the wind saw
> and chose among the dead leaves
> sealed to the wings their past runs through the streets
> death blows in every crack
> …
> red beaten earth
> never conquered
> among the multitudes antique fervors
> and the fraternity of man's unquenched myths
> the inferno of tomorrow's laughter[80]

253

These poems, although suffused with stock images of the revolutionary left (the laborer and weeping mothers, the street and a desiccated earth, rifles and shouts), nonetheless contain a certain detachment. This is evident in the final stanza of "Chant de Guerre Civile [Civil War Song]":

> it is I who wrote this poem
> in the solitude of my room
> while for those I am crying
> death is sweet they remain there[81]

The frank acknowledgment of the insuperable distance between the "engaged" poet and those engaged in battle creates a rare moment of pathos, for it questions the means by which social events divide humanity and the moral responsibility not just of the writer, but also of the individual, in broaching those divisions of "dirty life mixed with death."[82] If Tzara's political statements during this period were all about solidarity, the poetry, through its undercurrents of solitude and silence, openly questions

> what is this consciousness
> that erupts from one man to another[83]

Midis gagnés convinced critics that Tzara—installed by spring 1939 in a new apartment on the rue de Lille—had forged an independent path in French poetry. When the volume was reissued in a new edition ten years later, Joe Bousquet wrote: "It is the cry both happy and desperate of a great poet. ... Nothing happens here like in life: no feeling has the same price, nor the same meaning. It is the *entire language* of the *entirety of life*."[84] The need for a new language and vocabulary to describe the vagaries of life took on an even more pressing urgency once the false peace in which Europe had languished erupted in war, and people like Tzara—a foreign Jew, an artist, and a communist to boot—were at grave risk.

254

Tzara's sister Lucică and her family came to Paris in April 1939 in the hope of escaping from Romania, where vicious anti-Semitism and violent politics had created a situation of extreme instability for the Jewish community. Even if there was a poignant sense of loss after the death of the paterfamilias several years earlier, Tzara was overjoyed to see his sister's family, visiting them at their hotel and taking them to museums and art galleries. Since he was still not a French citizen, despite having lived in France for nearly twenty years, he could not intercede for visas on their behalf. Forced to return to Romania, when the war broke out in September of that year, they were unable to leave the country and could not even communicate with Tristan.[85]

Tzara spent the summer in the South of France, but after the general mobilization decree on 2 September, he was back in the capital even though the government advised

Parisians to leave the city if they had houses in the provinces.[86] Composed between June 1939 and January 1940 and published in the March 1940 issue of *Esprit*, "Quatre poèmes de petite guerre [Four Poems of a Minor War]" reflects Tzara's anxiety during this period:

> then here we are in the sleek shadow
> waiting for the heavy torment
> that comes from far away in the soul[87]

In this time when "nobody knows where our paths lead," Tzara's poetry sought a clarity of expression and directness, although it continued to insist on the primacy of the image:

> it is silence sealed on a big world too young
> these are lips that have not finished digging nothingness
> where death and creation plow the earth of the soul
> I think about the belief that set ablaze the boundlessness of things[88]

The haunting quality of the "boundlessness of things [*l'illimité des choses*]" took on a particular poignancy in subsequent years. Having been in Nice in late March 1940, Tzara returned to Paris when France was attacked in May to rapidly pack up his library and paintings. Although no one expected the French defeat to be so decisive, by 5 June the German army was bombing the capital: "We are rushed. War is at the door. Can you not already hear the hideous convoys brandishing scorpions and centipedes as they glide like mollusks and rush into the barns to inspect the destruction?"[89] Taking to the roads like millions of others, the human flotsam leaving Paris that June in a rush of haste, confusion, and desperation was the subject of "Exil":

> the road has stripped down the ash of miseries
> and the days that I saw and the words passed
> and the sun and me chilly in the instability
> the most rushed pain the most obscure love
> I am at the edge of the world a root going astray[90]

Tzara was fortunate in having financial resources and a familiarity with the South of France. He wrote "Exil" in Pinsac, a village in the Midi-Pyrénées he knew well because he had spent time before the war in the neighboring town of Souillac. But at this point he was trying to make it down to the south coast, in the hope of finding a ship to take him abroad. Tzara eventually reached Sanary-sur-Mer, a fishing village fifteen kilometers west of Toulon that had in the 1930s housed over 500 German exiles, among them Brecht, Lion Feuchtwanger, Thomas and Heinrich Mann, Joseph Roth, and Stefan Zweig. It was there that he also met up with Marcel Duchamp, who stayed in Sanary (his younger sister Yvonne had been living there for years) until May 1942.[91]

In August and September 1940 Tzara worked over the memories of the exodus from Paris in a play entitled *La Fuite* [The Exodus]:

> The whole country was being emptied. The old, women, children on foot, in carriages, their faces gaunt, carrying, dragging bundles, luggage, blankets, mattresses; the crippled on small carriages pushed by little old ladies, clusters of disarmed soldiers on foot among them, who said that they were going to find their families. The city was agitated, everyone gave what they could to those poor souls passing. No one understood yet. But those fleeing said: Your turn will come soon.[92]

Marked by loss and the "innocence of blood," an allusion to the widespread misery but also the risks that the Jewish community would face under a German regime, *La Fuite* not only comments on *le débâcle* but also restages Tzara's personal anguish at being separated from his family.[93] The work attempts to translate the crisis traversing France into more universal considerations of the cyclical nature of history and the impermeability of social currents and individual consciousness. *La Fuite* is a prose poem intended for the stage; the four main characters are Le Père [The Father], La Mère [The Mother], Le Fils [The Son], La Fille [The Daughter]; Le Récitant [The Reciter] takes the son's role after the first act.

The play contains two interlinked stories: the son revolting against his family and a coming war that will destroy a community. With "poetry plunged up to its neck in history," Tzara used *La Fuite* to confront his childhood memories and the question of origins.[94] As the son announces: "there are only two possibilities—death or flight."[95] Convinced of his higher destiny ("I only feel an undefined calling a rush of wind which is rising … I am the master of this thought which is mine but I feel myself enslaved to the tenacious force …"), he chooses flight.[96] His desired mastery will not be over material reality but, rather, over his own mind: "No one can do anything for me, the solution is within me but it is not yet ripe … but I have to be alone in the forefront of the fight to be victorious over myself, to conquer myself."[97] The necessity of leaving a backward country like Romania is made clear when the son proclaims: "I will come back full of all the perfumes of joyous science, of everything that I will have seen."[98]

But this flight, spurred by the hope that the creator could reshape the world, is categorized as a failure in *La Fuite*: "He rejects everything that is known, accepted, acquired. In his rage nothing is spared, neither the family blood nor honor as it is practiced, nor the consolation of beauty. Everything is included in his violent contempt. He becomes wicked to the point of drunkenness. … But yet I see him weeping in silence. He thinks of death. … I see him far from the world, already thinking of eternal solitude."[99] The larger destiny of history is marked by cycles that literature or science cannot displace: "despite the pain births and deaths succeed upon each other," the mother states, "[e]very birth in the bosom of a community is accomplished only at the price of a death."[100] A pointed self-appraisal by the Récitant follows, in words that put into doubt not only the lasting impact of Dada but also the last few years of political engagement: "He wants the carnage to end. He who felt within himself the echo of all the cries which flowed … lets weapons fall from his hands. Madness! No one hears him. At most a rustling of paper in a snowy silence. A glacial rustling; he himself is nothing but a paper that one carelessly throws away."[101] But the failures of the

past are never final, and a stubborn hope persists at the play's close: "[P]erhaps the strength will come to him to help others and by the force of his words [*la parole*] reinstate order and generosity in the country given over to wolves."[102]

La Fuite was not staged until after the war, and the poetry that Tzara wrote in the early years of the Occupation was composed without any thought of publication and, in fact, in a steadfast refusal of it. Silence became a principled strategy of resistance, as Tzara put it in "À soi-même promis [Promised to Himself]":

> torn away from my blood
> presence flower of the earth in a soft voice
> I listen to repetitions buried today
> but alive in the silence-colored bushes
> …
> I was walking a friend of the wind on rebellious paths
> and pavement too young for this world running
> to lose its silence in short breaths
> I was walking sowing silence
> …
> silence torn away from my blood
> I no longer cry for presences stolen
> it is by your cheek of phosphorescent shadow
> that I illuminate the route of my path among crystal awaiting[103]

Because any publication printed in the unoccupied South had to pass through the Vichy censor's office, Tzara felt that publication in itself was an act of collaboration. René Char, who commanded a clandestine military troop in the Basses-Alpes, and Pierre Reverdy felt the same way, refusing to publish at all during the Occupation. In his study on Resistance poetry, Pierre Seghers observes: "raging, orderly, meticulous, and ardent, Tzara does not want to publish. But he writes for himself to extirpate the burning fragment, the shrapnel of time that tears him apart—poems that he will take up once the Germans have left."[104] This strategy of silence in the early years of Occupation was immortalized in *Le Silence de la mer* [Silence of the Sea] (1942), a clandestine novel which *Les Lettres Françaises* called "the most moving, the most profoundly human" piece of war literature since the German Occupation.[105] In the novel, a French family is forced to quarter a cultured German military officer, but they refuse to speak a word to him during his stay with them. This resistance through absolute silence covered a boundless rage and hatred. Tzara was unforgiving of writers who had collaborated with Vichy, penning a series of personal attacks of a violence hard to match, even when it concerned former friends: "Marcel Jouhandeau may the blood of victims indirectly struck by your writings fall upon you! May your hands tremble every time you pick up a pen, because it is from your hand that the hand of the executioner gathered the force to handle the axe."[106]

257

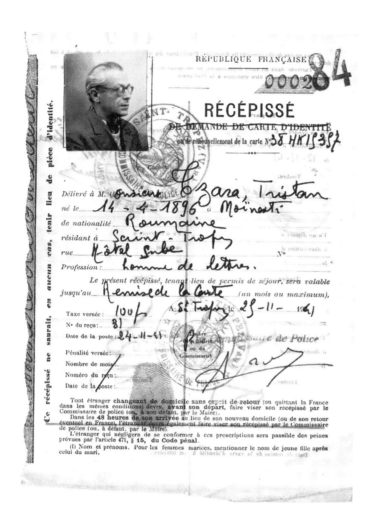

258

In the autumn of 1940 and the early part of 1941, a climate of suspicion ruled over Sanary-sur-Mer, with the local population resenting the large number of émigrés for the potential danger they would bring. Most of the Austrian and German writers who had settled there in the 1930s had been interned. When they were eventually released, the concentration of antifascist writers in the small village did not escape notice, and Vichy officials did not need direct orders to take action. The deportation of foreign Jews from the Southern Zone did not start until the summer of 1942, but in 1941 Tzara was expelled from Sanary for "Gaullist tendencies."[107] Even if it meant going on the roads in a hostile country, this was a lenient sentence compared to what happened to Benjamin Crémieux, the French president of the PEN-Club, who was arrested there and deported to Buchenwald, where he died in 1944.

By April 1941 Tzara was in Saint-Tropez, living at the Hôtel Sube at 15 Quai Suffren on the waterfront.[108] His hopes of leaving France through Varian Fry's American Emergency Rescue Committee proved illusory.[109] British composer Virgil Thomson recalls the desperate letters Tzara sent at the time, but the equally hopeless situation blocking any escape out of the country.[110] There were "a thousand daily little worries," but the greatest was the bureaucratic difficulty involved in going to see his son, who was in high school in Aix.[111] Tzara filed an application with the local commissar in late November for a foreigner's residence permit, and the local police commissioner granted the request, indicating that since his arrival in Saint-Tropez Tzara "has not been the object of any criticism," but that he "frequents a milieu quite doubtful from the national point of view and composed mainly of Jews."[112] For the most part unable to concentrate on his writing, in the poem "Chaque Jour [Every Day]" Tzara documents in detail the misery of this trapped, cornered life:

> every day the underwood moans deeper
> in the silence where you discover yourself
> In yourself the conqueror of your impure image
> every day you must conquer yourself
> fallen lower than a miserable autumn
> in the breaking of doors
> and the rustling of leaves
>
> …
>
> every day the jolt of waking up
> like the slap of white space
> the tearing where death arrives
> clacking its heels[113]

Tzara obtained the right to leave Saint-Tropez on 12 December 1942, and four days later he was staying at the Hôtel de l'Opéra in Aix-en-Provence, where Greta had been living since 1939 with Christophe.[114] Every day he took a long walk to the surrounding countryside,

where at "a charming spot" he lunched every day.[115] But this countryside idyll proved brief, as on 28 January 1942 the Services des Étrangers in Marseille indicated that Tzara could not receive his identity card unless he was "in possession of an *autorisation de séjour*" to reside in Aix.[116] Hitherto Tzara had scrupulously followed Vichy's regulations concerning foreign residents, which required registration with the local police upon arrival in a new town. He was now living illegally, and the archives show only official attempts to discover his whereabouts. By the end of the summer he was hiding out in the Pyrenean mountain village of Bagnères de Bigorre. At this point the deportation of Jews to death camps began in the Southern Zone. Tzara was at particular risk: of the 80,000 Jews deported from France during the war, 64,000 were either born abroad or had immigrant parents.[117] Tzara stayed in the mountains for the latter half of the year. Procuring false papers, he was able to move to Souillac, in the Lot department, in December 1942.[118]

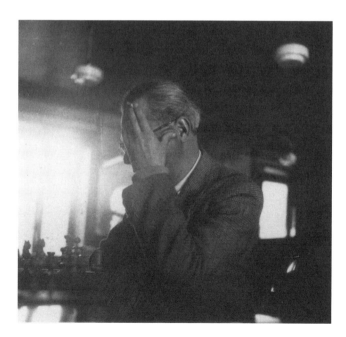

FIGURE 12.4
Playing chess in Souillac, 1943.
Courtesy of Christophe Tzara.

Situated on the Paris-Toulouse railway line, nestled between two hills a kilometer north of the Dordogne River, Souillac was a small village of several thousand inhabitants famed for its "austere" Roman-Byzantine church.[119] The Lot was a predominantly agricultural territory, which meant that the difficulty of obtaining foodstuffs was diminished, but the primarily rural residents of the area had an "innate distrust" of outsiders, which was reinforced by the local *patois* spoken.[120] Tzara rented a room outside Souillac but was frequently in town. The sense that the war was turning in the Allies' favor after America entered it, and German losses in the Soviet Union, made Tzara less cautious than he had been previously. He was bolstered by the presence of other intellectuals in Souillac. The painter Jean Lurçat—whose first exhibition had been in Zurich in 1917, and who had been part of Le Bœuf sur le Toit crowd in postwar Paris, as well as the Popular Front in the 1930s—was living on a nearby farm owned by the writer Pierre Betz. Betz and Tzara became very close friends, brought together by the war and a shared belief in the continuing relevance of poetry. Betz edited *Le Point*, an arts and literary monthly that had been started in the 1930s and featured work by Gabrielle Buffet and Max Jacob. During the war years, *Le Point* continued to appear, although its focus was mainly on painting, to avoid any suggestion of fidelity to the Vichy line. A certificate issued by the local authorities declares that Tzara was secretary to the editor of *Le Point* in June 1943, and after the Liberation Betz actively sought his opinion about upcoming numbers.[121]

Betz's friendship proved critical after Tzara was denounced in May 1943 in the Paris-based *Je suis partout* [I Am Everywhere], the daily run by Robert Brasillach whose circulation topped 200,000:

> For a few weeks ago, a new guest has settled in Souillac, in the Lot ... Tristan Tzara in person.
>
> Staying at the town's main hotel, he holds court there with a half-dozen fellow Jews, wailing about fascist persecution and prophetizing salvation by the Americans.
>
> ... What he is doing in France, and what his current resources are: that is what we would like to know.
>
> There is a whole tribe of Jewish "intellectuals" who are living the life in the Southern Zone.[122]

Having forged friendships in the village, Tzara was determined not to flee. After the Liberation, *résistants* in the region boasted that "not a single Gestapo agent" who came up to the area "made it back to Toulouse," but the reality was more dangerous.[123] The clandestine *Le Lot Résistant* in October 1943 denounced a certain gendarme in Souillac for being a well-known "hunter of foreign Jews."[124] "Small village it may be," the same clandestine paper noted in early 1944, but "Souillac does not lack traitors to our country," including individuals furnishing information to Gestapo agents.[125] Because of the village's

location on the railway line, and its position on the north-south axis of the region, the German army considered it a strategic point.[126] Yet Souillac was relatively safe, all things considered, with only a handful of deaths at German hands.[127] But Tzara could not take any risks and went into almost total hiding. This almost complete self-effacement took its toll:

what has he done with what savage silence
have they sealed his life a blow in the jaw
the jaw of his life adolescent fertilizer
of star splashed at the bottom of a formless earth
he has no clue his mind walks circles
his knees stunned his words dispersed
all around his shivering eyes
the invisible tide of cities countrysides
and the indisputable steel of their formidable sun[128]

In late August 1943, the Services des Étrangers in Cahors, acting upon information from the mayor of Souillac stating that Tzara was living in the village, asked for his file from the Var (Saint-Tropez) to be forwarded for inspection.[129] They received an immediate reply indicating that it had been sent on to Bouches-du-Rhône (Aix), and another request for the file was made in late January 1944.[130]

If the collaborators in Paris succeeded in driving Tzara underground, their denunciation otherwise backfired, for he was galvanized into breaking his vow of literary silence. Two poems, "Une Route seul soleil [One Road Alone Sun]" and "Ça va [Everything's Fine]" circulated through the informal network of the clandestine literary Resistance, and they reached René Tavernier, editor of a Lyon-based literary review, *Confluences*, in July 1943.[131] Thinking the poems marvelous, Tavernier asked if Tzara would allow his review to publish them; Tzara agreed, using the pseudonym "T. Tristan" when the two poems appeared in the December 1943 issue. *Confluences* had been suspended by the Vichy authorities a year earlier for publishing a poem by Aragon (who was at the time living in hiding with Tavernier).[132] If Tavernier had favorably reviewed a new edition of Pétain's speeches in 1941, by late 1943 *Confluences* published Aragon, Éluard, Max Jacob, and Clara Malraux, as well as Gertrude Stein and Albert Camus. A Parisian collaborationist daily decried *Confluence*'s penchant for publishing "Jews, pederasts, and Freemasons": "A writer is interned? At once his name appears in the table of contents of the next issue of *Confluences*."[133]

The transparent pseudonym Tzara chose was obvious to readers, who during the Occupation were attentive to the multiple layers of discourse within a poem. "Une Route seul soleil"—the letters in the title spell out *URSS*, the French abbreviation for the USSR— was written in a period of hope:

the knives are standing
the breath is missing
the ravens now spread out
the departures cancelled
the year of stone has descended upon us[134]

The departing black ravens clearly reference the defeat of the German army at Stalingrad, and the poem, in its rhythmic and formal simplicity, calls for a renewed energy and faith in the eventual victory over Nazism:

and I followed the star
and I foresaw the glee
words with a heart of mint
what is this space
that glows from within me[135]

The title "Ça va" created a surplus of irony in Tzara's poem, which opens:

trot trot little horse
the house is collapsing
the blows of the voice break against the anvil
the smoke is taking you
men or you who thought you were
poor little bits of wood gone astray
the words minced
take them off kill them off against the tree[136]

The horror of the scenes described in "Ça va" could not be read as anything but a call to defy the military Occupation. Communicating with a wider audience after years of intense solitude was an immense release: "Only by having risked death could you have arrived at self-awareness."[137] The worst was not over, as in late June 1944 over 1,200 German soldiers installed themselves in Souillac. There were armed skirmishes with some of the local Resistance groups, but the casualties were light (the Souillac Resistance managed, from November 1943 to late July 1944, to kill only a single German soldier). But the soldiers were on their way to Normandy, as was the convoy of thirty German vehicles that passed through the village in late July.[138] By early August, Souillac was a liberated town, and Tzara found himself free again.

263

13 THE SECRETS OF A RENAISSANCE: **1944–1963**

THE LONG YEARS OF THE WAR AND THE HEAVY PRICE OF SELF-IMPOSED SILENCE LED TO A FLURRY OF ACTIVITY ON TZARA'S PART AFTER THE LIBERATION. He began publishing again, not only in Swiss-based reviews like *Lettres* and *Labyrinthe* but also in *Les Étoiles du Quercy*, Éluard's *L'Éternelle revue*, and Aragon's *Les Étoiles*. Leaving Souillac in August 1944, Tzara moved to Toulouse, a city whose socialist and radical leanings, as well as large Spanish Republic refugee presence, made it a center of Resistance activity.[1] Tzara took up a position at the local branch of the Centre des Intellectuels. These centers had been founded during the Occupation; as Tzara explained to Cyril Connolly: "Their aim is to remake France, a freer, more vigorous, a socially more just France. For their members, 'to keep alive the spirit of Resistance' signifies that the intellectual must on no account remain foreign to highly important social and political questions, but must play his part effectively in whatever field it be, so that Fascism can *never again* exist in the world."[2] At the Centre, Tzara organized cultural events, such as an exbibition of nineteenth-century art; drafted plans for a local museum to the Resistance; and hosted visiting intellectuals who came to Toulouse, like Stephen Spender. He worked alongside two old friends, the poet Jean Cassou and the philosopher Henri Lefebvre. Tzara was also the presenter of a radio series, "Writers of the Resistance," for Radio Toulouse, fifteen-minute programs devoted to the Literary Resistance.[3] He was section head of the local branch of the Comité National des Écrivains (National Writers' Committee), a clandestine organization founded in 1943, and he played a critical role in setting up a Center for Occitan Studies, having becoming convinced of the need for "'decentralizing' cultural questions."[4]

In the summer of 1945, Tzara was invited to stay at Saint-Alban, a psychiatric hospital run by Lucien Bonnafé in the isolated Lozère department. Bonnafé was a communist who was close to leftist Resistance writers, such as Gaston Bachelard and Paul Éluard.[5] He was a vocal critic of treating mental health problems by internment in asylums, which he said amounted to an "official, formal, public proclamation of ... madness. ... So that no one can be mistaken, the internment seems to proclaim to everyone, 'This man is a stranger, he is no

265

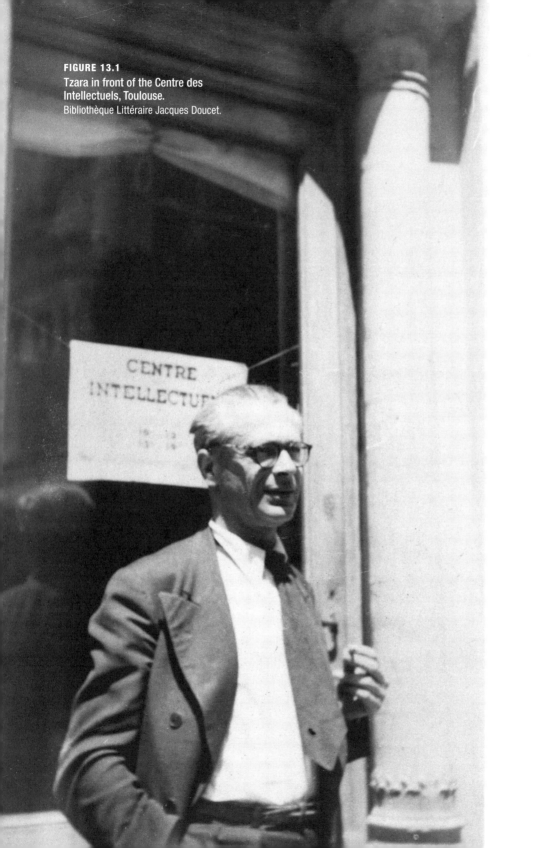

FIGURE 13.1
Tzara in front of the Centre des
Intellectuels, Toulouse.
Bibliothèque Littéraire Jacques Doucet.

longer one of us.'"[6] Bonnafé's ideas squared with Tzara's own intuitions about how society conditioned individuals into false binaries (sane/insane, normal/mad). In *Où boivent les loups*, Tzara had written:

> there is light in the house of the madman
> the hours have all become moldy
> only one rings from time to time
> which resembles your path[7]

He stayed for over two months at Saint-Alban and befriended a number of the inmates.[8] He was captivated by life in the "little city" of the asylum: "It is a bit like a voyage abroad. And truly more sensible than that which happens—in general—in civil life."[9] Tzara's stay at Saint-Alban was an immersion into a unique reality, but it was also a way of confronting the ravages of the war on his own psyche.

Tzara's stay resulted in *Parler seul* [Talking Alone] (1948), a short collection of poems, some of them dedicated to individuals interned at Saint-Alban. One of the constant worries of the volume is the struggle to find the "drowned vowels" after years of silence.[10] If some of the poems enter into the language of the patients, Tzara does not make the mad inhabit a separate, inaccessible universe. Rather, there is a common bond in the struggle for language and the fight against darkness:

> the right to speak goes to another darkness
> and it is the night's husk that lights up with nothing and hope
> the pure rapture of a honey bird illuminating
> in the lion's mouth
> the road long buried[11]

Even in the most damning solitude, the need for personal connections and human warmth remains:

> I will laugh last
> alone and deaf
> take me by the hand
> of flabby wool[12]

It is through these connections, steadily built up as the collection advances, that the final poem can end with a triumphant cry:

> shut up in the horizon of voices
> no wall resists your warm memory
> facing the broken voice
> rats can run between your legs
> the thin grass has not stopped escaping your call
> with an invisible sound on mouth and fingers
> you came out alive[13]

267

Tzara's return in late 1945 to "colorless" postwar Paris, where it seemed that "nothing will ever move again," was hardly simple.[14] Although an official restitution order for his apartment was issued in June 1946, he was forced to stay with art dealer Charles Ratton, and then for a longer period with composer René Leibowitz, for it was only in mid-1948 that he recovered his home and belongings.[15] This meant that the selection for his volume of poems, *Morceaux choisis* [Selected Poems] (1947), had to be made by Georges Hugnet because, as Tzara explained, his papers were "dispersed" and he was "still without a home."[16] On top of all that, he had to beg foreign friends to send razor blades, soap, and other items that could not be found in Paris. Yet amid these hardships, there was a flurry of literary activity. No fewer than three volumes of poetry—*Entre-Temps* [Meanwhile], *Le Signe de vie* [The Sign of Life], and *Terre sur terre* [Earth upon Earth]—came out in 1946. Their titles unmistakably announced that Tzara's poetic voice had not been silenced by the war.

And if Tzara's poetic voice was alive, scandal was not far off. On 21 January 1946, a large crowd filed into the Théâtre du Vieux-Colombier to hear a reading of *La Fuite*. The event was organized by Michel Leiris, who felt so strongly about the play that he almost resigned in protest from the editorial board of *Les Temps Modernes*, which refused to publish an extract from it.[17] At the public reading, Leiris outlined *La Fuite*'s relevance for postwar France:

> The flight of the child who to live his life must break away from his parents. …
> The flight of every living being, who separates himself from others, suffers himself
> and makes others suffer. … The flight of men. Flight of seasons. Flight of time. …
> Flight of history in the end. … Bankruptcy, collapse, confusion: because this total
> chaos is needed so that a new society can be reborn, one with other types of relations
> between men, between women, between women and men.[18]

This talk was interrupted by a young Romanian-Jewish man who had recently arrived in Paris and went by an alliterative pseudonym: "Mr. Leiris, we know about Dadaism. … Talk to us about a new movement, like Lettrism for example." Isidore Isou then went on stage to explain to a stunned audience that while Dada had detached words from phrases, Lettrism would detach letters from words. Isou, who had founded a review in Romania called *Da*, idolized Tzara, but Tzara was also the poetic double whom he had to kill off: "Isou, the justification of Tzara. … Against the critics who don't see Tzara or who seem him as minor, Tzara the liquidator, he who lays the ground for the future."[19]

For his part, Tzara knew nothing about Isou and was mystified by the scene. When *La Fuite* was finally read, Soupault was enchanted by Tzara's "*pièce de circonstance*": "It is so strange in its wisdom that I come to wonder whether T.T. did not believe that this wisdom was the surest way of scandalizing everyone, including his friends. I hear beautiful images but they are drowned in a fog of words."[20] Soupault was not the play's only admirer; it was read on national radio in early April, and Gallimard offered to publish it: this was the only work during Tzara's life published by the preeminent French publishing house.

268

If rebuilding France proved a challenging task, Tzara had the chance to see dynamic changes throughout Europe that year. In February he was in Switzerland and occupied Vienna, delivering a lecture, "Surréalisme et la crise littéraire [Surrealism and Literary Crisis]," while in April he gave a talk on "Surréalisme et l'après-guerre" in London.[21] Asked to represent France on a tour of Yugoslavia, Romania, Hungary, and Czechoslovakia, Tzara jumped at the opportunity. In 1920 he had come to Paris bent on destroying classical French culture; now he would be a representative of the French state charged with contributing to its growing influence: "our Romanian friends," Tzara explained afterward, hunger for "our language and our literature."[22]

Tzara's tour began in Belgrade, where he attended, along with PCF member and *Ce Soir* editor Jean-Richard Bloch, the First Congress of Writers of Yugoslavia. For two days in mid-November Tzara and Bloch listened to writers exhorting each other to create a new Yugoslav man and woman in their art. The calls for censorship for which the Congress is largely known eluded the two French writers. They were perhaps tempted to believe, like most of the French left, that intellectual freedom was not a problem in Eastern Europe.[23] After a lecture in Skopje on the revolutionary impulse in contemporary French poetry (illustrated by Aragon, Cassou, Éluard, and Moussinac), Tzara returned to Belgrade before arriving in Bucharest on the morning of 24 November. He was relieved to be reunited with his mother and sister, who had survived the harsh conditions Jews in Bucharest endured during the war and were in good health. But the political climate was tense, for the legislative elections a week earlier had resulted in a resounding communist victory (80 percent of the vote), but other parties, with some reason, felt that massive electoral fraud had been committed. The Soviet military occupation added to the political tensions but also raised the human cost of the severe drought afflicting Moldavia, as the occupying army took the lion's share of the diminished harvest (when Tzara got back to Paris, he organized an auction of donated artworks for the French Red Cross for famine relief).[24]

If Romania was "an Oriental state, closed upon itself" when he left it in 1915, Tzara later told the French press, it was now "nearly unrecognizable."[25] During his week in Bucharest, he attended official functions such as a dinner at the Romanian Writers' Association and a reception at the French Embassy, met with officials from the Ministry of Culture, and lectured at the Institut Français. Official business was conducted in French, but to the Romanian press he spoke his native tongue. The journalist who conducted a two-hour interview for *Contimporanul* was amazed to find the interviewee asking so many questions: "he wants to know every detail about what happened in this country which has remained dear to him and whose evolution he has followed for nearly a quarter of a century."[26] With *România liberă*, Tzara spoke at length about his war experiences.[27] He saw old friends like the avant-garde painter Maxy, the leftist journalist N. D. Cocea, former *Simbolul* contributor Claudia Millian, and the editor Sașa Pană, who had translated "Une Route seul soleil" for *Orizont*, the official literary review of the Romanian Communist Party.[28] Pană

269

profiled Tzara in the December issue of *Orizont*, calling him an "ambassador of the French Resistance," a "committed poet" whose work "was and continues to be in the service of man."[29] If this praise was perhaps too fulsome, Tzara's talk on "Surrealism and the Postwar World" did not play to a full house, and the Romanian Surrealists in attendance, Gherasim Luca and Gellu Naum, listened on in silence from the back row.[30]

Tzara then made his way to Hungary, although he stopped in the Transylvanian city of Cluj-Napoca beforehand, meeting with members of the Hungarian minority community and inspecting their newly established Hungarian-language university. He then spent a few days in Budapest before lecturing at the University of Bratislava. In Prague he met up with old friends, painter Adolf Hoffmeister and one of the founders of the Czech Surrealist group, poet Vítězslav Nezval. They all attended a performance of *La Fuite*—this time there were no upstarts interrupting the play. It was the only time in his life that Tzara saw his most personal play staged, and it brought back memories of loss, which he channeled into a poem in honor of Robert Desnos, who had died in Theresienstadt.

When he arrived back in Paris on 10 January 1947, the most important legacy of the Eastern European tour was *Le Surréalisme et l'après-guerre* [Surrealism and the Postwar Period]. While a Romanian translation appeared in the February 1947 issue of *Orizont*, it was in Paris that Tzara's talk created a literary scandal when he and Breton faced off at the Sorbonne on 17 March. When Breton arrived back in France in May 1946, he hoped to reinstate Surrealism as France's leading intellectual movement, but his absence during the war years had discredited him in the eyes of many.[31] The Communist Party's list of charges against Breton included not only his support of Trotsky and his writings against Stalin, but also his silence during the war years. Tzara laid into these charges, as might be expected of a convert to the PCF: "what is Surrealism today and how does it justify itself historically when we know that it was absent from this war, absent from our hearts and from our action during the Occupation, which, needless to say, has deeply affected our ways of acting and understanding reality?"[32] Tzara's moral attack on Surrealism was uncompromising: its war years, he noted, were spent in "Surrealist competitions and games which were harmless, to say the least."[33] If two years earlier he had defended Surrealism at meetings of the Comité National des Écrivains, noting that "nothing can be done without Surrealism," his position had shifted considerably.[34] This was due to his closer ties with the PCF but also, undoubtedly, his disappointment with Breton: "I saw Breton from far away," he related in June 1946. "As I did not have much to say to him nor to learn from him, I didn't bother speaking to him."[35] In the Sorbonne lecture Tzara borrowed a metaphor from his recently reissued *Sept Manifestes Dada* to back up his charge: "Surrealism [will] be incapable of adapting itself to current conditions and regaining the powerful virus that we once knew it had."[36]

With Jean Cassou chairing, Breton, who had been warned about the "Stalinist apparatus" dominating literary circles, was in a combative mood.[37] He had been given the right to reply to Tzara's lecture, but refused, insisting that he did not make it a point to "listen to

someone who revolts you and then critique him afterward."[38] Breton became so angry during the lecture that he got up on a bench and shouted that Tzara "should be ashamed to be speaking in such a place!" He then jumped on stage and knocked over Tzara's glass of water; over fifty years old now, he could not as easily transform his cane into a weapon as he had at the fracas over *Le Cœur à gaz*.[39] The scene was, according to *Les Nouvelles Littéraires*, one of "insults, fists, projectiles": it was "[t]he atmosphere of the former good times of Dada," but the "gray-haired" combatants were now inspired by politics rather than aesthetics.[40]

Yet *Surrealism and the Postwar Period* had a wider focus than settling personal scores. With its discussion of the relationship between poetry and social reality, the lecture restates many of the arguments from the 1931 "Essai sur la situation de la poésie." Beyond the general problems involved in analyzing the "revolutionary" content of art, Tzara's address was an attempt to confront the very specific problem of the "postwar": "Have we found a solution to the problems that brought about this war? Where is the end of this war, this shredded end that prolongs itself in each individual, bringing about new questions and temporary solutions and necessary but makeshift repairs and the crushing weight of pains and destructions and the gravity of wounds that are still raw? There is no war now, but there is no *après-guerre* yet."[41] Economic misery afflicting millions with want, political scores settled by bloodshed: in these matters, Tzara conceded, aesthetic movements were largely powerless. But the moral questions posed by the war were intractable, for the "liberation of man" in all its forms, as Surrealism had trumpeted, had included such things as the creation of gas chambers. Culture mattered when it came to revealing the contours of liberty. Rather than an absolute end, liberty made sense only in light of its social ends. Art, in that sense, was not simply an individual creation or a formal game, liberty in itself and for itself, but an expression of an embodied experience, a transposition of one lived reality to another. The mistake of the 1920s, when "resuming the prewar order" was the driving priority, had to be avoided at all costs.[42] If Surrealism could not help resolve the problems of *l'après-guerre*, Tzara contrasted it with Dada, which was "born of a moral exigency, the implacable desire to attain an absolute morality."[43] While acknowledging Surrealism's desire to "liberate man," Tzara not only spelled out the need for limits on that liberation but also criticized the means Surrealism employed, with techniques like automatism amounting to nothing more than mechanical applications rather than embodied experience.

Tzara did not have a concrete answer as to how the contradictions of this inchoate period could be resolved. While he depicted Dada as an example of individual liberty taken to its utmost limits, he acknowledged that "the *tabula rasa* that we consider[ed] the driving force of our actions was valuable only insofar as *something else* was to follow."[44] Although categorized as a failure, its all-encompassing attack upon existing institutions was subtly linked in his talk to the moral exigencies facing the postwar writer. The Dadaists had attempted to abolish "the distinction between life and poetry, our poetry was a manner of

existing."[45] So too the postwar writer had to continue the lessons of the Resistance, wherein poetry and action were not separated: "For some of us who during the years of the Occupation knew a specific form of struggle, in a fraternity of sentiments with people from all walks of life, from all origins and creeds, did we have the luxury during this struggle to pose the question of the dilemma between action and dreams? ... We found our *unity* [*unicité*]. We know now that the problem is not unsolvable, but that it is in action itself on the field of the struggle ... that the problem ceases to exist."[46] Tzara was calling for a continuation of the literary Resistance: "Some of us know what freedom means, because at the edge of death freedom was enriched with an exhilaration that made us reborn into consciousness, the consciousness of men."[47] Although he was not calling for literary censorship, the privilege accorded to the literary Resistance sets up a moral absolutism: those writers are uniquely positioned to guard the spirit of the Resistance "in its entirety" against any possible "alienation."[48] The passions of the era and the bitterness of years in hiding make themselves felt here. As a note to the 1948 published edition put it: "after a brush with death ... we have the impression that the entire nation, in going through a new adolescence, is becoming aware of its being."[49] But no final form can be given to this consciousness. Just as society has to continually evolve—"I do not believe in an earthly paradise, because at every stage of human evolution, everything becomes again an object to be conquered"—so too the poet has to understand that for poetry to be "a *conquest*," it has to be the result of a "movement which puts into question the entirety of his existence."[50] The theoretical basis of Tzara's argument—that poetry was not an expression of reality, but reality itself—had not changed in any significant respect since the closing line of *Manifeste Dada 1918*, "LA VIE." What had evolved was the acknowledgment that contemporary circumstances had brought an even greater urgency to the question.

Tzara became a French citizen in 1947, and his political convictions were institutionalized when he joined the French Communist Party (PCF). The largest party in the 1945 elections (with over 25 percent of the vote), the PCF presented itself as the party of the Resistance and as "zealous guardians of French culture."[51] Tzara's political beliefs since the 1930s had gravitated toward communism, but only now did he join the Party. He was fully committed to PCF cultural initiatives, such as the "Salon of Books" for PCF authors on Saturday afternoons. Working closely with fellow members Aragon and Éluard, Tzara was an elder literary statesman, guiding younger writers and contributing to the organization of cultural events. The Egyptian Raymond Aghion, who met Tzara at literary cafés, recalled years later that he was "a communist without passion": "He was taking his distance while nonetheless following the line. ... For him, the USSR was the country that had sacrificed itself to defeat Nazism for good. Moreover, he was not doing much for the Party."[52]

Aghion was not entirely correct, for in the immediate postwar period Tzara spoke about the Soviet Union in rapturous terms: "The USSR has guaranteed freedom of expression

272

to all those who are not a fifth column. ... We [in France] have known, alas, what this pseudo-liberty of expression has cost us."[53] Yet Aghion's testimony can be accorded some credit when we consider Tzara's postwar poetry. If he was indisputably a communist when it came to politics, going so far as to contribute to the 1947 brochure *Pourquoi je suis communiste* [Why I Am a Communist], and although some of his critical vocabulary was imbued with PCF terminology ("Picasso's spirit expresses itself by taking sides in the *contemporary* struggle: it is for the supporters of life against those supporting war, for the builders of the future against the exploiters of the past"), his poetry generally steered clear of political dogma.[54] There are, of course, certain ponderous lines—

we will have to seize life again
as it is
face to face
good and horrible
always fraternal

…

and maybe we will have to fight
so that life remains ours comrades
so that everyone can find their place[55]

—yet Tzara's political poetry is more likely to be found in reminiscences of Spain, "the most profound moment of our lives," and friends like Desnos, Jacob, and Unik who died at the hands of the Nazi death machine.[56] His search for "a new certainty in the given word" tended to avoid slogans or ideology.[57] Rather, the desire for

an imaginary path
where sea and fire mingle

could not be straightforwardly applied for political purposes.[58] Tzara even went so far as to critique political discourse for its reductive nature:

the yoke of speech
still weighs upon thought[59]

As a *résistant* and Party member, Tzara was well placed to benefit from the PCF's sizeable cultural apparatus, but the small print runs for his late poetry indicate that little support came his way, undoubtedly because the PCF could not use his work as cultural propaganda.[60] If in the Soviet Union works were issued in "tens of millions of copies," Tzara's poetry mainly came out in luxury editions: 22 copies for *La Rose et le chien* (1958), 30 copies for *La Première main* (1952), 42 copies for *La Bonne heure* (1955), 60 copies of *Le Fruit permis* (1956), 70 copies of *À haute flamme* (1955).[61] Although *Sans coups férir* (1948) was recited on national radio, only 100 copies were printed. Most of these volumes were lavishly illustrated, with Tzara hoping that the famous illustrators—Braque, Sonia Delaunay, but especially Picasso—would lead publishers to issue larger print runs.[62] But there was

273

little public demand for Tzara's challenging and hermetic poetry. Rather than new work, it was the republication of earlier volumes, like new editions of *L'Antitête* and then, just before his death, *Seven Dada Manifestos and Lampisteries*, that had a greater literary impact.

There is an incredible diversity within Tzara's late poetry: the simple octosyllabic lines of *Phases* (1948), the prose poems of *Miennes* (1955), the typographically innovative "perpetual poems" in *La Rose et le chien*, and a kind of epic free verse in *De Mémoire d'homme* (1950) and *La Face intérieure* (1953). Amid this formal diversity, though, a number of themes are obsessively reworked, none more important than the impact of the past, and of memory in general. There is an immediate past that Tzara is trying to escape from, the "unforgivable past" of the war: "Alone, alone, alone in solitude, the train started. I would rather not remember it—the earth had become so heavy with that day when the head bowed down for good."[63] But the poet is also concerned about "devastating memory," not only how memories become ever more slippery and uncertain as time advances—"day after the day the echo was shorter"—but also how the "search for hidden childhoods" can be complicated by the onslaught of the present.[64] Tzara's mother was diagnosed with stomach cancer in 1947, and she died a year later; he was too crushed to attend the funeral in Bucharest. This personal loss only added to the hatred and rancor brought on by the war and disappointments in love; yet Tzara wanted to explore how the "present evil" of the world was indissolubly linked to the "new joy" that the poet must claim:

> it is time to let the rotten fruit fall
> it is time to pick up what is left for us
> to take out the worms to order our lives[65]

As Tzara's last collection of poems, *Juste présent* (1961), announces:

> I put my feet back on the ground
> and I live in the now[66]

274

FIGURE 13.2
Tzara and Picasso.
Bibliothèque Littéraire Jacques Doucet.

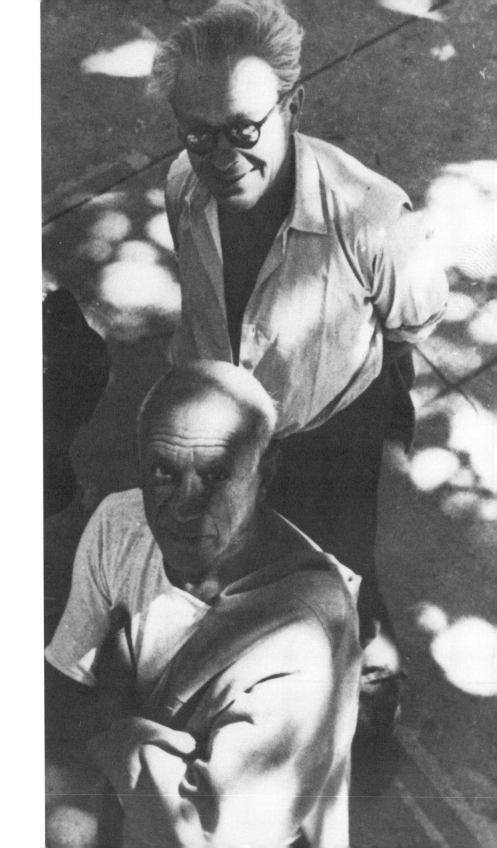

If his poetic concerns were defiantly centered upon the present, most of his time was engaged with the past.[67] The deaths of so many close friends—poets who committed suicide, like Attila József and Ilarie Voronca; poets who had been killed, like Desnos, Fondane, Jacob, Saint-Pol-Roux, and Pierre Unik—undoubtedly contributed to Tzara's musings about the legacy of a poetic work. As early as 1951, Tzara decided to organize his critical writings into three volumes. The first volume, *Lampisteries*, would consist of articles from the Dada period; the second, *Le Pouvoir des images* [The Power of Images], would collect writings about modern art; and the third, *Les Écluses de la poésie* [The Locks of Poetry], would assemble his literary essays. *Lampisteries* was published a few weeks before his death, but the other two volumes were never released. This was a personal disappointment, because Tzara wanted the three-volume series to underscore the artistic unity and coherence of his career.

In other words, Tzara had a desire to self-fashion his literary legacy. In that respect, his question about Apollinaire's legacy is pertinent: "By what strange processes did Guillaume Apollinaire, né Kostrowitsky, become an essentially French poet?"[68] Inserting "Tristan Tzara, né Rosenstock" in place of Apollinaire betrays Tzara's personal stake in this question. Even in Romania, Tzara considered himself a representative of France and its literary tradition: "As for the influence of French culture, it is still, in Romania, considerable. The Institut Français does excellent work, facilitated by the popularity that *our* language and *our* literature have always enjoyed there."[69] A significant part of his controversial interview about Hungary in 1956 was devoted to *the influence of French national culture* abroad.[70] To that end, one can discern in Tzara's self-styled *travaux d'érudition* a desire to orient French literary history so that his place in it could be cemented. He focused on a specific core of aesthetic innovators: Villon, Rimbaud, Tristan Corbière, Jarry, and Apollinaire. While these writers (with the exception of Corbière) are all central to French literary history, they are all marginal figures—either because of scandalous personal lives or, in the case of Apollinaire, foreign birth—and they are all virulently antibourgeois. In essays on the Douanier Rousseau, Jarry, Rimbaud, and Villon, Tzara insists on the need to strip away anecdotes about their personal lives in order to better appreciate their achievement: given that his legacy threatened to be overshadowed by Dada scandals and Le Bœuf sur le Toit, Tzara had good reason to be concerned about this matter. (And, just in case, he repeatedly insisted that the scandal Dada instigated was above all else poetic.) He also wrote extensively about poets of the Resistance, another opportunity to implicitly argue for his own legacy. Finally, he attempted—albeit unsuccessfully—to ensure that his material legacy, his collection of primitive art and his personal archive, would be housed at the two institutional repositories of French culture: the Louvre and the Bibliothèque Nationale.

This strategy of literary self-fashioning also underscored Tzara's universal legacy, Dada. If Tzara claimed to be surprised that Dada had become "an object of interest for museums, Sorbonne dissertations, and other semiofficial honors," he had no small role in that.[71] He

276

regularly counseled museum curators, advised young scholars, and referred to Dada in his writings. In *De Mémoire d'homme*, Tzara tries to distance himself from these activities, but in so doing he only draws attention to the impossibility of completely severing his Dada past:

> Everything was chaos and fervor. A goat was feeding on viscous lines. A monkey was hanging about. An ox was walking on a tightrope. … But me in this racket? I was well behind what was happening, joy was not to my taste. …
>
> So I ran away.
>
> To my great shame, I have to admit that I thought myself the corrosive center of the world, me who only wanted self-effacement, a hiding place and polite disapproval.[72]

If he indicated his intention to flee from this attention, Tzara carefully protected his Dada legacy. When the young American painter Robert Motherwell began compiling a Dada anthology at a time when the movement was largely "unknown in English," Tzara ensured that his version of Dada would have pride of place.[73] Eventually published in 1951, *Dada Painters and Poets* remains one of the most influential sourcebooks about Dada. Motherwell told Tzara that the anthology would be "as just and open as possible" about Dada history, but as word spread about the project, Motherwell was besieged by Dadaists "champing at the bit, like old war horses" as they tried to steer the project to their own personal ends.[74] Tzara was asked to write a preface: "An Introduction to Dada" does not mention Hugo Ball or the Cabaret Voltaire (to say nothing of Hausmann, Huelsenbeck, or Richter) but manages, in the space of five pages, to mention the French Revolution, the Commune, Apollinaire, Baudelaire, Descartes, Victor Hugo, Jarry, Lautréamont, Mallarmé, Nerval, Rimbaud, Jacques Rivière, Saint-Pol-Roux, Valéry, and Verlaine, plus the names of a score of Paris Dada participants. Huelsenbeck, who had also been asked to contribute an article, submitted "Dada Manifesto 1949," which ended with a note: "For reasons of historical accuracy, the undersigned consider it necessary to state that Dadaism was not founded by Tristan Tzara. … The undersigned hereby state that the 'discovery' of Dadaism was truthfully and correctly described by Richard Huelsenbeck in his book *En avant Dada*."[75] Tzara was furious when he saw the page proofs, telling Motherwell: "To keep intact the spirit of Dada (1916–1922), I have therefore no choice but *to renounce my collaboration from your Anthology in the event that the manifesto appears within it*."[76] When Huelsenbeck heard about Tzara's threat, he responded by threatening to withdraw his works from the anthology if his manifesto were not published. The only solution was for neither work to be published in the anthology but for both to be printed separately, which satisfied no one.[77]

This episode illustrates how personally entangled Tzara became in Dada historiography.[78] In 1950 he presented a ten-part radio series for the Chaîne Nationale on avant-garde reviews, from Apollinaire's *Les Soirées de Paris* to *La Révolution surréaliste*. He carefully perused the manuscript of René Lacôte's *Tristan Tzara* (1952), whose introduction

aligned Tzara's Dada past with his having "shown the path of the [literary] Resistance."[79] For Hugnet's *L'Aventure Dada* (1957), Tzara was the source of archival material, and he wrote the introduction.[80] Michel Sanouillet's influential *Dada à Paris* was based upon Tzara's personal archive. If the 1953 Sidney Janis Gallery show was organized by Marcel Duchamp, Tzara was careful to provide an original text; for the Düsseldorf and Amsterdam Dada show in 1958 and 1959, he personally supplied material to the curator.[81] And when the Italian publisher Einaudi proposed an Italian-language edition of his Dada writings, Tzara indicated that the translator should be based in Paris so that he could oversee the work (he conveniently put forward the name of a translator, Ornella Volta, daughter of Sandro Volta, a close friend who was in turn commissioned to write the preface).[82] If Tzara tried to pass himself off as disinterested in Dada's historical legacy, the conscious efforts he made to shape it paint a different picture.

The Janus face of Tzara's public statements and private sentiments was also evident when it came to the PCF. If he supported its policies and contributed to its official organ, *Les Lettres Françaises*, he was privately troubled by the direction of the Party. The PCF had actively courted intellectuals such as Aragon, Éluard, and Picasso for the prestige their adherence offered, but remained suspicious of intellectuals who "did not live the same life as the ensemble of the Party."[83] After Khrushchev's explosive revelations about Stalinist terror, the Political Bureau was more concerned about investigating the "social composition" of certain Parisian cells threatening to "undermine Congress decisions" than the gravity of revelations about Stalin.[84]

On one particular matter, Tzara was very active: PCF initiatives concerning decolonization. In 1951 he lectured at the Université Nouvelle in Tunisia, expressing his support for the independence movement there, and he later signed the "Manifesto of Insubordination," which called upon the French state not to prosecute individuals who refused to serve in the army in Algeria.[85] The issue of colonialism concerned Tzara personally. His literary debut in Romania had to navigate questions of cultural imperialism and exclusion because of religion. In Zurich Tzara's interest in primitive art made him sensitive to questions of racial superiority, and during the 1930s he argued that imperialism had provoked "such a sudden disorder" among the colonized.[86]

It was in this context that Tzara collaborated, with Hungarian photographer Étienne Sved, on the 1954 book *L'Égypte face à face* [Egypt Face to Face]. This was his most popular work during his lifetime, printed in over 20,000 copies for Éditions Clairefontaine and the Swiss-based La Guilde du Livre. Tzara's written text—purportedly about the evolution of Egyptian art, but in fact an imaginative travelog, a prose poem, lyrical art criticism, and subjective sociology of contemporary Egyptian politics—was coupled with over 100 black-and-white photographs pairing ancient Egyptian art with scenes from contemporary life. With long quotations from papyrus scrolls and contemporary Egyptologists, Tzara's text

does not directly address the immediate political context in Egypt (a military dictatorship outlawing political activity), but its support for the dispossessed is unmistakable: "the situation [of the *fellah*] could not have been in the past worse than it is today."[87] As a PCF member, Tzara would have been expected to analyze social conditions with reference to the Party line, yet his text does not take an orthodox Marxist position toward the social basis of art or the laws of historical progress. Admitting that art is "connected to the social forms from which it takes its roots," Tzara nonetheless argues that Egyptian art is not a simple mirror of life and that its center consists of "an interpretation, a transposition of a superior life, of the reality of the perceptible world."[88] He also refuses to adhere to an orthodox Marxist view of history: "Civilizations are born and grow, but it would be wrong to think that their growth operates in a rigorous and rectilinear manner."[89] Furthermore, there is a limit to how much society can be changed or revolutionized: "It is good at times to remind men of the vanity of their condition, to weigh up the contrast between what they are and what they pretend to be"—a line that faces a photograph of a monkey on a leash, showing that Tzara's sense of humor was still alive.[90]

There is one aspect of Tzara's text, though, that does adhere to what one might call the PCF aesthetic: the idea that "man in search of humanity" is realized through labor.[91] With its long paean to human hands and riffs on street life, the text flirts with the idea that objectively drawing attention to brute reality can jolt consciousness into political action. Even if there is no direct appeal for communist agitation, the call for workers to realize the power that inheres within them is a typical PCF appeal based upon "confidence in the future": "so much to perfect, to conquer, to win. ... The unlimited no longer frightens when the distance already covered appears in the palm of our hands."[92]

Tzrara had never been to Egypt; his analysis was necessarily detached and incomplete. This was not the case when it came to the Hungarian Revolution. Invited by poet Gyula Illyés, Tzara spent ten days in Hungary in early October 1956, accompanied by Tibor Tardos, a young poet who had been in France during the war. Tzara was officially there to take part in festivities honoring Attila József, whose poems had recently been translated into French. He spent time with writers of the Petofi Circle, one of the centers for revolutionary activity that autumn, and with his old friend Lajos Kassák, the former editor of *Ma* who was now blacklisted from publishing.[93]

Upon his return to Paris, Tzara wrote an article about the revolutionary climate in Hungary, but *L'Humanité* refused to publish it. The PCF's official position was that the uprising was a "counterrevolution"; internally, it called upon the communist press to "publish only positive information which aids the international workers' movement."[94] Finding himself at odds with his party, Tzara gave a forthright interview to the Hungarian Press Agency on 16 October. Calling the events "a second Hungarian revolution," he bemoaned the "conformism and State dogmatism" that intellectuals suffered under and the "bureaucratic formalism" which amounted to "a divorce between the people and the gov-

erning class."[95] Freedom of expression was "controlled in such a strict manner" that it was "impossible to translate, or even speak of, Apollinaire."[96] Although he considered democratic socialism the only proper path for Hungary, Tzara nonetheless applauded the "liberalization" taking place, considering that the Hungarian regime was drawing the logical conclusions of Khrushchev's de-Stalinization (a sore point for the PCF, as Aimé Césaire's resignation from the Party that autumn showed).[97] As Tzara put it, "I wanted to say all of this in our literary press [*L'Humanité*], by recounting everything that I saw in Hungary, but unfortunately I was not given the chance. I strongly regret that we have to read the bourgeois press to be informed of the current political events unfolding in Hungary and other socialist countries."[98]

For sociologist and ex-Party member Edgar Morin, Tzara's "first timid act of boldness" showed how for PCF intellectuals "it is morally impossible to speak and criticize outside the Party just as it is materially to speak out inside it."[99] But in the pages of *Combat*, André Breton praised Tzara for being "the first spokesman for Hungarian appeals" against Stalinist oppression; however, Breton regretted that the PCF apparatus had forced Tzara to stop at his initial interview.[100] For Tzara's interview was badly received by the Party leadership. Aragon, on the Central Committee since 1954, drafted a reply: although he refused to name Tzara, his communiqué of 21 October stated: "All of the Hungarian press has published this declaration in order to stoke the anticommunist and anti-Soviet campaign. The Secretariat of the Central Committee regrets the actions of the Hungarian press bureau."[101] A few days later Tzara was called before the Party leadership; Laurent Casanova, who took the lead on matters regarding intellectuals, ordered Tzara to remain silent about Hungary. But the PCF's continued blindness about Hungary (even after the Russian military invasion) led Tzara to compose for *Les Lettres Françaises* a text ostensibly about Paul Éluard but in reality about events in Hungary: "To those who deliberately close their eyes in order to say that they haven't seen anything, to those who bury their heads in the sand to make believe that nothing is happening ... the memory of Paul Éluard should serve as a reproach and warning."[102] He then signed (along with fifteen other intellectuals, including Simone de Beauvoir, Claude Lanzmann, Michel Leiris, Claude Roy, and Jean-Paul Sartre) a letter calling for "a free discussion with our comrades over points of disagreement."[103] In a letter to Casanova, Tzara noted that the text's "moderate tone and its largely constructive character" recommended it for publication in *L'Humanité*:

> I think that the new dialogue being undertaken should not be brutally stopped.
>
> Communist salutations, Tristan Tzara.[104]

But because the letter indicated that the Soviet press had given "a unilateral, that is to say deformed, interpretation" of events in Hungary, *L'Humanité* rejected the text (it was eventually printed in *France-Observateur*). The PCF had no desire to engage in dialogue as it clamped down and excommunicated renegade intellectuals. As Casanova explained in

L'Humanité: "It is clear that the Party finds itself in the presence of an enterprise plotted in bourgeois circles to disorganize its ranks."[105] He added: "Speaking the truth cannot be the specific mission of one category of communists in the Party. Intellectuals must not 'side with' the working class. As members of the Party, they must, we believe, tend to bind themselves body and soul with the proletariat."[106] A sense of the ruling ethos comes out in a communiqué from the PCF Federation of Indre-et-Loire: "Resolutely approve the action of the glorious Soviet Communist Party and its valiant army of workers and peasants who lost 17 million to free the world from fascism and who has yet again demonstrated its loyalty to proletarian internationalism by heeding the call of the Hungarian government to defeat the fascist counterrevolution supported by the entirety of global imperialism."[107]

Even though he was never officially sanctioned for his actions, Tzara's position within the PCF was severely compromised. Old friends refused to greet him on the street, and the PCF's control of certain sections of the press effectively led to him being blacklisted. Tzara "in some way found himself alone," his son recalls.[108] So many renaissances were called for after the war, and the one that engaged Tzara for the rest of his life was far away from the public spotlight. He would bury himself in work, and not just any work, but an obsessive project to unlock the secrets buried within language.

In 1956, Tzara began an exhaustive study of anagrams in literature, starting with François Villon and then moving on to other writers of the twelfth to the sixteenth centuries, such as Dante and Rabelais.[109] In some respects this research was a continuation of his long-held beliefs about the mystery of language: that life was nothing, as he said in Weimar in 1922, but "a game of words."[110] But Tzara's research turned out to be anything but playful, as the destroyer of language was determined to find the "key" to its "secrets." Yet another facet of his personality was at work in this research: the mania of the collector, which had previously confined itself to his collection of primitive art and his personal archive of the avant-garde. Just as Schwitters transformed everyday garbage into great art, the study of anagrams was a way for Tzara to catalog and order the treasure of a mysterious language whose true value had never been realized. No doubt the prevailing atmosphere of paranoia, the division of the world into hostile blocs, and Tzara's literary and political isolation made such a retreat attractive. "We live in a transitional epoch," Tzara admitted in late 1963; "the war is probably not over. People live in the fear of the atomic bomb and total annihilation."[111] His close friends knew how strongly he was attached to his research. Thirty-one files of notes fill up the Doucet archive; days were spent at the Bibliothèque Nationale examining manuscripts and learned tomes. Jack Lindsay recalls meeting Tzara in 1959: "He was working at cryptograms in Villon; and was so excited over some discoveries. ... He remarked about Paris, 'A heartless place, always after the latest sensation. Nothing lasts.' He seemed weary and ... thought the political situation stagnant and depressing."[112] Tzara's neighbor at 5 rue de Lille, Jacques Lacan, remembers that "Tzara was manic only about Villon: yet he was

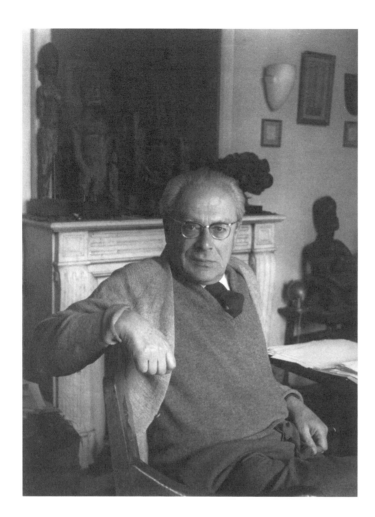

FIGURE 13.3
In his study, rue de Lille.
Courtesy of Christophe Tzara.

also wary of this mania."[113] As his son recalls, Tzara "spoke only about Villon": "it was a sort of immersion ... into the life of a colleague, or, if one can put it this way, a brother."[114] Even on his deathbed, Tzara was correcting his findings, which he never published in a definitive version.

All this began in 1949, when Tzara was asked to write a preface to a volume of François Villon's poetry, for which he was paid 22,000 francs.[115] Considering Villon's poetry as a defense of "*le petit peuple*" against "an odious, petty bourgeoisie," Tzara seems to suggest that its force lies in its apparent openness: "Villon's poetry has such a strong and insidious persuasive value that it often seems to touch upon a state of raw consciousness, while the very nudity of his voice is imbued with a pain that surpasses the historical conditions where it is located."[116] Tzara was then asked to prepare a critical edition of Villon's poetry, and in the course of his research he stumbled across research done by a philologist, Lucien Foulet, which showed that the twenty-fifth stanza of Villon's *Testament*—"Qui est ramply sur les chantiers!"—contained an anagram for "Itiers Marchant" (Qui est RAMplY sur les CHAN-TIERS). Foulet noted that Villon smuggled into his verse the name of one of his rivals, and left it at that. Tzara, though, was struck by the finding: "The anagram of Ythiers Marchant is perhaps not an isolated case. The analogy of certain lies of the *Lais* with the stanzas of the *Testament*, the nomenclature of the legatees, arranged according to category or order of importance ... are in no way gratuitous. It is in this direction, it seems to me, that one should pursue investigations."[117]

Even though the imminent publication of his critical edition was announced in June 1956, Tzara abandoned the project in favor of a deeper investigation into anagrams. Foulet's method did not lead to results, but Tzara discovered one which did: "The procedure consisted in including in a line or a portion of a line involving the anagram, a word or several words whose letters are symmetrically distributed with respect to a center formed by one or two alphabetic signs; the spaces between words do not count."[118] Because there was no rigorous spelling of words in the fifteenth century, certain letters in the line might have to be transposed (Tzara provides fourteen precise cases, such as suppressing the final *t* of a word ending in -*an* or -*en*, or *i* being signaled by either *j* or *y*). Although it sounds complicated, his procedure is relatively simple. The first thing to do is to serially arrange the letters in a line of verse. The letters forming the anagram are given through a specific code (which can vary) with respect to a central axis. As an example, Tzara finds in the line "*Si bien chantans, si bien parlans*" the anagram for "Catherine," the name of Villon's lover:

S I B I E N C H A N T A N S S I B I E N P A R L A N S
\+ + 0 + + 0 0 + + 0 0 + + 0 + +

The letters marked with a plus sign are used in the anagram, while the blank spaces indicate that a letter is not used. The code here (+ + o + + o o +) and its mirror image (+ o o + + o + +) lead to a set of letters to be included in the anagram (I, E, C, H, T, I, E, N, A, R) for "Catherine." But this same line also produces another anagram, "Itiers," if a different code is used:

<div align="center">

SIBIENCHANTANSSIBIENPARLANS
+ o o o + + + + o o o +

</div>

As Tzara explains: "A great number of combinations are possible, all of them strictly respecting the principle of symmetrical repartition."[119] A single line, such as "*Viel je seray: vous, laide, sans couleur*," could yield eight different anagrams.[120]

Finding over 1,200 such anagrams in Villon's *Le Lais*, Tzara was convinced that these were "the key" to unlocking Villon's "*pensée secrète*."[121] He speculates that Villon composed his poetry and then, a posteriori, inserted anagrams within it: "They are the result of a meticulous assemblage of scattered pieces, polished and repolished tirelessly so that they can be linked one to another."[122] Through anagrams, Villon was able to give one meaning to his poetry that only personal friends initiated in this "secret technique" could decipher.[123] This allowed him "to express himself in all secrecy," for there were certain matters that the prevailing religious and moral climate did not allow.[124] Tzara argues that the anagrams supply a further layer of meaning to the verse (by indicating the subject of a line, for instance) and clear up obscure events in Villon's life (by naming individuals in the crimes he was implicated in). The anagrams can also be used by scholars to reconstitute Villon's original text: "It was often the combination of two or three different versions, each one only partially reflecting the original, that helped me give to the verse the form it more likely had in Villon's time."[125] Finally, the anagrams can serve as signatures, either within signed work (the line "*Mais tout franc cuer doit, par Nostre Seigneur*" in Villon's "Ballade à s'amie" contains the anagram "*François m'a escripte*," François wrote me) or to anonymous works (Tzara claimed that Jean Vaillant was, in fact, Villon; as Aragon later put it when Tzara moved on to a study of Rabelais, "Tristan Tzara Discovers a New Work by Rabelais").[126]

In December 1959 Charles Dobzynski claimed that Tzara's work amounted to "one of the most breathtaking literary surprises of the century."[127] As *Le Monde* put it several days later, "[f]or three years now Tristan Tzara has been walking in this forest. He has left it dazzled, with the feeling of having grasped hold of something rare: a treasure, or a secret. In one month he will publish—or perhaps one should say, he will detonate, since it will be more like a bomb—a book on Villon, chock-full of explosive material."[128] The book, which was supposed to be published by Éditions Fasquelle (Tzara had signed the contract earlier that year), never appeared, though, as Tzara kept putting off the submission of a final manuscript as he reworked his findings. In May 1960 the editor asked for a photograph of Tzara and a short biography, indicating that the work was ready to go to press.[129] Tzara was also

negotiating with an Italian publisher to have an Italian-language edition come out simultaneously.[130] He had a complete text, with notes, but refused to let go of it. Persistent doubts about the validity of his research, and also new lines of inquiry to investigate (such as the work on Rabelais and other medieval anagrams), kept appearing. Tzara, convinced that anagrams represented "a substantial chapter of literary history unknown up till now," promised a longer study devoted to anagrams from the twelfth to the sixteenth century.[131]

There is no doubt that the anagrams Tzara discovered exist, but the critical success of his project has been minimal. His findings point to the radical instability of texts, as the following extract suggests:

> We can understand the confusion of copyists faced with his manner of writing and especially with Villon's apparent inconsequence when using or not using certain liberties … with an intention that totally escaped them. None of them seems to have been aware of the hidden treasure [*trésor caché*] at the heart of the verbal matter of his lines. There was an evident concern on their part to make Villon's spelling consistent, which deformed a number of lines, but the fact that some manuscripts *were dictated* only increased the confusion in these copies.[132]

But Tzara uses this information to speculate that "by adding or suppressing a letter" in the printed volume an intended anagram could be restored—but by the same logic, an unintentional anagram could have been added.[133] Rather than claiming that his research shows the incomplete and tangential nature of any reading, Tzara calls anagrams "secret treasure" and, in so doing, turns himself into a heroic code-breaker reestablishing an Ur-text and unlocking its secrets. But using anagrams to reconstitute the text is a circular procedure, for if one starts with the assumption that a certain line contains a certain anagram, the anagram will eventually appear through the modifications made. Establishing documentary proof about the life of a poet is subject to the same circular logic: "We cannot establish with any certainty a biographical point about Villon unless the clues given by the anagrams confirm these facts and vice versa."[134] Furthermore, although Tzara suggests that Villon's "secret technique" was known only to a small circle of "initiates," his later work on other poets, such as Charles d'Orléans and Rabelais, indicates that this was a common poetic procedure, making it very much an "open secret" or even a "society game"—but such a game is amusing only if its rules are known.[135] The final problem concerns intention: could the anagrams be there by chance? Tzara asked his son, who was a physicist, if a mathematical model could determine the answer to this question. When a young professor of mathematics visited Tzara in 1961 and showed him one such model which concluded that the anagrams were there by chance, "to my numbers, he opposed the faith of someone who has discovered a treasure and who is told that some of these pieces, perhaps all of them, are counterfeit."[136] One later scholar discovered, for instance, that a single line of *Le Lais* contained twenty different symmetrical anagrams for a single name: could Villon have meant them all?[137] A number of scholars have programmed computers to analyze Tzara's research, and there is no conclusive answer to this question, nor is there likely to be.[138]

True to Tzara's new form as a scholar, he was invited to take part in the first International Congress of African Culture at the National Gallery in Salisbury, Rhodesia. He was asked because of his expertise on the relationship between traditional African art and contemporary practice: "it is obvious that these productions of primitive peoples have a correlation with what I love in art today and in my own art."[139] The ten-day conference, which opened on 1 August 1962, spanned ancient and contemporary African art, music, and history, and brought together delegates from Africa, Europe, and North America, including an old friend, Alfred Barr, Jr. An exhibition coinciding with the conference included "masterpieces of African art that would have embellished any museum in the world."[140] Tzara, who then visited Mozambique and South Africa, was struck by the "constant circulation" of people and ideas and the "continual [cultural] transformation" in these countries.[141] This was true even for South Africa. Although he deplored the "Nazi police" enforcing an "extremely rigorous" system of racial separation, Tzara took some comfort in seeing that the black majority was culturally vibrant, indicating that it had not been defeated.[142]

Back in Paris, Tzara's days fell into the routine of scholarly research and early evenings with friends at the Café de Flore. In early 1963, though, he called one of his friends: "Something horrible has happened to me. I felt bad tonight, I looked in the mirror and saw that my neck was horribly swollen."[143] He was eventually diagnosed with advanced-stage lung cancer. Tzara held out hope that he would be able to defeat the illness, as Sandro Volta recalls: "This was the first sign ... that could not leave any illusions. But Tristan refused to think about it and spoke until his final days of being healed as if it were a certain thing, and was making plans for the future."[144] Tzara was treated with cobalt therapy that left him quite weak but allowed him to return home. He was even able to take a summer vacation in Rome and Sicily with his son and daughter-in-law. His curiosity undiminished, Tzara spoke of some interesting discoveries concerning Baroque architecture that he would work on after finishing his studies of anagrams. But in August the cancer returned; it had attacked his spine. For a month he was hospitalized, his legs having lost movement. If in *Approximate Man* Tzara had pleaded "and may death surprise you without too much bother with eyes too open," he was living in incredible pain.[145] He asked friends to visit him with news about the latest films and art shows. His friends were distraught, sensing the end, but Tzara told Arp: "Do not take it to heart: I know that it is very serious, but I will try to be stronger than the disease and you will see that I will finish by beating it."[146] He somehow managed to give interviews in late November about the publication of *Lampisteries*, a collection of Dada writings. His voice was unmistakably altered, but his spirit remained effervescent, even playful. When asked at the start of an interview for *L'Express* what personal interest he had in the republication of his Dada manifestos, Tzara responded in a manner typical of his 1920s insouciance: "None."[147] Expressing his doubts about the commodification of modern life and the imperatives of a planned society, he then reminisced about Dada's attack upon "everything: war, the nation, the family, religion, logic, order."[148] He was remarkably lucid,

286

but the end was near. A few days before his death, he could no longer move and could barely speak. Christophe came to read aloud from Rabelais; at a certain moment Tzara struggled to move his arms to indicate that a certain word should have taken an acute accent.

Finally succumbing to his illness on 24 December 1963, Tzara was buried on a cold winter's day at Père-Lachaise. The funeral was a simple affair, but it could not escape the controversy that distinguished his life. Isidore Isou and his Lettrist friends planned a public celebration of Tzara's work against the communist faithful who were now claiming his memory. Insults were exchanged between the two camps: *Piss off, dirty asshole; Go fuck yourself, bitch.*[149]

A few weeks before his death, Tzara had told a journalist: "I have spoken to you about many things, but in truth there is only one thing that is at the bottom of everything: poetry. It is the residue of everything, of every event, of every action. ... Everyone is a poet in one way or another, in a more or less conscious way. ... As soon as one dreams, as soon as one gives in to one's imagination, one enters into poetry."[150] If his dreams were forever stopped, his gravestone was marked with the single word that had eternal life: *poète.*

287

NOTES

1 "COME WITH ME TO THE COUNTRYSIDE": 1896–1906

1. *Manifeste Dada 1918*, in Tristan Tzara, *Œuvres Complètes*, ed. Henri Béhar, 6 vols. (Paris: Flammarion, 1975–1991), 1:363. Hereafter cited as *OC*. All translations mine unless noted, and original punctuation in the poetry has been followed.

2. Bibliothèque Littéraire Jacques Doucet (Paris, France), TZR 783. Hereafter cited as BLJD.

3. Direcția Judeţeană Bacău a Arhivelor Naționale, inventar Stare Civila (Moineşti), vol. 2 (1896), f. 30. Hereafter cited as DJAN Bacău.

4. See Victor Macarie, "Dada: Un nume bine căutat," in *Cahiers Tristan Tzara*, nos. 2–4 (2000): 11–12. Hereafter cited as *CTT*.

5. "La Grande Complainte de mon obscurité deux," *OC*, 1:93.

6. "Sainte," ibid., 1:98.

7. Henri Béhar, *Tristan Tzara* (Paris: Oxus, 2005), 15; interview with Michel Sanouillet, 26 August 2009 (Nice).

8. René Lacôte, *Tristan Tzara* (Paris: Pierre Seghers, 1952).

9. François Buot, *Tristan Tzara: L'homme qui inventa la révolution Dada* (Paris: Grasset, 2002), 15.

10. *Cabaret Voltaire* (1916), 5.

11. Raluca Michaela Dub, "O încercare de integrare a avant-gardei artistice româneşti în contextul occidental," in *Romania and Western Civilization*, ed. Kurt W. Treptow (Iaşi: Center for Romanian Studies, 1997), 85–92, at 86.

12. Sandqvist puts Moineşti ten miles from Iaşi, when the distance is closer to one hundred (30), and also has Tzara arriving in Paris in 1921 (4), not 1920. But his is otherwise an admirable effort to supply vital information about the Romanian context of Dada, especially concerning the Ianco brothers and Arthur Segal. See Tom Sandqvist, *Dada East: The Romanians of Cabaret Voltaire* (Cambridge, MA: MIT Press, 2006).

13. Tristan Tzara to Şaşa Pană, 17 January 1934, in *Primele poeme ale lui Tristan Tzara*, ed. Saşa Pană (Bucharest: Editura Cartea Românească, 1971), 121.

14. Tzara to Francis Picabia, 28 July 1920, in Michel Sanouillet, *Dada in Paris*, trans. Sharmila Ganguly (Cambridge, MA: MIT Press, 2009), 420.

289

NOTES TO CHAPTER 1

15. Mira Rinzler to author, 16 August 2009.

16. *Faites vos jeux*, *OC*, 1:251.

17. Interview with Christophe Tzara, 14 September 2009 (Paris).

18. Interview with Serge Fauchereau, 12 September 2011 (Paris).

19. "Sur la Roumanie libérée," *OC*, 5:319.

20. D. Ciurca, "Noi considerații privind orașele și târgurile din Moldova în secolele XIV–XIX," *Anuarul Institutului A.D. Xenopol* (Iași, 1970), 57.

21. Le Corbusier, *Le Voyage d'Orient* (Paris: Éditions Forces Vives, 1966), 19.

22. David Turnock, *The Romanian Economy in the Twentieth Century* (New York: St. Martin's Press, 1986), 27.

23. Gheorghe Ravaș, *Din istoria petrolului românesc* (Bucharest: ESPLA, 1957), 10, 95.

24. David Turnock, "The Pattern of Industrialization in Romania," *Annals of the Association of American Geographers* 60, no. 3 (September 1970): 540–559, at 541; Joseph S. Roucek, "Economic Geography of Roumania," *Economic Geography* 7, no. 4 (October 1931): 390–399, at 395.

25. Tristan Tzara, "Red Life Boils in Pits," in *Primele Poeme/First Poems*, trans. Michael Impey and Brian Swann (Berkeley: New Rivers Press, 1976), 63 (hereafter cited as *First Poems*); "Arc," *OC*, 1:227.

26. *La Première Aventure céleste de Monsieur Antipyrine*, *OC*, 1:80.

27. *Faites vos jeux*, ibid., 1:259.

28. Solomon Șapira, *O legendă vie—Moinești* (Jerusalem: Hitahdut Olei Romania, 1989), 24.

29. "Furtuna și cîntecul dezertorului," in *Primele poeme*, 10.

30. Theodor Enesco, "Stefan Luchian," *Revue roumaine* 21, no. 1 (1967): 136–141, at 140.

31. Șapira, *Legendă vie*, 19.

32. "Vino cu mine la țara," in *Primele poeme*, 13.

33. "Furtuna și cîntecul dezertorului," in ibid., 10.

34. *Faites vos jeux*, *OC*, 1:259.

35. *Revista "Liga Cultura" din Bacau* 1, nos. 9–10 (March–April 1912), 13.

36. Vasile Anghel, *Moinești: 565 de ani de la prima atestare documentara* (Moinești: n.p., 2002), 182.

37. *Revista Israelită* (1908), quoted in Șapira, *Legendă vie*, 54–55.

38. "Autour," *OC*, 1:204.

39. "Poemă modernă," in *Primele poeme*, 76.

40. "Suflete pe aici," in ibid., 56.

41. BLJD TZR 562.

42. *Faites vos jeux*, *OC*, 1:276; "Furtuna și cîntecul dezertorului," in *Primele poeme*, 11.

43. "Dezgust," in ibid., 82–83.

44. Șapira, *Legendă vie*, 24.

45. "Vacanța în provincie," in *Primele poeme*, 6.

46. Iacob Psantir, "În memoria Zionului" (1877), in *Evreii din România în texte istoriografice: antologie*, ed. Lya Benjamin (Bucharest: Hasefer, 2002), 50–55, at 53; "Vino cu mine la țara," in *Primele poeme*, 14.

47. *Première Aventure céleste*, OC, 1:83.

48. Hary Kuller, *Opt studii despre evreiilor din România* (Bucharest: Editura Hasefer, 1997), 45.

49. Elias Schwarzfeld, *Din istoria evreilor: Împopularea, reîmpopularea și întemeiarea târgurilor și a târgușoarelor în Moldova* (1914), in Benjamin, ed., *Evreii din România*, 163–199, at 176.

50. Moses Rosen, *Dangers, Tests, and Miracles* (London: Weidenfeld and Nicolson, 1990), 11.

51. DJAN Bacău, 1711 (Primaria Moinești), d.1/1925.

52. In his introduction to *First Poems*, Michael Impey falsely claims that Romanian "was not even [Tzara's] mother tongue" (10).

53. See Ileana Popovici, ed., *Evreii din România în secolul XX: 1900–1920: Fast și nefast într-un răstimp istoric, Documente și mărturii*, 2 vols. (Bucharest: Editura Hasefer, 2003), 1:29.

54. Carol Iancu, *Evreii din România (1866–1919): De la Excludere la Emancipare*, trans. C. Litman (Bucharest: Editura Hasefer, 1996), 140.

55. Quoted in Andrei Oișteanu, *Inventing the Jew: Antisemitic Stereotypes in Romania and Other Central-East European Cultures*, trans. Mirela Adăscăliței (Lincoln: University of Nebraska Press, 2009), 12.

56. Quoted in Leon Volovici, *Nationalist Ideology and Antisemitism: The Case of Romanian Intellectuals in the 1930s*, trans. Charles Kormos (Oxford: Vidal Sassoon International Center for the Study of Antisemitism, the Hebrew University of Jerusalem, 1991), 32.

57. E. Schwarzfeld, *Adeverul asupra revoltei de la Brusturoasa* (Bucharest: Stefan Mihalescu, 1885), x, 17.

58. Quoted in Șapira, *Legendă vie*, 147–148.

59. Quoted in Popovici, ed., *Evreii din România în secolul XX*, 1:148.

60. Irina Atanasiu, "Vacances à Gârceni," CTT 1 (1998): 16.

61. *Première Aventure céleste*, OC, 1:82.

62. Filip Rosenstock to Tzara, 20 August 1925, BLJD TZR C3487.

63. Emilia Rosenstock to Tzara, 10 June 1926, BLJD TZR C3493.

64. Emilia Rosenstock to Tzara, 16 November 1925, BLJD TZR C3489.

65. *Première Aventure céleste*, OC, 1:81–82.

66. Interview with Michel Sanouillet, 26 August 2009 (Nice).

67. Filip Rosenstock to Tzara, 29 July 1925, BLJD TZR C3484.

68. "Prietenă Mamie," in *Primele poeme*, 70–71.

69. Emilia Rosenstock to Tristan Tzara, 7 August 1925, BLJD TZR C3485.

70. Tristan Tzara to Rosenstock family, 27 October 1926, in "Scrisori către familie, în România," *Aldebaran*, nos. 2–4 (1996), 16.

71. Tristan Tzara to Lucie-Marie Rosenstock, 22 July 1947, in ibid., 17.

72. Interview with Christophe Tzara, 14 September 2009 (Paris).

73. Ion Vinea to Tristan Tzara, 1925, BLJD TZR C4164.

74. *Faites vos jeux*, OC, 1:269–270.

75. "Hamlet—Fragmentary Sketches," in *First Poems*, 68.

76. Ibid.

77. Tristan Tzara to Emilia and Lucie-Marie Rosenstock, 18 June 1936, in "Scrisori către familie," 17.

78. Şapira, *Legendă vie*, 14.

79. *Faites vos jeux*, OC, 1:267.

80. *Manifeste Dada 1918*, ibid., 1:367.

81. "Un Beau Matin aux dents fermées," ibid., 1:217.

82. "Domestic Sadness," in *First Poems*, 36.

83. Filip Rosenstock to Tristan Tzara, 16 November 1925, BLJD TZR C3489.

84. Emilia Rosenstock to Tristan Tzara, 16 March 1927, BLJD TZR C3493.

85. Filip Rosenstock to Tristan Tzara, 9 July 1928, BLJD TZR C3500.

86. "Prietenă mamei," in *Primele poeme*, 71.

87. Anghel, *Moineşti*, 182.

88. "Suflete pe aici," in *Primele poeme*, 57.

89. Constandina Brezu, "Tristan Tzara—Liniile Ascunse ale portretului," *CTT* 1 (1999): 21.

90. Filip Rosenstock to Tristan Tzara, 13 July 1927, BLJD TZR C3501.

91. "Note sur l'art: H. Arp," *OC*, 1:395.

92. "Insomnia," in *First Poems*, 54.

93. "Nocturne," in ibid., 55.

94. *Faites vos jeux*, OC, 1:250.

95. Ibid., 266–267.

96. Vasile Robciuc, *Tristan Tzara, sau a patra dimensiune a poeziei secolului XX* (Bacău: Imprimeria Bacovia, 1991), 4.

97. Keith Hitchins, *Rumania 1866–1947* (Oxford: Clarendon Press, 1994), 171.

98. Alex Drace-Francis, *The Making of Modern Romanian Culture: Literacy and the Development of National Identity* (London: Tauris Academic Studies, 2006), 151.

99. DJAN Bacău, 2242 (Şcoala generală nr. 1 Moineşti), d.1/1893, f.27; d.1/1900, f.2, f.48.

100. Ibid., d.1/1893, f.23.

101. Ibid., d.1/1893, f.7.

102. http://romanianjewish.org/ro/?page_id=729 (Dr. Burah Zeilig).

103. *Faites vos jeux*, OC, 1:275.

104. "Cîntec de război," in *Primele poeme*, 17.

2 THE EDUCATION OF SAMUEL ROSENSTOCK: 1906–1912

1. Archives Départementales du Lot (46), Dossier Tristan Tzara, 209W695, f. 4.

2. "Cousin, Prep-School Girl," in *Primele Poeme/First Poems*, trans. Michael Impey and Brian Swann (Berkeley: New Rivers Press, 1976), 21. Hereafter cited as *First Poems*.

3. Serviciul Municipiului al Arhivelor Naționale, Bucharest, 336 (Liceul Dimitrie Cantemir), 861/1910, unpaginated. Hereafter cited as SMAN Bucharest.

4. Ibid.

5. Antoine Roger, *Les Fondements du nationalisme roumain (1791–1921)* (Geneva: Droz, 2003), 156.

6. D. Huruzeanu and M. Iosa, "Situația social-economică și politică a țărănimii la începutul secolului al XX-lea," in *Marea răscoală a țăranilor din 1907*, ed. I. Popescu-Puțuri, 2nd rev. edn. (Bucharest: Editura Academiei Republicii Socialiste Romănia, 1987), 17–44, at 41.

7. "Cei Uciși în 1907," *Seara*, 30 April 1910, 1. On the peasant revolt, see Andrei Otetea et al., *Marea Răscoală a Țăranilor din 1907* (Bucharest: Editura Academiei, 1967); Jack Tucker, "The Rumanian Peasant Revolt of 1907" (Ph.D. thesis, University of Chicago, 1972).

8. Leften Stavros Stavrianos, *The Balkans since 1453* (New York: Rinehart, 1958), 488.

9. C. Dobrogeanu-Gherea, *Neoiobăgia* (Bucharest: Editura Librariei SOCEC, 1910), 5.

10. Ion Luca Caragiale, "1907 din primăvară pănă'n toamnă: câteva note," in *Opere*, vol. 5, ed. Șerban Cioculescu (Bucharest: Fundația pentru Literatură și Artă Regele Carol II, 1938), 167.

11. Alexandru Marghiloman, *Note Politice, 1897–1924* (Bucharest: Editura Institutului de Arte Grafice Eminescu, 1927), 61.

12. S. A. Mansbach, "The 'Foreignness' of Classical Modern Art in Romania," *Art Bulletin* 80, no. 3 (September 1988): 534–554, at 536.

13. "Samică și 1907," *Viitorul*, 17 March 1910, 1.

14. A. C. Cuza, *Naționalitatea in artă: Principii, fapte, concluzii: Introducere la doctrina naționalistă-creștină*, 3rd edn. (Bucharest: Editura Cartea Românească, 1927), viii–ix.

15. Radu Ioanid, "Nicolae Iorga and Fascism," *Journal of Contemporary History* 27, no. 3 (July 1992): 467–492, at 470.

16. "Insemnări privitoare la istorie culturii românești," *Convorbiri literare* 44, no. 1 (March 1910): 1–4, at 1.

17. Cuza, *Naționalitatea in artă*, 103 (emphasis original).

18. "Chestia evreiasca," *Critica*, 10 April 1910, 2.

19. Paul Cernat, *Avangarda romăneasca și complexul periferiei* (Bucharest: Cartea Românească, 2007), 29.

20. Eugène Pittard, *La Roumanie: Vallachie, Moldavie, Dobroudja* (Paris: Bossard, 1917), 178.

21. Paul Labbé, *La vivante Roumanie* (Paris: Hachette & Cie, 1913), 25.

22. Constantin C. Giurescu, *Histoire de Bucarest*, trans. Andrée Fleury (Bucharest: Éditions Sportives et Touristiques, 1976), 74–76.

23. Frédéric Damé, *Bucarest en 1906* (Bucharest: Socec, 1907), 116–117.

24. Charles de Moüy, *Lettres du Bosphore, Bucarest, Constantinople, Athènes* (Paris: E. Plon, 1879), 8–9.

25. Paul Morand, *Bucarest* (Paris: Plon, 1990 [1935]), 242.

26. Giurescu, *Histoire de Bucarest*, 77.

27. Quoted in Gheorghe Parusi, *Cronica Bucureștilor* (Bucharest: Compania, 2005), 250.

293

28. Constantin C. Giurescu, *Amintiri*, ed. Dinu C. Giurescu (Bucharest: ALL Educational, 2000), 66–67.

29. Ibid., 39.

30. Damé, *Bucarest en 1906*, 357.

31. "Mai Sunt Copii?," *Viitorul*, 17 March 1910, 1.

32. Emil Lovinescu, "Psihologia 'Exoticului'," in *Scrieri*, vol. 1 (Bucharest: Minerva, 1969), 136–137.

33. Richard Huelsenbeck, *En avant dada: l'histoire du dadaisme*, trans. Sabine Wolf (Alençon: Éditions Allia, 1983), 11.

34. "Sunday," in *First Poems*, 34.

35. SMAN Bucharest, 46 (Liceul Schewitz Thierrin), 91/1907–1912, f.36.

36. Ibid.

37. Ibid., 8/1909–1910, f.113.

38. Ibid., 6/1907–1908, f.82.

39. Ibid., 7/1908–1909, f.115.

40. Ibid., f.48.

41. Ibid.

42. Ibid., 6/1907–1908, f.82.

43. See SMAN Bucharest, 336 (Liceul Dimitrie Cantemir), 861/1910, which contains a September 1910 letter by Tzara documenting his four years of *gymnasium*.

44. SMAN Bucharest, 46 (Liceul Schewitz Thierrin), 91/1907–1912, f.21, 88, 92, 138.

45. Maiorul I. Chirițescu, *Ostașul: Calitățile și virtuțile militare trebuincioase școlarului român* (Bucharest: Socec, 1907), 57.

46. Ibid., 18.

47. Gr. G. Tocilescu, *Manual de istoria românilor pentru clasa IV gimnazială și scoalele secundare de fete* (Bucharest: Niculescu, 1904), 2 (emphasis original).

48. Ibid., 250.

49. J.-A. Candréa and D.A. Teodoru, *Cours de langue française: Quatrième livre* (Bucharest: Libraire de l'Indépendance Roumaine, 1909), 86.

50. Ibid., 124–125.

51. Vlad Georgescu, *The Romanians: A History*, ed. Matei Călinescu, trans. Alexandra Bley-Vroman (Columbus: Ohio State University Press, 1991 [1984]), 177.

52. "Educația Higienică," *Seara*, 19 August 1910, 1–2.

53. "Salubritatea Publică," *Seara*, 21 August 1910, 1.

54. Günter Berghaus, *Theater, Performance, and the Historical Avant-Garde* (Basingstoke: Palgrave Macmillan, 2005), 38; Filippo Tommaso Marinetti, "La Guerra, Sola Igiene del Mondo," in *Manifesti Futuristi*, ed. Guido Davico Bonino (Milan: Rizzoli, 2009), 279–280.

55. Tristan Tzara, "Importanța, istoricul și foloasele igienei," *Aldebaran*, nos. 2–4 (1996): 46–47, at 46.

56. Ibid.

57. Ibid., 47.

58. Dr. Urechia, *Noţiuni de igienă cu anatomia şi fiziologia omului* (Bucharest: Socec, 1909), 29.

59. Tzara, "Importanţa, istoricul şi foloasele igienei," 47.

60. Ibid.

61. SMAN Bucharest, 336 (Liceul Dimitrie Cantemir), 861/1910.

62. Tom Sandqvist, *Dada East: The Romanians of Cabaret Voltaire* (Cambridge, MA: MIT Press, 2006), 161.

63. SMAN Bucharest, 43 (Liceul teoretic de băieţi Sf. Gheorghe), 19/1911–1912.

64. "Elegy," in *First Poems*, 43.

65. It was reviewed in *Noua Revistă Română* (4 November 1912, 2 December 1912, 6 January 1913), *Viitorul* (18 November 1912), *Dimineaţa* (19 November 1912), and *Rampa* (23 November 1912, 29 December 1912).

66. *Ilustraţiunea romană*, nos. 11–12 (1913); quoted in *Centenar Marcel Iancu 1895–1995/Marcel Iancu Centenary 1895–1995* (Bucharest: Simetria, Union of Romanian Architects and Editura Meridiane, 1996), 24.

67. Marin Simionescu-Rîmniceanu, "Expoziţia Iser, I: Modernism," *Noua Revistă Română*, 21–28 February 1916, 12; "Expoziţia Iser, II," *Noua Revistă Română*, 6–13 March 1916, 26.

68. Interview with Marcel Janco, published in *Facla*, March 1934; quoted in Luminiţa Machedon and Ernie Scoffham, *Romanian Modernism: The Architecture of Bucharest, 1920–1940* (Cambridge, MA: MIT Press, 1999), 35.

69. Elena Zaharia, *Ion Vinea* (Bucharest: Editura Cartea Românească, 1972), 17. Alexandru Iovanache's occupation is given in Ion Vinea's enrollment sheet at Sf. Sava; see SMAN Bucharest, Liceul Sf. Sava, 15 bis/1912–1913.

70. See SMAN Bucharest, Liceul Sf. Sava, 15 bis/1912–1913, p. 8; and 15/1913–1914 (unpaginated).

71. "Victimele Bohemei," *Seara*, 23 December 1910, 1.

72. Mircea Eliade, *Romanul adolescentului miop* (Bucharest: Muzeul Literaturii Române, 1989), 96–111.

73. Nicolae Davidescu, "Reviste, public şi autori," *Noua Revistă Română*, 20 April 1914, 310–311.

74. Dennis Deletant, "Slavonic Letters in Moldavia, Wallachia and Transylvania from the Tenth to the Seventeenth Centuries," *Slavonic and East European Review* 58, no. 1 (January 1980): 1–21, at 4.

75. Dan Simonescu and Gheorghe Buluţă, *Scurtă istorie a cărţii româneşti* (Bucharest: Editura Demiurg, 1994), 58; "Publicaţiile Româneşti in 1909," *Viitorul*, 27 May 1910, 1.

76. "Din Duminică in Duminică," *Viitorul*, 15 February 1910, 1; M.A. Renert, "Publicul şi scriitori noştri: Simple reflexii," *Bibliotecă Modernă*, 15 January 1911, 15.

77. Joan Dragan and Angela Popescu-Bredicine, *Le Livre et la lecture en Roumanie* (Paris: UNESCO, 1986), 11.

78. Z. Ornea, *Sămănătorismul*, 2nd edn. (Bucharest: Minerva, 1971), 75.

79. Constantin Beldie, *Memorii: Caleidoscopul unei jumătăţi de veac în Bucureşti, 1900–1950* (Bucharest: Editura Albatros, 2000), 169.

80. *Seara*, 29 July 1914; quoted in Zaharia, *Ion Vinea*, 34.

81. Ibid.

82. Victor Eftimiu, *Portrete și Amintiri* (Bucharest: Editura pentru Literatură, 1965), 8, 11.

83. Vasile V. Haneș, "O prietenie înălțatoare: Alexandri și Balcescu," *Noua Revistă Română*, 12 January 1914, 74.

84. *Simbolul*, no. 3 (1 December 1912): 48 (emphasis original). Iovanache first signed himself as "Ion Vinea" in March 1914; see Gh. Sprințeroui, "Contribuții la cunoașterea vieții și activității lui Ion Vinea," *Revista de istorie și teorie literara* 20, no. 4 (1971): 623–630.

85. Ov. S. Crohmălniceanu, *Literatura română între cele două războaie mondiale*, 2 vols. (Bucharest: Editura Minerva, 1974), 2:366.

86. *Insula* 1, no. 1 (18 March 1912), cover page.

87. Emil Isac, "Modernismul pe toate liniile," *Viața nouă* 13, no. 20 (1913): 301–302.

88. Quoted in Ion Pop, "Dada en Roumanie: Échos et Prémisses," in *Dada Circuit Total*, ed. Henri Béhar and Catherine Dufour (Lausanne: L'Âge d'Homme, 2005), 82–89, at 83.

89. Quoted in Adrian Marino, *Modern, modernism, modernitate* (Bucharest: Editura pentru Literatură Universală, 1969), 52.

90. Ion Vinea, "Răsfoind Revistele," *Facla*, 15 October 1913; in Vinea, *Publicistică literară*, ed. Constantina Brezu-Stoian (Bucharest: Editura Minerva, 1977), 37–38.

91. Poldy declared his adherence to Futurist principles in an article in *Rampa*, 8 November 1912.

92. *Simbolul*, no. 3 (1 December 1912), 48.

93. Dimitrie Karnabatt, "Poezie Noua," *Seara*, 18 October 1910, 1.

94. Jean Moréas, "Le Manifeste symboliste," in *Les Manifestes littéraires de la Belle Époque, 1886–1914: Anthologie critique*, ed. Bonner Mitchell (Paris: Seghers, 1966), 27–32, at 28.

95. Angela Ion and Silvia Pandelescu, "Baudelaire en Roumanie—Traductions et Commentaires," in *La Littérature française dans l'espace culturel roumain*, ed. Angela Ion (Bucharest: Universitatea din București, 1984), 188–206, at 191.

96. Alexandru Macedonski, "In Arcane de Pădure" and "Rondelul orașului mic," in *Antologia poeziei simboliste românești*, ed. Lidia Bote (Bucharest: Editura pentru Literatură, 1968), 20, 24.

97. See E. Lovinescu, *Istoria literaturii române contemporane*, vol. 1 (Bucharest: Editura Minerva, 1973 [1926–1927]), 91.

98. Quoted in Constantin Ciopraga, *Literatura română între 1900 și 1918* (Bucharest: Editura Junimea, 1970), 122–123.

99. Emil Isac, "Protopoii familiei mele," *Simbolul*, no. 1 (25 October 1912), 2–4.

3 SONGS OF WAR: 1912–1915

1. "Sister of Charity," in *Primele Poeme/First Poems*, trans. Michael Impey and Brian Swann (Berkeley: New Rivers Press, 1976), 52. Hereafter cited as *First Poems*.

2. Muzeul Național al Literaturii Române (Bucharest), "Duminecă," 221/II/7/10.919/1–2.

3. A. C. Cuza, *Naționalitatea in artă: Principii, fapte, concluzii: Introducere la doctrina naționalistă-creștină*, 3rd edn. (Bucharest: Editura Cartea Românească, 1927), 4 (emphasis original).

4. *Sămănătorul*, 18 May 1903, quoted in Z. Ornea, *Sămănătorismul*, 2nd edn. (Bucharest: Editura Minerva, 1971), 67.

5. Ornea, *Sămănătorismul*, 33.

6. "Sister of Charity," in *First Poems*, 52.

7. See Ilie Bădescu, *Sincronism European și cultură critic româneasca: Contribuții de sociologie istorică privind cultura modernă românească* (Bucharest: Editura Științifică și Enciclopedică, 1984).

8. Titu Maiorescu, "În contra direcției de astăzi in cultura română," in *Opere*, vol. 1, ed. Georgeta Rădulescu-Dulgheru and Domnica Filimon (Bucharest: Editura Minerva, 1978), 143–154, at 153.

9. Ibid., 153.

10. Lucian Boia, "La Roumanie un pays à la frontière de l'Europe," *Plural* 28, no. 2 (2006): 23–38, at 25.

11. "Lipsa de inițiativă a Români," *Răsăritul: Revistă pentru popor și școala*, October 1905, 105.

12. "Legea Teatrelor," *Seara*, 7 February 1910, 1.

13. Emil Cioran, *Schimbarea la față a României* (Bucharest: Humanitas, 1990), 32, 29 (emphasis original).

14. Constantin D. Mavrodin, "Une Colonie intellectuelle française au bord de la Mer Noire," *La Tribune Roumaine*, 6 June 1914, 7. See also John C. Campbell, *French Influence and the Rise of Roumanian Nationalism* (New York: Arno Press, 1971).

15. Quoted in Ovid S. Crohmălniceanu, *Evreii în mișcarea de avangardă Românească*, ed. Geo Șerban (Bucharest: Editura Hasefer, 2001), 56.

16. Sultana Craia, *Francofonie și francofilie la români* (Bucharest: Demiurg, 1995), 30.

17. Pompiliu Eliade, *De l'influence française sur l'esprit publique en Roumanie* (Paris: Ernest Leroux, 1898), 11.

18. Nicolae Iorga, "O rugăminte," *Epoca*, 12 March 1906; quoted in Ornea, *Sămănătorismul*, 205–206.

19. Corneliu Șenchea, *Glorii și păcate bucureștene* (Bucharest: Ideea Europeană, 2007), 101–102.

20. E. Lovinescu, *Istoria literaturii române contemporane*, vol. 1 (Bucharest: Editura Minerva, 1973 [1926–27]), 66.

21. Iorga quoted in Micaela Slăvescu, "Impact du symbolisme français sur la littérature roumaine," in *La Littérature française dans l'espace culturel roumain*, 207–211, at 208; Ion Trivale, "Pentru doi panegeriști ai simbolismului român," *Noua Revistă Română*, 23 February 1914, 190.

22. G. Ibrăileanu, "Caracterul specific național în literature română," in *Viața românească*, no. 11 (1922), at http://ro.tititudorancea.org/z/garabet_ibraileanu_caracterul_specific_national_in_literatura.htm.

23. Gheorghe Coșbuc, "Uniți," *Sămănătorul*, 1901; quoted in Ornea, *Sămănătorismul*, 15.

24. A. C. Cuza, *Meseriașul romîn* (Iași: Tipografia Națională, 1893), 61.

25. Quoted in Ornea, *Sămănătorismul*, 16.

26. Quoted in Geo Șerban, "Préludes à l'avant-garde chez les Roumains," *Euresis: Cahiers roumains d'études littéraires*, nos. 1–2 (1994): 11–24, at 13.

297

27. Dimitrie Karnabatt, "Poezia Noua," *Seara*, 18 October 1910, 1.

28. Ibid.

29. "Frondări," *Fronda*, April 1912, 14.

30. Ion Vinea, "O Şcoala nouă: *Simultaneismul*," *Facla*, 1 March 1914; in *Publicistică literară*, ed. Constantina Brezu-Stoian (Bucharest: Editura Minerva, 1977), 109–113, at 109.

31. Emil Isac, "Probleme," *Noua Revistă Română*, 29 September 1913, 237.

32. I. Nisipeanu, "Intensitatea vieţiei sociale, in timpul mobilizării," *Noua Revistă Română*, 1 September 1913, 167.

33. Richard C. Hall, *The Balkan Wars, 1912–1913: Prelude to the First World War* (London: Routledge, 2000), 118. See also Barbara Jelavich, "Romania in the First World War: The Pre-War Crisis, 1912–1914," *International History Review* 14, no. 3 (August 1992): 441–451.

34. Hall, *The Balkan Wars,* 135–136.

35. Ibid., 136–137.

36. Carnegie Endowment for International Peace, *Report of the International Commission to Inquire into the Causes and Conduct of the Balkan Wars* (Washington, DC: Carnegie Endowment, 1914), 108.

37. Nisipeanu, "Intensitatea vieţiei sociale, in timpul mobilizării," 168 (emphasis original).

38. Alfred L. P. Dennis, "Diplomatic Affairs and International Law, 1913," *American Political Science Review* 8, no. 1 (February 1914): 25–49, at 25.

39. Tudor Arghezi, "Cântecul Europei" (1912), in *Opere*, vol. 3, ed. Mitzura Arghezi and Traian Radu (Bucharest: Editura Academiei Române, 2003), 593.

40. *Noua Revistă Română*, 4 November 1912, 1.

41. "The Storm and the Deserter's Song," in *First Poems*, 23.

42. "Furtuna şi cîntecul dezertorului," in *Primele Poeme ale lui Tristan Tzara*, ed. Saşa Pană (Bucharest: Editura Cartea Românească, 1971), 10.

43. Ibid., 12.

44. Ibid.

45. See Alexandru Marghiloman, *Note Politice, 1897–1924* (Bucharest: Editura Institutului de Arte Grafice Eminescu, 1927), 230–236.

46. Quoted in I. G. Ducă, *Amintiri politice*, vol. 1 (Munich: Jon Dumitru-Verlag, 1981), 54.

47. *Epoca*, 11 March 1916, quoted in Şerban Rădulescu-Zoner and Beatrice Marinescu, *Bucureştii în anii primului război mondial, 1914–1918* (Bucharest: Editura Albatros, 1993), 31–32.

48. Vasile Cancicov, *Impresiuni şi păreri personale din timpul războiului României, Jurnal zilnic, 13 August 1916–31 Decembrie 1918*, 2 vols. (Bucharest: Atelierele Societătei Universul, 1921), 1:14.

49. "Cîntec de război," in *First Poems*, 17.

50. Ibid.

51. Ibid.

52. Ibid., 18.

53. Walt Whitman, "Song of Myself," in *Leaves of Grass* (Philadelphia: Rees Welsh and Co., 1882), 63.

298

54. Ibid., 63–64.

55. Elena Zaharia, *Ion Vinea* (Bucharest: Editura Cartea Românească, 1972), 39.

56. Ion Vinea, "'Dada,'" *Adevărul*, 15 April 1920, in *Publicistică literară*, 187–188.

57. Quoted in I. Hangiu, *Dicționarul presei literare românești (1790–2000)*, 3rd edn. (Bucharest: Editura Institutului Cultural Român, 2004), 145.

58. S. A. Mansbach, "The 'Foreignness' of Classical Modern Art in Romania," *Art Bulletin* 80, no. 3 (September 1988): 534–554, at 534.

59. *Noua Revistă Română*, 18–25 October 1916, 231–232.

60. Benjamin Fondane, "Cenzura," *Chemarea* 1, no. 13 (15 January 1918), 201–202; *Chemarea* 1, no. 18 (26 February 1918).

61. Serviciul Municipiului al Arhivelor Naționale (hereafter cited as SMAN Bucharest), 1441 (Universitatea București, Facultatea de Litere), 139/1912–1914, f. 253.

62. *Noua Revistă Română*, 19 January 1914, 103.

63. The attendance sheets are found in SMAN Bucharest, 1008 (Universitatea București, Rectorat), 5/1914.

64. Ovid Densusianu, *Scrieri literare*, vol. 1 (Bucharest: Editura Grai și Suflet, 1998), 176.

65. See Ștefan Afloroaei, "Temps historique et critique de la culture: C. Rădulescu-Motru," in *Culture and Society: Structures, Interferences, Analogies in the Modern Romanian History*, ed. Al. Zub (Iași: Editura Academiei, 1985), 137–153.

66. Constantin Rădulescu-Motru, "Războiul și cultura modernă," *Noua Revistă Română*, 4 January 1915, 262.

67. "Să deschidem ochii!," *Cuvântul Studențimii*, 8 November 1913, 1.

68. *Viața studențească*, 25 March 1914, 7.

69. SMAN Bucharest, 1441 (Universitatea București, Facultatea de Litere), 145/1913–1915, f.32.

70. Ibid.

71. See *Omagiu lui Ramiro Ortiz, cu prilejul a douazeci de ani de învățământ in România* (Bucharest: Tipografia Bucovina, 1929).

72. SMAN Bucharest, 1441 (Universitatea București, Facultatea de Litere), 144/1913–1914, f.51.

73. See Ramiro Ortiz, "Spre o nouă poezie și critică italiana," *Noua Revistă Română*, 15 March 1915, 32–34; "Viață și literatură de razboi," *Noua Revistă Română*, 18 October 1915, 193–197.

74. Ramiro Ortiz, *Către studenți, despre ceva de pe acest pământ* (Bucharest: n.p., 1923), 5, 9.

75. SMAN Bucharest, 1441 (Universitatea București, Facultatea de Litere), 145/1913–1915, f.32.

76. Quoted in Michael Impey, "Before and after Tzara: Romanian Contributions to Dada," in *The Eastern Dada Orbit: Russia, Georgia, Ukraine, Central Europe and Japan*, ed. Gerald Janecek and Toshiharu Omuka (New York: G. K. Hall, 1998), 126–136, at 129.

77. "Introducerea lui Don Quichotte," in *Primele poeme*, 55.

78. "Verișoară, fată de pension," in ibid., 6.

79. "Mamie, n-o să înțelegi" [variant], in *First Poems*, 72–73.

80. "Duminecă," in ibid., 32.

4 AT THE CABARET: 1915–1916

1. *Faites vos jeux*, OC, 1:276.

2. Ibid., 275.

3. Richard Huelsenbeck, *Memoirs of a Dada Drummer*, trans. Joachim Neugroschel, ed. Hans J. Kleinschmidt (New York: Viking Press, 1974), 14.

4. *Faites vos jeux*, OC, 1:275–276.

5. Michael Ilk, *Marcel Janco: Das Graphische Werk, Catalogue Raisonné* (Kunsthal Rotterdam: Antiquariat Zerfass & Linke, 2002), 6.

6. *Faites vos jeux*, OC, 1:276.

7. *La Suisse et les parties limitrophes de la Savoie et de l'Italie, Manuel du Voyageur*, 21st edn. (Leipzig: Baedeker, 1898), 35.

8. *Journal de Genève*, 2 February 1916, 1.

9. Friedrich Glauser, "Souvenirs du mouvement dada," in *Dada Circuit Total*, ed. Henri Béhar and Catherine Dufour (Lausanne: L'Âge d'Homme, 2005), 176–190, at 178.

10. *Faites vos jeux*, OC, 1:278.

11. Universität Zürich, *Rektoratsrede und Jahresbericht, April 1915 bis ende März 1916* (Zurich: Orell Füssli, 1916), 32–33.

12. Procès-verbal, Police de la ville de Zurich, 30 September 1919, in Marc Dachy, *Tristan Tzara dompteur des acrobates* (Paris: L'Échoppe, 1992), 67.

13. "Quelques Souvenirs," OC, 1:733; Marcel Janco, "Creative Dada," in *Dada: Monograph of a Movement*, ed. Hans Bolliger, Marcel Janco, and Willy Verkauf (Teufen: Arthur Niggli, 1957), 26–49, at 28.

14. Quoted in Debbie Lewer, "Dada in Zurich," in *A New Order: An Evening at the Cabaret Voltaire* (Manchester: Manchester University Press, 1994), 9–26, at 12.

15. *Journal de Genève*, 6 February 1916, 4.

16. Hugo Ball, *Flight Out of Time: A Dada Diary*, ed. John Elderfield, trans. Ann Raimes (Berkeley: University of California Press, 1974), 50–51.

17. Jean Arp, *Jours effeuillés: poèmes, essais, souvenirs, 1920–1965* (Paris: Gallimard, 1966), 309.

18. Philip Mann, *Hugo Ball: An Intellectual Biography* (University of London: Institute of Germanic Studies, 1987), 17. See Hugo Ball, "Nietzsche in Basel: Eine Streitschrift," in *Hugo Ball—Der Künstler und die Zeitkrankenheit: Ausgewählte Schriften*, ed. Hans Burkhard Schlichting (Frankfurt: Suhrkamp, 1988), 61–102.

19. On Reinhardt, see Peter Jelavich, *Berlin Cabaret* (Cambridge, MA: Harvard University Press, 1993), 62–64, 81–83.

20. Erdmute Wenzel White, *The Magic Bishop: Hugo Ball, Dada Poet* (London: Camden House, 1998), 10.

21. Eva Zimmerman, Regina Bucher, and Bernhard Echte, *Hugo Ball: Dichter Denker Dadaist* (Wädenswi: Nimbus, 2005), 12.

22. Hugo Ball to Maria Hildebrand, 29 July 1914, in *Briefe 1904–1927*, ed. Gerhard Schaub and Ernst Teubner (Göttingen: Wallstein Verlag, 2003), 59.

23. Ball, *Flight*, 4.

24. Ball to Marie Hildebrand, 7 August 1914, in *Briefe*, 62.

25. Ball, *Flight*, 10–11.

26. Ibid., 15.

27. Quoted in Mann, *Hugo Ball*, 53.

28. Jelavich, *Berlin Cabaret*, 119, 123; Ball to Maria Hildebrand, 13 March 1915, in *Briefe*, 73.

29. Ball to Maria Hildebrand, 8 March 1915, in ibid., 71.

30. Hubert van den Berg, "The Star of the Cabaret Voltaire: The Other Life of Emmy Hennings," trans. Roy F. Allen, in *Dada Zurich: A Clown's Game from Nothing*, ed. Brigitte Pichon and Karl Riha (New York: G. K. Hall, 1996), 69–88.

31. Ball to August Hofmann, 11 June 1915, in *Briefe*, 79.

32. Schweizerisches Sozialarchiv (Zurich), Fritz Brupbacher Papers, Ar 101.10.4, BT29.

33. Ball to Käthe Bodnitz, 16 November 1915, in *Briefe*, 92.

34. Karl Riha, "Dada in the Cabaret Voltaire," trans. Barbara Allen, in *Dada Zurich: A Clown's Game*, 36–44, at 36–37; see also Annabelle Melzer, *Latest Rage the Big Drum: Dada and Surrealist Performance* (Ann Arbor: UMI Research Press, 1980), 28.

35. Gustav Huonker, *Literarszene Zürich: Menschen, Geschichten und Bilder, 1914 bis 1945* (Zurich: Unionsverlag, 1985), 11.

36. Raimund Meyer, *Dada in Zürich: Die Akteure, die Schauplätze* (Frankfurt: Luchterhand Literaturverlag, 1990), 43; *Hugo Ball (1886–1986): Leben und Werk*, ed. Ernst Teubner (Berlin: Publica, 1986), 133.

37. White, *Magic Bishop*, 87.

38. Ball to Käthe Bodnitz, 29 December 1915, in *Briefe*, 95–96.

39. Ball to Maria Hildebrand, 12 November 1915, in ibid., 89.

40. As Ball later put it, "[t]he question of our isolation has occupied me since 1914." In Hugo Ball, *Critique of the German Intelligentsia*, trans. Bryan L. Harris (New York: Columbia University Press, 1993 [1919]), 1.

41. Hans Richter, *Dada Art and Anti-Art*, trans. David Britt (London: Thames and Hudson, 1997), 13.

42. Frank Budgen, *James Joyce and the Making of "Ulysses" and Other Writings* (Oxford: Oxford University Press, 1972), 28.

43. Debbie Lewer, "From the Cabaret Voltaire to the Kaufleutensaal: 'Mapping' Zurich Dada," in *Dada Zurich: A Clown's Game*, 45–59, at 47.

44. Ibid., 50.

45. See Meyer, *Dada in Zürich*, 37.

46. Ephraim's petition to the police, dated 19 January 1916, is reprinted in *Cabaret Voltaire Dada Zürich: Ein Eingriff von Rossetti +Wyss* (Zurich: Verlag ETH Zurich, 2004), 8–9.

47. Ball to Käthe Brodnitz, 16 November 1915, in *Briefe*, 92.

48. Ball to Käthe Brodnitz, 27 January 1916, in ibid., 98.

49. Ball to Käthe Brodnitz, 8 February 1916, in ibid., 99.

50. See Harold B. Segel, *Turn-of-the-Century Cabaret: Paris, Barcelona, Berlin, Munich, Vienna, Cracow, Moscow, St. Petersburg, Zurich* (New York: Columbia University Press, 1987).

51. Quoted in Lewer, "Dada in Zurich," 15.

52. Ball, *Flight*, 52.

53. Marcel Janco quoted in Michael Howard, "Visualising the Cabaret Voltaire," in *A New Order*, 27–50, at 48.

54. *Volksrecht* (Zurich), 12 February 1916, in *Dada Zurich: A Clown's Game*, 199–200.

55. Quoted in Ball, *Flight*, 63.

56. Huelsenbeck, *Dada Drummer*, 10.

57. "Chronique zurichoise 1915–1919," *OC*, 1:562.

58. Hugo Ball to Käthe Bodnitz, 8 February 1916, in *Briefe*, 99.

59. Ball, *Flight*, 54.

60. "Chronique Zurich," *OC*, 1:560.

61. Ball, *Flight*, 51.

62. Ibid., 51–52.

63. Ibid., 67.

64. Ibid., 56–57.

65. Stefan Zweig recalls that Café Odeon was the "home of ... revolutionaries and deserters" during the First World War; quoted in Huonker, *Literarszene Zürich*, 28. See also Curt Reiss, *Café Odeon* (Zurich: Europa Verlag, 2010).

66. Janco, "Creative Dada," 28.

67. Jean Arp, "Dadaland," in *Collected French Writings: Poems, Essays, Memoirs*, ed. Marcel Jean, trans. Joachim Neugroschel (London: John Calder, 1974), 234.

68. "Chronique zurichoise 1915–1919," *OC*, 1:561.

69. Ball, *Flight*, 66.

70. Richard Huelsenbeck, *En avant dada: l'histoire du dadaisme*, trans. Sabine Wolf (Alençon: Éditions Allia, 1983), 10–12.

71. See Roy Allen, "Aesthetic Transformations: The Origins of Dada," in *Dada: The Coordinates of Cultural Politics*, ed. Stephen C. Foster (New York: G. K. Hall, 1996), 59–82.

72. Richter, *Dada Art and Anti-Art*, 27.

73. Ball, *Flight*, 64.

74. Ibid., 57.

75. *Cabaret Voltaire* (1916), 6–7.

76. T. J. Demos, "Zurich Dada: The Aesthetics of Exile," in *The Dada Seminars*, ed. Leah Dickerman and Matthew S. Witkovsky (Washington, DC: CASVA Seminar Papers 1, National Gallery of Art, 2005), 7–29, at 12.

77. *Cabaret Voltaire* (1916), 6–7.

78. Huelsenbeck, *Dada Drummer*, 23.

79. Francis M. Naumann, "Janco/Dada: Entretien avec Marcel Janco," in *Dada Circuit Total*, 163–175, at 166.

80. *Cabaret Voltaire* (1916), 5.

81. "Gebouza," *OC*, 1:459.

82. BLJD TZR 567.

83. K. Kaeser to Tzara, 5 January 1917, BLJD TZR C2234.

84. Béhar, notes, *OC*, 1:715.

85. Tzara to Francesco Meriano, 8 December 1916, in Giovanni Lista, *De Chirico et l'avant-garde* (Lausanne: L'Âge d'Homme, 1983), 89–90.

86. *Dada 1* (July 1917): 8.

87. Ball, *Flight*, 67.

88. Ibid., 71.

89. Ibid., 61.

90. Ibid., 56.

91. Ibid., 67.

92. Quoted in Günter Berghaus, *Theater, Performance, and the Historical Avant-Garde* (Basingstoke: Palgrave Macmillan, 2005), 144.

93. Quoted in ibid., 145.

94. Ball, "Dance of Death," in *A New Order*, 53.

95. "Chronique zurichoise 1915–1919," *OC*, 1:561.

96. Huelsenbeck, *Dada Drummer*, 12.

97. Mary Curran, "Impressions of Zürich," *Studies: An Irish Quarterly Review* 9, no. 36 (December 1920): 613–619, at 614.

98. Richard Ellmann, *James Joyce*, rev. edn. (New York: Oxford University Press 1982), 390.

99. Sascha Bru, *Democracy, Law and the Modernist Avant-Gardes: Writing in the State of Exception* (Edinburgh: Edinburgh University Press, 2009), 140.

100. *Cabaret Voltaire* (1916), 32.

101. Claire Raymond-Duchosal, *Les Étrangers en Suisse (Étude géographique, démographique et sociologique)* (Paris: Félix Alcan, 1929), 34.

102. See John Elderfield, "Afterword," to Ball, *Flight*, 238–255.

103. Huelsenbeck, *Dada Drummer*, 32.

104. Jean-Michel Rabaté, *1913: The Cradle of Modernism* (Malden, MA: Blackwell, 2007), 47–48.

105. Giovanni Lista, *Dada libertin et libertaire* (Paris: L'Insolite, 2004), 33.

106. Elderfield, "Afterword," 240.

107. Quoted in Dawn Ades, *Dada and Surrealism Reviewed* (London: Arts Council of Great Britain, 1978), 146.

108. Quoted in Georges Hugnet, *L'Aventure Dada (1916–1922)* (Paris: Seghers, 1957), 106.

109. Richard Huelsenbeck, "Dada Lives!," in *The Dada Painters and Poets*, ed. Robert Motherwell (Cambridge, MA: Harvard University Press, 1981), 277–281, at 280.

110. Ball, *Flight*, 63.

111. Ball to Tristan Tzara, 29 April 1916, in *Briefe*, 109.

112. "Chronique zurichoise 1915–1919," *OC*, 1:562.

113. Ibid.

114. Richter, *Dada Art and Anti-Art*, 31.

115. Meyer, *Dada in Zürich*, 51.

116. Hugo Ball, "Eröffnungs-Manifest, 1. Dada-Abend, Zurich, 14 July 1916," in *Dada Zürich: Texte, Manifeste, Dokumente*, ed. Karl Riha (Stuttgart: Reclam, 2010), 30.

117. *Cabaret Voltaire* (1916), 5.

118. Ball, *Flight*, 60.

119. Ibid., 63.

120. *Cabaret Voltaire* (1916), 5.

121. Ball, *Flight*, 65.

122. *Cabaret Voltaire* (1916), 31.

123. Ibid.

124. Huelsenbeck, *Dada Drummer*, 18.

125. "Dada 5," *OC*, 1:506.

5 DADA IN PRINT AND IN THE POST: 1916–1917

1. Friedrich Glauser, "Souvenirs du mouvement dada," in *Dada Circuit Total*, ed. Henri Béhar and Catherine Dufour (Lausanne: L'Âge d'Homme, 2005), 176–190, at 178.

2. Richard Huelsenbeck, *En avant dada: l'histoire du dadaisme*, trans. Sabine Wolf (Alençon: Éditions Allia, 1983), 11, 14.

3. Emily Hage, "New York and European Dada Art Journals, 1916–1926: International Venues of Exchange" (Ph.D. thesis, University of Pennsylvania, 2005).

4. Cantarelli to Tzara, 25 May 1917, BLJD TZR C677.

5. Huelsenbeck, *En avant Dada*, 25–26.

6. Hans Richter, *Dada Art and Anti-Art*, trans. David Britt (London: Thames and Hudson, 1997), 19.

7. "Esposizione d'arte modernissime," *Giornale del Mattino* (Bologna), 12 July 1916, BLJD TZR I.4.

8. "Chronique zurichoise 1915–1919," *OC*, 1:562, Debbie Lewer, "From the Cabaret Voltaire to the Kaufleutensaal: 'Mapping' Zurich Dada," in *Dada Zurich: A Clown's Game*, ed. Brigitte Pichon and Karl Riha (New York: G. K. Hall, 1996), 45–59, at 52.

9. Ball to August Hofmann, 2 June 1916, in *Briefe 1904–1927*, ed. Gerhard Schaub and Ernst Teubner (Göttingen: Wallstein Verlag, 2003), 111.

10. "Chronique zurichoise 1915–1919," *OC*, 1:563.

11. Zurich Kunsthaus, Dada Collection, V:7.

12. Ibid.

13. Max Jacob to Tzara, 26 February 1916, BLJD TZR C2138.

14. *Première Aventure céleste*, *OC*, 1:81–82.

15. Ibid., 82.

16. "Chronique zurichoise 1915–1919," *OC*, 1:563.

17. "Dada-Abend," *Neue Zürcher Zeitung*, 18 July 1916, in *Dada Zurich: A Clown's Game*, 203.

18. Ibid.

19. Mary Wiegmann to Tzara, 27 September 1916, in Raoul Schrott, *Dada 15/25* (Innsbruck: Haymon, 1992), 66.

20. Henri Guilbeaux, "Marcel Janco: La prèmiere aventure céleste de M. Antipyrine," *Demain*, no. 8 (August 1916): 124–125.

21. Henri Guilbeaux, "L'Art de demain," *La Guerre Mondiale*, no. 580 (18 July 1916): 4634.

22. *Première Aventure céleste*, *OC*, 1:81.

23. Ibid.

24. Alfred H. Barr, Jr., *Cubism and Abstract Art* (Cambridge, MA: Harvard University Press, 1986 [1936]), 58; *Zürcher Post*, 11 July 1916.

25. Richter, *Dada Art and Anti-Art*, 33.

26. "Picasso et la poésie," *OC*, 4:400.

27. Quoted in Christine Poggi, *Inventing Futurism: The Art and Politics of Artificial Optimism* (Princeton: Princeton University Press, 2009), 4.

28. Glauser, "Souvenirs du mouvement dada," 179.

29. Quoted in Günter Berghaus, "Futurism, Dada, and Surrealism: Some Cross-Fertilisations among the Historical Avant-Gardes," in *International Futurism in Arts and Literature*, ed. Günter Berghaus (Berlin: Walter de Gruyter, 2000), 271–304, at 290.

30. Philippe Sers, *Sur Dada: Essai sur l'expérience dadaïste de l'image, Entretiens avec Hans Richter* (Nîmes: Éditions Jacqueline Chambon, 1997), 68.

31. Giovanni Lista, "Marinetti et Tzara," *Les Lettres nouvelles* 3/72 (May–June 1972): 82–97, at 87.

32. F. T. Marinetti and M. Drăgănescu, "O nouă scoală literară," *Democrația*, 20 February 1909, 3–7, at 6.

33. Ion Vinea, "Literatura rusă. Poeții. Futurism. Acmeism. Adamism. Curente noi," *Facla*, 13 November 1913, in *Publicistică literară*, ed. Constantina Brezu-Stoian (Bucharest: Editura Minerva, 1977), 50; Emil Isac, "Probleme," *Noua Revistă Română*, 29 September 1913, 236.

34. Guillaume to Tzara, 28 June 1916, BLJD TZR C1849.

35. Alberto Savinio, "Bizzarrie Artistiche: Dadaismo," *Popolo d'Italia*, 28 July 1919; quoted in Paola Italia, *Il pellegrino appassionato: Savinio scrittore 1915–1925* (Palermo: Sellerio, 2004), 146.

36. Quoted in Berghaus, "Futurism, Dada, and Surrealism," 290.

37. Italia, *Il pellegrino appassionato*, 143. See also Rosita Tordi, "Savinio e Dada. Sugli anni zurighesi del movimento Dada, con inediti di Camillo Sbarbaro," *Letteratura italiana contemporanea* 5, no. 11 (1984): 235–241.

38. "Esposizione d'arte modernissime," *Giornale del Mattino* (Bologna), 12 July 1916, BLJD TZR I.4.

39. Tzara to Jacques Doucet, 30 October 1922, in *OC*, 1:642.

40. Tzara to Moscardelli, 3 March 1917, in Giovanni Lista, *De Chirico et l'avant-garde* (Lausanne: L'Âge d'Homme, 1983), 159.

41. Giovanni Lista, *Dada libertin et libertaire* (Paris: L'Insolite, 2004), 55; Valeria Paoletti, "Dada in Italia. Un'invasione mancata" (Ph.D. thesis, Università delgi Studi della Tuscia, 2009), 97.

42. Ball to Tzara, 31 July 1916, in *Briefe*, 117.

43. Ball to Tzara, 4 August 1916, in ibid., 118.

44. Unidentified to Tzara, BLJD Ms. 23186, f.116–120.

45. Vasile Cancicov, *Impresiuni și păreri personale din timpul războiului României, Jurnal zilnic, 13 August–31 Decembrie 1918*, 2 vols. (Bucharest: Atelierele Societătei Universul, 1921), 1:32–33.

46. Ball to Hennings, 28 October 1916, in *Briefe*, 139.

47. Ibid.

48. Dumitru Hîncu, ed., *Evreii din România în războiul de reîntregire a țarii 1916–1919* (Bucharest: Hasefer, 1996), 42.

49. Glauser, "Souvenirs du mouvement dada," 179.

50. Ibid.

51. Baltescu to Tzara, June 1918, BLJD TZR C324.

52. Ball to Emmy Hennings, 28 October 1916, in *Briefe*, 140.

53. Baltescu to Tzara, undated (spring 1917), BLJD TZR C329.

54. Baltescu to Tzara, 30 January 1917, BLJD TZR C309.

55. Tzara to Meriano, 8 December 1916, in Lista, *De Chirico*, 89.

56. *Cabaret Voltaire* (1916), 31.

57. Tzara to Giuseppe Raimondi, 5 February 1917, in Lista, *De Chirico*, 214.

58. Ball to Hennings, 29 October 1916, in *Briefe*, 145.

59. Richter, *Dada Art and Anti-Art*, 33.

60. Janco to Tzara, 3 August 1917, in Henri Béhar, *Les Enfants perdus: essai sur l'avant-garde* (Lausanne: L'Âge d'Homme, 2002), 43.

61. Hugo Ball, *Flight Out of Time: A Dada Diary*, ed. John Elderfield, trans. Ann Raimes (Berkeley: University of California Press, 1974), 81.

62. Ball to Tzara, 15 September 1916, in *Briefe*, 127.

63. Ball to Käthe Brodnitz, 6 October 1916, in ibid., 131–132.

64. Ibid., 132.

65. Ball to Hennings, 29 October 1916, in *Briefe*, 146.

66. Ibid.

67. Ball to Maria Hildebrand, 28 November 1916, in *Briefe*, 152.

68. Ball to Tzara, 14 December 1916, in ibid., 154; Ball to Marie Hildebrand, 19 December 1916, in ibid., 156.

69. Tzara to Meriano, 8 December 1916, in Lista, *De Chirico*, 89.

70. Richter, *Dada Art and Anti-Art*, 48.

71. Corray to Tzara, undated (late 1916/early1917), TZR C969.

72. Neitzel to Tzara, 16 December 1916, in Raoul Schrott, *Dada 15/25* (Innsbruck: Haymon, 1992), 75; Guillaume to Tzara, 24 December 1916, TZR C1857.

73. De Pisis to Tzara, 28 December 1917, TZR C1149.

74. "Note 1 sur quelques peintres," *OC*, 1:554.

75. Arp, exhibition catalog, Galerie Tanner 1915; quoted in Eric Robertson, *Arp: Painter, Poet, Sculptor* (New Haven: Yale University Press, 2006), 33.

76. "Note 1 sur quelques peintres," *OC*, 1:554.

77. Quoted in Harry Seiwert, "Marcel Janco," in *Zurich Dada: A Clown's Game*, 127.

78. "Chronique zurichoise 1915–1919," *OC*, 1:564.

79. "Note 1 sur quelques peintres," *OC*, 1:553.

80. Ibid.

81. "Chronique zurichoise 1915–1919," *OC*, 1:563.

82. Maria d'Arezzo to Tzara, 16 March 1917, BLJD TZR C1081.

83. Ball, *Flight*, 95.

84. Ibid., 95–96.

85. Ibid., 98.

86. Ibid.

87. *Dada 1* (July 1917), 18.

88. Ball, *Flight*, 101.

89. *Neue Zürcher Zeitung*, 24 April 1917, in *Dada Zurich: A Clown's Game*, 210.

90. Richard Huelsenbeck, *Memoirs of a Dada Drummer*, trans. Joachim Neugroschel, ed. Hans J. Kleinschmidt (New York: Viking Press, 1974), 25.

91. "Chronique zurichoise 1915–1919," *OC*, 1:564.

92. Ball, *Flight*, 102, 104.

93. Ibid., 112.

94. "Chronique zurichoise 1915–1919," *OC,* 1:565.

95. Ibid.

96. Michel Sanouillet, ed., *Dada: Réimpression intégrale et dossier critique de la revue publiée de 1917 à 1922 par Tristan Tzara*, 2 vols. (Nice: Centre du XXe siècle, 1984), 2:148–155.

97. Francesco Meriano, "Walk," *Dada 1* (July 1917): 2.

98. Tzara, "Note 18 sur l'art," *Dada 1* (July 1917): 2.

99. Meriano, "Walk," 2–4.

100. Baltescu to Tzara, undated (probably late summer 1917), BLJD TZR C333.

101. Tzara, "Note 2 sur l'art: H. Arp," *Dada 2* (December 1917): 2.

102. Ibid.

103. Notes, *Dada 2* (December 1917): 18.

104. Ibid.

6 BEYOND THE SWISS SANATORIUM: 1918–1919

1. Bruno Goetz to Tzara, 17 January 1918, in Raoul Schrott, *Dada 15/25* (Innsbruck: Haymon, 1992), 151.

2. Enrico Prampolini to Tzara, 30 January 1918, in Giovanni Lista, "Prampolini, Tzara, Marinetti inédits sur le futurisme," *Les Lettres nouvelles* 3/73 (September–October 1973): 111–141, at 133.

3. Tzara to Jacques Doucet, 30 October 1922, in *OC*, 1:643.

4. Waldemar Jollos, review of *Vingt-cinq poèmes*, *Neue Zürcher Zeitung*, 23 July 1918, in *Dada Zurich: A Clown's Game*, ed. Brigitte Pichon and Karl Riha (New York: G. K. Hall, 1996), 219.

5. "Le Géant blanc lépreux du paysage," *OC*, 1:87.

6. Ibid.

7. Stephen Forcer, *Modernist Song: The Poetry of Tristan Tzara* (Leeds: Legenda, 2006), 11; "Le Géant blanc lépreux du paysage," *OC*, 1:87–88.

8. "La Grande Complainte de mon obscurité un," *OC*, 1:90.

9. Ibid., 91.

10. "Petite ville en Sibérie," *OC*, 1:114.

11. "Essai sur la situation de la poésie," *OC*, 5:15.

12. "Sainte," *OC*, 1:98.

13. Louis Aragon to Jacques Doucet, December 1922, in *OC*, 1:642; Louis Aragon, review of *Vingt-cinq poèmes*, *Littérature*, no. 1 (March 1919), 22.

14. J. Pérez-Jorba, review of *Vingt-cinq poèmes*, *SIC*, nos. 40–41 (March 1919), 314.

15. *Züricher Post*, 27 July 1918, in *Dada Zurich: A Clown's Game*, 219.

16. "Chronique zurichoise 1915–1919," *OC*, 1:565.

17. *Zürcher Morgen-Zeitung*, 29 July 1918, in *Dada Zurich: A Clown's Game*, 220.

18. Ibid., 219.

19. *La Feuille* (Geneva), 3 August 1918, in *Dada Zurich: A Clown's Game*, 220.

20. *Le Genevois*, 16 August 1918, quoted in Michel Sanouillet, *Dada: Réimpression intégrale et dossier critique de la revue publiée de 1917 à 1922 par Tristan Tzara*, 2 vols. (Nice: Centre du XXe siècle, 1984*)*, 2:191.

21. "Entretiens avec Georges Ribemont-Dessaignes," *OC*, 5:403.

22. Michel Sanouillet, *Dada in Paris,* trans. Sharmila Ganguly (Cambridge, MA: MIT Press, 2009), 99.

23. Richard Huelsenbeck, *En avant Dada: l'histoire du dadaisme*, trans. Sabine Wolf (Alençon: Éditions Allia, 1983); translation in *The Dada Painters and Poets*, ed. Robert Motherwell (Cambridge, MA: Harvard University Press, 1981), 33.

24. Filippo Tommaso Marinetti, *Teoria e invenzione futurista*, ed. Luciano de Maria (Milan: Mondadori, 1968), 19.

25. "Dada Manifesto 1918," in *Dada Painters and Poets*, 77, 81.

26. Martin Puchner, *Poetry of the Revolution: Marx, Manifestos, and the Avant-Gardes* (Princeton: Princeton University Press, 2006), 2; "Dada Manifesto 1918," in *Dada Painters and Poets*, 76.

27. "Dada Manifesto 1918," in *Dada Painters and Poets*, 78–79.

28. Moréas and Baju quoted in *Les Manifestes littéraires de la Belle Époque, 1886–1914: Anthologie critique*, ed. Bonner Mitchell (Paris: Seghers, 1966), 27, 19.

29. Jeanne Demers, "Entre l'art poétique et le poème: le manifeste poétique ou la mort du père," *Études françaises* 16, nos. 3–4 (October 1980): 3–20, at 11; Isidore Isou, *Introduction à une nouvelle poésie et à une nouvelle musique* (Paris: Gallimard, 1947), 17; "Dada Manifesto 1918," in *Dada Painters and Poets*, 81 (emphasis original).

30. Paul Éluard to Tzara, 9 July 1918, BLJD TZR C1297.

31. See Roger Shattuck, *The Banquet Years: The Origins of the Avant-Garde in France, 1885 to World War I*, rev. edn. (New York: Vintage, 1968).

32. Quoted in François Buot, *Tristan Tzara: L'homme qui inventa la révolution Dada* (Paris: Grasset, 2002), 66.

33. *Nord-Sud*, no. 1 (15 March 1917): 2.

34. Tzara, review of *Le Voleur de Talan*, *Dada 2* (December 1917): 17–18.

35. Reverdy to Tzara, 9 February 1918, in Sanouillet, *Dada in Paris*, 494.

36. Reverdy to Tzara, 5 July 1918, in ibid., 495.

37. Henri Béhar, "*SIC*, au carrefour des influences," in *Dada Circuit Total*, ed. Henri Béhar and Catherine Dufour (Lausanne: L'Âge d'Homme, 2005), 68–73, at 68.

38. *SIC*, nos. 21–22 (September–October 1917): 9.

39. Dermée to Tzara, 14 July 1918, in Sanouillet, *Dada: Réimpression intégrale*, 2:188.

40. Dermée to Tzara, 10 June 1918, in ibid., 2:186.

41. Dermée to Tzara, 14 July 1918, in ibid., 2:188.

42. Reverdy to Tzara, 18 August 1918, in Sanouillet, *Dada in Paris*, 496.

43. See Willi Gautschi, ed., *Dokumente zum Landesstreik 1918* (Zurich: Chronos Verlag, 1988).

44. "Dada Manifesto 1918," in *Dada Painters and Poets*, 78.

45. "Les Revues d'avant-garde," *OC*, 5:509.

46. Tzara to Picabia, 7 September 1918, in Sanouillet, *Dada in Paris*, 382.

47. Tzara to Dermée, 29 January 1918, in ibid., 466.

48. Hans Richter, *Dada Art and Anti-Art*, trans. David Britt (London: Thames and Hudson, 1997), 80.

49. *SIC*, nos. 42–43 (30 March/15 April 1919): 339.

50. *Littérature*, no. 10 (December 1919): 4.

51. Francis Picabia, "C'est assez banal," *391*, no. 8 (February 1919): 7; Germaine Everling, *L'Anneau de Saturne* (Paris: Fayard, 1970), 63.

52. *391*, no. 5 (New York, June 1917): 8.

53. William Camfield, *Francis Picabia: His Art, Life, and Times* (Princeton: Princeton University Press, 1979), 116.

54. Tzara to Picabia, 26 September 1918, in Sanouillet, *Dada in Paris*, 384.

55. Picabia to Tzara, 7 January 1919, in ibid., 391.

56. Picabia to Tzara, 11 January 1919, in ibid., 393.

57. Jean Arp, "Francis Picabia," in *Collected French Writings: Poems, Essays, Memoirs*, ed. Marcel Jean, trans. Joachim Neugroschel (London: John Calder, 1974), 260–261.

58. Michel Sanouillet, *Francis Picabia et "391,"* 2 vols. (Paris: Eric Losfeld, 1966), 2:87.

59. Picabia to Tzara, 9 February 1919, in Sanouillet, *Dada in Paris*, 394.

60. Tzara, "Exégèse sucre en poudre sage," *391*, no. 8 (February 1919): 4.

61. *391*, no. 8 (February 1919): 8.

62. Sanouillet, *Francis Picabia et "391,"* 2:90.

63. Tzara to Picabia, 15 February 1919, in Sanouillet, *Dada in Paris*, 395.

64. Picabia to Tzara, 12 March 1919, in ibid., 400.

65. Breton to Tzara, 22 January 1919, in ibid., 333.

66. See Louis Aragon to Breton, 3 June 1918, in Aragon, *Lettres à André Breton, 1918–1931*, ed. Lionel Follet (Paris: Gallimard, 2011), 92.

67. Breton to Tzara, 22 January 1919, in Sanouillet, *Dada in Paris*, 333.

68. Georges Auric, *Quand j'étais là* (Paris: Grasset, 1979), 111.

69. Breton to Tzara, 18 February 1919, in Sanouillet, *Dada in Paris*, 335.

70. Breton to Tzara, 12 June 1919, in ibid., 343.

71. Tzara to Breton, 21 March 1919, in ibid., 338.

72. Debbie Lewer, "From the Cabaret Voltaire to the Kaufleutensaal: 'Mapping' Zurich Dada," in *Dada Zurich: A Clown's Game*, 45–59, at 54.

73. Richter, *Dada Art and Anti-Art*, 77; "Achte Dada-Soirée," *Neue Zürcher Zeitung*, 4 April 1919, in *Dada Zurich: A Clown's Game*, 238.

74. *National-Zeitung* (Basel), 14 April 1919, in *Dada Zurich: A Clown's Game*, 241; *Basler Nachrichten*, 30 April 1919, in ibid., 244.

75. Zurich Kunsthaus, Dada Collection, V:40.

76. Marc Dachy, *Dada et les dadaïsmes: Rapport sur l'anéantissement de l'ancienne beauté*, rev. edn. (Paris: Gallimard, 2011), 141.

77. *National-Zeitung* (Basel), 14 April 1919, in *Dada Zurich: A Clown's Game*, 241.

78. "Proclamation sans prétention," *OC*, 1:369.

79. "Chronique zurichoise 1915–1919," *OC*, 1:568.

80. *Dada 4–5* (May 1919): 27.

81. *National-Zeitung* (Basel), 14 April 1919, in *Dada Zurich: A Clown's Game*, 241; *St. Galler Tagblatt*, 23 April 1919; in ibid., 244 (emphasis original).

82. See Gabrielle Buffet-Picabia, "Some Memories of Pre-Dada: Picabia and Duchamp," in *Dada Painters and Poets*, 266.

83. *Dada 4–5* (May 1919): 10.

84. Hans Richter, "Against Without for Dada," in Mary Ann Caws, ed., *Manifesto: A Century of Isms* (Lincoln: University of Nebraska Press, 2001), 320–322, at 321.

85. *Dada 4–5* (May 1919): 1.

86. *St. Galler Tagblatt*, 5 July 1919, in *Dada Zurich: A Clown's Game*, 248.

87. Ibid.

88. *Neues Wiener Journal*, 20 September 1919, in *Dada Zurich: A Clown's Game*, 251–252.

89. Ibid.

90. See Marc Dachy, *Archives Dada* (Paris: Hazan, 2005), 73.

91. Ibid.

92. *La Tribune de Genève*, 14 October 1919, in *Dada Zurich: A Clown's Game*, 253.

7 "EVERYONE IS DADA": 1920

1. Picabia to Tzara, 12 March 1919, in Michel Sanouillet, *Dada in Paris*, trans. Sharmila Ganguly (Cambridge, MA: MIT Press, 2009), 400.

2. Breton to Tzara, 14 January 1920, in ibid., 358.

3. Germaine Everling, *L'Anneau de Saturne* (Paris: Fayard, 1970), 98.

4. Germaine Everling-Picabia, "C'était hier: DADA," in *Les Œuvres Libres* 109 (June 1955): 119–178, at 137.

5. Everling, *L'Anneau de Saturne*, 98.

6. Ibid., 99.

7. Elmer Peterson, "Paris Dada: Publications and Provocations," in *Paris Dada: The Barbarians Storm the Gates*, ed. Elmer Peterson (Farmington Hills, MI: Gale Group, 2001), 1–32, at 11.

8. Quoted in Sanouillet, *Dada in Paris*, 100.

9. Breton to Tzara, 26 December 1919, in ibid., 357.

10. See Henri Béhar, *André Breton: Le grand indésirable* (Paris: Calmann-Lévy, 1990), 95.

11. Louis Aragon, *Projet d'histoire littéraire contemporaine*, ed. Marc Dachy (Paris: Gallimard, 1994), 55.

12. Ibid., 56.

13. *Dadaphone* (March 1920), 2.

14. William A. Camfield, *Francis Picabia*, exh. cat. (New York: Solomon R. Guggenheim Museum), 27.

15. Henri-Jacques Dupuy, *Philippe Soupault* (Paris: Seghers, 1957), 35.

16. Georges Ribemont-Dessaignes, *Déjà jadis, ou du mouvement Dada à l'espace abstrait* (Paris: René Julliard, 1958), 82.

17. Jeanne Singer-Kérel, *Le Coût de la vie à Paris de 1840 à 1954* (Paris: Armand Colin, 1961), 136.

18. See Henri Mazel, "Le Problème de la vie chère," *Mercure de France*, no. 520 (15 February 1920): 105–121.

19. See *Comœdia*, 17 January 1920.

20. See John Richardson, *A Life of Picasso: The Triumphant Years, 1917–1932* (New York: Alfred A. Knopf, 2007), 41–42.

21. André Breton, *Conversations: The Autobiography of Surrealism*, trans. Mark Polizzotti (New York: Paragon House, 1993), 40.

22. Laure Murat, *Passage de l'Odéon: Sylvia Beach, Adrienne Monnier et la vie littéraire à Paris dans l'entre-deux-guerres* (Paris: Fayard, 2003), 38; Adrienne Monnier, *Rue de l'Odéon* (Paris: Albin Michel, 1989), 59–60.

23. Breton to Tzara, 8 November 1919, in Sanouillet, *Dada in Paris*, 353.

24. Mark Polizzotti, *Revolution of the Mind: The Life of André Breton* (New York: Farrar, Straus, and Giroux, 1995), 107.

25. *Nouvelle Revue Française*, no. 72 (1 September 1919): 158–160.

26. André Salmon, *Souvenirs sans fin* (Paris: Gallimard, 1961), 54.

27. Ruth Brandon, *Surreal Lives: The Surrealists, 1917–1945* (London: Macmillan, 1999), 137–138.

28. Everling, *L'Anneau de Saturne*, 95.

29. *Comœdia*, 24 January 1920, 3.

30. "Le Géant blanc lépreux du paysage," *OC*, 1:87–88.

31. *Les Potins de Paris*, undated, in BLJD, Picabia Dossiers, vol. 3.

32. Aragon, *Projet d'histoire littéraire contemporaine*, 74.

33. Tzara, "Memoirs of Dadaism," in Edmund Wilson, *Axel's Castle: A Study in the Imaginative Literature of 1870 to 1930* (New York: Charles Scribner, 1931), 304.

34. Claude Arnaud, *Jean Cocteau* (Paris: Gallimard, 2003), 224.

35. Breton to Picabia and Tzara, 24 January 1920, in Sanouillet, *Dada in Paris*, 427.

36. Unidentified to Tzara, February 1920, BLJD MS 23186, f. 92–96.

37. *Dadaphone* (March 1920), 7.

38. "Le Dadaisme n'est qu'une farce inconsistante," *L'Action Française*, 14 February 1920, 2.

39. *Bulletin Dada*, February 1920, 1.

40. Ibid., cover.

41. *Le Journal du Peuple*, 2 February 1920, quoted in Sanouillet, *Dada in Paris*, 109–110.

42. "Incompatibilité d'humour," *OC*, 5:397.

43. See Louis Aragon, *Chroniques I: 1918–1932*, ed. Bernard Leuilliot (Paris: Stock, 1998).

44. Ribemont-Dessaignes, *Déjà jadis*, 67.

45. André Breton, "Artificial Hells: Inauguration of the '1921 Dada Season,'" trans. Matthew S. Witkovsky, *October* 105 (Summer 203): 137–144, at 138.

46. "Incompatibilité d'humour," *OC*, 5:397.

47. Sanouillet, *Dada in Paris*, 112.

48. Aragon, *Chroniques I*, 94.

49. Tzara, "Memoirs of Dadaism," 305.

50. Quoted in Sanouillet, *Dada in Paris*, 114.

51. "Tristan Tzara," *OC* 1:373, translation from *The Dada Painters and Poets*, ed. Robert Motherwell (Cambridge, MA: Harvard University Press, 1981), 84.

52. See Aragon to Tzara, 14 March 1920, in Louis Aragon, *Papiers inédits: De Dada au surréalisme (1917–1931)*, ed. Lionel Follet and Édouard Ruiz (Paris: Gallimard, 2000), 178–179.

53. *Bulletin Dada* (February 1920), 4.

54. Tzara to Francis Picabia, undated (early February 1920), in Sanouillet, *Dada in Paris*, 416.

55. Tzara, "Memoirs of Dadaism," 306.

56. See Ruth Hemus, "Céline Arnauld: Dada Présidente?," *Nottingham French Studies* 50, no. 3 (2011): 67–77.

57. *Dadaphone* (March 1920), 2.

58. Ibid., 3.

59. Ibid.

60. Albert Gleizes, "L'Affaire Dada," *Action*, no. 3 (April 1920), 26–32, in BLJD, Picabia Dossiers, vol. 2.

61. *Dadaphone* (March 1920), 5.

62. Tzara, "Memoirs of Dadaism," 306.

63. Everling, *L'Anneau de Saturne*, 122.

64. "Quelques souvenirs," *OC*, 1:595.

65. Ibid.

66. Ibid.

67. See Lugné-Poe to Tzara, 18 March 1920, BLJD TZR C4360, for the rental contract.

68. *Carnet de la Semaine*, 10 April 1920, in BLJD, Picabia Dossiers, vol. 5.

69. Alfred Bicard, "Une Soirée chez les Dadas," *Œuvre*, 29 March 1920, in Bibliothèque de l'Arsenal (Paris, France), Fonds Rondel 1211, f. 2.

70. "Manifestation dada," *Comœdia*, 29 March 1920, 2.

71. Aldous Huxley to B. G. Brooks, 4 May 1920, in *The Letters of Aldous Huxley*, ed. Grove Smith (London: Chatto and Windus, 1969), 184.

72. Quoted in Sanouillet, *Dada in Paris*, 122.

73. Germaine Everling to Tzara, 13 July 1920, in ibid., 419.

74. *Projecteur* (May 1920), 1, 12.

75. Quoted in Sanouillet, *Dada in Paris*, 126.

76. Étienne Gaveau to Francis Picabia, 21 May 1920, in ibid., 484.

77. "DaDa DaDa: Ils ont rugi, miaulé, aboyé, mais ne se sont pas fait tondre les cheveux," *Petit Parisien*, 27 May 1920, 1.

78. Ribemont-Dessaignes, "History of Dada," in *Dada Painters and Poets*, 113.

79. *La Deuxième Aventure céleste de Monsieur Antipyrine*, *OC*, 1:147.

80. Ibid., 143–144.

81. Ibid., 148.

82. Louis Aragon, "L'homme coupé en deux," *Les Lettres Françaises*, 8 May 1968, 8.

83. Quoted in Sanouillet, *Dada in Paris*, 138 (emphasis original).

84. "Dadaists Disappoint: Still Unshaven," *Daily Mail* (London), 28 May 1920, in BLJD, Picabia Dossiers, vol. 2.

85. Source unspecified (1920), in BLJD, Picabia Dossiers, vol. 2.

86. *L'Éclair*, 28 May 1920, in ibid.

87. *Carnet de la Semaine*, 6 June 1920, in ibid.

88. See Ribemont-Dessaignes, *Déjà jadis*, 73–74.

89. "DaDa DaDa," *Petit Parisien*, 27 May 1920, 1.

90. *Revue Bleue*, 5 June 1920, in BLJD, Picabia Dossiers, vol. 2.

91. "Quelques souvenirs," *OC*, 1:596.

92. "Cinéma calendrier du cœur abstrait," *OC*, 1:128.

93. *391*, no. 14 (1920): 4.

94. "Cinéma calendrier du cœur abstrait," *OC*, 1:124.

95. Ibid.

96. Ibid.

97. Gleizes, "L'Affaire Dada."

98. "Dadaisme," *Radical*, 7 June 1920, in BLJD, Picabia Dossiers, vol. 2.

99. *Proverbe*, no. 5 (May 1920): 3.

100. Source unspecified (1920), BLJD, Picabia Dossiers, vol. 2.

101. Ibid.

102. Maurice Schwob, "Le Dada du Boche: Cheval de Troie moderne," *Le Phare* (Nantes), 24 April 1920, in BLJD, Picabia Dossiers, vol. 2.

103. Marcel Boulenger, "Herr Dada," *Nouvelle* (Bordeaux), 3 May 1920, in ibid.

104. "Dadaisme," *Liberté*, 19 May 1920; *La Mouette* (Le Havre), May 1920, both in ibid.

105. "Le Mouvement Dada," *Quatrième État* (Toulouse), 10 April 1920; Camille Le Senne, "Le Dadaisme," *La Petite République*, n.d., both in BLJD, Picabia Dossiers, vol. 5.

106. "Dadaisme," *Le Carillon* (Caen), 5 May 1920, in BLJD, Picabia Dossiers, vol. 2.

107. *Comœdia*, 17 February 1920, in Bibliothèque de l'Arsenal (Paris), Fonds Rondel 1212, f. 3.

108. André Gide, "Dada," *Nouvelle Revue Française*, April 1920, 477.

109. Everling, *L'Anneau de Saturne*, 111; Ribemont-Dessaignes, *Déjà jadis*, 55.

110. *Carnet de la Semaine*, 18 April 1920, in BLJD, Picabia Dossiers, vol. 5.

111. Béhar, *André Breton*, 98.

112. See Gide to Aragon, 3 March 1920, in Aragon, *Papiers inédits*, 154.

113. Breton, *Conversations*, 45.

114. Picabia to Tzara, 3 July 1920, in Sanouillet, *Dada in Paris*, 417.

1. Serner to Tzara, 24 June 1920, in Raoul Schrott, *Dada 15/25* (Innsbruck: Haymon, 1992), 265.
2. Tzara to Picabia, 11 July 1920, in Michel Sanouillet, *Dada in Paris*, trans. Sharmila Ganguly (Cambridge, MA: MIT Press, 2009), 418.
3. Ibid.
4. BLJD TZR 783.
5. Cantarelli to Tzara, 13 July 1920, BLJD, TZR C696.
6. Evola to Tzara, 17 March 1920, BLJD, TZR C1491; Cantarelli to Tzara, 14 May 1920, BLJD, TZR C695.
7. Tzara to Picabia, 20 July 1920, in Schrott, *Dada 15/25*, 266.
8. Tzara to Picabia, 23 July 1920, in ibid., 266.
9. Tzara to Picabia, 28 July 1920, in Sanouillet, *Dada in Paris*, 420 (emphasis original).
10. Gregor von Rezzori, *Memoirs of an Anti-Semite*, trans. Joachim Neugroschel (New York: New York Review of Books, 2008), 73.
11. See *Faites vos jeux*, OC, 1:245–246.
12. André Breton, "Pour Dada," in *Les Pas perdus*, rev. edn. (Paris: Gallimard, 1969 [1924]), 69.
13. Ibid., 71.
14. Tzara to Picabia, 8 September 1920, in Sanouillet, *Dada in Paris*, 420.
15. "Quelques souvenirs," OC, 1:599.
16. Ibid.
17. Tzara to Picabia, 19 September 1920, in Sanouillet, *Dada in Paris*, 420.
18. Éluard to Tzara, 16 August 1920, BLJD, TZR C1309.
19. Tzara to Picabia, 25 September 1920, in Sanouillet, *Dada in Paris*, 421.
20. Tzara to Picabia, 8 October 1920, in ibid.
21. Breton to Tzara, 14 October 1920, in ibid., 361.
22. Pansaers to Picabia, 11 September 1920, in ibid., 163.
23. *391*, no. 14 (November 1920), front cover.
24. Ibid.
25. "Comment je suis devenu charmant sympathique et délicieux," OC, 1:388.
26. "Dada manifeste sur l'amour faible et l'amour amer," OC, 1:381.
27. Quoted in François Buot, *Tristan Tzara: L'homme qui inventa la révolution Dada* (Paris: Grasset, 2002), 117–118.
28. "Comment je suis devenu charmant sympathique et délicieux," OC, 1:388.
29. "Dada manifeste sur l'amour faible et l'amour amer," OC, 1:378, translation from *The Dada Painters and Poets*, ed. Robert Motherwell (Cambridge, MA: Harvard University Press, 1981), 86.
30. Ibid., 382, modified translation from *Dada Painters and Poets*, 92.

31. Ibid., 381 (emphasis original).

32. Ibid., 379, translation from *Dada Painters and Poets*, 87.

33. *Dada soulève tout*, January 1921.

34. F. T. Marinetti, "Tactilism: A Futurist Manifesto," in *Critical Writings*, ed. Günter Berghaus, trans. Doug Thompson (New York: Farrar, Straus, and Giroux, 200), 370–376, at 372.

35. Ibid., 376, 374.

36. Sanouillet, *Dada in Paris*, 178.

37. Quoted in ibid.

38. Philippe Soupault, *Mémoires de l'oubli, 1914–1923* (Paris: Lachenal and Ritter, 1981), 145.

39. Éluard to Tzara, 4 March 1921, BLJD TZR C1321.

40. *Comœdia*, 15 April 1921, quoted in Sanouillet, *Dada in Paris*, 179.

41. Georges Ribemont-Dessaignes, *Déjà jadis, ou du movement Dada à l'espace abstrait* (Paris: René Julliard, 1958), 94.

42. See Éluard to *Nouvelle Revue Française*, August 1931, 328.

43. Francis Picabia, "M. Picabia Separates from the Dadas," in *I Am a Beautiful Monster: Poetry, Prose, and Provocation*, trans. Marc Lowenthal (Cambridge, MA: MIT Press, 2007), 262–263.

44. Max Ernst to Tzara, 24 February 1920, BLJD TZR C1417.

45. Reprinted in *Documents Dada*, ed. Y. Poupard-Leiussou and M. Sanouillet (Bienne: Weber, 1974), no. 30.

46. Sanouillet, *Dada in Paris*, 181–182.

47. Breton to Tzara, 29 July 1919, in Sanouillet, *Dada in Paris*, 345; Aragon to Barrès, 30 March 1923, in Marguerite Bonnet, *L'Affaire Barrès* (Paris: José Corti, 1987), 95–96. As Bonnet details, Breton, Éluard, and Soupault sent dedicated copies of their recent works to Barrès (15).

48. Maurice Barrès, *Un homme libre* (Paris: Perrin, 1889), 19 (emphasis original).

49. Maurice Barrès, "Le Mausolée du cœur français," *Revue Hebdomadaire*, June 1921, 432–438, at 432–433.

50. *Littérature*, no. 19 (August 1921): 1; Bonnet, *L'Affaire Barrès*, 24.

51. Quoted in Bonnet, *L'Affaire Barrès*, 11.

52. André Breton, *Conversations: The Autobiography of Surrealism*, trans. Mark Polizzotti (New York: Paragon House, 1993), 53.

53. Ibid.

54. *Littérature*, no. 18 (March 1921): 1; Breton, *Conversations*, 52.

55. Sanouillet, *Dada in Paris*, 189.

56. In Bonnet, *L'Affaire Barrès*, 25–33. Bonnet reprints the trial in its entirety.

57. Ibid., 34.

58. Ibid., 38.

59. Ibid., 39.

60. Ibid., 39–40.

61. Ibid., 41–42.

62. Ibid., 43.

63. Ibid., 44–45.

64. Ibid., 47.

65. *Comœdia*, 15 May 1921, in Bonnet, *L'Affaire Barrès*, 91.

66. *La Nation belge*, 18 May 1921, in ibid., 92.

67. Soupault, *Mémoires*, 150–151.

68. Picabia, "Francis Picabia and Dada," in *I Am a Beautiful Monster*, 265.

69. Breton to Jacques Doucet, 5 June 1921, in André Breton, *Œuvres complètes*, ed. Marguerite Bonnet, 4 vols. (Paris: Gallimard, Bibliothèque de la Pléiade, 1988–2008), 1:1399.

70. Man Ray, *Self-Portrait* (London: Penguin Books, 2012 [1963]), 107.

71. Sanouillet, *Dada in Paris*, 203.

72. Ibid., 202.

73. See Stanton B. Garner, Jr., "*The Gas Heart*: Disfigurement and the Dada Body," *Modern Drama* 50, no. 4 (Winter 2007): 500–516.

74. *Le Cœur à gaz*, OC, 1:155, 157, 154.

75. Ibid., 158.

76. Ibid., 158–159.

77. Ibid., 163, 165.

78. Ibid., 166–167.

79. Ibid., 167.

80. Quoted in Sanouillet, *Dada in Paris*, 207.

81. Ibid.

82. *391*, no. 15 (July 1921): 7.

83. Ibid., 9.

84. Melchior Vischer, *Sekunde durch Hirn: Ein unglaublich schnell rotierender Roman* (Hanover: Verlag Paul Steegemann, 1920), at http://www.gutenberg.org/files/32814.

85. Tzara to Éluard, 25 August 1921, BLJD TZR C 4037. See Raoul Schrott, *Dada 21/22: Musikalische Fischsuppe mei Reiseeindrücken* (Vienna: Haymon, 1988).

86. *Dada au grand air* (1921), 4.

87. Ibid., 1.

88. Ibid.

89. "Au Salon d'Automne," *L'Intransigeant*, 13 October 1921, 2.

90. Francis Picabia, "L'Œil cacodylate," *Comœdia*, 29 November 1921, 1.

91. Quoted in Sanouillet, *Dada in Paris*, 218.

92. Ibid.

93. "Dada n'est pas mort," *Paris-Midi*, 16 December 1921, in BLJD, Picabia Dossiers, vol. 8.

94. Ibid.

95. Translation from Man Ray, *Self-Portrait*, 113.

96. Unidentified to Tzara, 30 December 1921, BLJD Ms. 23186, f.101.

9 DADA'S FINAL HOURS: 1922–1923

1. *Comœdia*, 3 January 1922, 1.

2. Quoted in Michel Sanouillet, *Dada in Paris*, trans. Sharmila Ganguly (Cambridge, MA: MIT Press, 2009), 238.

3. Tzara to Breton, 27 December 1921, in ibid., 365.

4. Quoted in ibid., 237.

5. *Radical*, 29 January 1922, in Bibliothèque Nationale de France (BNF), Naf 14316, f.59.

6. Tzara to Breton, 3 February 1922, in Sanouillet, *Dada in Paris*, 240.

7. Quoted in ibid., 240 (emphasis original).

8. Ibid.

9. Quoted in Mark Polizzotti, *Revolution of the Mind: The Life of André Breton* (New York: Farrar, Straus, and Giroux, 1995), 155.

10. BLJD TZR 758; *Liberté*, 13 February 1922, in BNF Naf 14316, f. 98.

11. Sanouillet, *Dada in Paris*, 242.

12. André Breton, *Les Pas perdus*, rev. edn. (Paris: Gallimard, 1969 [1924]), 100.

13. André Breton, *Conversations: The Autobiography of Surrealism*, trans. Mark Polizzotti (New York: Paragon House, 1993), 54.

14. Jacques-Émile Blanche, "À propos d'un Congrès de l'"Esprit Moderne,"" *Revue hebdomadaire*, July 1922, 405–422, at 410.

15. *Comœdia*, 20 February 1922, 2.

16. "Tristan Tzara va cultiver ses vices," *OC*, 1:624.

17. "Les Dessous de Dada," *OC*, 1:588.

18. *Le Cœur à barbe* (1922), 7.

19. Matthew Josephson, *Life among the Surrealists* (New York: Holt, Rinehart and Winston, 1962), 104.

20. Ibid., 104–105.

21. Jean Hugo, *Le Regard de la mémoire (1914–1945)* (Arles: Actes Sud, 1983), 204.

22. Brancuși to Tzara, undated (1921), BLJD, TZR C538.

23. "Brancusi," *OC*, 1:619.

24. Brancuși to Tzara, undated (1921), BLJD, TZR C 538; Brancuși quoted in Dore Ashton, "On Constantin Brancusi," *Raritan* 25, no. 4 (2006): 20–38, at 21.

25. "Brancusi," *OC*, 1:619.

26. Quoted in Sanouillet, *Dada in Paris*, 263.

27. Ribemont-Dessaignes to Tzara, 10 April 1922, in BLJD, TZR C3297.

28. Tristan Tzara, "Memoirs of Dadaism," in Edmund Wilson, *Axel's Castle: A Study in the Imaginative Literature of 1870 to 1930* (New York: Charles Scribner, 1931), 304.

29. Matthew Josephson to Malcolm Cowley, 5 December 1921, Newberry Library, Midwest MS Cowley, Series 1, Box 33, Folder 2024.

30. Josephson, *Life among the Surrealists*, 179 (emphasis original).

318

31. Ibid., 183, 179.

32. Van Doesburg to Tzara, 17 August 1922, BLJD TZR C4094.

33. Werner Graeff, "The Bauhaus, the De Stijl group in Weimar, and the Constructivist Congress of 1922," in *Bauhaus and Bauhaus People*, ed. Eckhard Neumann, trans. Eva Richter and Alba Lorman, rev. edn. (New York: Van Nostrand Reinhold, 1993), 75–77, at 77.

34. "L'Allemagne—un film à episodes," *OC*, 1:600.

35. László Moholy-Nagy, *Vision in Motion* (Chicago: Paul Theobald, 1947), 315.

36. "L'Allemagne—un film à episodes," *OC,* 1:603.

37. "Conférence sur Dada," *OC*, 1:419.

38. Ibid., 421.

39. Ibid., 420–421.

40. Ibid., 424 (emphasis original).

41. "L'Allemagne—un film à episodes," *OC*, 1:603, 602.

42. Gropius to Tzara, 22 September 1922, BLJD TZR C1826.

43. Gropius to Tzara, 27 June 1923, BLJD TZR C1828.

44. See BLJD TZR 418.

45. "L'Allemagne—un film à episodes," *OC*, 1:603.

46. Kurt Schwitters, "Die Merzmalerei," *Der Sturm* 10, no. 4 (July 1919), in Marc Dachy, *Journal du mouvement Dada: 1915–1923* (Geneva: Skira, 1989), 211.

47. "L'Allemagne—un film à episodes," *OC*, 1:604.

48. Ibid.

49. Ibid.

50. Malcolm Cowley to Tzara, 7 January 1922, 24 December 1922, BLJD TZR C984, 985.

51. Philippe Soupault, Review of *De nos oiseaux*, *Manomètre*, no. 4 (August 1923), 75–76; reprinted in *OC*, 1:672.

52. See Willand Mayr to Tzara, 6 June 1923, 19 August 1923, TZR C2600, 2601.

53. Robert Aron to Tzara, 18 February 1924, BLJD TZR C219.

54. Henri Berge to Tzara, 7 August 1926, BLJD TZR C418.

55. René Hilsum to Tzara, 21 November 1928, BLJD TZR C1981.

56. Soupault to Tzara, 8 January 1926, BLJD TZR C3850.

57. Quint to Tzara, 16 February 1929 and 7 June 1930, BLJD TZR C3088, 3093.

58. "Sur une ride du soleil," *OC*, 1:238, translation from Tristan Tzara, *Chanson Dada*, trans. Lee Harwood (Boston: Black Widow Press, 2005), 49.

59. "Liquidation esthétique," *OC*, 1:190.

60. "Réalités cosmiques vanille tabac éveils," *OC*, 1:221, translation from *Chanson Dada*, 19.

61. "L'optimisme dévoilé," *OC,* 1:226.

62. Benjamin Fondane, "Poésie pure: de Paul Valery à Tristan Tzara," *Unu* 3, no. 22 (February 1930): 5–6, at 6; "Cirque," *OC*, 1:185.

63. "Boxe," *OC*, 1:230; "Le Marin," *OC*, 1:210; and "Le Cierge et la vierge," *OC*, 1:193.

64. "Herbier des jeux et des calculs," *OC*, 1:199.

65. "Cirque," *OC*, 1:184–185.

66. Ibid., 185; "Autour," *OC*, 1:203.

67. *Les Feuilles Libres*, no. 36 (March–April 1924): 388.

68. Jana Fromka to Tzara, July 1926, BLJD TZR C1702; Willand Mayr to Tzara, 23 November 1923, BLJD TZR C4336.

69. *Les Feuilles Libres*, no. 1 (15 December 1918): 1.

70. Ibid.

71. Willand Mayr, "Psychologie du tam-tam littéraire," *Les Feuilles Libres*, no. 8 (June 1920): 304–305, at 304.

72. Breton, *Les Pas perdus*, 147.

73. Willand Mayr to Tzara, June 1923, BLJD TZR C4335.

74. The seventh chapter is explicitly devoted to this question.

75. Nicolas Beauduin to Tzara, 19 October 1923, BLJD TZR C364.

76. E. L. T. Mesens to Tzara, 17 November 1923, BLJD TZR C2652.

77. *Faites vos jeux, OC*, 1:243.

78. Ibid.

79. Jean-Jacques Rousseau, *Confessions*, in *Œuvres complètes*, 5 vols., ed. Bernard Gagnebin (Paris: Gallimard, Bibliothèque de la Pléiade, 1959–1995), 1:3.

80. *Faites vos jeux, OC*, 1:250.

81. Ibid., 263.

82. Ibid., 246.

83. Ibid.

84. Ibid., 251.

85. Ibid., 249.

86. Ibid., 252.

87. Ibid., 288.

88. Breton, *Les Pas perdus*, 146, 162.

89. Quoted in Sanouillet, *Dada in Paris*, 277.

90. "Tristan Tzara va cultiver ses vices," *OC*, 1:623.

91. "Lettre aux *Cahiers d'Art*" (16 February 1937), *OC*, 5:276.

92. Sanouillet, *Dada in Paris*, 278.

93. Man Ray, *Self-Portrait* (London: Penguin Books, 2012 [1963]), 260.

94. Marc Dachy, *Dada et les dadaïsmes: Rapport sur l'anéantissement de l'ancienne beauté*, rev. edn. (Paris: Gallimard, 2011), 365.

95. See Doina Lemny, *Lizica Codreanu: O dansatoare română în avangarda pariziană* (Bucharest: Vellant, 2012).

320

96. Paul Éluard to Tzara, 10 February 1923, BLJD TZR C1361.

97. Georges Hugnet, *L'Aventure Dada (1916–1922)* (Paris: Seghers, 1957), 119; Iliadz to Tzara, February 1936, in "Lettre aux *Cahiers d'Art*," *OC*, 5:278; Erik Satie, *Correspondance presque complète*, ed. Ornella Volta (Paris: Fayard/IMEC, 2000), 546–547.

98. Quoted in Sanouillet, *Dada in Paris*, 279.

99. Breton sent Tzara a copy of *Les Pas perdus* with the following dedication: "To Tristan Tzara, to the 1924 novelist, to the utter crook, to the old parrot, to *the police informer*." Quoted in Sanouillet, *Dada in Paris*, 611.

100. Quoted in Dachy, *Dada et les dadaïsmes*, 367.

101. Jean Cocteau to Max Jacob, 1 August 1923, quoted in Marc Dachy, *Archives Dada* (Paris: Hazan, 2005), 334.

102. Theo van Doesburg, "Ils ont presque tué Tzara," in Dachy, *Archives Dada*, 342.

103. Quoted in Malcolm Haslam, *The Real World of the Surrealists* (London: Weidenfeld and Nicolson, 1978), 120.

104. Paul Éluard to Breton, 27 August 1923, in Sanouillet, *Dada in Paris*, 281.

105. See Robert McNab, *Ghost Ships: A Surrealist Love Triangle* (New Haven: Yale University Press, 2004).

106. Hugnet, *L'Aventure Dada*, 120.

107. "Lettre aux *Cahiers d'Art*," *OC*, 5:277.

108. Anna Gray to Tzara, 22 September 1924, BLJD TZR C1114.

10 AFTER THE WAKE: 1924–1929

1. Paul Budry to Tzara, 2 July 1923, BLJD TZR C649.

2. Paul Budry to Tzara, 8 April 1924, BLJD TZR C650.

3. Compagnie française d'édition, éditions de La Sirène to Tzara, 16 May 1924, BLJD TZR C3796.

4. René Crevel, "Voici Tristan Tzara et ses souvenirs sur Dada," *Les Nouvelles littéraires*, 25 October 1924, 5.

5. *Faites vos jeux*, *OC*, 1:262.

6. *Vanity Fair* to Tzara, 8 June 1923, BLJD TZR C4377.

7. Tzara to Rosenstock family, 1 April 1924, in "Scrisori către familie, în România," *Aldebaran*, nos. 2–4 (1996), 15.

8. *L'Art et les hommes*, dir. Jean-Marie Drot, Office national de radiodiffusion télévision française, 16 September 1963, at http://www.ina.fr/video/I00008250.

9. Tzara, "Le Secret du Mouchoir de Nuages," 1924 press release, in Bibliothèque Richelieu (Paris), RO 12581, f. 71.

10. See Lois Gordon, *Nancy Cunard: Heiress, Muse, Political Idealist* (New York: Columbia University Press, 2007).

11. Cunard to Tzara, 20 January 1962, BLJD TZR C1066.

12. Syndicat Professionel des Gens de Lettres to Tzara, 22 April 1930, BLJD TZR C4362.

13. Tzara, "Handkerchief of Clouds," trans. Aileen Robbins, *Drama Review* 16, no. 4 (December 1972): 112–129, at 113. See Martine Lévesque, "*Hamlet* dans *Mouchour de nuages* de Tristan Tzara," *Urgences*, no. 25 (1989): 30–40.

14. Tzara, "Handkerchief of Clouds," trans. Robbins, 112.

15. Ibid., 113.

16. Ibid., 117, 115.

17. Ibid., 115.

18. Ibid., 118.

19. Ibid., 119.

20. Ibid., 115.

21. Ibid., 124.

22. Richelieu, RO 12581, f. 63.

23. Ibid.

24. Ibid.

25. Ibid., f. 61.

26. Ibid.

27. Ibid., f. 64.

28. Ibid., f. 74, 78.

29. René Crevel, "Les Soirées de Paris," *La Revue Européenne*, 1 July 1924; at http://melusine. univ-paris3.fr/EspritRaisonCrevel/Paris.htm; Paul Collaer quoted in Sally Banes, *Writing Dancing in the Age of Postmodernism* (Middletown, CT: Wesleyan University Press, 1994), 91.

30. Richelieu, RO 12581, f. 74.

31. Ibid., f. 77.

32. Ibid. See also BLJD TZR 13, f. 9.

33. Ibid., f. 72.

34. Ibid., f. 86.

35. Ibid., f. 74, 75.

36. Ibid., f. 83.

37. Ibid., f. 108 (Pierre de Massot, "Avec Tristan Tzara," 20 June 1924).

38. Erik Satie to Rolf de Maré, 16 June 1924, quoted in Robert Orledge, "Satie's Ballet 'Mercure' (1924): From Mount Etna to Montmartre," *Journal of the Royal Musical Association* 123, no. 2 (1998): 229–249, at 245.

39. Anonymous, *Le Théâtre indiscret de l'an 1924* (Paris: Georges Crès, 1925), 107.

40. Tzara to Lucia Rosenstock, 7 June 1924, in "Scrisori către familie," 15.

41. Béhar, notes, *OC*, 1:688.

42. Alice Halicka, *Hier (Souvenirs)* (Paris: Éditions du Pavois, 1946), 114.

43. Lars Bergquist, *Greta Knutson* (Paris: Centre culturel suédois, 1980), 2.

44. Greta Knutson, "Foreign Land," trans. Penelope Rosemont, in *Surrealist Women: An International Anthology*, ed. Penelope Rosemont (London: Continuum, 2000), 68–69.

45. François Buot, *Tristan Tzara: L'homme qui inventa la révolution Dada* (Paris: Grasset, 2002), 178–180.

46. Quoted in ibid., 181.

47. Bergquist, *Greta Knutson*, 4.

48. Tzara to Lucia Rosenstock, 7 June 1924, in "Scrisori către familie," 15.

49. Tzara to René Char, 23 July 1934, BLJD Ms. 22171.

50. "Voie," *OC*, 2:7.

51. Richelieu, RO 12581, f. 108.

52. André Breton, *Conversations: The Autobiography of Surrealism*, trans. Mark Polizzotti (New York: Paragon House, 1993), 56.

53. René Crevel, "Voici Tristan Tzara et ses souvenirs sur Dada," *Les Nouvelles littéraires*, 25 October 1924, 5.

54. "Démarrage," *OC*, 2:15.

55. Tzara to *Transatlantic Review*, September 1924, in *OC*, 1:724.

56. See Thora Dardel to Tzara, 23 September 1924, BLJD Ms. 23186 f. 78.

57. Crevel, "Voici Tristan Tzara."

58. *La Révolution Surrealiste*, no. 1 (December 1924), cover.

59. Crevel, "Voici Tristan Tzara."

60. Tzara to Marcel Jouhandeau, 19 June 1925, BLJD JHD C6003.

61. Emilia Rosenstock to Tzara, 6 January 1926, BLJD TZR C3490.

62. Gyula Illyés to Tzara, 10 December 1925, BLJD TZR C2124.

63. Tzara to Filip and Emilia Rosenstock, 27 October 1926, in "Scrisori către familie," 16.

64. See Le Corbusier to Tzara, 27 July 1925, BLJD TZR C2175.

65. Yvonne Brunhammer, "Les Années parisiennes d'Adolf Loos: 1922–1928," in *Adolf Loos 1870–1933* (Liège: Pierre Mardaga, n.d.), 113–118, at 115.

66. August Sarnitz, *Adolf Loos, 1870–1933: Architecte, critique culturel, dandy* (Paris: Taschen, 2003), 9; Werner Oechslin, *Otto Wagner, Adolf Loos, and the Road to Modern Architecture*, trans. Lynnette Widder (Cambridge: Cambridge University Press, 2002), 114.

67. See Daniel Purdy, "The Cosmopolitan Geography of Adolf Loos," *New German Critique* 99 (Fall 2006): 41–62.

68. Adolf Loos, *Spoken into the Void: Collected Essays, 1897–1900*, trans. Jane O. Newman and John H. Smith (Cambridge, MA: MIT Press, 1982).

69. Kenneth Frampton, "Adolf Loos and the Crisis of Culture, 1896–1931," in *The Architecture of Adolf Loos* (London: Arts Council, 1985), 8–12, at 12.

70. Giovanni Denti and Silvia Peirone, *Adolf Loos: opere complete* (Rome: Officina Edizioni, 1997), 215.

71. Quoted in Panayotis Tournikiotis, *Adolf Loos*, trans. Marguerite McGoldrick, 2nd edn. (Princeton: Princeton Architectural Press, 2002), 18. This was written for *Adolf Loos zum 60 Geburtstag am 10 Dezember 1930* (Vienna: Lanyi, 1930).

72. Adolf Loos, "Architecture" (1910), quoted in Sarnitz, *Adolf Loos*, 10 (emphasis original).

73. Stansilaus von Moos and Margaret Sobiesky, "Le Corbusier and Loos," *Assemblage* 4 (October 1987): 24–37, at 34. On the similarity between Maison Tzara and Villa Müller, see William Richer Eric Tozer, "A Theory of Making: Architecture and Art in the Practice of Adolf Loos" (Ph.D. thesis, University College London, 2011), 129–131, 156–157, 159, 175, 200–202, 218.

74. Sarnitz, *Adolf Loos*, 61–62. See also Cynthia Jara, "Adolf Loos's 'Raumplan' Theory," *Journal of Architectural Education* 48, no. 3 (1995): 185–201.

75. Sarnitz, *Adolf Loos*, 62.

76. Brunhammer, "Années parisiennes d'Adolf Loos," 116.

77. Jane Heap to Tzara, undated, BLJD TZR C1928.

78. Halicka, *Hier*, 114.

79. See BLJD TZR 672, f. 17.

80. Denti and Peirone, *Adolf Loos*, 218.

81. Tzara to Filip and Emilia Rosenstock, 27 October 1926, in "Scrisori către familie," 16.

82. BLJD TZR 672, f. 10–11. See also Johan van de Beek, "Adolf Loos—patterns of town houses," trans. Ruth Koenig, in *Raumplan versus Plan Libre: Adolf Loos and Le Corbusier, 1919–1930*, ed. Max Risselada (Delft: Delft University Press, 1988), 27–46, at 27.

83. Quoted in Beatriz Colomina, "Intimacy and Spectacle: The Interiors of Adolf Loos," *AA Files* 20 (1990): 5–15, at 12.

84. Halicka, *Hier*, 114.

85. Tzara to Filip and Emilia Rosenstock, 27 October 1926, in "Scrisori către familie," 16; Paul Charbonnier to Tzara, summer 1927, BLJD TZR C820.

86. Tzara to Filip and Emilia Rosenstock, 15 May 1927, in "Scrisori către familie," 16.

87. *De Mémoire d'homme*, OC, 4:99.

88. Tzara to Filip and Emilia Rosenstock, 15 May 1927, in "Scrisori către familie," 16.

89. Ibid.

90. Ibid.

91. "L'art et l'Océanie," OC, 4:310.

92. Emilia Rosenstock to Tzara, 16 March 1927, BLJD TZR C3493.

93. Emilia Rosenstock to Tzara, June 1927, BLJD TZR C3498.

94. Emilia Rosenstock to Tzara, 9 July 1927, BLJD TZR C3500.

95. Filip Rosenstock to Tzara, 30 August 1927, BLJD TZR C3503.

96. Leiris to Tzara, 2 July 1926, BLJD TZR C2354 (emphasis original).

97. Ilarie Voronca, "Marchez au pas: Tristan Tzara parle à *Integral*," *Integral* 3, no. 12 (April 1927): 6–7.

98. Louis Marcoussis to Tzara, 1 March 1928, reprinted in Hélène Lévy-Bruhl, "Tristan Tzara et le livre: ses éditeurs et ses illustrateurs" (Ph.D. thesis, École Nationale des Chartes, 2001), Annex "Indicateur des chemins de cœur."

99. Jeanne Bucher to Tzara, 9 March 1928, BLJD TZR C639.

100. Georges Hugnet, *Les Feuilles Libres*, no. 48 (May–June 1928), in *OC*, 2:408.

101. "Bifurcation," *OC*, 2:9.

102. Ibid.

103. "Pente," *OC*, 2:10.

104. See "Joan Miró et l'interrogation naissante," *OC*, 4:427–433.

105. "Hiboux," *OC*, 2:24.

106. "Approximation," *OC*, 2:31.

107. "Le dégel des ombres," *OC*, 2:48.

108. "Le Feu défendu," *OC*, 2:76; "Abords," *OC*, 2:45.

109. "Abords," *OC*, 2:45.

110. "Le Feu défendu," *OC*, 2:72.

111. "Rappel," *OC*, 2:47; "Le Pouilleux," *OC*, 2:34.

112. "À propos de Joan Miró," *OC*, 4:430 (emphasis original).

113. Ascher to Tzara, 27 November 1929, BLJD TZR C233.

114. Philippe Pelter, "L'art océanien entre les deux guerres: expositions et vision occidentale," *Journal de la Société des océanistes* 65 (1979): 271–281, at 279.

115. See correspondence from Éditions Duchartre, BLJD TZR C1260–1263.

116. On the 1928 exhibition, see Christine Laurière, "Lo bello y lo útil, el esteta y el etnógrafo: El caso del Museo Etnográfico de Trocadero y del Museo del Hombre (1928–1940)," *Revista de Indias* 72, no. 254 (2012): 35–66, at 39–45.

117. Tzara, "À propos de l'exposition d'Art précolombien," *L'Intransigeant*, 14 May 1928, 5.

118. Tzara, "L'Art et l'Océanie," *Cahiers d'Art* 4, nos. 2–3 (1929): 179–185.

119. Raoul Lehuard, "Charles Ratton et l'aventure de l'art nègre," *Arts d'Afrique noire*, no. 60 (Winter 1986): 11–33, at 16. Also see the exhibition catalog, *Charles Ratton, L'invention des arts "primitifs"* (Paris: Musée du Quai Branly, 2013).

120. See Maureen Murphy, "L'Exposition d'art africain et d'art océanien à la galerie du théâtre Pigalle, Paris, 1930," in *D'un regard l'autre: Histoire des regards européens sur l'Afrique, l'Amérique et l'Océanie*, exh. cat., ed. Yves Le Fur (Paris: Musée du Quai Branly, 2006), 308–310.

121. Quoted in Buot, *Tristan Tzara*, 224–225.

122. Henri Clouzot, "L'art africain et océanien au théâtre Pigalle," *Miroir du Monde*, 5 April 1930, 147–148, at 147.

123. Maurice Raynal, "Les 'nègres' font leur entrée dans le 'monde,'" *L'Intransigeant*, 4 March 1930, 5.

124. Carl Einstein, "A propos de l'Exposition de la Galerie Pigalle," *Documents* 2, no. 2 (1930): 104–110. See also Denis Hollier, "The Use-Value of the Impossible," trans. Liesl Ollman, *October* 60 (Spring 1992): 3–24.

125. Quoted in Maureen Murphy, "Du champ de bataille au musée: les tribulations d'une sculpture fon," at http://actesbranly.revues.org/213.

126. Ibid.

127. Ibid.

11 APPROXIMATE SURREALISM: 1929–1935

1. Benjamin Fondane, "Poésie pure: de Paul Valéry à Tristan Tzara," *Unu* 3, no. 22 (February 1930): 5–6, at 6.

2. André Breton, "Second Manifesto of Surrealism," in *Manifestoes of Surrealism*, trans. Richard Seaver and Helen R. Lane (Ann Arbor: University of Michigan Press, 1972), 171–172.

3. Maurice Nadeau, *The History of Surrealism*, trans. Richard Howard (London: Plantin, 1987), 75.

4. Georges Bataille, "Figure humaine," *Documents* 1, no. 4 (August 1929): 194–200, at 200.

5. Breton, "Second Manifesto," 172.

6. Ibid.

7. See "Un cadavre," "Déclaration du 27 janvier 1925," and "Papillons surréalistes," in *Tracts surréalistes et déclarations collectives 1922–1939*, ed. José Pierre (Paris: Le terrain vague, 1980), 24, 34–35, 32.

8. See Mark Polizzotti, *Revolution of the Mind: The Life of André Breton* (New York: Farrar, Straus, and Giroux, 1995), 278–279.

9. Auction catalog, *Importante partie de la bibliothèque de Tristan Tzara: éditions originales, documentation, livres illustrés, manuscrits et lettres autographes, dessins; Dada-surréalisme et les précurseurs* (Paris, Hôtel Druot, 4 March 1989), n.p.

10. Tzara to André Breton, 28 August 1929, in Michel Sanouillet, *Dada in Paris*, trans. Sharmila Ganguly (Cambridge, MA: MIT Press, 2009), 368.

11. André Breton, *Conversations: The Autobiography of Surrealism*, trans. Mark Polizzotti (New York: Paragon House, 1993), 119.

12. "Un cadavre," in *Tracts surréalistes*, 133.

13. Georges Ribemont-Dessaignes to André Breton, 12 March 1929, in *Tracts surréalistes*, 126–127.

14. Breton, "Second Manifesto," 124.

15. Jacques Costin to Tzara, 1 June 1930, BLJD TZR C974.

16. Alberto Giacometti to Tzara, 3 November 1930, BLJD TZR C1757.

17. Louis Aragon, "L'aventure terrestre de Tristan Tzara," *Les Lettres Françaises*, 2 January 1964, 1, 6–7; André Thirion, *Révolutionnaires sans révolution* (Arles: Actes Sud, 1999), 513.

18. See *OC*, 5:256–257.

19. See Fernand Drijkoningen, "Entre surréalisme et marxisme: Révolution et poésie selon Tzara," *Mélusine* 1 (1979): 265–280.

20. "Essai sur la situation de la poésie," *OC*, 5:21.

21. Ibid., 11, 16.

22. "Conférence sur Dada," *OC*, 1:421.

23. "Essai sur la situation de la poésie," *OC*, 5:25.

24. "Prosélyte à prix fixe," in *L'Antitête*, *OC*, 3:268.

25. "Essai sur la situation de la poésie," *OC*, 5:18.

26. Ibid., 20.

27. Ibid., 9.

28. Ibid., 12.

29. Ibid., 28.

30. See "Paillasse!" in *Tracts surréalistes*, 223–228.

31. Ilarie Voronca, "Marchez au pas: Tristan Tzara parle à *Integral*," *Integral* 3, no. 12 (April 1927): 6–7. Matthew Josephson read the debut of "Approximation" in late 1923; see Josephson to Tzara, 1 January 1924, BLJD TZR C2156.

32. Tzara to Breton, undated (1929), in Sanouillet, *Dada in Paris*, 369.

33. Tzara, *Approximate Man*, in *"Approximate Man" and Other Writings*, trans. Mary Ann Caws (Detroit: Wayne State University Press, 1973), 123.

34. Ibid., 83–84.

35. Ibid., 67.

36. Ibid.

37. Ibid., 45.

38. Ibid., 51.

39. Ibid., 45.

40. Ibid.

41. "Dada manifeste sur l'amour faible et l'amour amer," *OC*, 1:378.

42. Tzara, *Approximate Man*, 76, 79, 69.

43. Ibid., 69.

44. Ibid., 90.

45. Ibid., 103.

46. Ibid., 90.

47. Ibid., 44.

48. Ibid., 117.

49. Ibid., 57.

50. Ibid., 56, 55, 95, 126.

51. Ibid., 130–131.

52. Ibid., 80, 102.

53. Ibid., 43.

54. Jean Cassou to Tzara, 10 March 1930, BLJD TZR C729; Jean Cassou, *Les Nouvelles littéraires*, quoted in *OC*, 2:419.

55. Gyula Illyés to Tzara, 14 January 1930, BLJD TZR C2127.

56. Jacques Lévesque to Tzara, 25 June 1931, BLJD TZR C2388 (emphasis original).

57. Gaston Bachelard, "The Dialectics of Inside and Outside," in *The Continental Aesthetics Reader*, ed. Clive Cazeaux (London: Routledge, 2000), 151–163, at 159–160.

58. Jeanne-Marie Baude, "Tzara-Breton: comment peut-on être lyrique?," *Mélusine* 17 (1997): 155–168, at 158.

59. *Où boivent les loups*, OC, 2:177.

60. Ibid., 180.

61. Ibid., 179–180.

62. Ibid., 242.

63. Ibid., 212, 243.

64. Ibid., 186.

65. Ibid., 218.

66. Ibid., modified translation from Marcel Raymond, *From Baudelaire to Surrealism* (Fakenham: Cox and Wyman, 1970 [1933]), 286–287.

67. Ibid., 212.

68. Ibid., 257.

69. Tzara, "Notes et discussions," *Nouvelle Revue Française*, 1 August 1931, 329.

70. Jacques-Henry Lévesque, "Un inédit de Tzara et un rappel de Dada: Minuits pour Géants," *Journal des Poètes*, 15 December 1932, 2.

71. Tzara to Breton, 20 December 1932, in Sanouillet, *Dada in Paris*, 375.

72. Tzara, "Lettre ouverte au *Journal des Poètes*," 22 December 1932, in *Tracts surréalistes*, 237.

73. E. E. Cummings to Ezra Pound, 26 February 1938, in *Pound/Cummings: The Correspondence of Ezra Pound and E. E. Cummings*, ed. Barry Ahearn (Ann Arbor: University of Michigan Press, 1996), 123.

74. Alice Halicka, *Hier (Souvenirs)* (Paris: Éditions du Pavois, 1946), 115.

75. Unidentified to Tzara, undated (1932/3), BLJD Ms. 23186, f. 124.

76. Unidentified to Tzara, undated (1932/3), BLJD Ms. 23186, f. 132.

77. Unidentified to Tzara, undated (1932/3), BLJD Ms. 23186, f. 134.

78. Knutson to Tzara, quoted in François Buot, *Tristan Tzara: L'homme qui inventa la révolution Dada* (Paris: Grasset, 2002), 267. Although I have read the letters from Knutson to Tzara, I am obliged to quote from Buot because the original correspondence has been closed to researchers.

79. "Myrtilles sonores," in *L'Antitête*, OC, 2:382.

80. "D'un certain automatisme du goût," OC, 4:327–328.

81. Paul Vaillant-Couturier, "'Monde'? Non! Un 'Nouveau Monde'? Oui," *L'Humanité*, 28 June 1932, 4.

82. Wolfgang Klein, *Commune, revue pour la défense de la culture (1933–1939)*, trans. D. Bonnaud-Lamotte and M.-A. Couadou (Paris: Éditions du CNRS, 1988), 19.

83. "Le Manifeste de l'Association des Écrivains et Artistes révolutionnaires," *L'Humanité*, 29 March 1932, 4; *L'Humanité*, 22 March 1932, 4.

84. "Manifest Proletkunst," *Merz*, no. 2 (April 1923): 24.

85. "D'un certain automatisme du goût," *OC*, 4:327.

86. Ibid., 330.

87. Voronca, "Marchez au pas," 7.

88. Denis de Rougemont, Preface to *Cahier de Revendications, Nouvelle Revue Française*, 1 December 1932, 801. See also Dudley Andrew and Steven Ungar, *Popular Front Paris and the Poetics of Culture* (Cambridge, MA: Harvard University Press, 2005), 114–118.

89. Quoted in Paul A. Loffler, *Chronique de l'Association des écrivains et des artistes révolutionnaires, le mouvement littéraire progressiste en France, 1930–1939* (Rodez: Éditions Subervie, 1971), 17.

90. Breton, "Second Manifesto," 151.

91. Paul to Gala Éluard, February 1934, in *Lettres à Gala* (Paris: Gallimard, 1984), 230–231.

92. *Phases, OC*, 4:12.

93. Tzara to Char, 4 April 1934, BLJD Ms. 22168.

94. *Grains et issues, OC*, 3:137.

95. Ibid., 53.

96. Ibid., 101.

97. Ibid., 61.

98. Ibid., 86.

99. Ibid., 9, translation from Tzara, "*Approximate Man" and Other Writings*, 214–215.

100. Ibid., 25.

101. Ibid., 47.

102. Ibid., 117.

103. Notes, *OC*, 3:512.

104. "Lettre aux *Cahiers du Sud*," *OC*, 5:258–259 (emphasis original).

105. Quoted in Polizzoti, *Revolution of the Mind*, 370.

106. BLJD TZR 55, quoted in Notes, *OC*, 3:514.

12 POETRY AND POLITICS IN TIMES OF WAR: 1935–1944

1. *Grains et issues, OC*, 3:103.

2. Ibid., 131.

3. Ibid., 133.

4. Roger Shattuck, "Writers for the Defense of Culture," *Partisan Review* 51, no. 3 (1984): 393–416, at 394. On its organization, see Wolfgang Klein, "La préparation du Congrès: quand l'appareil communiste ne fonctionne pas," in *Pour la défense de la culture: Les textes du Congrès international des écrivains, Paris, juin 1935*, ed. Sandra Teroni and Wolfgang Klein (Dijon: Éditions Universitaires de Dijon, 2005), 35–64.

5. *L'Humanité*, 21 June 1935, 1.

6. *Le Temps* (Paris), 23 June 1935, 6; see also Sandra Teroni, "Défense de la culture et dialogues manqués," in *Pour la défense de la culture*, 13–33, at 18.

7. André Breton, *Conversations: The Autobiography of Surrealism*, trans. Mark Polizzotti (New York: Paragon House, 1993), 138.

8. See Jean Cassou, *Une vie pour la liberté* (Paris: Robert Laffont, 1981), 104–105.

9. Quoted in Herbert R. Lottman, *The Left Bank: Writers, Artists, and Politics from the Popular Front to the Cold War* (Chicago: University of Chicago Press, 1982), 86.

10. In *Pour la défense de la culture*, 375.

11. "Initiés et précurseurs," *OC*, 5:33.

12. Ibid., 36.

13. Ibid., 36–37 (emphasis original).

14. Tzara to Rosenstock family, 18 June 1936, in "Scrisori către familie, în România," *Aldebaran*, nos. 2–4 (1996), 17.

15. Mira Rinzler to author, 16 August 2009.

16. René Char to Tzara, 20 September 1936, BLJD TZR C798.

17. *Inquisitions*, no. 1 (June 1936), 65.

18. Ibid.

19. Gaston Bachelard, "Le Surrationalisme," *Inquisitions*, no. 1 (June 1936): 1–5, at 2 (emphasis original).

20. Louis Aragon, "Entre nous," *Inquisitions*, no. 1 (June 1936): 42–44, at 42.

21. Alfred H. Barr, Jr., "Preface," in *Fantastic Art, Dada, Surrealism*, ed. Alfred H. Barr, Jr. (New York: Museum of Modern Art, 1936), 7–8, at 7.

22. Barr, ed., *Fantastic Art*, 11, 17; Michel Sanouillet, "Tzara ou la quatrième dimension," *Strophes* 1, no. 2 (April 1964): 12–15, at 14.

23. Tzara to Alfred H. Barr, Jr., 6 October 1936, BLJD TZR C4031.

24. "Aux Avant-postes de la liberté," *OC*, 5:264.

25. Frederick R. Benson, *Writers in Arms: The Literary Impact of the Spanish Civil War* (New York: New York University Press, 1967), 6–7; "Propósito," *Hora de España*, no. 1 (January 1937): 5–6, at 5.

26. "Federico García Lorca," *OC*, 5:310.

27. *L'Humanité*, 26 July 1936, 1. See also Jean Cassou, *La Mémoire courte* (Paris: Éditions Mille et une nuits, 2001), 9–10; Jean-Marie Ginesta, "Jean Cassou et l'Espagne en 1936," *Matériaux pour l'histoire de notre temps*, nos. 7–8 (1986): 18–21.

28. Robert Delaunay to Tzara, 10 October 1925, BLJD TZR C1102; Guillermo de Torre to Tzara, 30 September 1925, BLJD TZR C3986.

29. Louis Fernandez to Tzara, 8 May 1936, BLJD TZR C1599.

30. Andrés Trapiello, *Las armas y las letras: literatura y Guerra Civil (1936–1939)* (Barcelona: Planeta, 1994), 124. See also Nicole Racine, "Une cause: L'antifascisme des intellectuels dans les années trente," *Politix* 5, no. 17 (1992): 79–85, at 82–83.

31. *La Voz* (Madrid), 30 July 1936, 3.

32. "Federico García Lorca," *OC*, 5:309.

33. "Sur le chemin des étoiles de mer," *OC*, 3:298, translation from Tristan Tzara, *Chanson Dada*, trans. Lee Harwood (Boston: Black Widow Press, 2005), 79.

34. Ibid., 300, translation from *Chanson Dada*, 81.

35. Ibid., 301, modified translation from *Chanson Dada*, 82.

36. Ibid., 301–302, translation from *Chanson Dada*, 82–83.

37. "Aux Avant-postes de la liberté," *OC*, 5:266.

38. Ibid.

39. Georges Soria, *Guerre et révolution en Espagne*, 5 vols. (Paris: R. Laffont, 1975–1977), 2:299.

40. "Discours à la radio," *OC*, 5:273.

41. *L'Humanité*, 17 January 1937, 7.

42. "Rapport du Comité pour la défense de la culture espagnole," *OC*, 5:281–283.

43. See Tzara to Robert Desnos, 26 October 1937, BLJD DSN C2148.

44. Corpus Braga, "El II Congreso Internacional de Escritores: Su significación," *Hora de España*, no. 8 (August 1937): 5–10, at 7.

45. See Manuel Aznar Soler, *Pensamiento literario y compromise antifascista de la inteligencia española republicana* (Barcelona: Editorial Laia, 1978), 137–162.

46. *L'Humanité*, 5 July 1937, 3.

47. *L'Humanité*, 17 July 1937, 8.

48. Interview with *La Libertad*, 13 July 1937; quoted in Luis Mario Schneider, *Inteligencia y guerra civil española* (Barcelona: Edtiorial Laia, 1978), 249–250.

49. Malcolm Cowley, "To Madrid: II," *The New Republic*, 1 September 1937, 93–96, at 95.

50. Malcolm Cowley, "To Madrid: III," *The New Republic*, 15 September 1937, 152–155, at 153–154.

51. Peter Monteath, *Writing the Good Fight: Political Commitment in the International Literature of the Spanish Civil War* (Westport, CT: Greenwood Press, 1995), 69.

52. "L'Individu et la conscience de l'écrivain," *OC*, 5:54–55.

53. Quoted in Paul Preston, *We Saw Spain Die: Foreign Correspondents in the Spanish Civil War* (London: Constable, 2009), 194–195.

54. "L'Individu et la conscience de l'écrivain," *OC*, 5:56.

55. Ibid.

56. Ibid.

57. Ibid.

58. Ibid.

59. "Ponencia colectiva," *Hora de España*, no. 8 (August 1937): 81–95, at 83–84.

60. "L'Individu et la conscience de l'écrivain," *OC*, 5:56.

61. *Commune*, September 1937, p. 1.

62. "Rapport du Comité pour la défense de la culture espagnole," *OC*, 5:283.

63. "Rencontres avec Adolf Hoffmeister," *OC*, 5:369.

64. "Le discours de M. Milan Hodza, président du Conseil," *L'Europe Centrale* 13, no. 27 (2 July 1938): 432.

65. "Le discours de M. Jules Romains," *L'Europe Centrale* 13, no. 27 (2 July 1938): 433–436, at 435–436.

66. Unidentified to Tzara, 16 July 1939, BLJD Ms. 23186, f. 106.

67. *Personnage d'insomnie*, *OC*, 3:157.

68. Marthe Baillon-Duret to Tzara, 13 October 1939, BLJD TZR C279.

69. Lars Bergquist, *Greta Knutson* (Paris: Centre culturel suédois, 1980), 5.

70. "Abrégé de la nuit," *OC*, 3:225, 243.

71. "Toute une vie," *OC*, 3:334.

72. Isabelle Ville, *René Char: Une poétique de résistance: être et faire dans les Feuillets d'Hypnos* (Paris: Presses de l'Université Paris-Sorbonne, 2006), 155; Bergquist, *Greta Knutson*, 8.

73. "Dévidée," *OC*, 3:253.

74. "Abrégé de la nuit," *OC*, 3:223.

75. Ibid., 243.

76. Ibid., 239, translation from *"Approximate Man" and Other Writings*, trans. Mary Ann Caws (Detroit: Wayne State University Press, 1973), 223.

77. Ibid., 240, translation from *"Approximate Man" and Other Writings*, 224; "Abrégé de la nuit," *OC*, 3:249.

78. Ibid., 240, translation from *"Approximate Man" and Other Writings*, 224.

79. "Le Géant des murs," *OC*, 3:277.

80. "Espagne 1946," *OC*, 314–315.

81. "Chant de Guerre Civile," *OC*, 3:317.

82. "Tournesol des passants," *OC*, 3:268.

83. "Pieds nus," *OC*, 3:305.

84. *Paru*, 15 January 1949, 46–47; quoted in *OC*, 3:582.

85. Mira Rinzler to author, 16 August 2009.

86. *Le Petit Parisien*, 2 September 1939, 2.

87. "Quatre poèmes de petite guerre," *OC*, 3:380.

88. Ibid., 383.

89. *La Fuite*, *OC*, 3:491.

90. "Exil," *OC*, 3:384.

91. See Marcel Duchamp to Tzara, January 1946, BLJD TZR C1257.

92. *La Fuite*, *OC*, 3:497.

93. Ibid., 444.

94. "Le Surréalisme et l'après-guerre," *OC*, 5:59.

95. *La Fuite*, *OC*, 3:452.

96. Ibid., 447.

97. Ibid., 446.

98. Ibid., 454.

99. Ibid., 464.

100. Ibid., 445, 472.

101. Ibid., 468.

102. Ibid., 503.

103. "A soi-même promis," *OC*, 3:368–369.

104. Pierre Seghers, *La Résistance et ses poètes* (Paris: Seghers 1974), 392.

105. *Les Lettres Françaises*, no. 5 (January–February 1943): 2.

106. "Marcel Jouhandeau," *OC*, 5:290–291.

107. AD46, Dossier Tzara 209W695, f. 6.

108. AD46, Dossier Tzara 209W695, f. 4.

109. See Rosemary Sullivan, *Villa Air-Bel: The Second World War, Escape, and a House in France* (London: John Murray, 2006).

110. François Buot, *Tristan Tzara: L'homme qui inventa la révolution Dada* (Paris: Grasset, 2002), 352.

111. Tzara to René Bertelé, 2 December 1941, BLJD Ms. Ms. 48126.

112. AD46, Dossier Tzara 209W695, f. 3, 6.

113. "Chaque Jour," *OC*, 3:430.

114. AD46, Dossier Tzara 209W695, f. 11.

115. Tzara to René Bertelé, 19 March 1942, BLJD Ms. Ms. 48127.

116. AD46, Dossier Tzara 209W695, f. 9.

117. Denis Peschanski, "Exclusion, persécution, répression," in *Le Régime de Vichy et les Français*, ed. Jean-Pierre Azéma and François Bédarida (Paris: Fayard, 1992), 209–234, at 226.

118. BLJD TZR C4364.

119. Abbé P. Pons, *Souillac et ses environs: histoire, archéologie, tourisme* (Souillac: Éditions La Liberté, 1923), 161.

120. Pierre Laborie, *Résistants Vichyssois et autres: l'évolution de l'opinion et des comportements dans le Lot de 1939 à 1949* (Paris: Éditions CNRS, 1980), 16.

121. BLJD TZR C4364; see Betz to Tzara, BLJD TZR C442–456.

122. *Je suis partout*, 21 May 1943, 2.

123. *Le Patriote du Sud-Ouest*, 24 August 1944, 2.

124. *Le Lot Résistant*, no. 2 (October 1943), 2.

125. *Le Lot Résistant*, no. 3 (early 1944), 2; *Le Lot Résistant*, no. 5 (April 1944), 3.

126. Raymond Picard and Jean Chaussade, *Ombres et espérances en Quercy, 1940–1945: Les groupes Armée Secrète Vény dans leurs secteurs du Lot* (Gourdon: Les Éditions de la Bouriane, 1999), 307.

127. Laborie, *Résistants Vichyssois*, 318.

128. "La Vague," *OC*, 3:431.

129. AD46, Dossier Tzara 209W695, f. 14.

130. Ibid., f. 8, 15.

131. René Tavenier to Tzara, 29 July 1943, BLJD TZR C3947.

132. See Aragon to Malcolm Cowley, 8 March (1945?), Beinecke Library, Yale University, Matthew Josephson Papers, YCAL MSS26, Series 1, Correspondence, Box 1, folder 7.

133. Quoted in Herbert R. Lottman, *The Left Bank: Writers, Artists, and Politics from the Popular Front to the Cold War* (Boston: Houghton Mifflin, 1982), 209.

134. "Une Route seul soleil," *OC*, 3:408.

135. Ibid.

136. "Ça va," *OC*, 3:411.

137. "Poésie et culture," *OC*, 5:325.

138. Picard and Chaussade, *Ombres et espérances*, 308, 317.

13 THE SECRETS OF A RENAISSANCE: 1944–1963

1. Jean Estèbe, *Toulouse 1940–1944* (Paris: Perrin, 1996), 22.

2. Tzara to *Horizon*, 1 August 1945, BLJD TZR C4366.

3. Pierre Mazars to Tzara, 14 June 1945, BLJD TZR C2608. Henri Lefebvre, who also worked at Radio Toulouse, relates a series measures taken at the station against Tzara; see Lefebvre to Tzara, BLJD TZR C2230–2232. See also Henri Sempéré, "Le radio de la Libération à Toulouse," in *La Libération dans le midi de la France*, ed. Rolande Trempé (Toulouse: Eché, 1986), 347–357.

4. Tzara to *Horizon*, 1 August 1945, BLJD TZR C4366.

5. Marie Bonnafé, "Révolution surréaliste, révolution psychiatrique: Changer de regard, un travail infini," in *Lucien Bonnafé, psychiatre désaliéniste*, ed. Bernadette Chevillion (Paris: L'Harmattan, 2005), 13–21.

6. Georges Daumezon and Lucien Bonnafé, "L'Internement: conduite primitive de la société devant le malade mental: recherché d'une attitude plus évoluée," in *Documents de la l'information psychiatrique: La Malade mentale dans la société* (Paris: Desclée de Brouwer, 1946), 79–108, at 97.

7. *Où boivent les loups*, *OC*, 2:202.

8. Tzara, radio interview, 8 June 1950, in *OC*, 5:582.

9. Tzara to Leiris, 20 August 1945, BLJD Ms. 44335.

10. *Parler seul*, *OC*, 5:51.

11. Ibid., 53.

12. Ibid., 42.

13. Ibid., 66.

14. "Le Surréalisme et l'après-guerre," *OC*, 5:59.

15. Tzara to unidentified, 12 June 1948, BLJD TZR C4043 (indicating that he "just now recuperated" his apartment).

16. Tzara to Hugnet, 8 September 1945, BLJD Ms. Ms. 47158.

17. René Leibowitz to Tzara, 29 June 1945, BLJD TZR C2348; Michel Leiris, *Journal, 1929–1989*, ed. Jean Jamin (Paris: Gallimard, 1992), 422–423.

18. Michel Leiris, "Présentation de *La Fuite*," in *Brisées* (Paris: Gallimard, 1966), 110–114, at 113.

19. Isidore Isou, *Introduction à une nouvelle poésie et à une nouvelle musique* (Paris: Gallimard, 1947), 29–30 (emphasis original).

20. Philippe Soupault, *Journal d'un fantôme* (Paris: Les Éditions du Point du Jour, 1946), 140.

21. *The Times*, 25 April 1946, 2.

22. "Interview de Tristan Tzara à travers les Balkans," *OC*, 5:383.

23. See Richard Sacker, *A Radiant Future: The French Communist Party and Eastern Europe, 1944–1956*, ed. Michael Kelly (Bern: Peter Lang, 1999).

24. Pavel Țugui, "Tristan Tzara și regimul democrat popular din România," *Caiete critice*, no. 222 (April 2006): 23–31, at 25–26.

25. "Entretien avec Tristan Tzara," *OC*, 5:390.

26. Florica Șelmaru, "Colaborationiști și maquisarzi: Tristan Tzara ne vorbește despre situația politică din Franța, despre cultură și România," *Contimporanul*, 29 November 1946, 1.

27. Liana Maxy, "Tristan Tzara, poet în slujbă libertății vorbește la ziarului nostru," *România liberă*, 27 November 1946, 1, 6.

28. *Orizont* 2, no. 7 (April 1946): 3.

29. Sașa Pană, "Importanța prezenței lui Tristan Tzara in România," *Orizont* 3, no. 2 (December 1946): 2–3, at 2.

30. Ovid S. Crohmălniceanu, "Semne la orizont," *Orizont* 3, no. 2 (December 1946): 14–15.

31. See Michel Fauré, *Histoire du surréalisme sous l'Occupation* (Paris: La Table Ronde, 1982).

32. "Le Surréalisme et l'après-guerre," *OC*, 5:71.

33. Ibid., 99, 72.

34. Tzara, "Le Surréalisme et la crise littéraire," *Mélusine* 21 (2001): 307–317, at 317.

35. Tzara to Georges Ribemont-Dessaignes, 27 June 1946, BLJD Ms. 24342.

36. "Le Surréalisme et l'après-guerre," *OC*, 5:73.

37. André Breton, *Conversations: The Autobiography of Surrealism*, trans. Mark Polizzotti (New York: Paragon House, 1993), 162.

38. "Journal à plusieurs voix," *Esprit*, April 1947, 659–663, in *OC*, notes, 5:640.

39. Mark Polizzotti, *Revolution of the Mind: The Life of André Breton* (New York: Farrar, Straus, and Giroux, 1995), 491.

40. *Les Nouvelles Littéraires*, 20 March 1947, 4.

41. "Le Surréalisme et l'après-guerre," *OC*, 5:77.

42. Ibid.

43. Ibid., 65.

44. Ibid., 68.

45. Ibid., 66.

46. Ibid., 76 (emphasis original).

335

47. Ibid., 77.

48. Ibid.

49. Ibid., 95.

50. Ibid., 76, 95.

51. Sudhir Hazareesingh, *Intellectuals and the French Communist Party: Disillusion and Decline* (Oxford: Clarendon Press, 1991), 15.

52. Quoted in François Buot, *Tristan Tzara: L'homme qui inventa la révolution Dada* (Paris: Grasset, 2002), 397.

53. BLJD TZR 550, f. 7.

54. "Picasso et la peinture de circonstance," *OC*, 4:535 (emphasis original).

55. *De Mémoire d'homme*, *OC*, 4:145.

56. "Ton Cri Espagne," *OC*, 4:245.

57. "Des Profondeurs," *OC*, 4:267.

58. *Phases*, *OC*, 4:11.

59. Ibid., 23.

60. See Marc Lazar, "Les 'batailles du livre' du parti communiste français (1950–1952)," *Vingtième Siècle* 10, no. 1 (1986): 37–50.

61. BLJD TZR 550, f. 4.

62. See Tzara to Éditions du *Sagittaire*, May 1945, BLJD TZR C4050.

63. *Phases*, *OC*, 4:15; *De Mémoire d'homme*, *OC*, 4:86.

64. *De Mémoire d'homme*, *OC*, 4:88, 89, 93.

65. *Phases*, *OC*, 4:17, 9; *À Haute flamme*, *OC*, 4:206.

66. "Saison," *OC*, 4:267.

67. Béhar, notes, *OC*, 5:618.

68. "Guillaume Apollinaire," *OC*, 5:297–298.

69. "Interview de Tristan Tzara à travers les Balkans," *OC*, 5:383 (emphasis added).

70. "Un Écrivain français parle de la portée internationale des événements de Hongrie," *OC*, 5:420 (emphasis original).

71. BLJD TZR 532, f. 1.

72. *De Mémoire d'homme*, *OC*, 4:96–97.

73. Motherwell to Tzara, 3 April 1947, BLJD TZR C2806.

74. Motherwell to Tzara, 22 September 1949, BLJD TZR C2810; Motherwell, "Preface," *The Dada Painters and Poets*, ed. Robert Motherwell (Cambridge, MA: Harvard University Press, 1981), xvii.

75. Richard Huelsenbeck, "Dada Manifesto, 1949," in *Dada Painters and Poets*, 402.

76. Tzara to Motherwell, 26 September 1949, BLJD TZR C4042.

77. See Motherwell, "Introduction," in *Dada Painters and Poets*, xxxvi.

78. See Henri Béhar, "Tristan Tzara, historiographe de Dada," *CTT* 1 (1999): 57–63.

79. René Lacôte, *Tristan Tzara* (Paris: Pierre Seghers, 1952), 10–11.

80. The extent of Tzara's rich archive of the literary avant-garde can be seen in the auction catalog *Dokumentations—Bibliothek III: Teile der Bibliothek und Sammlung Tristan Tzara, Paris* (Bern: Kornfeld and Klipstein, 1968).

81. Tzara to Ribemont-Dessaignes, 30 July 1958, BLJD MS. 24343.

82. Tzara to Giulio Einaudi, 11 December 1961, BLJD TZR C4036.

83. Laurent Casanova, *Le Parti Communiste, les intellectuels et la nation* (Paris: Éditions Sociales, 1949), 11.

84. Réunion du bureau politique, 14 June 1956, 17 August 1956, Archives départementales de Seine-Saint-Denis (93), 261 J 4/13. Hereafter cited AD93.

85. Charles Dobzynski, "En Tunisie avec Tristan Tzara," *Les Lettres françaises*, 20 December 1951, 1.

86. "Sur l'art des peuples africains," *OC*, 4:317.

87. *L'Égypte face à face*, *OC*, 4:556.

88. Ibid., 545.

89. Ibid., 543.

90. Ibid., 551.

91. Ibid., 544.

92. Ibid., 542.

93. See Farkas János, "Tristan Tzara în Ungaria, Octombrie 1956," *Apostrof* 17, no. 12 (2006), at http://www.revista-apostrof.ro/articole.php?id=154.

94. *Vérités sur la Hongrie* (Paris: PCF, November 1956), 10; Réunion du bureau politique, 26 October 1956, AD93, 261 J 4/13.

95. "Un Écrivain français parle," *OC*, 5:419.

96. Ibid., 420.

97. Ibid.

98. Ibid., 419; Aimé Césaire to Maurice Thorez, November 1956, AD93, 261 J 6/9.

99. Edgar Morin, "L'heure zéro des intellectuels du parti communiste français," *France-Observateur*, 25 October 1956, 19.

100. André Breton, *Œuvres complètes*, vol. 4, ed. Marguerite Bonnet (Paris: Gallimard, Bibliothèque de la Pléiade, 2008), 1067.

101. Quoted in Farkas, "Tristan Tzara în Ungaria."

102. "Paul Éluard à toute épreuve," *OC*, 5:664.

103. "La réponse des écrivains français," *France-Observateur*, 29 November 1956, 14.

104. Tzara to Casanova, 27 November 1956, AD93, 261 J 6/9.

105. *L'Humanité*, 24 November 1956, 5.

106. Ibid.

107. *L'Humanité*, 5 December 1956, in AD93, 267 J 2 (1956).

108. "Tristan Tzara et les arts dits primitifs," *France-Culture*, 22 December 2006, at http://www.fabriquedesens.net/Peinture-fraiche-Tzara.

109. For an excellent analysis, see Daniel Heller-Roazen, *Dark Tongues: The Art of Rogues and Riddlers* (New York: Zone Books, 2013), 153–183.

110. "Conférence sur Dada," *OC*, 1:419.

111. "Dada est un microbe vierge," *OC*, 5:449.

112. Jack Lindsay, *Meetings with Poets: Memories of Dylan Thomas, Edith Sitwell, Louis Aragon, Paul Éluard, Tristan Tzara* (London: Muller, 1968), 225.

113. Jacques Lacan, "Dissolution, 18 mars 1980," at http://www.ecole-lacanienne.net/stenos/seminaireXXVII/1980.03.18.pdf.

114. "Tristan Tzara et les arts dits primitifs."

115. Barrillot to Tzara, 27 October 1948, BLJD TZR C349.

116. "L'Actualité de Villon," *OC*, 5:122, 115–116.

117. Quoted in *OC*, 6:539, translation from Heller-Roazen, *Dark Tongues*, 157–158.

118. *Le Secret de Villon*, *OC*, 6:10–11, translation modified from Heller-Roazen, *Dark Tongues*, 158.

119. Ibid., 11.

120. Ibid., 275–276.

121. Ibid., 10, 145.

122. Ibid., 219.

123. Ibid., 91.

124. *Annexe Rabelais*, *OC*, 6:518.

125. *Secret de Villon*, *OC*, 6:16.

126. Ibid., 282, *Annexe Rabelais*, *OC*, 6:511; Louis Aragon, "Tristan Tzara découvre une œuvre nouvelle de Rabelais," *Les Lettres Françaises*, 24 October 1963, 7.

127. Charles Dobzynski, "Le Secret de Villon," *Les Lettres Françaises*, 17 December 1959, 1.

128. *Le Monde*, 22 December 1959, 9; quoted in Heller-Roazen, *Dark Tongues*, 153.

129. Jean-Claude Fasquelle to Tzara, 10 May 1960, BLJD TZR C1524.

130. Giangiacomo Feltrinelli to Tzara, 23 October 1959, BLJD TZR C1593.

131. *Annexe Rabelais*, *OC*, 6:517.

132. *Secret de Villon*, *OC*, 6:16.

133. *Annexe Rabelais*, *OC*, 6:529.

134. *Secret de Villon*, *OC*, 6:215.

135. Ibid., 17; *Annexe Rabelais*, *OC*, 6:513.

136. M. Puisségur, "Rabelais, Dada et les probabilités," *Bulletin de l'association des professeurs de mathématiques de l'enseignement public*, no. 277 (January–February 1971): 9–23, at 23.

137. Lynn D. Stults, "A Study of Tristan Tzara's Theory Concerning the Poetry of Villon," *Romania* 96 (1975): 433–458, at 457–458.

138. See Heller-Roazen, *Dark Tongues*, 171–180.

139. "Le Bureau des rêves perdus," *OC*, 5:426–427.

140. *The Times*, 13 August 1962, 5.

141. "Propos sur la culture africaine," *OC*, 5:569, 568.

142. Ibid., 569–570.

143. Quoted in Sandro Volta, "Ricordo di Tristan Tzara," *L'Europa letteraria*, January 1964, 66–69, at 68.

144. Volta, "Ricordo di Tristan Tzara," 68.

145. In Tristan Tzara, *"Approximate Man" and Other Writings*, trans. Mary Ann Caws (Detroit: Wayne State University Press, 1973), 49.

146. Quoted in Volta, "Ricordo di Tristan Tzara," 68.

147. "Dada est un microbe vierge," *OC*, 5:447.

148. Ibid., 448.

149. Isidore Isou, *Considérations sur la mort et l'enterrement de Tristan Tzara* (Paris: Centre de Créativité, 1965), 5.

150. "Dada est un microbe vierge," *OC*, 5:451.

342

343

344

346

349

352

354

355

356